AFRICAN WARRIORS

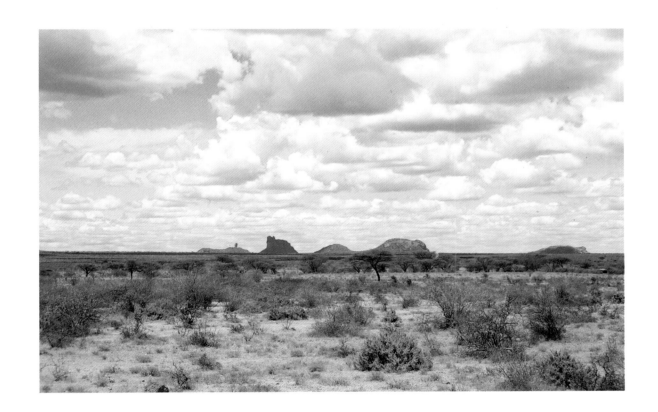

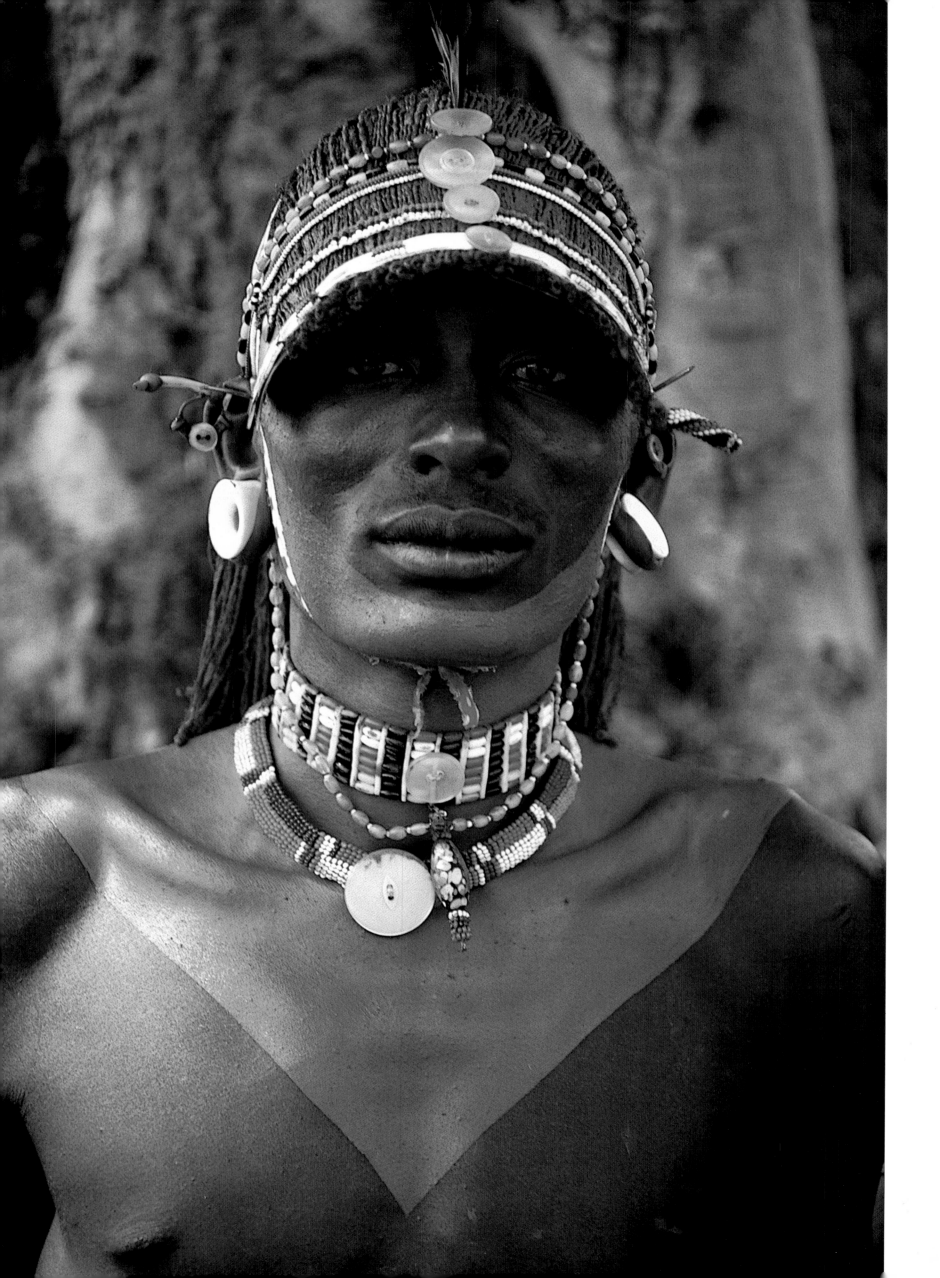

AFRICAN WARRIORS
The Samburu

Thomasin Magor

DESIGN BY BARNEY WAN

Harry N. Abrams, Inc.
PUBLISHERS

When darkness seemed to cloud me,
When doubt seemed to crowd me,
When deep fear seemed to creep within,
I remembered this . . .

I said to the man who stood at the Gate: "Give me a light
that I may tread safely into the unknown."
And he replied: "Go out into the darkness and put your
hand into the hand of God. That shall be to you better
than light and safer than a known way."

<div align="right">MINNIE LOUISE HASKINS (1875–1957)</div>

HALF-TITLE PAGE: Ndonyomurto, a rocky outcrop, rises from the wide expanse of the Samburu district.

FACING TITLE PAGE: A warrior, with characteristic headdress, jewellery and striking geometric ochre patterns painted on his face and chest.

OPPOSITE: A *laibartani*, a young initiate approaching warriorhood, wears the headdress appropriate to his status during the "month of birds".

Library of Congress Cataloging-in-Publication Data

Magor, Thomasin.
 African warriors. The Samburu / Thomasin Magor.
 p. cm.
 ISBN 0-8109-1943-5
 1. Samburu (African poeple) I. Title.
DT433.545.S26M34 1994
967.62'004965—dc20 93-47465

Text and photographs © 1994 Thomasin Magor
Maps and diagrams © 1994 HarperCollins*Publishers*
Drawings © 1994 Barney Wan

First published in Great Britain in 1994 by Harvill,
an imprint of HarperCollins*Publishers*

Published in 1994 by Harry N. Abrams, Incorporated, New York
A Times Mirror Company

Printed and bound in Germany

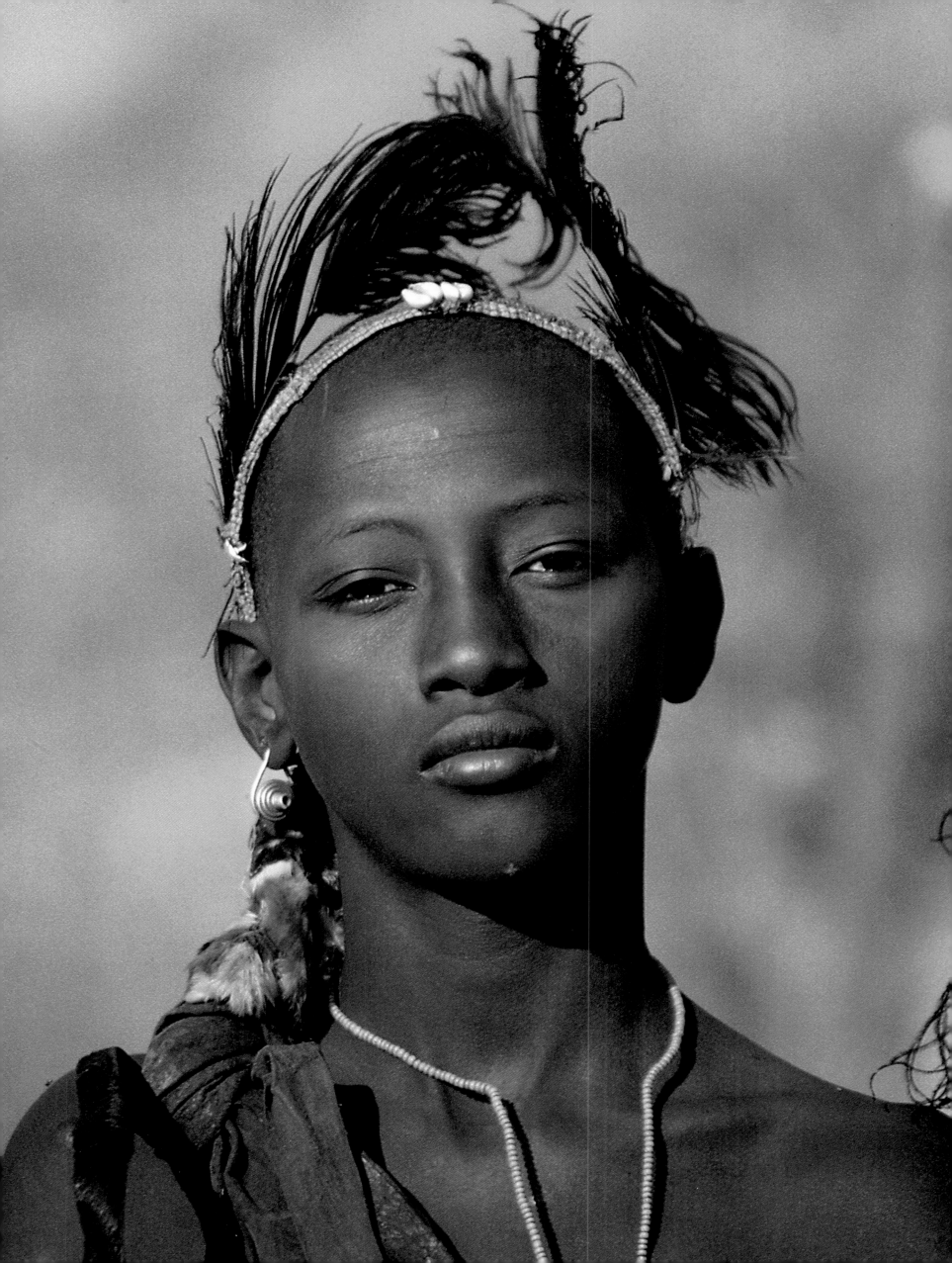

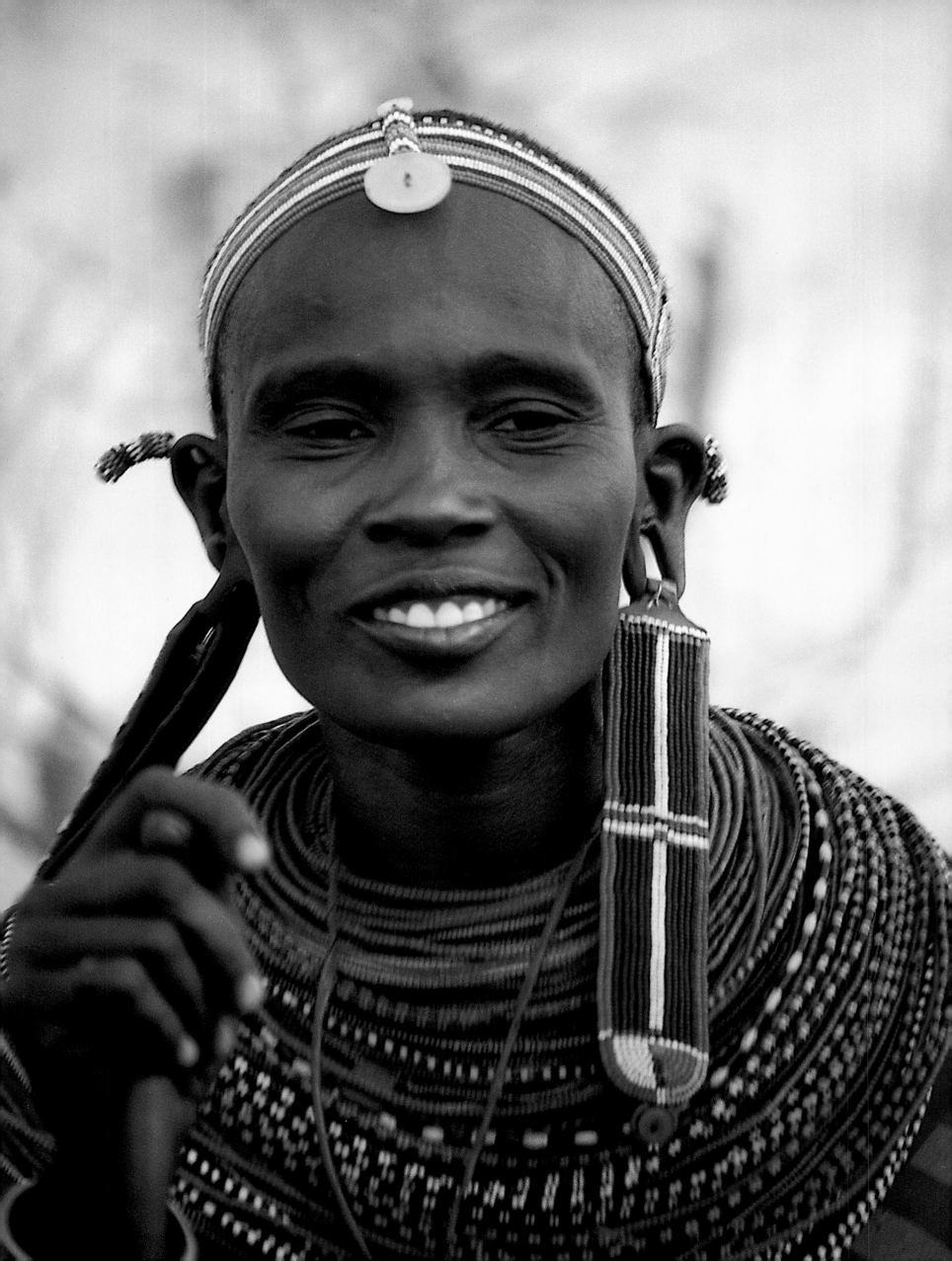

CONTENTS

LEFT: A woman of the Lpisikishu clan wearing long beaded earrings which denote her married status.

I dedicate this book to my father, himself a warrior of life.

I owe a great debt to the people of Samburu who allowed me into their lives, and without whose kindness and acceptance *African Warriors* would not have been dreamt of. I would especially like to thank all those who cared for and nurtured me, guarded and nursed me, shared and joked with me, and like a family stood by me through tears and laughter, above all Lmairan, Lananguru, Lemetien and Ldeke.

I would also like to thank my mother and family, who staunchly supported me, especially my sister, Jenny, who from the start never doubted me, and my many friends, who have stood by me with unshakable loyalty, especially when light seemed to fade.

I must also acknowledge the Tilleys, who were my only link by radio to the outside world; my agent and mentor, Toby Eady, who always said he knew this book would one day be; and Barney, my friend and designer, who has invested an immeasurable amount of time and patience in this book, and is the only man I know to have cooked a gourmet Chinese meal on a camp fire within an *nkang*.

I am grateful to Christopher MacLehose who set the challenge of creating a "monument" to the Samburu; to Bill Swainson, who put long hours into editing the book and designing the text; to Jeremy Coote, who read the text; and especially to Michael Rainy, *babalai asche oleng*, and Lekale Lesorogal.

Finally, I may have lost one of my guiding lights during the course of making this book, but I was blessed with two more, my husband and my son, who led me to the completion of *African Warriors*.

RIGHT: A married woman of the Longeli clan stands silent and serene, wrapped in her long shawl.

OVERLEAF: Grevy zebra, characteristic of Samburu district, blend in among the long grass and thorny scrub trees.

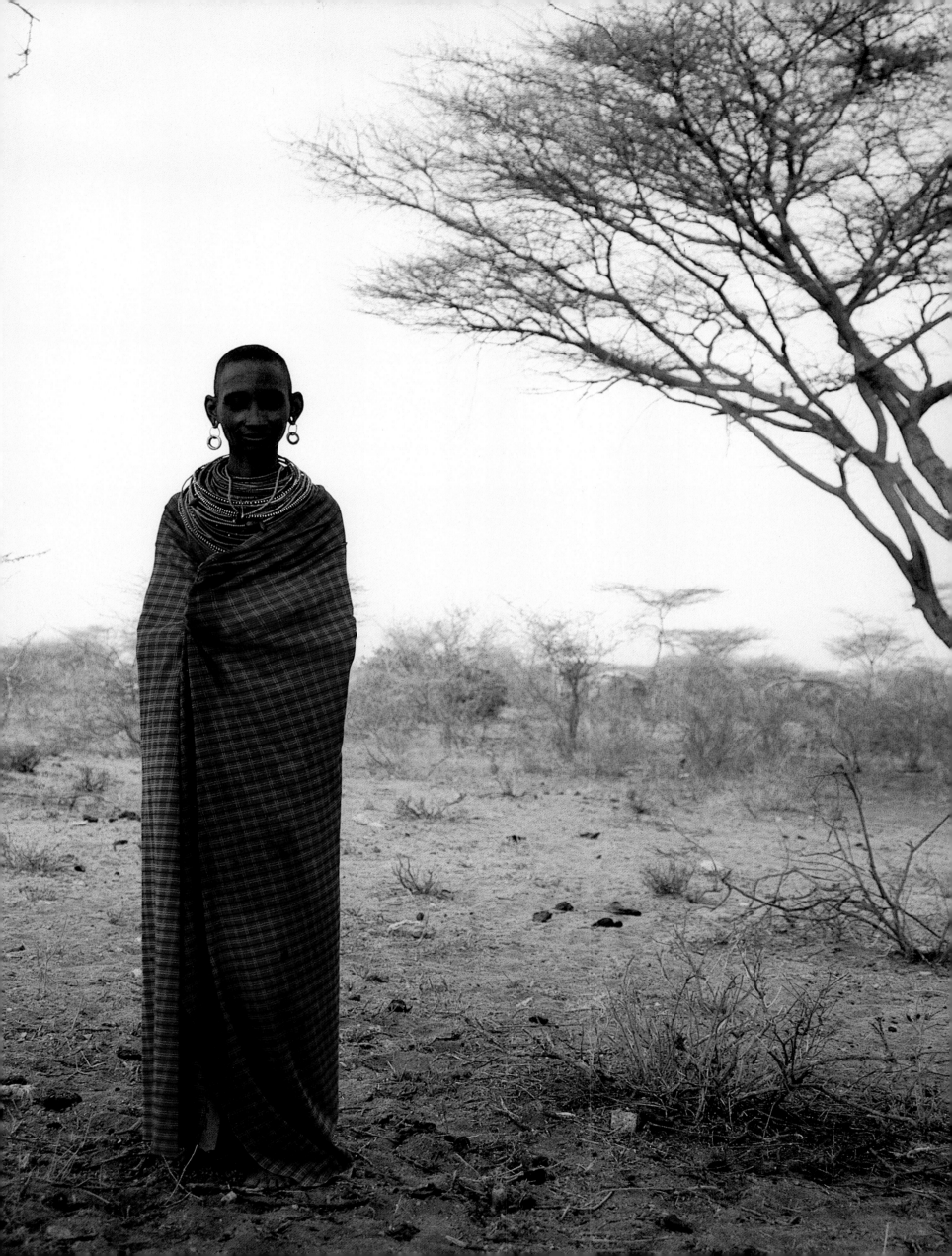

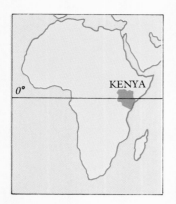

KENYA

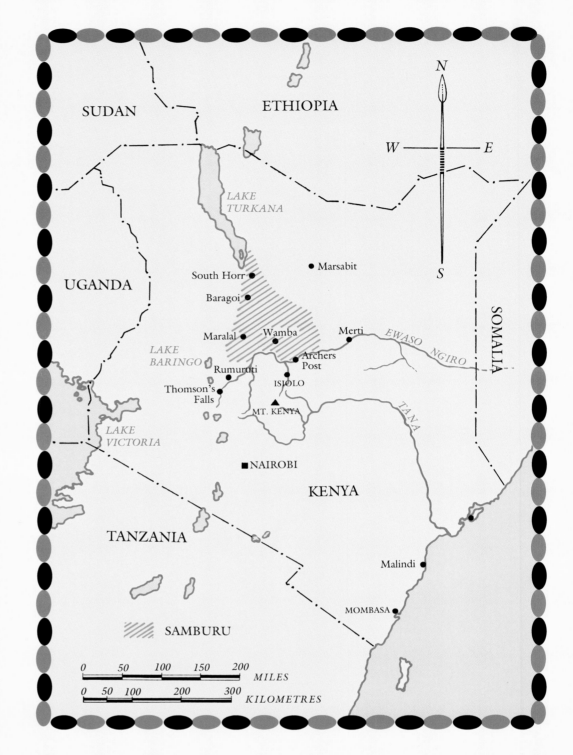

SUDAN

ETHIOPIA

N

W — *E*

S

LAKE TURKANA

UGANDA

• Marsabit

South Horr •

Baragoi •

SOMALIA

Maralal • • Wamba

Merti •

EWASO NG'IRO

LAKE BARINGO

Archers Post

Rumuruti •

ISIOLO

Thomson's Falls •

▲ MT. KENYA

LAKE VICTORIA

TANA

■ NAIROBI

KENYA

TANZANIA

Malindi •

MOMBASA •

SAMBURU

0 50 100 150 200
 MILES
0 50 100 200 300
 KILOMETRES

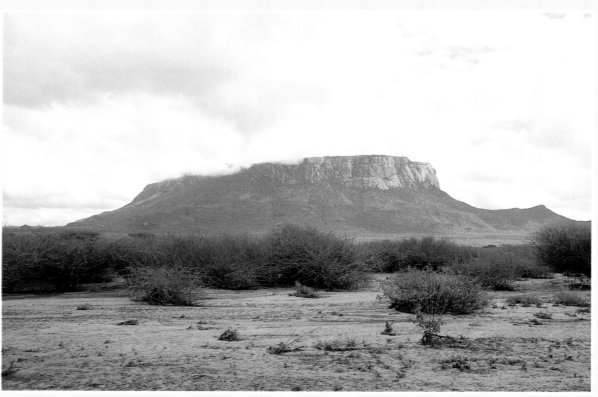

RIGHT: Mount Lololokwi or Ol Doinyo Lololokwi Sabache, as the Samburu call it.

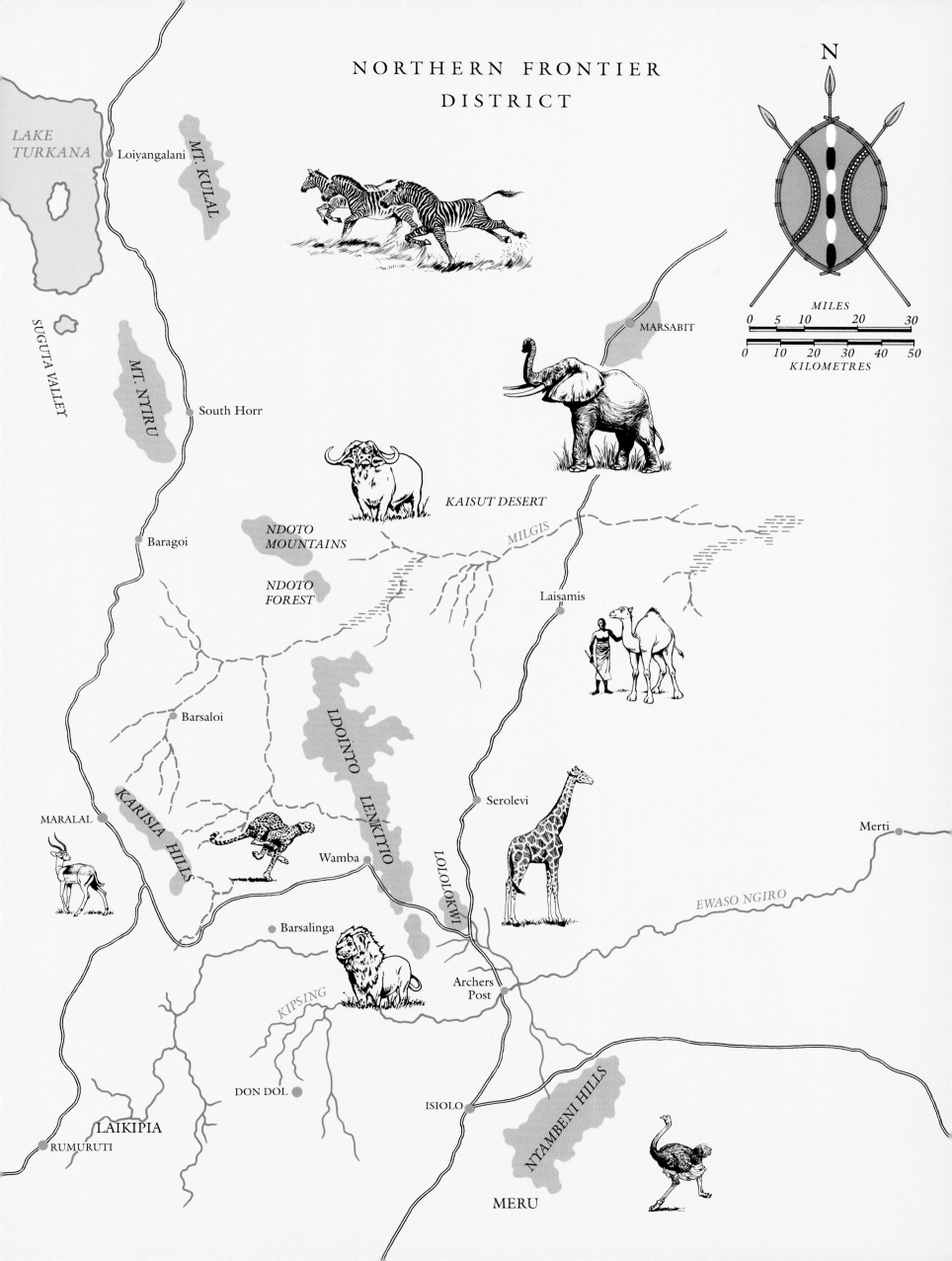

NORTHERN FRONTIER DISTRICT

N

LAKE TURKANA

Loiyangalani

MT. KULAL

SUGUTA VALLEY

MT. NYIRU

South Horr

MARSABIT

MILES

0 5 10 20 30

0 10 20 30 40 50

KILOMETRES

KAISUT DESERT

NDOTO MOUNTAINS

Baragoi

MILGIS

NDOTO FOREST

Laisamis

Barsaloi

LDOINYO LENKIYIO

MARALAL

KARISIA HILLS

Serolevi

Merti

Wamba

LOLOLOKWI

Barsalinga

EWASO NGIRO

KIPSING

Archers Post

DON DOL

ISIOLO

LAIKIPIA

NYAMBENI HILLS

RUMURUTI

MERU

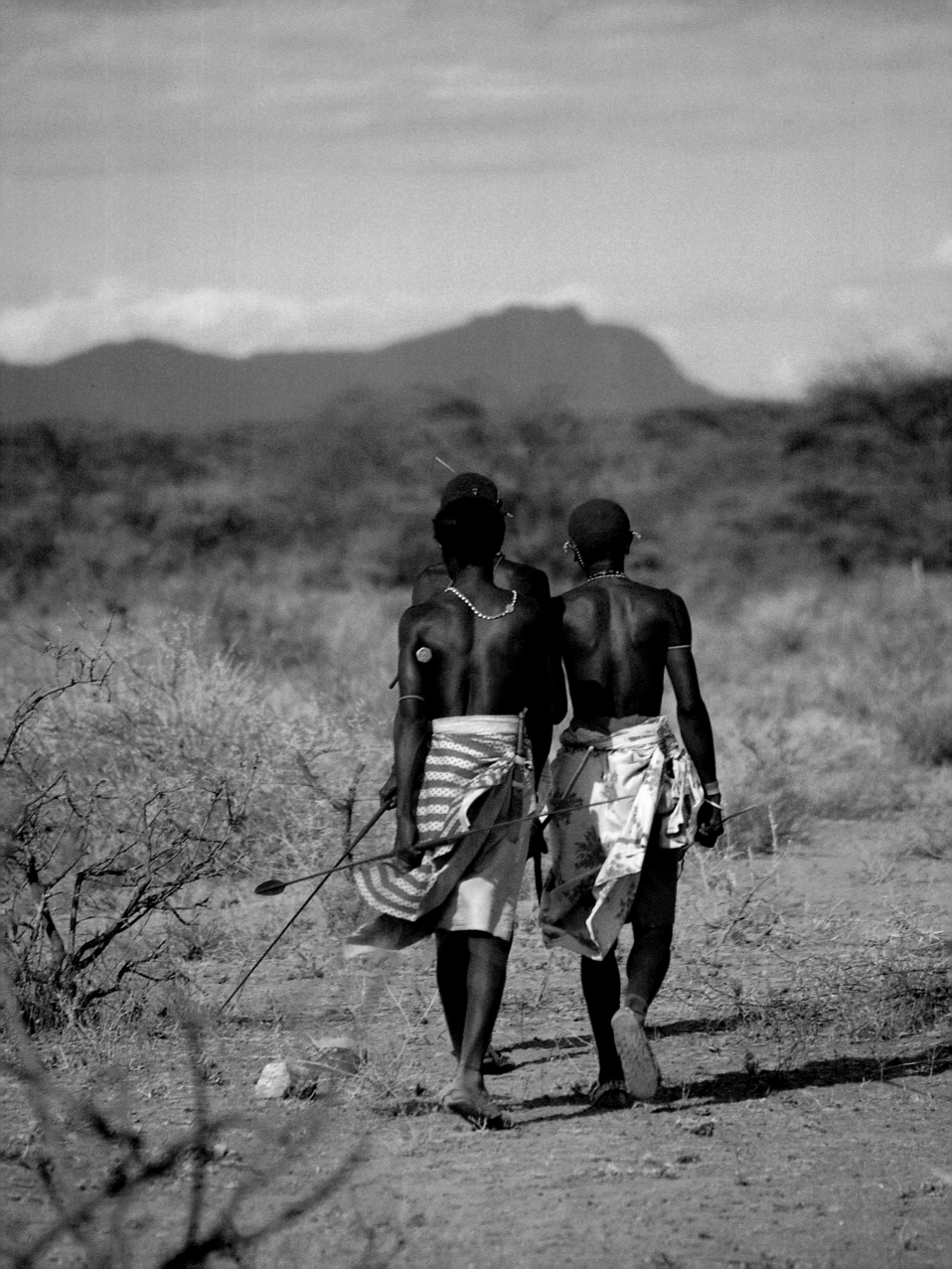

INTRODUCTION

Northern Butterflies

The exact origin of the Samburu, who inhabit an area in Kenya's rugged Northern Frontier District, is unknown. They are a tall, lean, flamboyant people with fine bone structure, whose strong profiles, distinctive *lalema* (short fighting swords) and elaborate hairstyles reminiscent of Roman helmets have given rise to the legend that they are the descendants of a lost legion. Samburu history itself is entirely oral and does not go back much further than the late nineteenth century. Mainly concerned with cattle-raids and tribal skirmishes, intermingled with accounts of family history, it provides no supporting evidence.

What can be said with rather more certainty is that the Samburu are one of several East African Nilotic peoples, who show traits of Hamitic acculturation. Like the Maasai and other tribes of Nilotic origin they shave the women's heads, remove the two middle teeth from the lower jaw, adopt a one-legged stance while herding, and use milk in their blessings. Like peoples of Hamitic origin they perform initiation rites of which circumcision and clitoridectomy are important features, a social organization based on age-sets, called *laji*, a dislike of fish, a suspicion of blacksmiths, and a great love of cattle. Their habits, dress and customs, as well as their language – they speak a Maa dialect – are similar but by no means identical to those of the Maasai. Although there is no firm evidence, it seems likely that the Samburu are an offshoot of the Maasai.

Even the meaning of their name is disputed: some say that it derives from the Maasai word for butterfly *o-sampurumpuri*, others that it derives from an old Maasai word for bag, *e-sampur* (pl. *i-sampurri*). During the nineteenth century the Samburu ancestors were drawn into conflicts between neighbouring tribes, including the Maasai, and suffered punishing defeats. The scattered remnants fled far and wide and had to beg for food. As a result the surrounding tribes scornfully named them after the bags in which their womenfolk carried their food. As for the Samburu, they refer to themselves as *loibor kineji* (they of the white goats) and also as *lokop*, a term which means people of the land.

The Samburu are semi-nomadic pastoralists, and thus the seasons and the search for grazing and water have helped to shape their lives and their intricate social system. Goats and sheep are kept for meat, donkeys for transport, especially for carrying water, and camels are kept by some of the elders for their milk, their meat and for transport. However, the number and condition of a man's cattle are the true indicators of his wealth.

The Samburu territory is a harsh, inhospitable terrain which consists of vast expanses of low-lying plains covered with thorny scrub out of which buttes and mountains, like Lololokwi, rise imposingly. The higher ground receives a greater rainfall and the taller peaks are forested and covered with lush vegetation which varies according to altitude. There are tall trees from whose branches hang wild orchids, and occasionally moorland grasses cover the highest ground. Elephant and buffalo are common in the forests and the Samburu walk the narrow paths between the trees with their spears at the ready. These green forests are oases in an often parched landscape, yet most Samburu favour the lowlands, for during times of drought their precious livestock seem to fare better on the plains, where there is a greater supply of minerals and salts.

Throughout the dry season, which lasts for most of the year, there is little water to be had. At these times the Samburu have to make long trips to the few permanent flowing water sources, like the Ewaso Ngiro river, or dig wells in the dry sandy riverbeds, called *lbaan*, and at

LEFT: Three young elders, who have recently left warriorhood behind, stride across open land. 15

the base of rocky outcrops. The temperature soars to over 105°F (40.5°C), turning the trees into barren, lifeless forms. A thick layer of dust covers everything and a strong seasonal wind blows relentlessly. The long rains (*Ingerngerwa*), which last from April to June, transform the land into a green paradise that rapidly reverts to a hostile and merciless terrain with only a brief interlude during the short rains (*ltumurin*) of November.

The soil is often sandy and full of pebbles or white quartz, marked with red and orange veins, that legend tells is the spilt blood of the warriors. It is unfit for cultivation, which suits the Samburu, who say: "We are a people of safari, we do not cut up the land, this land is of the Samburu. It does not belong to one person or another, it belongs to all of us. We the Samburu do not listen when we are told to divide the land."

The Samburu diet consists of milk, blood and meat. They will eat impala and other antelope, buffalo, giraffe and lion fat, but not fish, rabbit, warthog, rhino, zebra, ostrich, snake, or hyena, which they say have an offensive odour. Nor do they eat elephant, which they say is like a man, or claw-footed animals because, say the Samburu, they eat the flesh of other animals. They value certain roots and herbs for their medicinal properties, but eat no salt and survive on very little water. However, they have been introduced to tea, to which they add copious amounts of sugar and consume with relish at all ceremonies.

Goat meat has taken over from game as the main meat source since the introduction of licensed hunting, but many of the older men can remember when their fathers kept no goats and relied on the game they would shoot with bow and arrow. As one old man told me:

> In the old days the villages were always near the mountains and on the plains there was so much meat that it was easy to shoot for food. Our fathers would go out hunting early in the morning, with a companion, when the game would not see the bow or the men. It is then that the game walks like sheep and sees nothing. The men would eat their share where they killed and then would bring their wives and children the rest. The warriors would shoot game and eat it in the bush, as they do now with goats. Now we do not know the work of the bow. We know only the work of the spear.

There are eight patrilineal clans, which are divided into the four clans of the black cattle and the four clans of the white cattle.* Clan and sub-clan members can be identified by subtle differences of dress and custom, which strengthen ties by distinguishing one group from another. There are many sub-clans within these clans and within each sub-clan there is a hereditary hierarchical system, which governs each man's place or seat within the council of the elders. When an elder dies his eldest son takes over his father's seat; when the second son becomes an elder he will also enter the council but will never be as vocal as his older brother, and he will only take his father's seat if his brother dies without an heir.

The powerful moral and social codes of the Samburu are designed to ensure their collective welfare and are based on *nkanyit* (respect) – respect for all their rituals and customs, and especially for the elders, whose role it is to maintain Samburu social codes and community order and to arrange the various ceremonies which enshrine the way of the Samburu. This "way" may at first be hard for an outsider to comprehend, particularly as it appears fluid and formless, but it is more strongly adhered to than in societies where such things have been codified.

The most important ceremonies for young men are the circumcision rites that initiate them into warriorhood, and for girls the circumcision rites that prepare them for marriage. The *e-muratare*, the days of male circumcision, is the most important of all the Samburu ceremonies. Not only does it ensure the continuity of the *laji* (age-set) system, and mark the

Clans of the Black Cattle				*Clans of the White Cattle*			
Lmasula	Lpiskishu	Nyaparai	Lngwesi	Lorogushu	Longeli	Lokumai	Loimusi

time at which the new generation of *lmurran* (warriors) begins to take the place of the previous *laji*, which in turn moves on to marriage and elderhood, but the ceremony also unites the whole Samburu nation and re-establishes clan bonds and the social hierarchy.

The Samburu believe in God omnipotent and omnipresent. God, Ngai, is within every person, in the trees, in the rocks, in the springs, but his presence is felt most strongly at the top of a mountain. In daily life, the elders perform many small ceremonies during which they invoke Ngai's blessing.

The Samburu do not believe in life after death. When a man dies the immediate family shave their hair as a sign of respect and mourning, and the man's strongest bull is castrated to symbolize that he will have no more children. His children divide his possessions among themselves, and if there are no children, his things will not be touched. The Samburu used to wrap the bodies of their dead in a piece of hide or cloth and leave them out in the bush, perhaps by some rocks or under a tree, not far from the *nkang* (village). But nowadays they are required by the government to bury the body. Sometimes the dead are said to return as haunting spirits, called *milika*, and the Samburu believe that the *milika*, who cannot be seen but are always present, trouble people in their sleep.

Some Samburu are said to be able to predict the future and make good or bad charms to influence fate. They are called *laibonok* (sing. *laibon*) and their gift is passed down from father to son. The *laibonok* brew a beer made from honey, which is drunk at ceremonies, and in which they say they see the future. They are treated with a healthy respect and are never provoked, for they have the power to curse.

The Samburu are renowned for their xenophobia and indeed they have no word for welcome. They say of themselves that they have hard hearts. Some say that the Samburu take whatever they can get. But for the Samburu it is no disgrace to ask and a refusal does not offend, for only what cannot be spared will be refused. They are one huge extended family in which responsibility for the welfare of all falls on everyone in the community. To this day they share the community fine if one of their clan wrongs a member of another.

There are several small towns within the Samburu territory including Wamba and Maralal, which are the administrative headquarters for the whole area. They consist of little more than a main street with an assortment of shops selling basic wares, small hotels and bars, churches, schools, missionary medical facilities and government offices. There are other smaller trading posts, including Archer's Post, Serolipi and Barsalinga, made up of similar though less numerous establishments. The Samburu travel to these outposts to buy the few items they need which they cannot get from the land; namely tea, sugar, soap, tobacco, cloth, beads and ochre. Here they come into contact with the modern world: men in tribal clothing sit with policemen in uniform, and women wearing beads and traditional leather skirts (*nkela*) stand beside nurses in neat white dresses.

The Samburu have always resisted change, but as more and more of the younger generation attend school in the small towns the inevitable move to western ways is occurring, and with it the breakdown of respect for the elders. However, the majority still prefers to live away from the settled areas and to live in the traditional manner. This book is an attempt to record their way of life and customs before the twentieth century overtakes them.

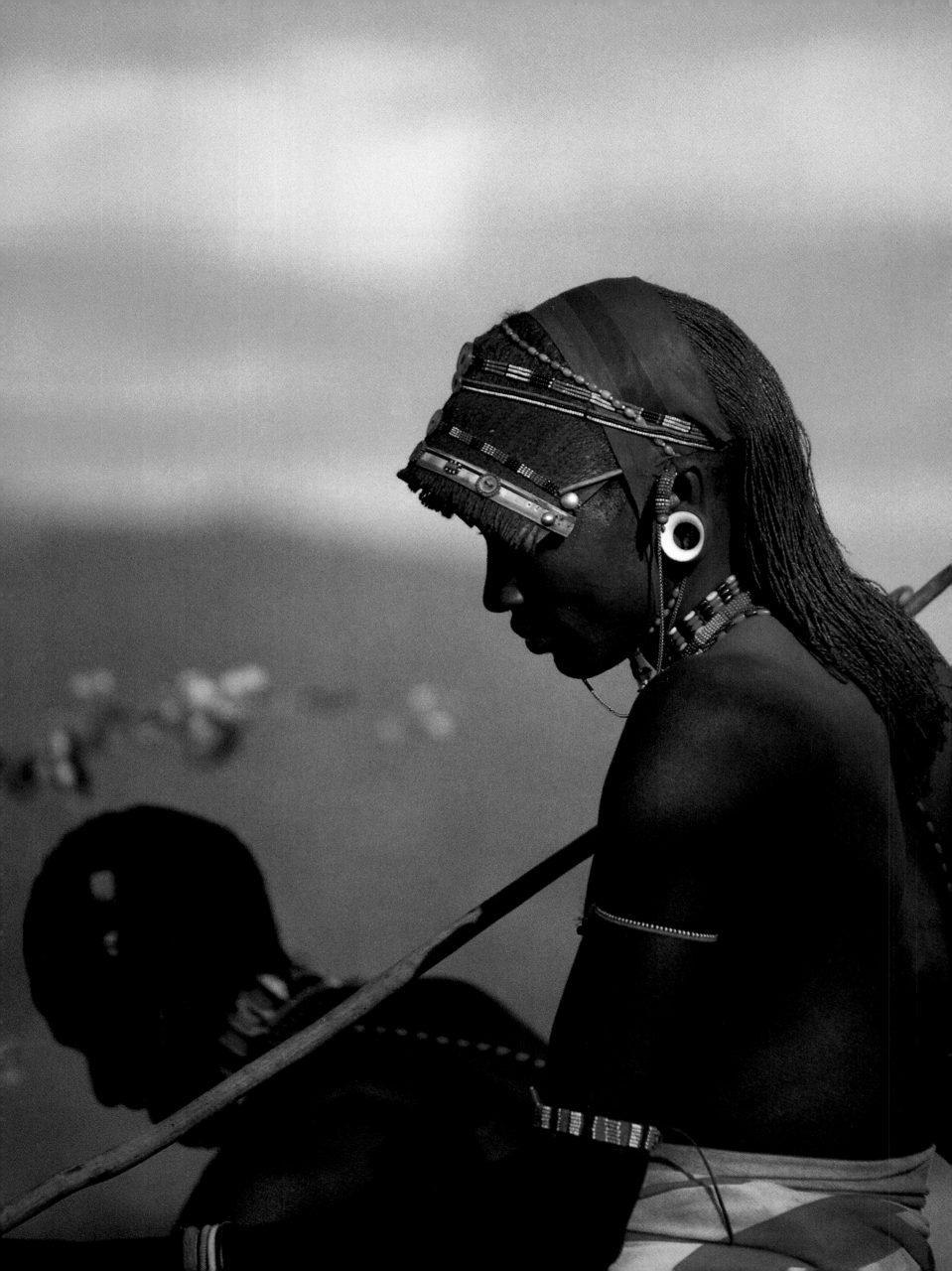

LMURRANO

Warrior Pride

Warriorhood (*lmurrano*) is the most glamorous time of a Samburu man's life. During this period, not only are warriors (*lmurran*) at the peak of their physical prowess and strength, but as a group they are the guardians of the community and its cattle. Free from family responsibilities, they occupy themselves with their appearance and with other honourable masculine concerns.

The *laji* (age-set) system divides a Samburu man's life into three main stages: boyhood, warriorhood and elderhood. A *laji* consists of those who are circumcised at the same time and each man identifies strongly with his own *laji* and has a close bond with his fellow initiates. Each *laji* is given a name by the elders at the *ilmugit lnkarna*, a feast held about halfway through warriorhood, and the system can be traced back to about 1880.*

From the time that a new warrior's head is ceremonially shaved at his initiation into *lmurrano* until perhaps a decade later when he becomes an elder, he will only cut his hair if his father or a close relative dies. Throughout *lmurrano* the warriors spend many hours braiding each other's hair into ever longer strands that fall evenly down their backs. They also smear red ochre mixed with animal fat over their hair, and on their faces and torsos they create dramatic ochre patterns using a wooden spatula which they often carry tucked behind one ear.

Beaded jewellery is an important part of warrior decoration. They are given bracelets, necklaces and anklets by their mothers and girlfriends, or by former warriors as signs of friendship. Occasionally they wear a charm around their necks given to them by a *laibon* for protection. Over each shoulder they wear a long loop of oval-shaped beads, which cross and fall to their waists; sometimes they wear an additional twisted loop of small blue beads. Over their ears they hook a thin copper chain. They also wear beaded decorations across their foreheads, often entwined with their braided hair.

All warriors wear ivory earplugs in the stretched holes in their earlobes. As little as two *laji* ago, they would find ivory lying in the bush, but nowadays, as a result of poaching, few elephants die of natural causes and they have to rely on warriors who have become elders to pass their earplugs on to their younger brothers or male relatives.

Lmurran carry two spears that match their height; the shafts are made of wood and the leaf-shaped spearhead and the butt are made of iron forged by blacksmiths, the gypsies of Samburu society. Warriors also carry several other weapons including a *lalema*, which is worn in a scabbard secured at the waist, and a club-headed stick called a *rungu*. The Samburu used to carry stout shields made from rhinoceros, buffalo or hippopotamus hide, but these were banned under British Colonial rule as a penalty for troublesome behaviour.

*	*Approximate year of circumcision*	*Approximate duration of laji in years*	*Approximate age of youngest laji members in 1990*	*Laji name*
	1990		9	Lmwoli
	1976	14	23	Lkorroro
	1960	16	39	Lkishili
	1948	12	51	Lkimaniki
	1936	12	63	Lmekuri
	1921	15	78	Lkiliako
	1912	9	87	Lmerisho
	1893	19		Ltero
	1880	13		Lmerikon

Source: Paul Spencer, *The Samburu*, Routledge, London, 1965.

LEFT: A warrior in his prime combines grace and power in his bearing.

Lmurran wear two red or red-and-white pieces of cloth wrapped around their waists; in the chill of early morning they wrap one around their shoulders. Until recently they wore leather sandals made, for preference, from giraffe hide, but since the introduction of licensed hunting, cow leather has become usual and latterly even rubber treads from discarded tyres are used.

The warriors are usually tall and lean. They seem to glide effortlessly over rocks and stride easily across long distances. They never travel alone, but always in pairs. They will always greet other *lmurran*, even though they may be strangers, with "Sopa!" and then ask where the strangers are from and where they are going.

They are tremendously proud and competitive, constantly proving themselves and rivalling one another – not for one-up-manship, but for the glory of living up to the ideal of *lmurrano*. When faced with danger they bristle with adrenalin, puffing up like porcupines facing an enemy, every nerve quivering and tuned for combat, their spears raised in anticipation. When they are woken unexpectedly they erupt into fearful snorts and bellows, like a disturbed rhinoceros, huffing, puffing and stomping – a performance designed to instill fear into any assailant.

The worst insult for a *murrani* (warrior) is to be called a woman; a *murrani* should never die within an *nkang* like a woman or an elder. He accepts no criticism and any challenge must be met and dealt with or he will be considered cowardly and his honour slighted. If one *murrani* considers himself wronged by another he will challenge him to a duel with *ngudisin* (thin straight staffs), which is witnessed and overseen by the other warriors. Rare though they are, such duels are considered a fair way to settle a dispute, rather than lurking in ambush and attacking one's opponent with a spear or a *rungu*.

Lmurran spend most of their time living away from the settlements, apart from the elders and women in transient thorny enclosures with their hump-backed cattle. The herd is made up mainly of the elders' cattle, but also of a growing number of animals that will become the nucleus of each warrior's wealth. *Lmurran* follow the best grazing and are constantly on the move. During times of drought and hardship, they help the family groups to find grazing for the village's livestock and maintain the deep wells dug in the *lbaan*. The elders may visit the enclosures to oversee *lmurran* and to check on the cattle, but generally they do not spend much time in the enclosures and sleep and eat separately from the warriors when they do visit. Women never visit the warriors' territory.

During times of lush grazing *lmurran* will take several cattle up into the mountains and remain there feasting, roasting the beef over an open fire or boiling it in a fired earthenware pot with various herbs, which they say give them strength.

Meat, blood and milk is all they eat. Warriors bleed their cattle by tying a tourniquet round the animal's neck until a vein becomes prominent. Then, while two warriors hold the cow, another fires an arrow with a sharp, shallow head into the vein from close range. The arrow immediately bounces out and the jet of red blood is collected in an *nkarau* (container). About a litre (c. two pints) of blood is taken, then the wound is closed by the brief application of finger pressure. The blood is stirred with a stick on which the fatty solids coagulate, and the stick is thrown to the dogs. Men always drink blood straight from the cow, perhaps mixed with a little milk, unlike the women, who always cook it first. The cattle may be bled as often as every two weeks, but usually they are left for a month or more before being bled again.

Lmurran do not drink alcohol or chew or smoke tobacco as such practices are considered inappropriate to the honourable status of *lmurrano*, although taking snuff is acceptable.

The warriors carry no possessions with them except for their weapons, an *nkarau* for milk, the ochre they use to decorate themselves and a *lorika*, a carved wooden head-rest which they use as a pillow. They sleep in the open on cowhides around their fires, with their cloths pulled

over their heads. When it rains they tuck their hair under headcloths and their ochre patterns are washed away. They huddle under their hides, watching their spitting fires. The rain is usually intermittent and there are always a few sunny hours when they can spread their cloths over bushes to dry.

There are usually about twenty warriors and several boys – apprentices of the life they will live once circumcised – grouped together in a thorny stockade with their cattle. The men enjoy a roguish camaraderie. They are wild and unabashed, they laugh and tease, and indulge the characteristics that pride restrains in the company of elders, women and young girls.

At dusk the warriors pull to one side a thorny branch to make an opening in the cattle enclosure and lead their stock inside. They milk the cows and drink the still warm liquid. Some of the warriors keep camels, which complain noisily while being milked for their rich, sweet milk. In the darkness, while the cattle rustle and stir, the warriors sit around their fires singing songs under the huge expanse of sky, scattered with thousands of stars undulled by artificial light. Their singing, which is powerful and intense, creates an intimate magic. Each *laji* has its own songs, composed and led by the *laranyak* (song-writers), the most talented of the group. They never sing laments or dirges but only songs about their cattle and their bravery in combat.

Once it was expected that every *murrani* would kill a lion, and spill the blood of a man with his spear. It was not that *lmurran* went out blood-thirstily to kill. Indeed, this would have been considered dishonourable, but were they to encounter hostile neighbours or were a lion to attack their livestock, or were they to be drawn into a battle while raiding cattle, then to kill an enemy was considered a highly honourable deed.

At these times they would sing a special war song:

> Draw up your *nkarau*,
> Draw up your *nkarau* and draw water for your cattle,
> Return home with your cattle and be honoured.

Here *nkarau* stands for spear, water for blood, and cattle for enemy. Warriors of some clans who had killed an enemy would cut the dead man's throat and redden their lips with his blood. On his return, such a *murrani* would stand in front of his mother's hut and she would anoint him with milk. He would be given a new name and would wear a special broad, twisted copper bracelet to signify that he had killed a man nobly.

When a warrior kills a lion, he cuts off its right ear and skewers it on the shaft of his spear. The heavy skin is carried back to the *nkang* by several warriors, and the carcass is left to the hyenas. The lion's head is stuck on the right side of the warrior's mother's entrance to the *nkang*, facing the family's cattle in the compound. The claws and skin are kept as potent symbols of courage: the claws being used for jewellery, the skin for the ceremonial thongs and sandals worn by the groom at a wedding, and by fathers at their sons' circumcision. Any hair balls found within the lion's stomach are highly prized and secretly kept, being considered powerful omens of fortune, health, wealth, courage and strength.

Although these expectations are dying out, *lmurran* are still undaunted by a fight to the death. Today, such confrontations are mainly confined to the shifta (bandits), who frequently make cattle raids against the Samburu. The previous *laji* of *lmurran* was still skilled in the use of weapons, but few warriors earned the right to a second name. The *laji* of warriors initiated in 1990 will no doubt develop its own aspirations in the years ahead.

During *lmurrano* there are several *ilmugit* or feasts. These ceremonies are important, not only because they allow the warriors to move through the various stages of *lmurrano*, but also because they re-establish bonds between clans and allow the elders to monitor the progress of *lmurran*.

From time to time *lmurran* wander far from their own villages and visit those of other clans or sub-clans. No *nkang* ever refuses entry to a *murrani* and it is often during these times that a warrior will find the young girl he will eventually marry. He will give gifts of beads to the girl, and may sleep with her. However she must not become pregnant as a warrior is not permitted to marry and father children, and thus become an elder, until the end of his term of *lmurrano*.

 If a girl does become pregnant the child is considered cursed and the warrior has to pay a fine to her father of maybe three or four cattle. The Samburu have herbs which they use to cause abortions and the older women will also manipulate a girl's abdomen to terminate an unwanted pregnancy. The pregnant girl will always be circumcised immediately and married off as soon as possible. Until recent times, if the pregnancy was not terminated, the newborn baby would be stifled before it could take its first breath; usually its mouth would be stopped with earth or tobacco. Similarly, any severely deformed baby would also be stifled at birth.

Since girls are always married to elders or warriors at the end of their term of *lmurrano* marriage can be an emotionally painful time. The girl will more than likely be taken away from her lover and married to a man of an older generation, but neither the girl nor the warrior will dispute the decision of the elders. As only elders are allowed to marry and become fathers, one might think *lmurran* would resent losing their girlfriends, but this custom is accepted, and the arrangement does give the warriors a chance to explore their world unencumbered by responsibilities; as a result, they are usually willing to assume the role of elderhood and remain within the *nkang* when they do eventually marry.

When *lmurran* come to the settlement in any numbers, most commonly for ceremonies, dancing commonly ensues, usually on a flat piece of ground just outside the *nkang*. This is the only time that men and women mingle in public. The dancing begins in the relative cool of the early evening and may last far into the night. They play no musical instruments, but create music with their voices and a rhythm beaten out in handclaps or with their *rungu* on their spears or staffs. They sing in riddles of their cattle and their feats of bravery and the warriors and girls taunt each other with the words of their songs. Grouped close together, they dance simply for their own pleasure, not for an audience.

There are several slightly different dances which are usually performed in a particular order. The first dances are for *lmurran* alone. They leap high in the air, each warrior trying to jump higher, straighter and more powerfully than the next. Their dance is enthusiastic, and the dust is kicked up under their feet. Later the unmarried girls, and sometimes the young married women, join in and sing in a high-pitched wail, perhaps holding hands with a warrior or holding a warrior's spear for the duration of a song. Immediately the song is over they loose hands and the girls and women retreat a short distance away. The warriors dance and sing until their voices become hoarse and they have to spit to moisten their mouths. A final dance, incorporating a skipping step, is performed, in which the warriors, each partnered by a girl, form a long line and work their way in a twisting path for a short distance before returning to dance again in a tight circle.

The pitch and volume of the warriors' songs is tremendous. The air vibrates with the sound. It is all-compelling and seems to take hold of them. Their bodies start to twitch and they become entranced. Sometimes while singing a warrior will start to shake and go into a violent fit called *ndokuna*. There are many theories about *ndokuna*, which is a trancelike trauma. It appears to be induced by the combination of the charged atmosphere, the deep resonant singing and an almost hypnotic mental state. Afterwards, the warrior, as is the case with epilepsy, can remember nothing of the experience. No stigma is attached to such fits and those who experience them are carried to one side and held by their contemporaries to prevent them from harming themselves. *Ndokuna* also occurs among women, but it is much rarer.

22

If a warrior dies his sub-clan mourns deeply and the elders perform a special ceremony in which they bless the surviving warriors, both to raise their morale and to bring the whole community together. For this ceremony the elders of the sub-clan gather and spend days sitting in a group under the meeting tree, a little away from the *nkang*. Every warrior from within the sub-clan contributes a gift to the elders, either goats for slaughter or tobacco or *miraa*, a bushy plant which has a narcotic effect when chewed.

When the moon's phase is judged to be favourable, the elders agree to bless the warriors who start to sing and dance in the late afternoon to one side of the settlement. In the evening, once the cattle have returned from grazing, the warriors gather together in a tight group and sing as they slowly advance into a circle in the centre of the village within the cattle stockade. The circle, marked by a low ring of cow dung, will have been made a little earlier by the elders. The elders remain outside the circle and pray to Ngai and give the traditional blessing, holding their sticks up high. They sprinkle milk and bless the warriors. The warriors sing and finally move out of the circle. It is a short but highly significant ceremony in which they ask for Ngai's protection. The women play no part, but merely carry on milking the cows and seeing to their chores. That night the cattle will not be permitted to enter the stockade, and the following morning, before the first rays of sun come over the mountains, the same ceremony is performed once more to complete the blessing.

The honoured time of *lmurrano* seems to be becoming vulnerable to change, not just because of the incursion of western culture, but also because there is less need for armed warriors. There are fewer hostile encounters, other than those with the shifta, and game is steadily being exterminated outside the National Parks, with the result that there is less need for *lmurran* to defend their flocks and herds against predators. Sadly, *lmurrano* may be destined to decline from its once exalted status to a purely decorative period in a young Samburu male's life. The one aspect of *lmurrano* which may survive is its importance as a way of instilling in Samburu youth *nkanyit*, the respect on which the continuance of Samburu social and moral codes depends.

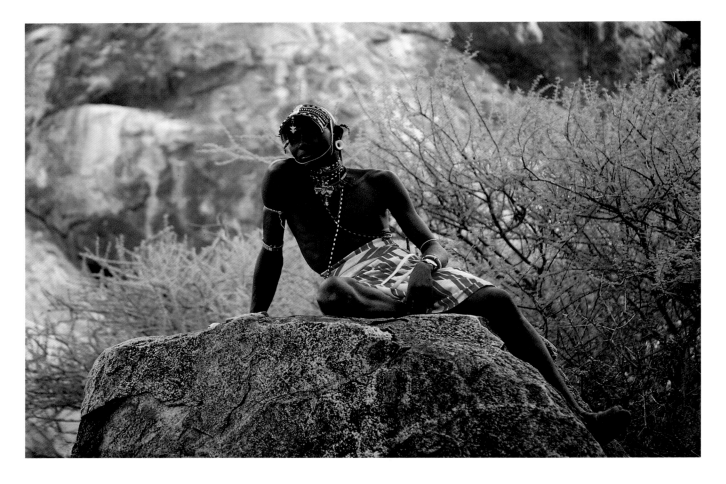

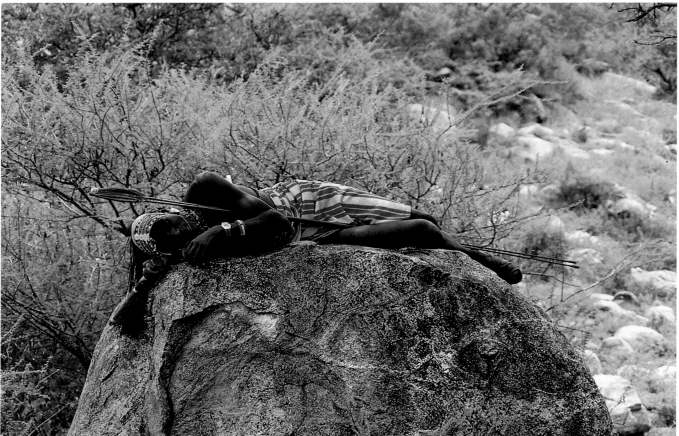

TOP AND ABOVE: The warriors carry themselves with grace and poise, even when resting on a large rock.

RIGHT: A warrior, amid lush vegetation just after the rains, wears two pieces of red-and-white cloth wrapped around his middle and sandals on his feet. Over each shoulder are looped the long strands of beads which denote his status as a warrior. He takes the traditional Samburu stance, with one foot crossed behind the other while balancing his weight on his two identical spears, which are made by Samburu blacksmiths; his *rungu* (club) is held between his legs. It is made from the thin branch of a hardwood tree which is hacked off so that part of the trunk remains attached; this crude bludgeon is then worked into a lethal club.

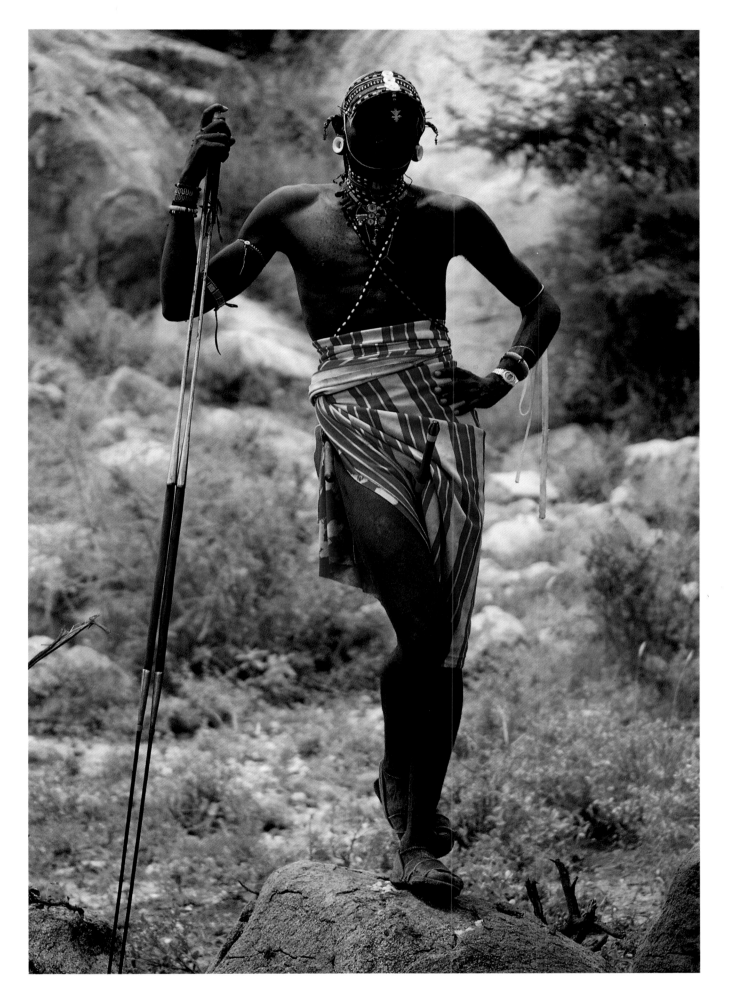

OVERLEAF: The warriors spend hours dressing each other's hair, which they braid into elaborate styles. They create visors, usually of stiff animal hide, overlaying them with braids of hair held in place by leather strips which they decorate with beads and buttons. They smear red ochre mixed with animal fat over their hair, foreheads, cheekbones and torsos, and use a small wooden spatula to create sharp edges to the blocks of colour. The intricate designs on their cheeks and foreheads are drawn with a thin, whittled twig.

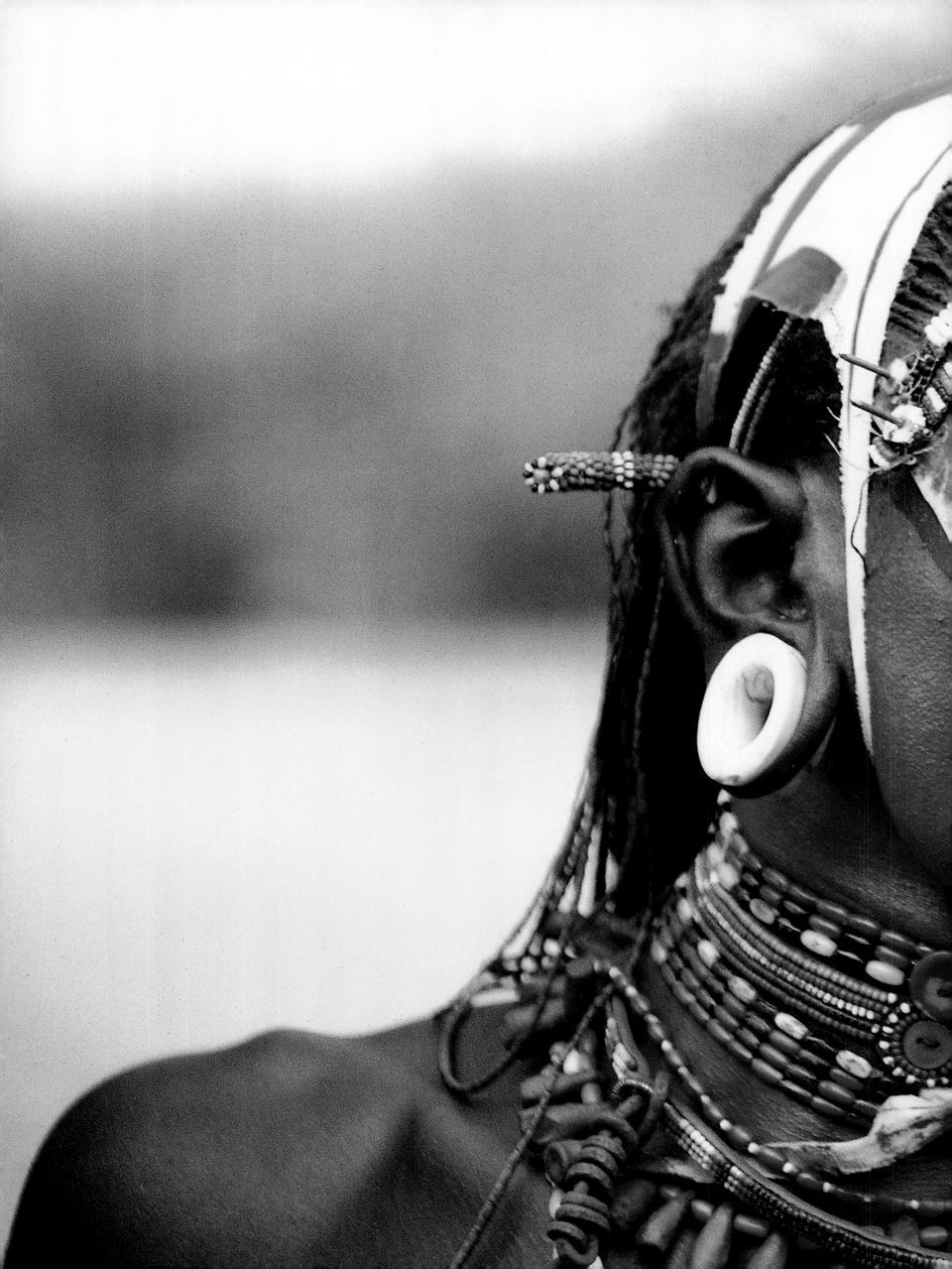

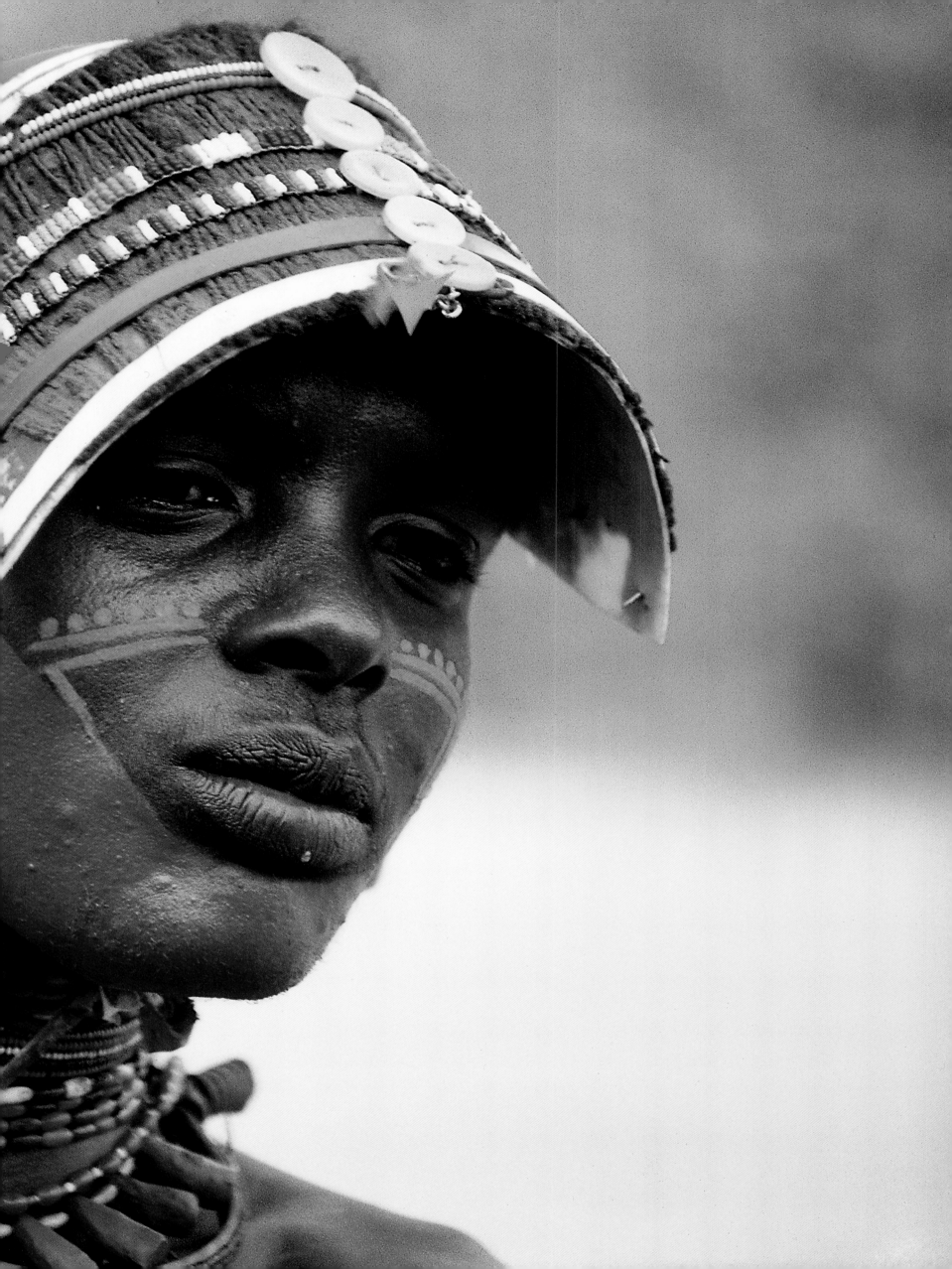

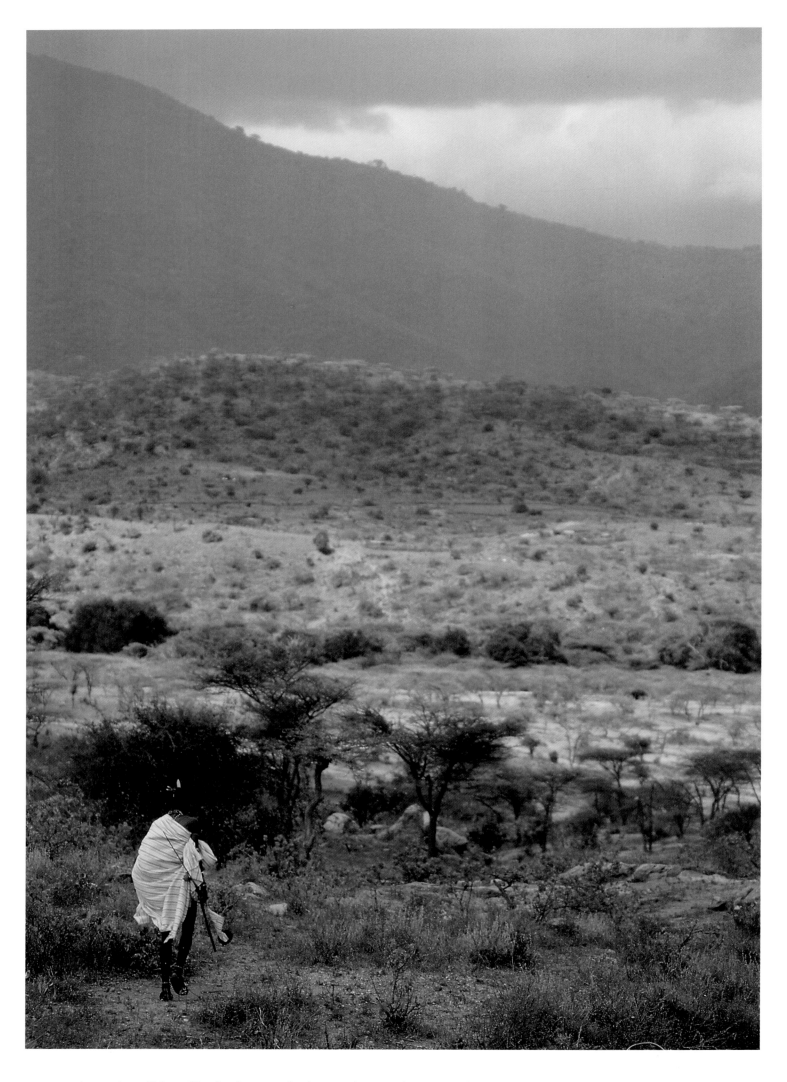

ABOVE: A warrior glides effortlessly over the hot and rugged terrain of Samburu district with his fluid, rhythmic gait.

RIGHT: *Lmurran* live apart from the elders, women and children and wear a feather in their hair as a symbol that they eat away from the *nkang* (village). A warrior is like a bird, they say, not only in swiftness, but because he searches for food in the bush like a vulture, which circles and feeds from a lion's kill. Here (RIGHT), a warrior has twisted a feather smeared with ochre into a cone-shape before fixing it to the back of his head with another feather sliced down its shaft.

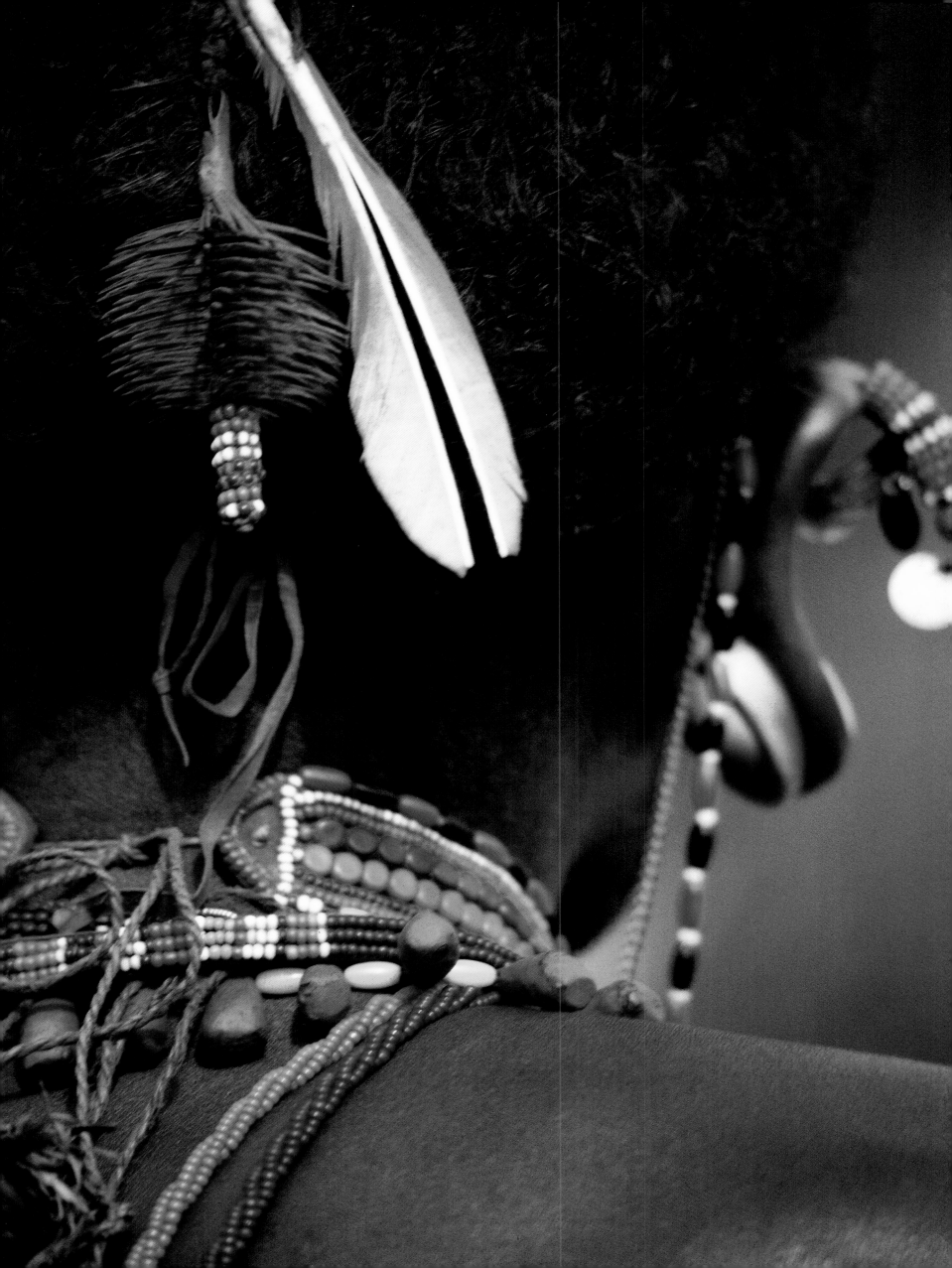

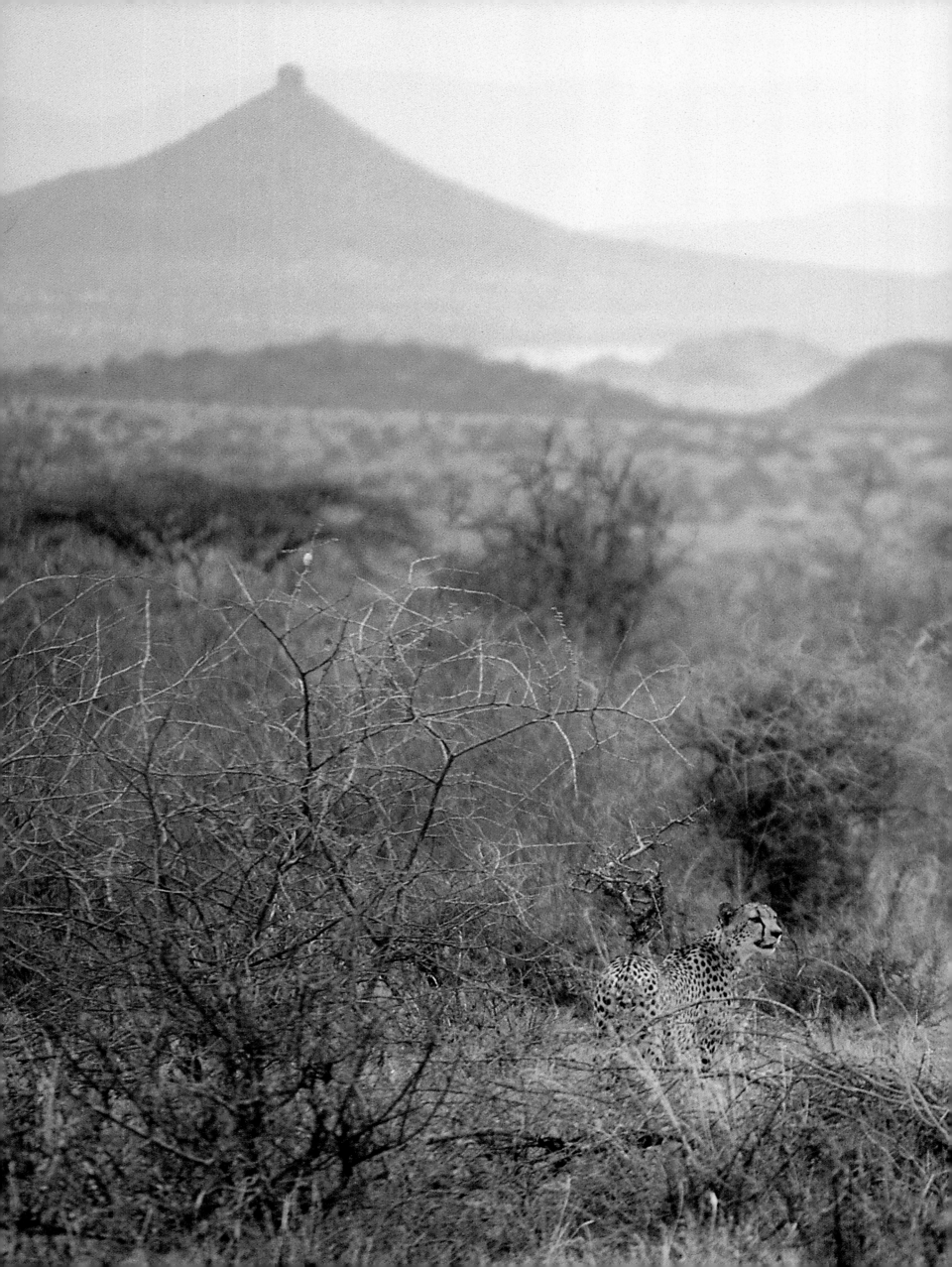

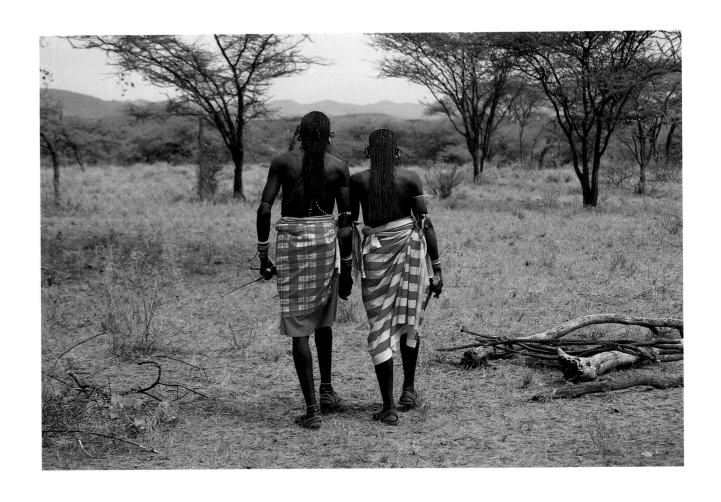

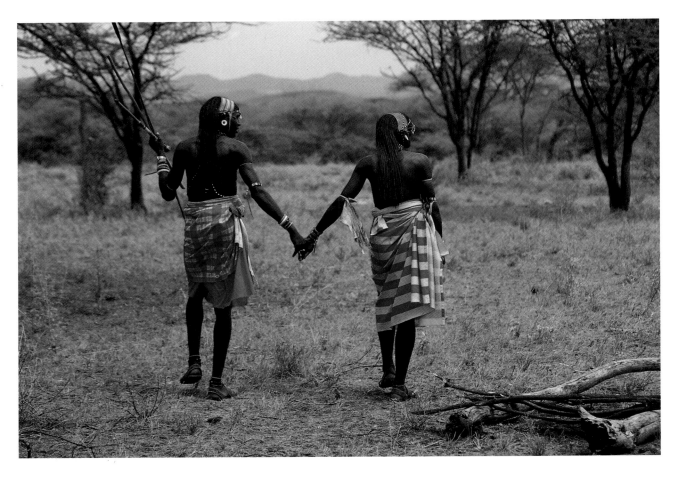

PRECEDING PAGE: The warriors' terrain is a vast, seemingly endless expanse of dry, wild country, covered with acacia bushes. This cheetah, alert and hunting, is well camouflaged in its thorny cover.

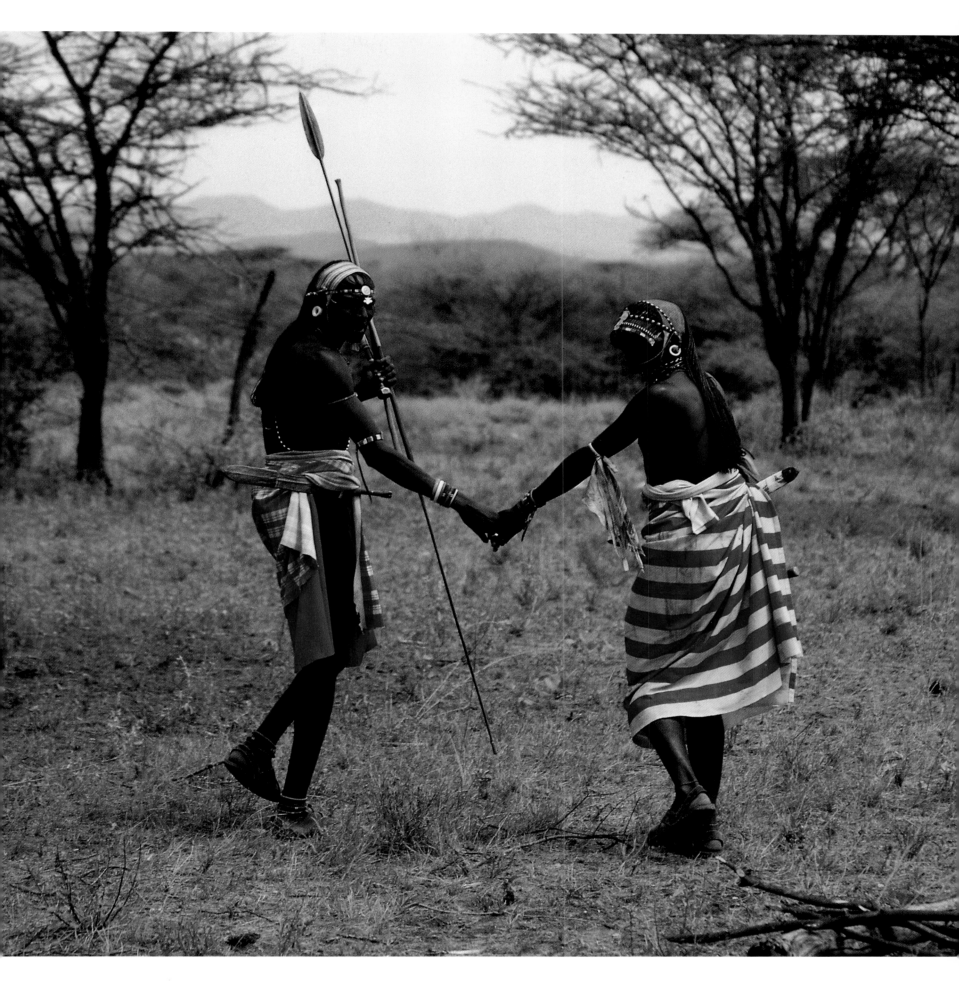

LEFT AND ABOVE: The warriors of one *laji* (age-set) form a close bond. They refer to each other as *murata* and continue this companionship into elderhood. They must never travel, or eat or drink alone, but always with fellow warriors.

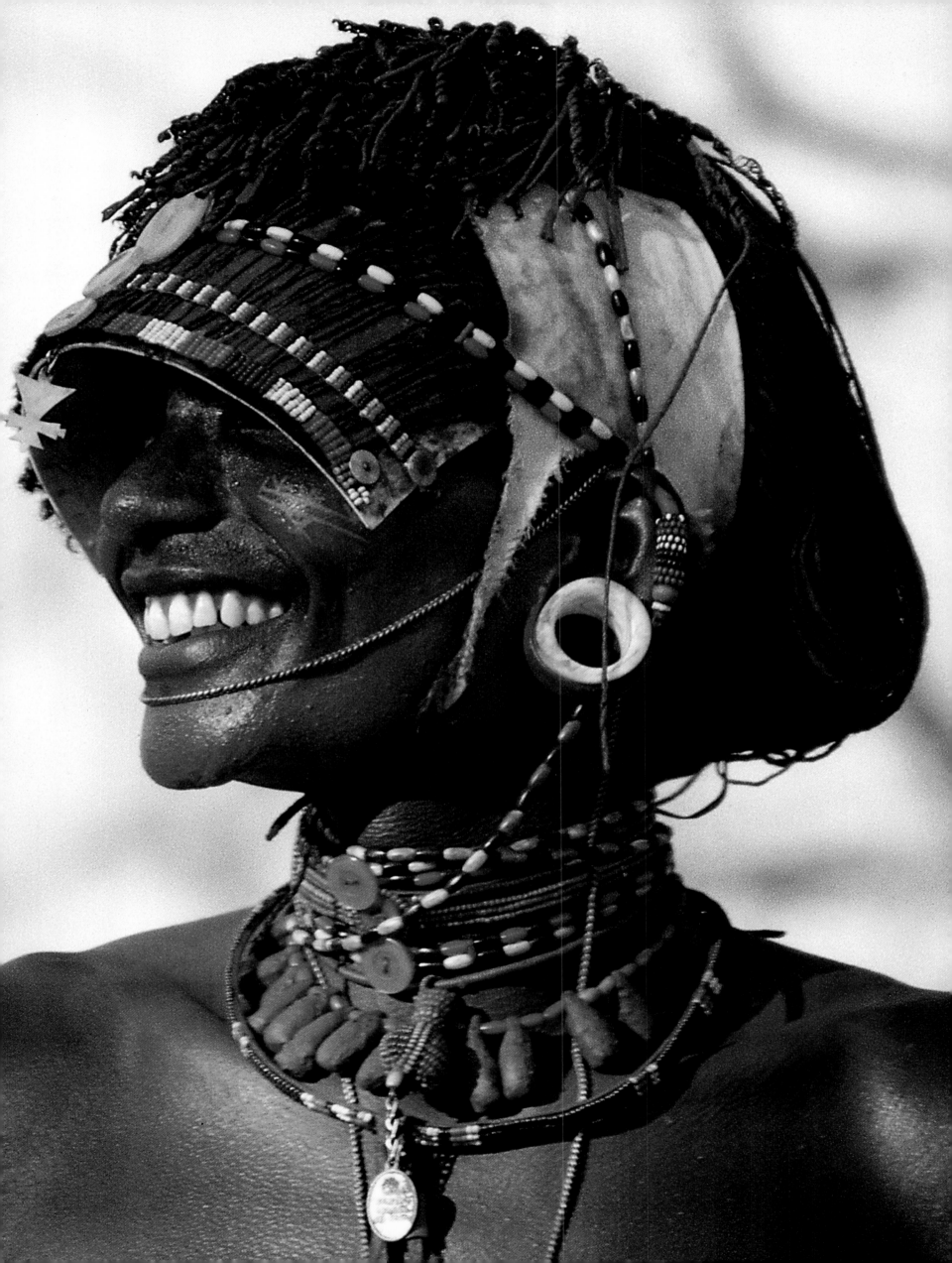

PRECEDING PAGE: A warrior with angular features, high cheek bones and shining white teeth breaks into laughter. His hair is piled up on his head in a casual moment among fellow warriors, which contrasts with the aloof manner he will maintain in mixed or hostile company. Around his neck he wears a beaded charm given to him by a diviner or *laibon*. The ivory for his earplugs, which all warriors wear, would until recently have been found lying in the bush. Nowadays, as a result of poaching, few elephants die of natural causes and the warriors have to rely on earplugs passed down from the previous *laji*.

RIGHT: A warrior with his hair dressed to perfection. Aggression, pride and an uncompromising attitude is part of a warrior's sub-conscious. Always ready for battle, warriors can be suspicious, turning the greeting "Sopa!" into a threatening grunt. They constantly prove themselves and rival each other. As an ultimate challenge and insult they will plant their spear in the ground point first. If a warrior kills a man in battle he is given a new name and wears a special broad, twisted copper bracelet, or in some clans a ring of similar style, to signify that he has killed a man.

The warriors used to paint their faces with designs intended to frighten their enemies in battle. The intricate painting they use today continues this tradition but is almost purely decorative. They sometimes wear a metal chain hooked over their ears, the upper loop resting just below their lower lip, the lower loop hanging down over their chests. They wear ivory earplugs in their lobes and beaded plugs in the upper rim of their ears. These plugs, like their ochre and braided hair, also denote warrior status.

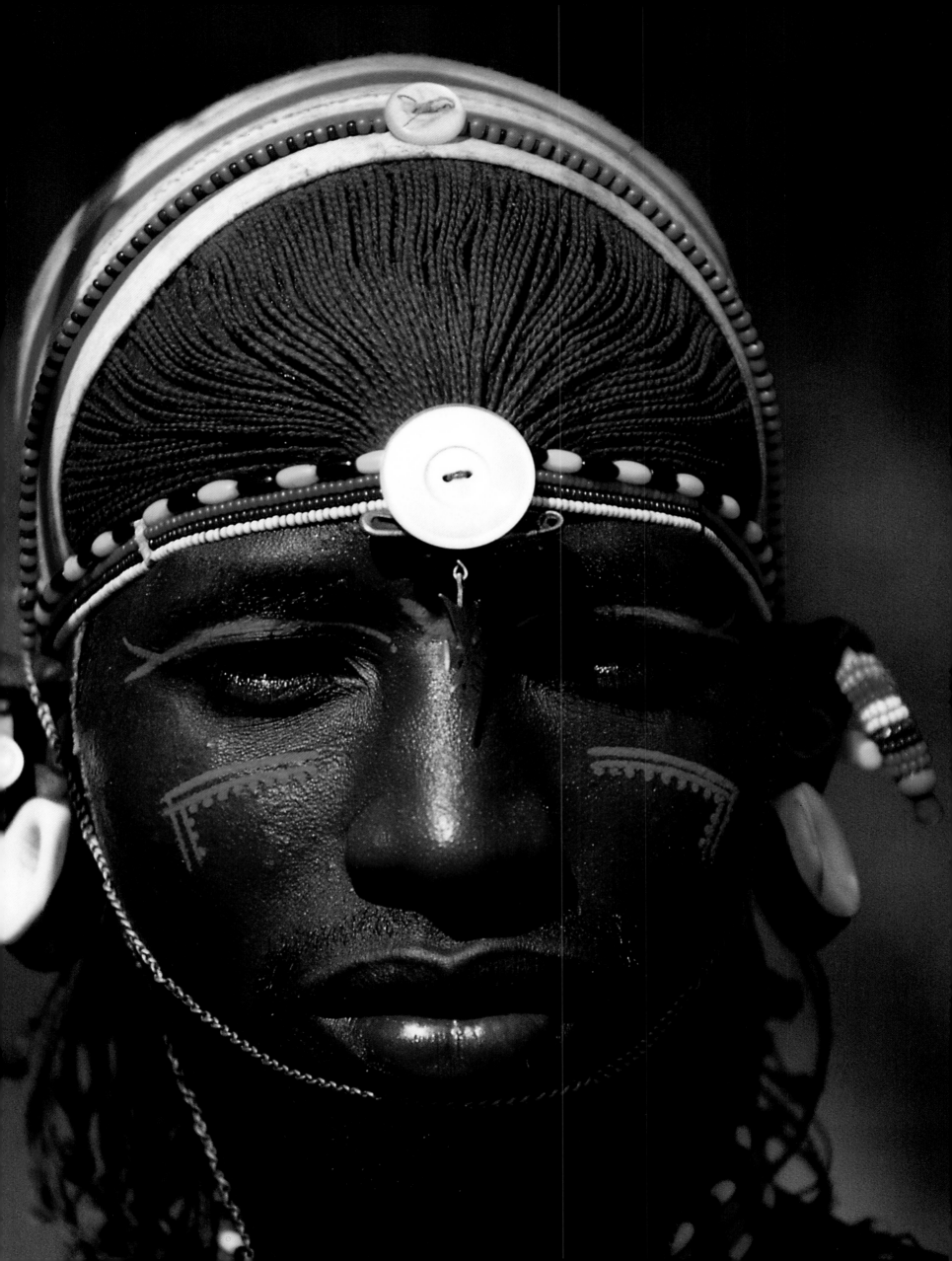

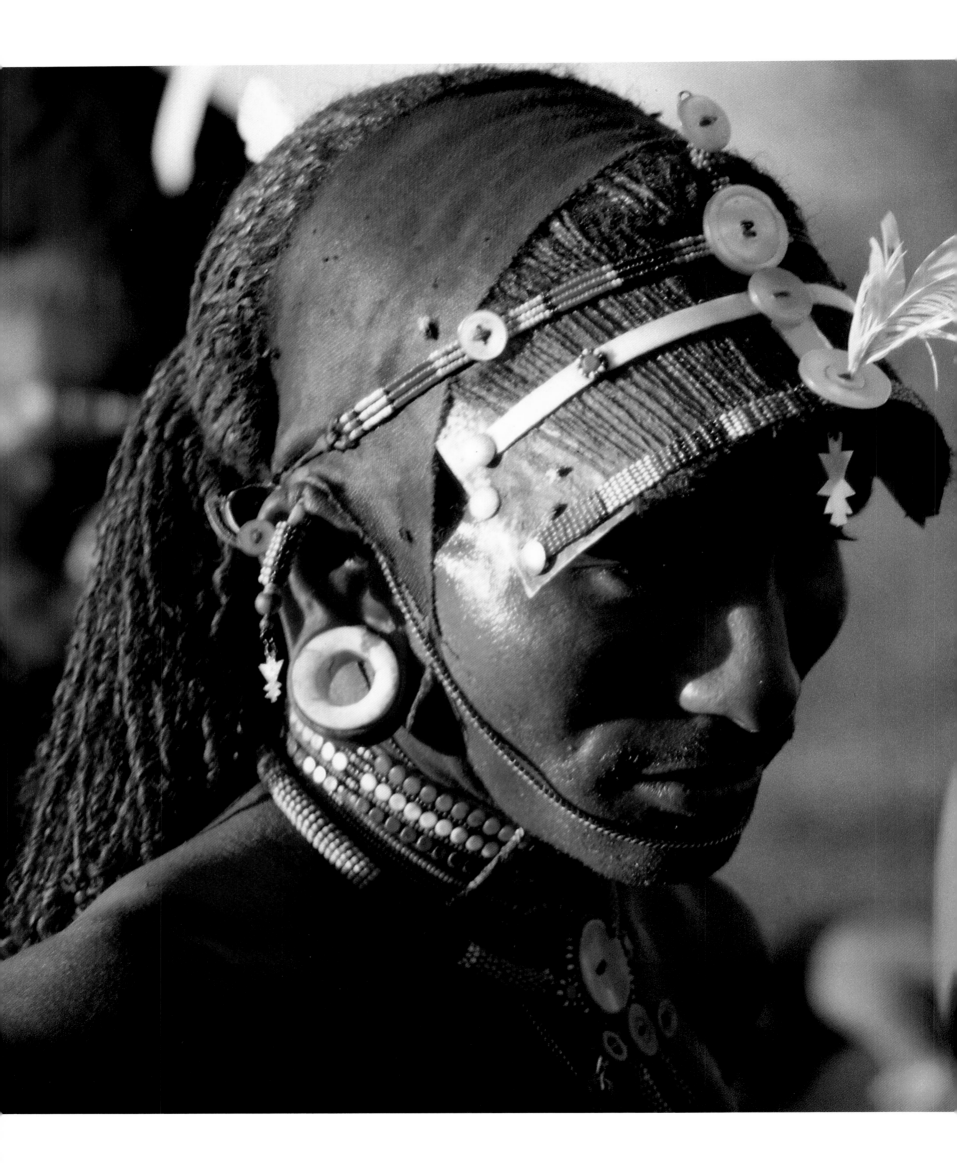

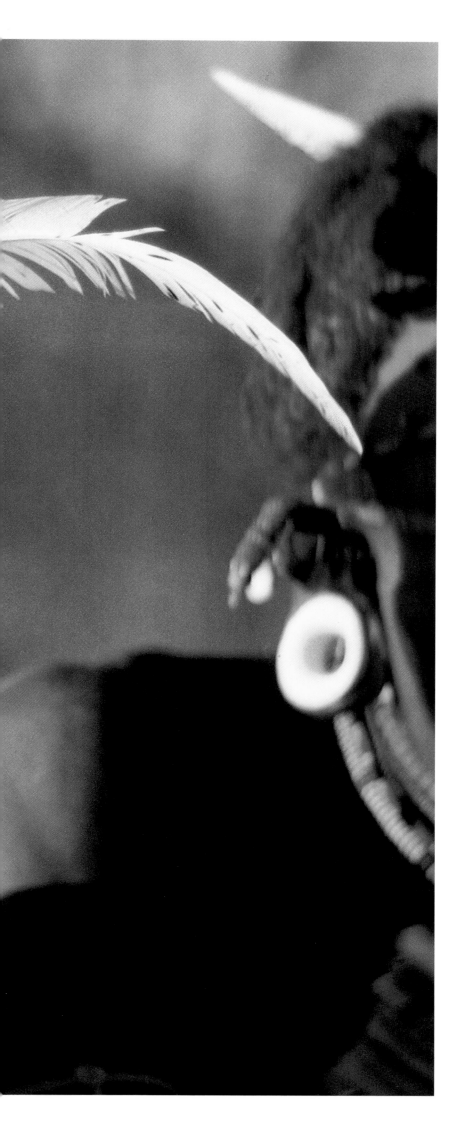

LEFT: A warrior, dignified and confident in the prime of *lmurrano*, glistens with wet red ochre. A white feather crowns his headdress.

LEFT: A *lalema*, a long knife or short fighting sword, with a double-edged blade, rests in its leather scabbard attached to a webbing belt worn around the warrior's waist.

41

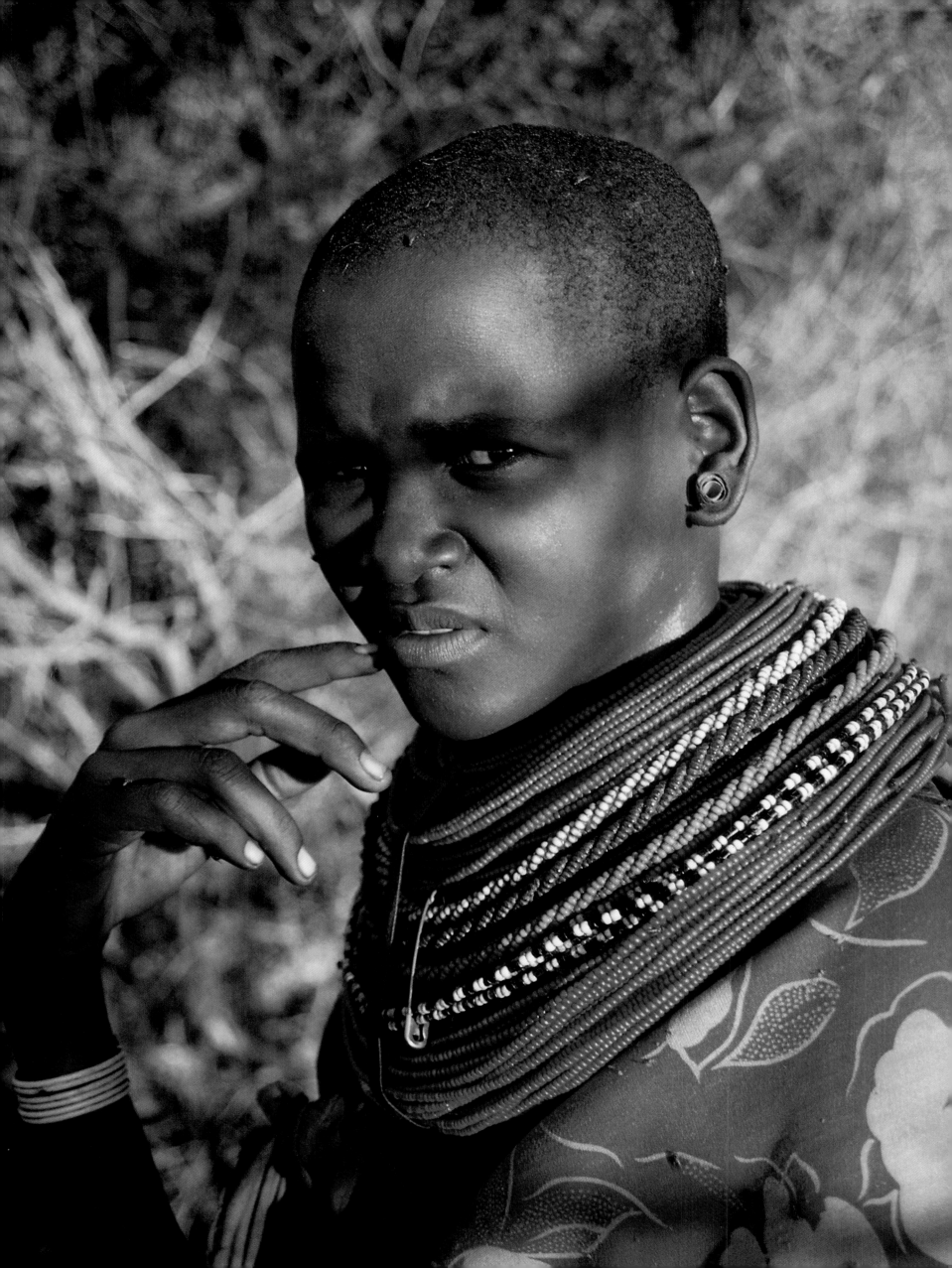

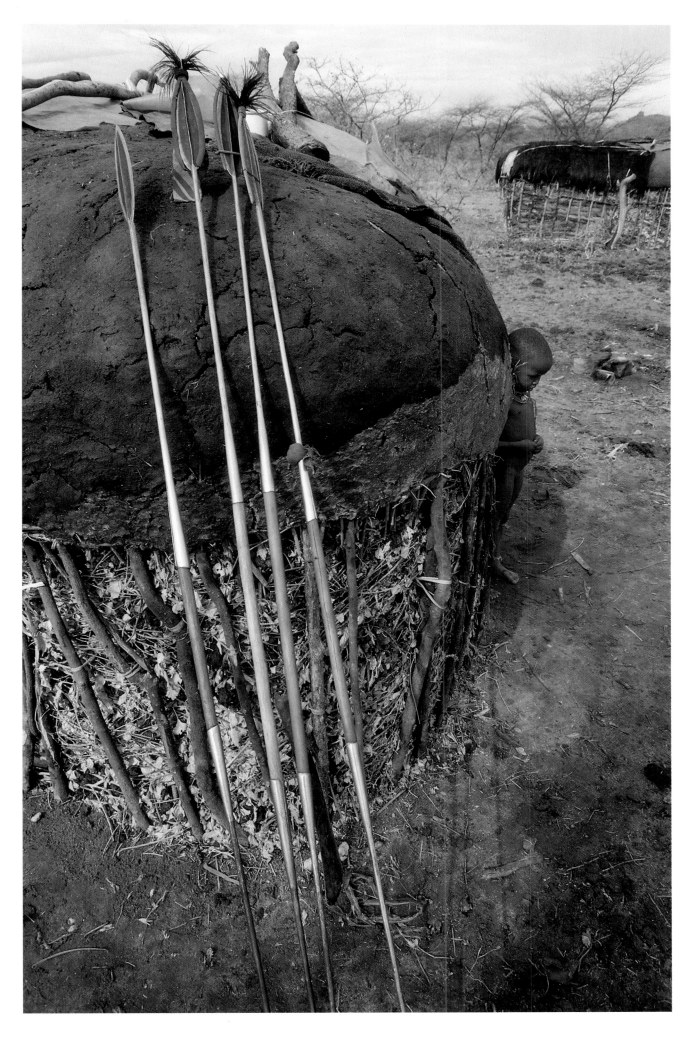

LEFT: An *nkoliontoi* (young uncircumcised girl). As the warriors become ready for elderhood and marriage they will search out girls of an appropriate age and exchange gifts of beaded jewellery. The upper rim, as well as the lobes of this girl's ears, will be pierced and plugged prior to circumcision and marriage.

ABOVE: Once a man's sons have become warriors he will usually take another wife with whom he will live in a second house, leaving his first wife's house for his warrior sons and their comrades to sleep in when they visit the *nkang*. The warriors leave their spears outside to show their presence within.

43

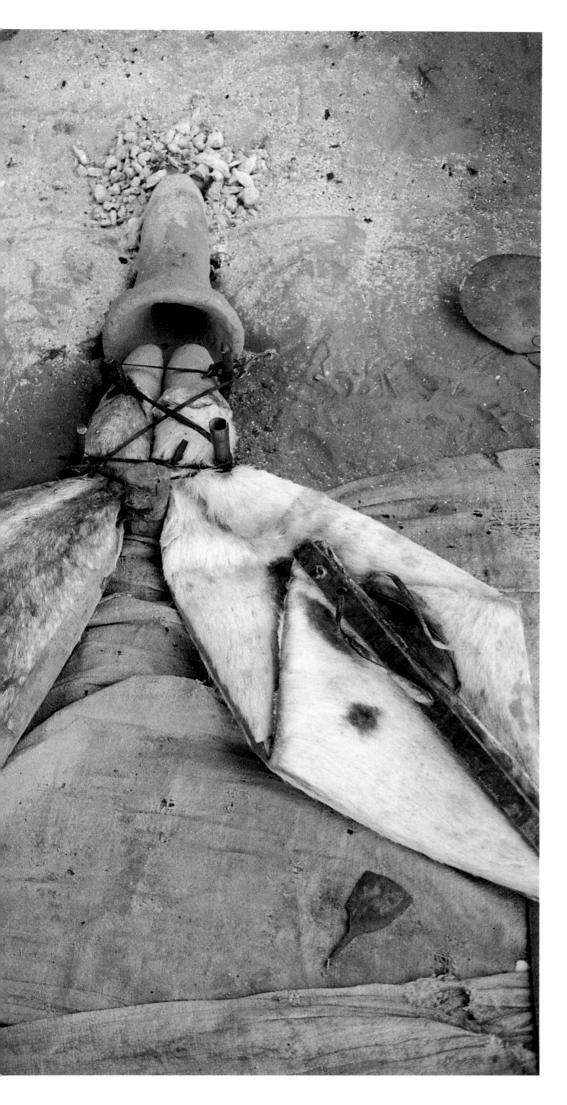

LEFT: The blacksmiths' foundries are enclosed in shady shelters of thorn branches. Here the blacksmiths make all the spears, knives and metal jewellery for the surrounding villages. Double bellows of goatskin are worked by hand to operate a rudimentary but highly efficient furnace. The blacksmith pumps the bellows to funnel air through a cast-clay cone onto a fire of red-hot charcoal. Rods of metal are laid in the fire and then hammered into shape with basic tools. The spear and knife edges, held in the vice-like grip of the craftsmen's feet, are then filed sharp. With this simple equipment they make strong, even blades.

The Samburu blacksmith families are known as *ilconone*. They hold themselves apart from the rest of the Samburu and their trade is passed down from father to son. They are said to have power over iron and to have potent curses. They always score a thin, shallow trench in a straight line from the charcoal fire, and at right angles to the bellows; it is said that anyone who crosses this line will be cursed with bad luck. Only those to whom the blacksmith has given a special bracelet made of twisted iron are free to cross the line. Other Samburu do not eat with the blacksmiths, believing that those who share their food with the *ilconone* and their families will not acquire wealth.

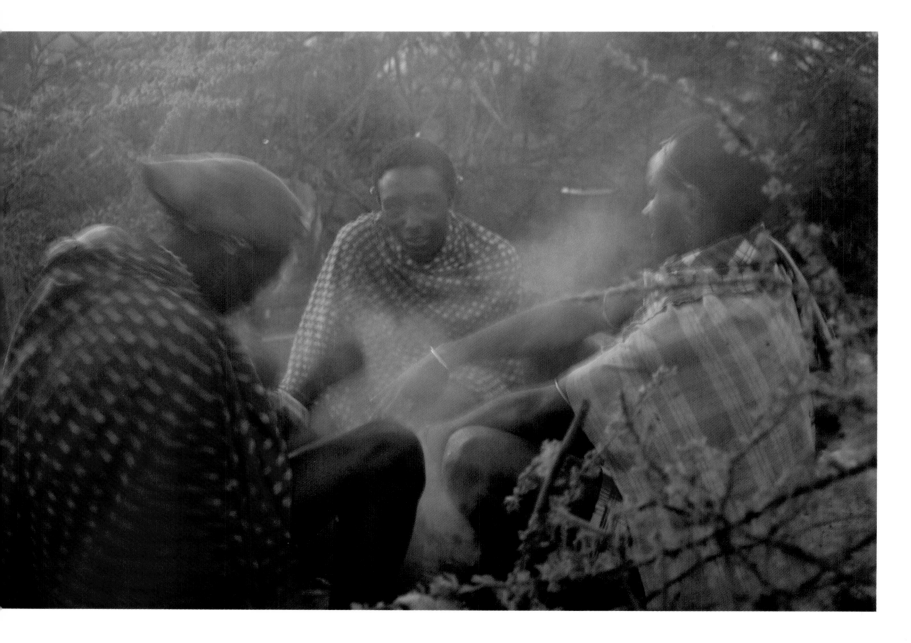

ABOVE: The warriors relish their lives in the open, tending their herds wherever the search for the most abundant grazing leads them. They sleep out under the stars on animal hides; in the early morning they huddle around their fires and wrap one of their two pieces of cloth around their shoulders to keep off the chill.

RIGHT: A herd of hump-backed cattle in the early morning. Cattle are at the heart of Samburu life and everything, from wealth and marriage to the survival of the community, is related to the health of the herds. The elders know their stock individually and can recite the lineage of each animal. The warriors protect the cattle from thieves and track down and kill any lion which tries to attack their herds. A lion's hairball, which the Samburu believe has mystical potency, is the most precious and sacred, yet most secret gift.

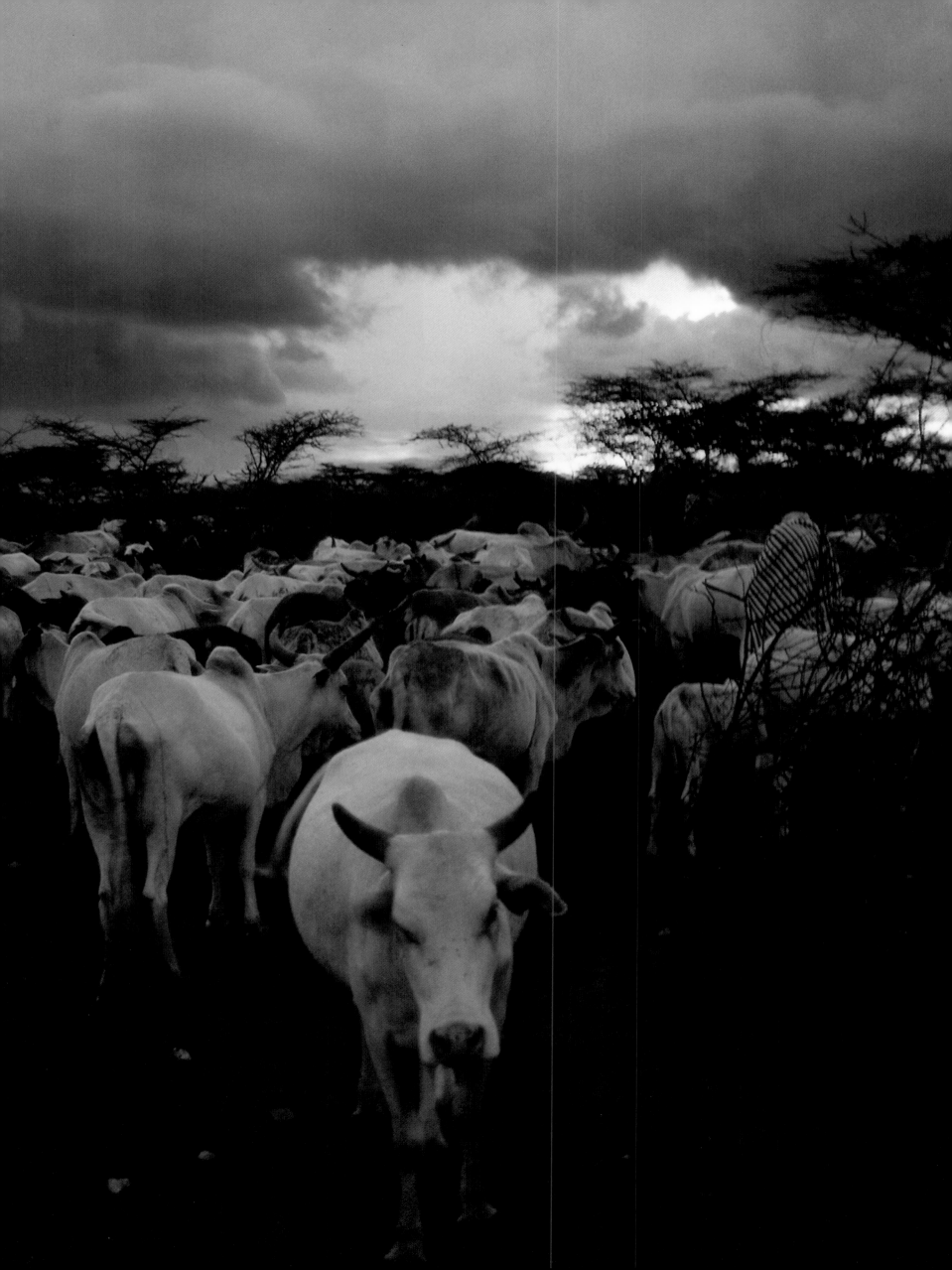

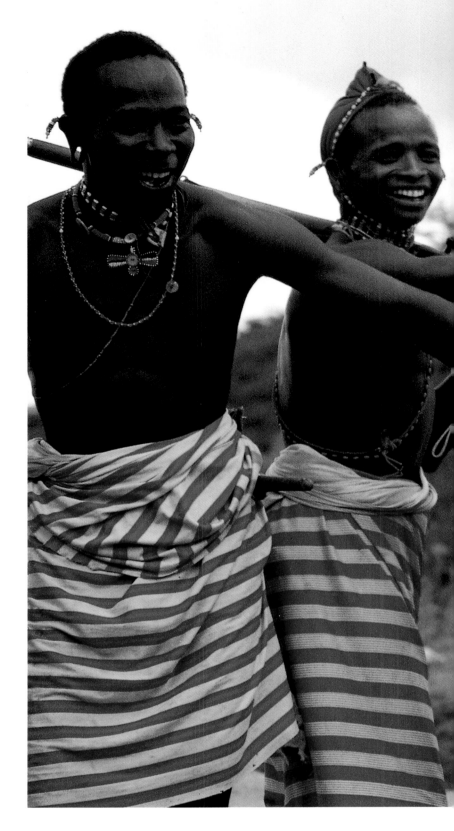

RIGHT: The warriors display a cheeky, jovial side to their usually proud characters only at times of relaxed familiarity among their peers. In mixed company they will never run or tease as they must always behave respectfully in front of the elders, and they are forever open to the slights of girls and women, who delight in teasing the warriors.

BELOW: Cattle rest after watering at the Ewaso Ngiro River.

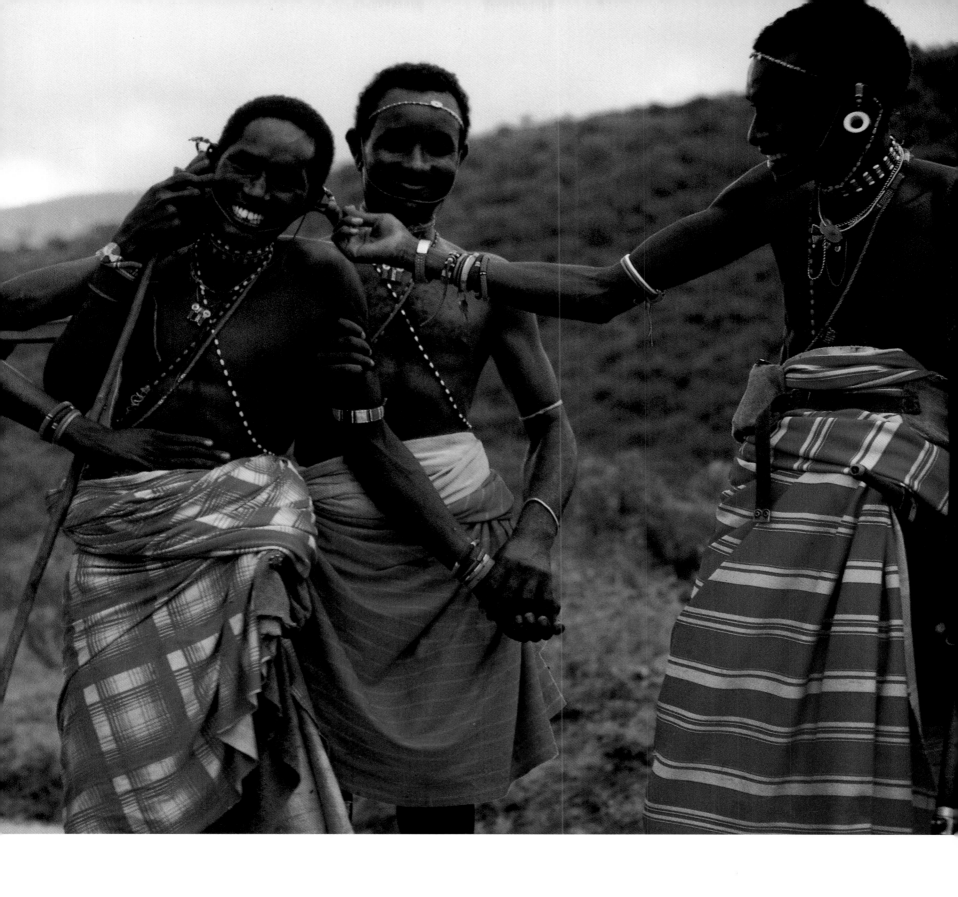

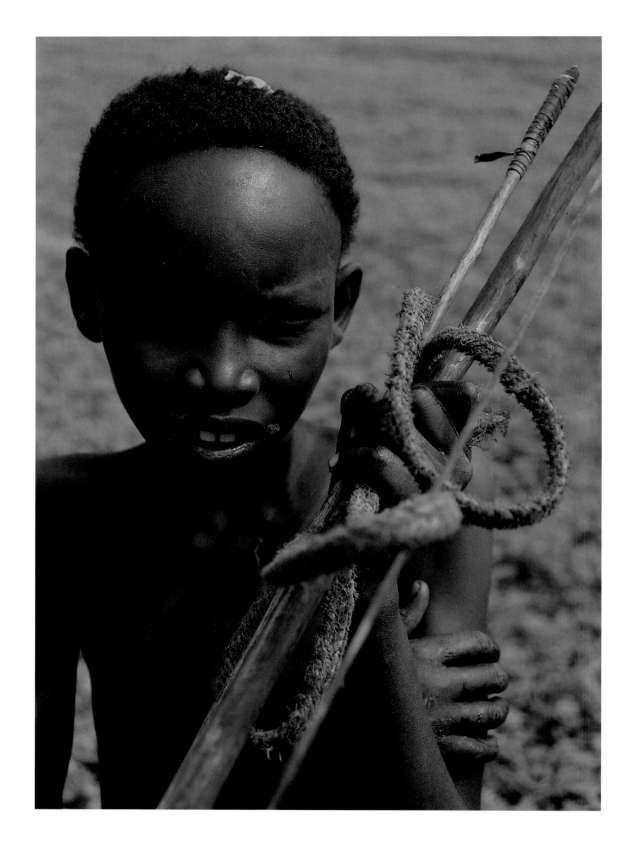

ABOVE AND RIGHT: Before they are circumcised, the young boys will from time to time join the warriors in tending the cattle. The Samburu staple diet is meat, blood and milk which the men drink still warm from the cows. The young boys are taught by the warriors to take blood from the cattle with a bow and arrow and a tourniquet.

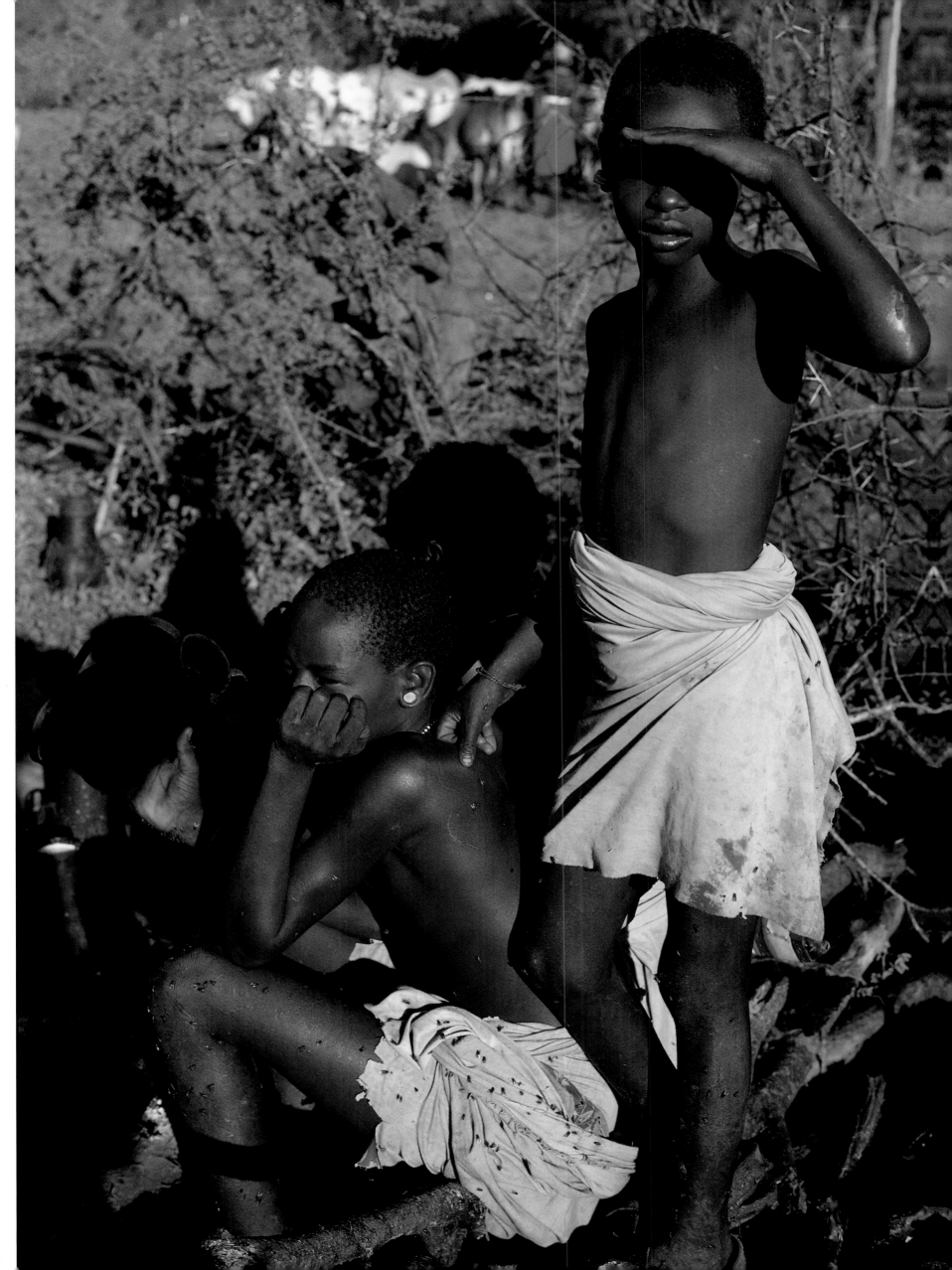

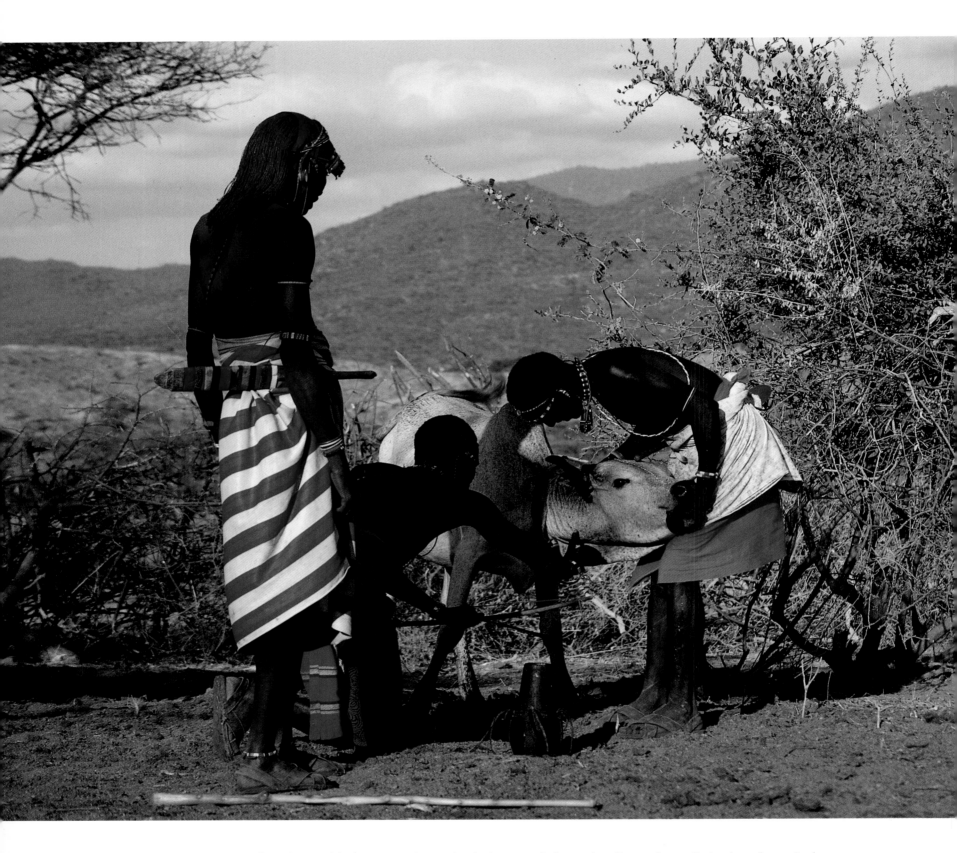

ABOVE AND RIGHT: Before being bled, a tourniquet is tied around the animal's neck until the jugular vein becomes prominent. An arrow with a sharp but shallow head is shot into the vein at close range. The arrow immediately bounces out and the flow of red blood is collected in an *nkarau*. About one litre (c. two pints) is taken, then the wound is closed by the brief application of finger pressure to the punctured vein. Cattle may be bled as often as every two weeks, but preferably they are left for a month or more before being bled again.

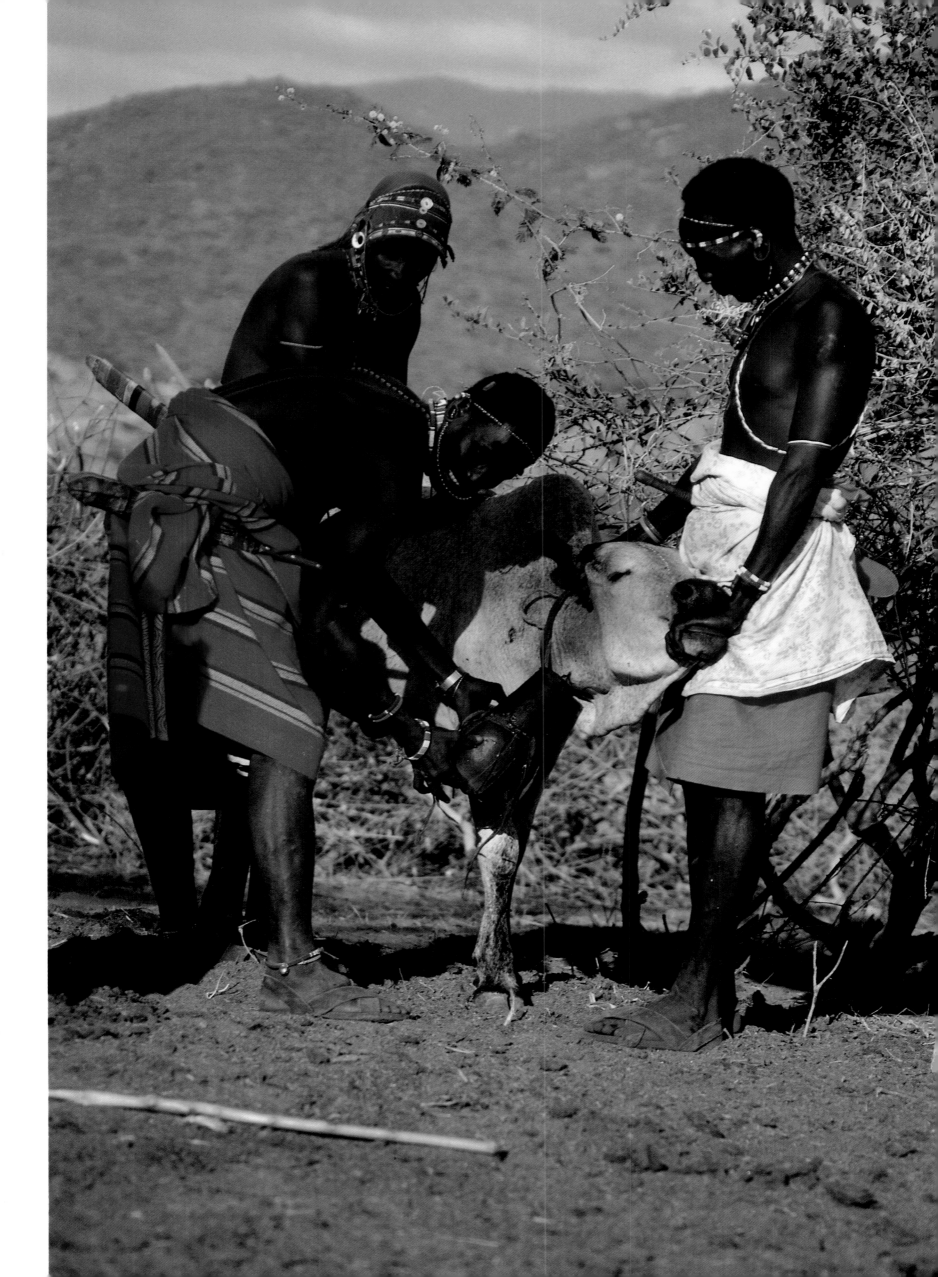

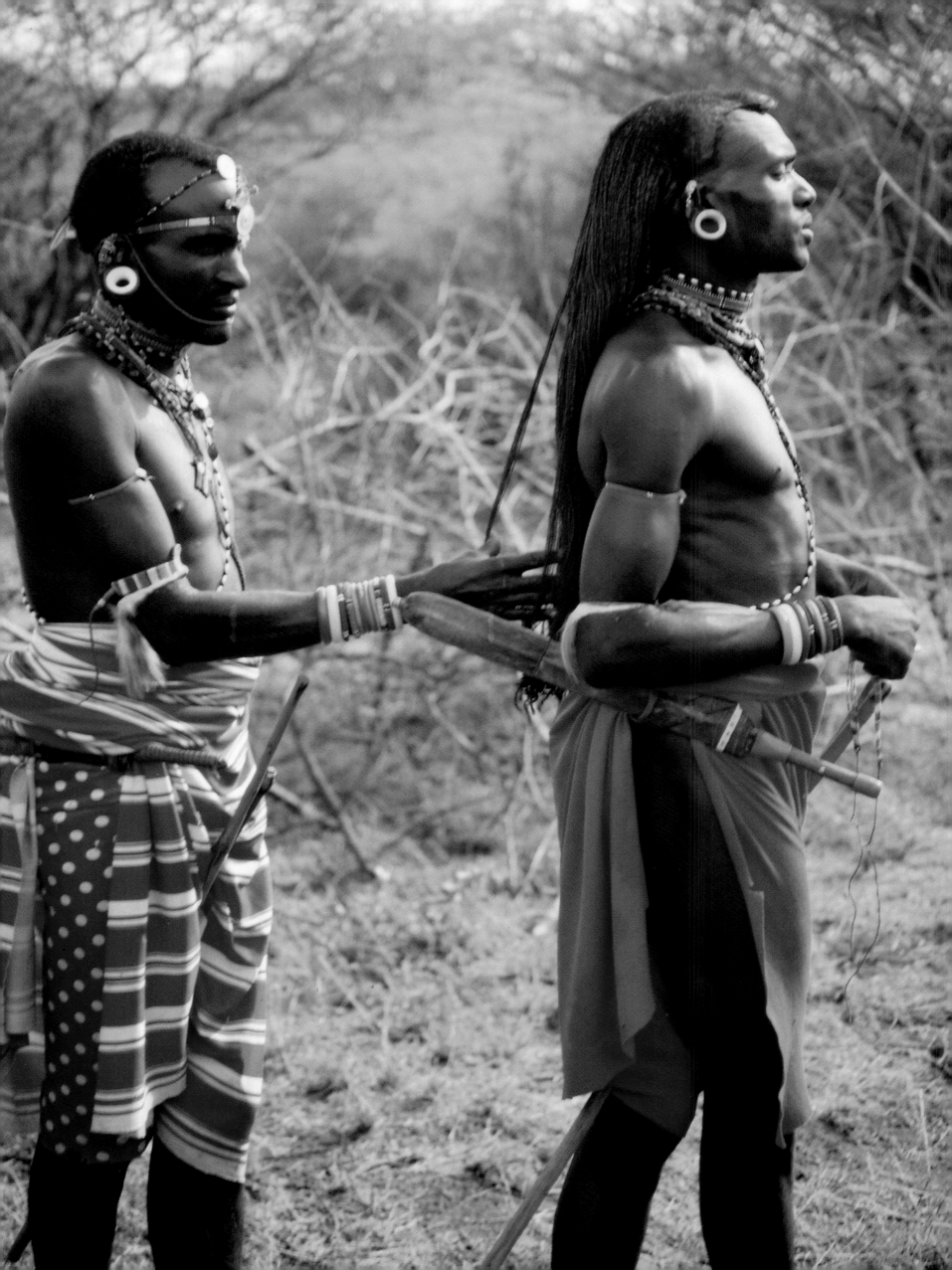

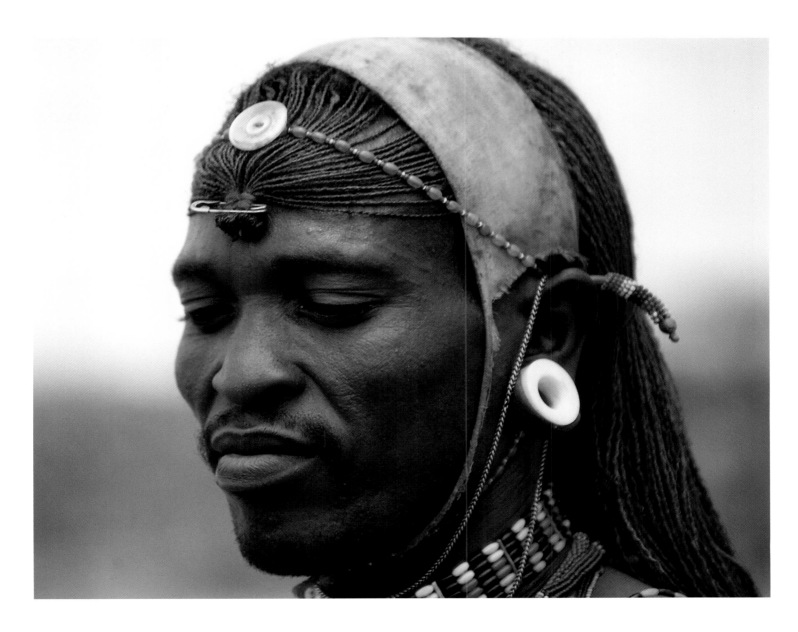

LEFT AND ABOVE: As the warriors reach the end of their term of *lmurrano*, their faces start to age. Like butterflies which have reached their glory and begun to fade, the warriors, too, have passed their prime and begin to take on a slightly tattered appearance. One by one they marry, become elders and their *laji* makes way for the new generation of *lmurran*. A warrior will attempt to keep his hair throughout his *lmurrano*, only cutting it if his father dies. A warrior who has kept his hair for his full term of warriorhood will have braids that reach to his waist. The Samburu use the length of a warrior's hair to mark the passage of time and to determine when to hold the *ilmugit* – the feasts whereby the warriors move on to the next stage of warriorhood (see p. 158 for a table showing the various *ilmugit*). The decision as to when to cut his hair and thenceforth wear it short in the manner of the elders rests with the warrior. However, the elders will not allow a warrior wilfully to keep his hair much past his time of *lmurrano*.

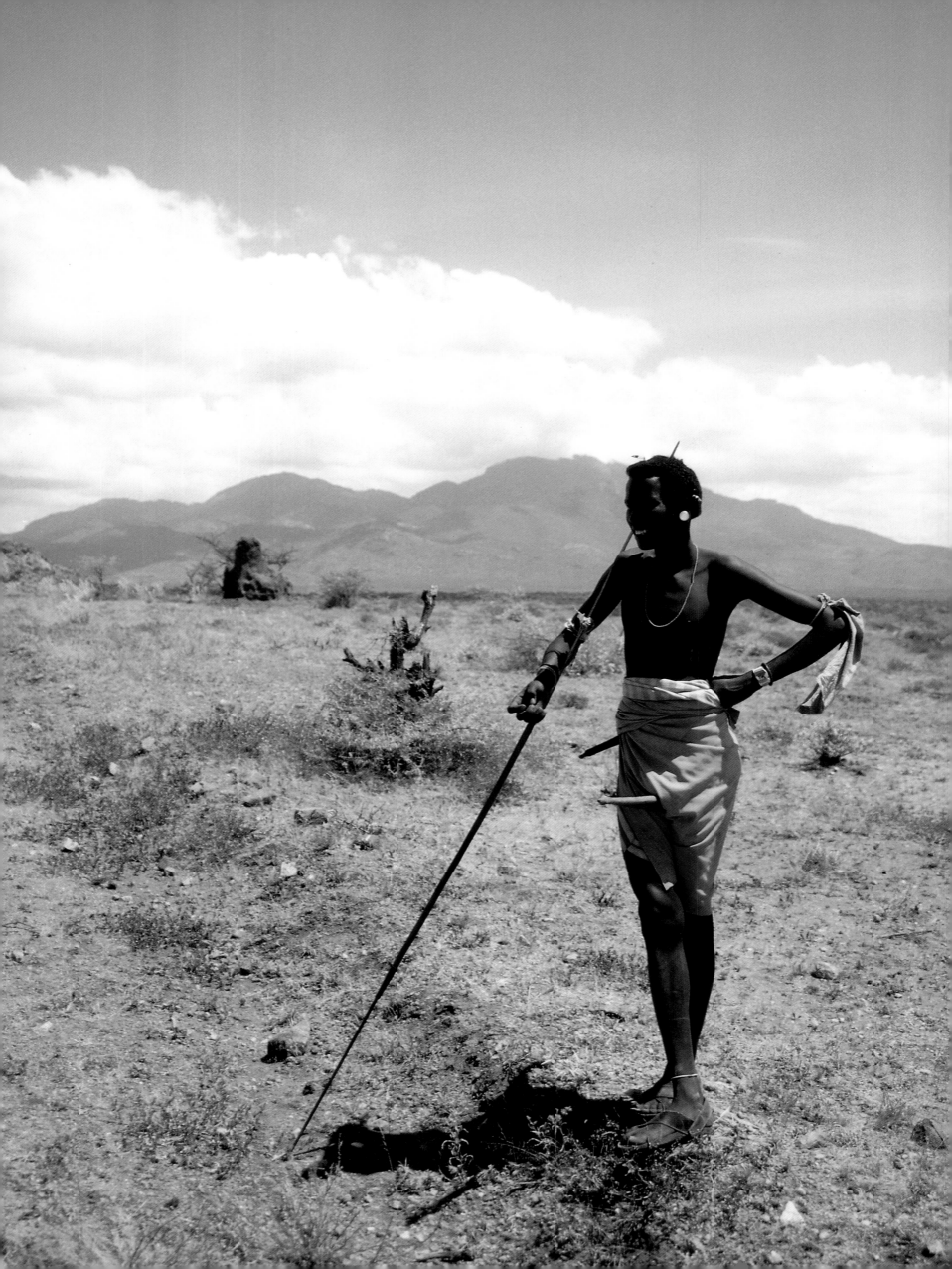

NKANG

Village Life

The *nkang* (village) is the focus of Samburu family and social life, and the meeting place for the council of the elders. Here the elders live with their wives and children, a small number of their cattle, all their goats and sheep, some of their camels and the women's donkeys. The warriors, who herd the majority of cattle and may also look after some of the elders' camels, follow the grazing and live away from the *nkang*.

An *nkang* usually consists of about forty people belonging to several close family groups from the same clan. It is composed of a number of houses arranged in a circle inside a thorny stockade, which keeps predators at bay and gives some protection against enemies. At night all the livestock is brought into the *nkang*, where each family's animals are corralled in separate smaller stockades. Villages are always well situated for defence, often on the brow of a hill or tucked away near a *lbaan* (dry riverbed). During the day the stockade of thorny acacia branches blends into the surrounding landscape making an *nkang* almost impossible to see until one is quite close, but at night, when sound travels far on the still air, the constant background murmuring of the villagers gives their location away.

The site of an *nkang* is chosen by the elders, with grazing rather than water as the priority; indeed, the nearest available water may be a three-hour walk away. The elders may decide to move the *nkang* for any one of a number of reasons: in the dry season, to find fresh grazing; during the rains, when the compound becomes muddy, to avoid the risk of foot-rot to their livestock; or, at the time of an *ilmugit* (feast), to join up with others of their sub-clan. Once the new site has been chosen, the women begin to build the houses while the men cut acacia branches for the main stockade and the inner enclosures.

The senior wife of the senior elder builds her house a fraction to the north of the easternmost point of the new compound, with her doorway slightly offset from the rising sun. The second most senior wife then begins to build her house to the south of the first wife's house and the women continue in hierarchical order to build their houses in a clockwise direction, with their doorways always offset from the direct rays of the rising or setting sun. The building of the houses is strictly a woman's task and each house (*nkaji*) is known as the woman's, not the man's: thus a husband dwells in his wife's house, a warrior visits his mother's house and children live in their mother's house.

The houses are usually low, oval structures, about 1.5 metres (five feet) in height, and consist of one undivided living space about 3.5 metres (eleven feet) in diameter. The frame is made of flexible staves driven into the ground, which are then bent over and secured with strips of bark. Into this skeleton are woven thin twigs and leaves to form walls, which are sometimes covered with hides or cow dung. The roofs are also sealed with cow dung or thatched with a sisal-like plant called sansevieria, or covered with hides. In the highlands, where the grazing is more reliable, the houses are more permanent, usually rectangular rather than oval in shape and of much more solid construction.

A Samburu house has no door but a low entrance through which one has to stoop to enter. Inside, immediately opposite the entrance, are oval-shaped donkey pack frames, which are secured vertically and act as a screen to the interior. The cooking fire is just inside the entrance; this combination of low doorway, pack frames and fire makes entering a house a precarious operation and helps protect the inhabitants against unwelcome visitors.

The sleeping area within a hut is slightly raised, and consists of a rudimentary mattress of

LEFT: An adolescent boy begins to take up the stance of a warrior. He leans on his spear and holds his *rungu* between his crossed legs. He still wears the green beads of boyhood and is not yet permitted to wear ochre.

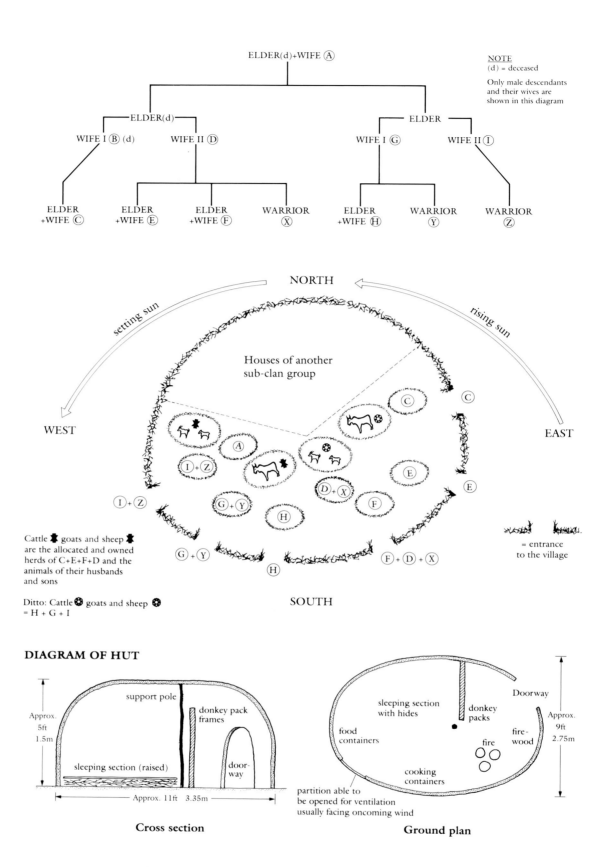

ELDER(d)+WIFE Ⓐ

NOTE
(d) = deceased

Only male descendants
and their wives are
shown in this diagram

ELDER(d)

WIFE I Ⓑ (d) WIFE II Ⓓ

ELDER

WIFE I Ⓖ WIFE II Ⓘ

ELDER
+WIFE Ⓒ

ELDER
+WIFE Ⓔ

ELDER
+WIFE Ⓕ

WARRIOR
Ⓧ

ELDER
+WIFE Ⓗ

WARRIOR
Ⓨ

WARRIOR
Ⓩ

NORTH

setting sun

rising sun

WEST

EAST

Houses of another
sub-clan group

Cattle goats and sheep
are the allocated and owned
herds of C+E+F+D and the
animals of their husbands
and sons

Ditto: Cattle goats and sheep
= H + G + I

SOUTH

= entrance
to the village

DIAGRAM OF HUT

support pole

donkey pack
frames

Approx.
5ft
1.5m

sleeping section (raised)

door-
way

Cross section

Approx. 11ft 3.35m

sleeping section
with hides

donkey
packs

Doorway

food
containers

fire-
wood

Approx.
9ft
2.75m

fire

cooking
containers

partition able to
be opened for ventilation
usually facing oncoming wind

Ground plan

twigs and leaves which have antiseptic properties that help repel insects, and this whole section is covered with hides. When the children are about four or five years old, they will usually sleep with their siblings in a small shelter next to their mother's house called a *sinkera*, meaning a place where there is no husband.

Once the elders have decided to move to a new village site, the women dismantle those parts of the house which have not been sealed with dung and re-use the basic frame at the new site. They are so adept at moving that they only need a couple of hours to load all their belongings, house included, onto the donkeys.

Each elder has his own entrance in the fenced village, called *il-tim*, which is closed at night

with a large thorny branch. There is a close bond between those who share an entrance, and *Itimito obo*, meaning "one entrance", is often used to refer to a line of descent or one family. The most senior woman in the village decides the position of the gateways which, like the entrances to the huts, must never directly face the setting sun.

The daily routine of the *nkang* is regulated by the needs of the livestock. The women rise before dawn and rekindle their fires. At first light they milk their cattle, then the goats and sheep. Later they separate the young from their mothers, as kids, lambs and calves are considered too vulnerable to graze with the adult animals. The young calves are tethered in the main stockade, the newborn calves are kept inside the houses, and the kids and lambs are put in a covered enclosure.

The village cattle are usually taken out to graze by the adolescent, uncircumcised boys, and occasionally by the elders. The goats and sheep always graze apart from the cattle, and are tended by young married women and children of eight years or more. They will return to the *nkang* around midday to rest before going out again in the afternoon, whereas the older uncircumcised boys and the cattle stay out all day.

Most of the everyday household chores fall upon the married women. Collecting firewood and water, cooking, curing animal hides, caring for the children, milking cattle, goats and sheep, aiding the birth of kids and lambs, weaving thatch from sansevieria, making cooking utensils, and hollowing out and smoking gourds and other *nkarau* to keep them clean, are all women's responsibilities.

Depending on how far the *nkang* is from a water source the women will take their donkeys every few days to collect water. All water for drinking and household needs is carried and stored in gourds, which the women load onto the donkeys and this water will have to last the village until the next trip.

The main tasks of the men are to care for their cattle and camels. They take blood from the cattle, tend the cattle while grazing, oversee the grazing and watering of all their livestock, and practise selective breeding. They also build the stockades, maintain the wells and make wooden stools and headrests, wooden drinking troughs, and wooden or leather water bails.

A man begins to accumulate his herds from birth when his father gives him his first cow. The Samburu consider it important for a man to continue the blood line of this first cow throughout his life. He will value it very highly and will rarely give it or its offspring away as a gift. Slowly he builds up his herd, which is considered his wealth and his investment in survival; he will also accumulate flocks of sheep and goats. All the skills of animal management, from the careful balancing of numbers against limited grazing, especially in time of drought, to selective breeding in order to maintain healthy lines, are passed down to the young men by the elders.

During *lmurrano* a warrior must build up his herd so as to be able to pay bride wealth. He will then allocate a portion of his herd to his wife's care. When in milk these cattle will remain in the *nkang*, but otherwise they will graze with the remainder of the husband's herd under the watchful eye of the warriors. When an elder takes a second wife he will allot another portion of his cattle and each wife will care for her allotted cattle.

A woman owns no cattle until her marriage day, when the two women who hold her during her circumcision may each give her a young female calf. Her husband's family will also give her cattle, donkeys, goats or sheep and these will remain her property. The giving and receiving of cattle is vitally important. Special names are bestowed on those that give and receive and bonds of friendship are reinforced. No other gift or gesture carries such weight.

Men do most of the slaughtering for the village, although a woman may slaughter a goat or sheep if her men are absent. Cattle and camels are killed by driving a knife or a spear into the base of the skull. Then the animal's throat is cut and the blood collected in an *nkarau* or bowl

and drunk raw by the men, or cooked by the women. The skin is removed in one piece and given to the women to peg out to dry. The men divide up the meat according to strict rules. For goats and sheep the right hindleg, right side and head are eaten by the elders; the stomach, the right foreleg and throat are eaten by the women; the back is eaten by the uncircumcised girls; the ribs and belly meat is eaten by the uncircumcised boys. The left hindleg, left foreleg and left side are distributed among those in the settlement in need of food, or eaten by the family of the woman who owned the animal.

The meat of a cow or a camel is divided similarly, except that the elders are allotted the right leg and some of the meat from the right side; the women, the stomach, back, head and throat; the uncircumcised boys, the heart. The rest of the meat is shared out within the village according to need. If warriors visit and are given a goat or sheep, they slaughter the animal a discrete distance from the village. They eat their share of the meat in the bush, leaving only the head, stomach, throat and back, which they carry back to the village in the animal's skin and give to the wife of the man who gave the animal.

The ritual of eating is complex. Each sex eats separately, and within each sex a group of a certain status will only eat with those of a similar status. No woman, other than a warrior's own mother, will ever offer him food or eat in front of him. It is only after his *lodo* ceremony, which takes place a year or more after marriage, that an elder will eat food prepared by his wife. Then, too, the elder's close friends may eat in front of his wife within her home. Similarly, in very intimate family situations a mother may drink milk in front of her warrior brother or son. The rules governing other exceptions are minutely detailed and are described in the chapters on warriorhood and circumcision. These codes of behaviour formalize sharing and are the foundation of community respect.

An elder above the firestick *laji*, that is a man of about fifty, will often have a son or younger relative who will carry out most of the older man's physical tasks while he concerns himself with the duties of his inherited seat within the council. These councils are important for maintaining the social order, and close to every *nkang* there is usually a large shady tree under which the elders meet and hold their *nkiguena* (discussions).

Any major event, for example a forthcoming *ilmugit*, is discussed and planned at the council. The right time to move the *nkang*, which water sources to use, livestock management, and the movement of the herds are also discussed by the elders. Any moral misdemeanour or social issue, such as divorce or theft, is debated. Justification, guilt or innocence is judged and repayment of bride wealth or a suitable fine is then decided upon and enforced. All major disputes – even those between women – are discussed and settled within the elders' *nkiguena*. If a wife has a dispute with her mother-in-law, for example, she will talk to her husband stating her wish to call upon the elders who will then preside over the dispute.

The elders' council is an effective way of solving communal problems and resolving argu-ments amicably. However, it involves time-consuming debates as each elder is permitted to speak at great length. The moment an elder decides an injustice has occurred, the calm atmos-phere of the *nkang* changes, becoming fraught and tense, and the elders, with long, grim faces, retreat to the meeting tree to debate the alleged offence for hours, even days. Goats, usually provided by the person around whom the dispute revolves, are slaughtered to feed the elders, and beer and sometimes *miraa* are also provided.

Nkanyit (respect) is the bedrock of Samburu society and the means by which the elders ensure that the codes of behaviour and morality continue. Respect enters into all their conduct, from their eating codes and the way they behave toward each other to their stance and their speech. A child will only address an elder meekly, standing at distance and waiting until he is called to speak; an elder will always stand at a respectful distance while talking to a

married woman. The manner in which a subject is broached will determine whether or not the response will be favourable.

The Samburu usually refer to someone by their status, for example, elder or child, or by some distinguishing characteristic or by physical appearance. Warriors of the same age group call each other *murata*, and will go on doing so long after they have become elders. A woman and her sister-in-law call each other *sintani*, a term also used by an elder towards a female friend other than his wife. Very old men are addressed as *akuyia*, as a term of respect by younger generations, and very old women are similarly addressed respectfully as *nkokoo*. A man will never speak his wife's name, nor a wife her husband's name. They refer to and address each other as *mparatut* (wife) and *lepayian* (husband). Once a woman has a child, she is referred to as the mother of her first born. Fathers are also referred in a similar manner. If a person is not known well, he or she is referred to by his or her clan or sub-clan name. It is quite common for someone to know another person quite well and yet not know his or her birth name. A name is considered an extremely intimate possession and its misuse in a spell could bring misfortune on its owner.

Within the village, both boys and girls are prepared for circumcision and leaving childhood. As a child reaches puberty, his or her right, then left, earlobe is cut and plugged with a bundle of thin sticks. The hole is gradually enlarged until it will accommodate the ivory plugs worn by men during *lmurrano* and the earrings worn by women in marriage. Then the upper rim of the right ear is pierced with a hot stick, then the left. Lastly the two lower front teeth are removed. Many explanations of what lies behind these practices are given, from the theory that, like scarification, they were intended to put off slave-traders, to the belief that such practices make the Samburu appear fierce to their enemies. The teeth may be removed as a simple precaution against starving to death in the event of lockjaw. Whatever the reason behind them, these practices require a considerable display of bravery and courage on the part of the children, the physical pain they experience symbolizing the often spiritually painful transition into adulthood.

PRECEDING PAGE: Flat, arid plains interspersed with distant mountains and rocky outcrops create a vast, harsh, seemingly inhospitable environment, which nevertheless may suddenly reveal something delicate and beautiful such as the pink flowers of this Lokiteng (*Ipomoea cicatercosa*).

ABOVE: The Samburu do not necessarily construct their villages near water sources, but as close as possible to the best grazing. Villages are always well situated for defence, either on a slightly raised piece of ground with a panoramic view or near a dry river bed, where the *nkang*'s thorny stockade blends into the surrounding scrub trees. Within the stockade the houses are arranged in a circle in strict hierarchical order and each family's livestock is corralled separately at the centre.

RIGHT: A married woman wearing traditional leather *nkela*, one around her waist and another tied over her shoulder. They are made of goatskins which have been worked until soft, smeared with ochre and embroidered with beads and sometimes cowrie shells. The elongated *nkarau* she holds is typical of those used by women of the Lpisikishu for carrying milk, and in a style possibly adapted from the neighbouring Rendille.

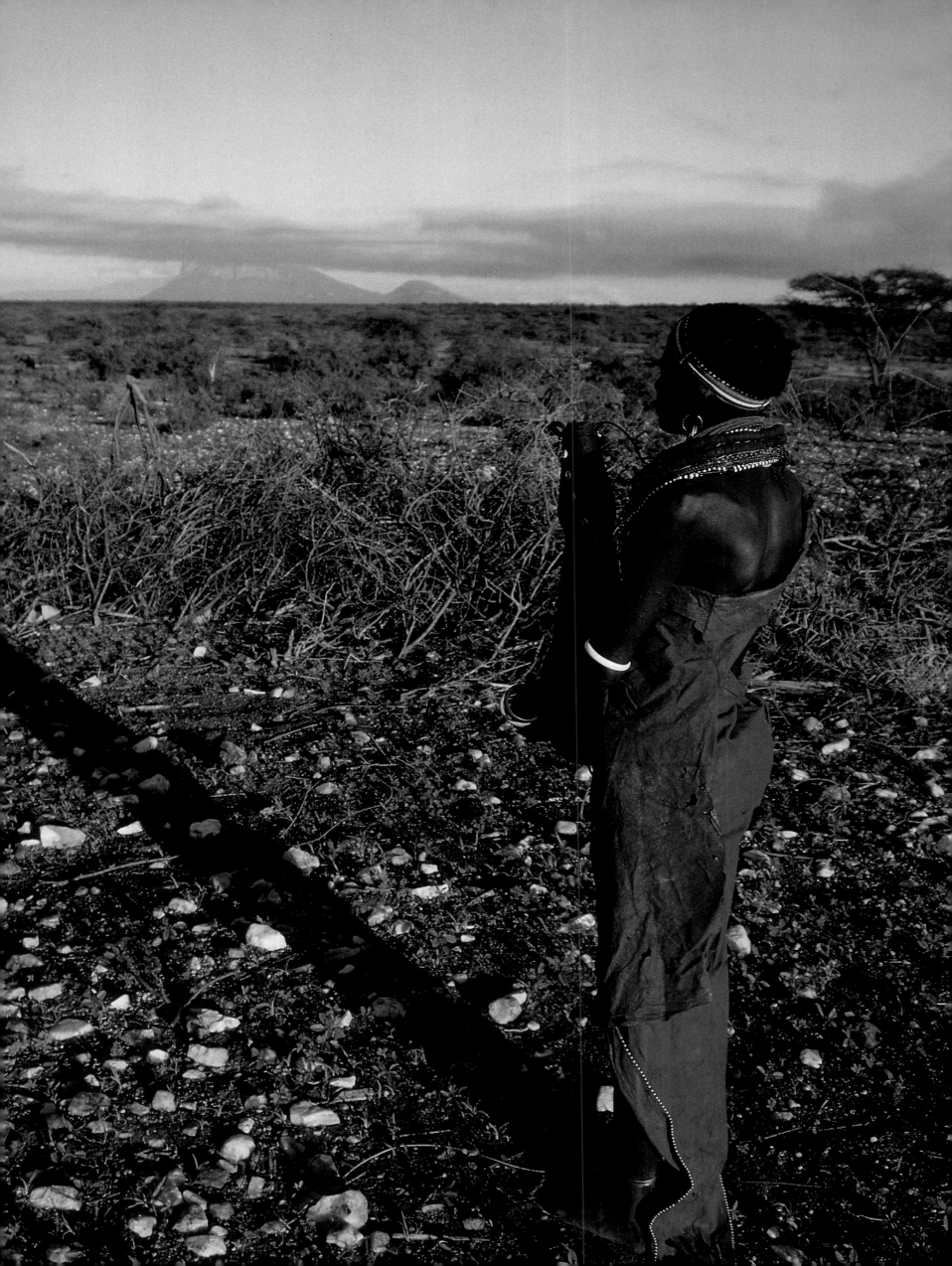

BELOW: The elders live with their wives and children in the villages, while the warriors spend most of their time with the cattle in the outlying bush. From time to time the warriors visit their mothers' homes. Here, a warrior at the end of his *lmurrano* who has shaved his long hair but who has not yet forsaken the clothing or jewellery of a warrior, stands with his younger sister outside his mother's home, whittling smooth a long stick.

RIGHT: With the exception of a parent and child, it is considered disrespectful for members of the opposite sex or of a different age group to touch in public. The Samburu say that this is the behaviour of a troublemaker. Here, an elder talks to a married woman from a respectful distance. The Samburu will never force a meeting but approach slowly and gradually greet one another. *Nkanyit*, an all encompassing respect for life, which includes respect for the elders and one another, is instilled from an early age.

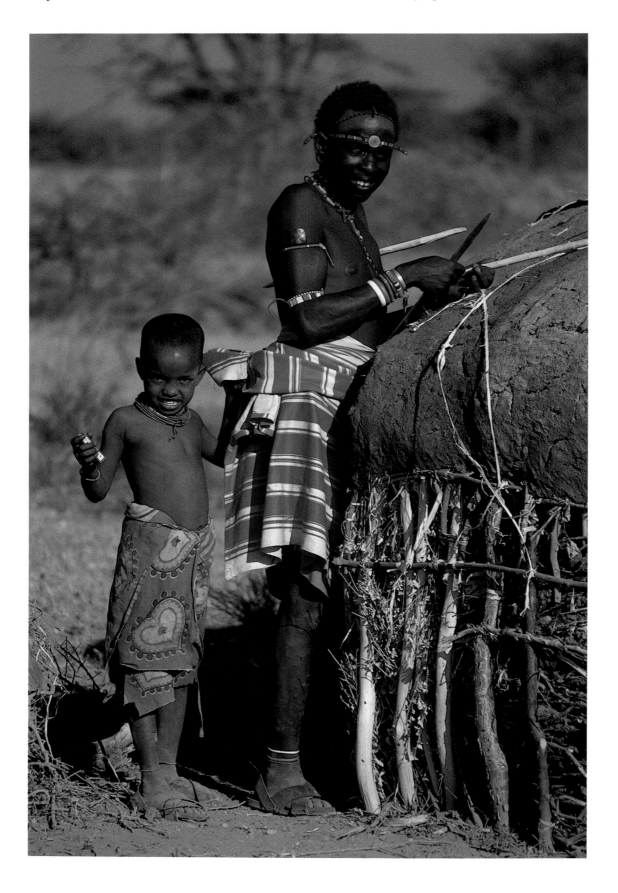

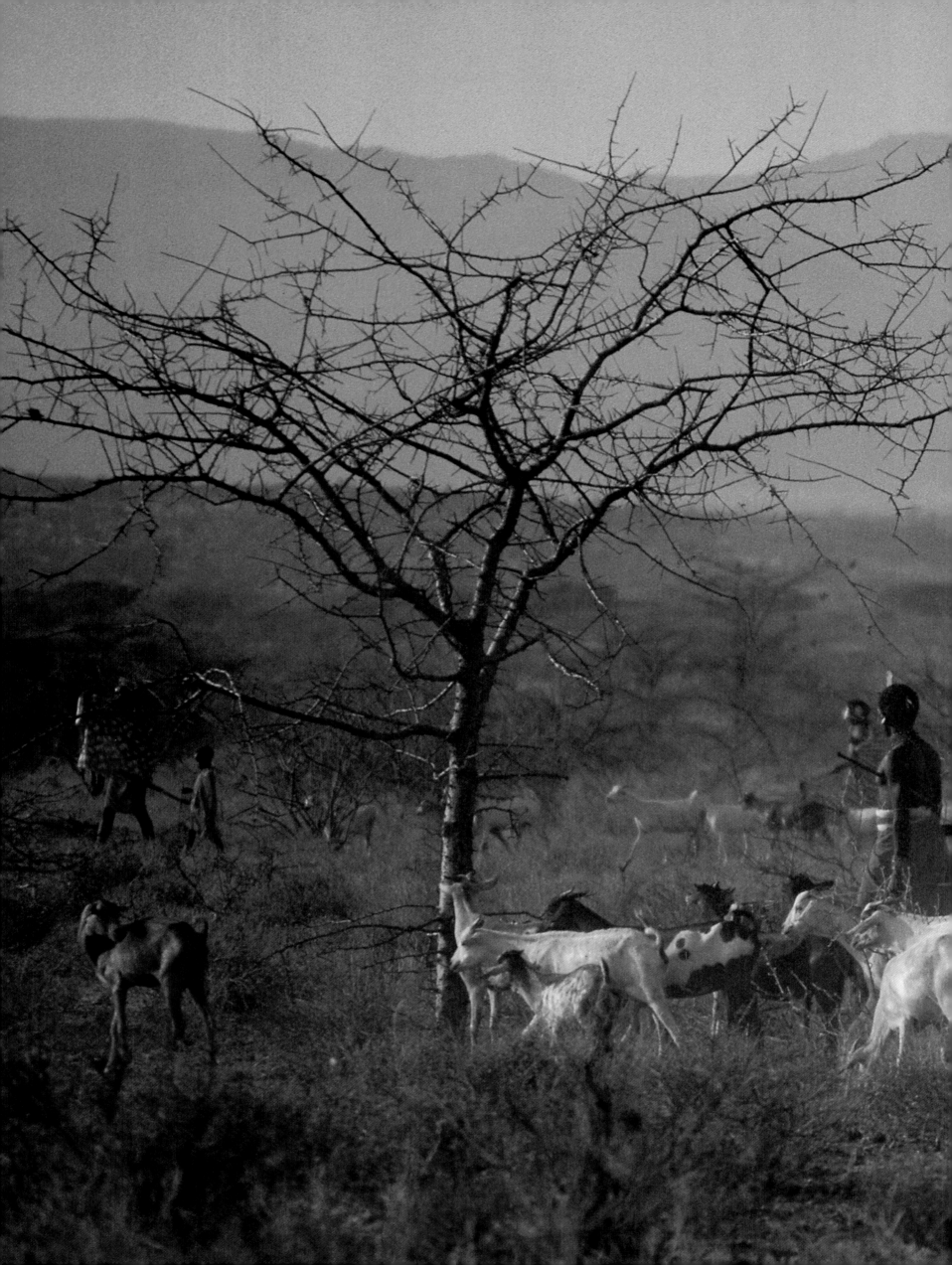

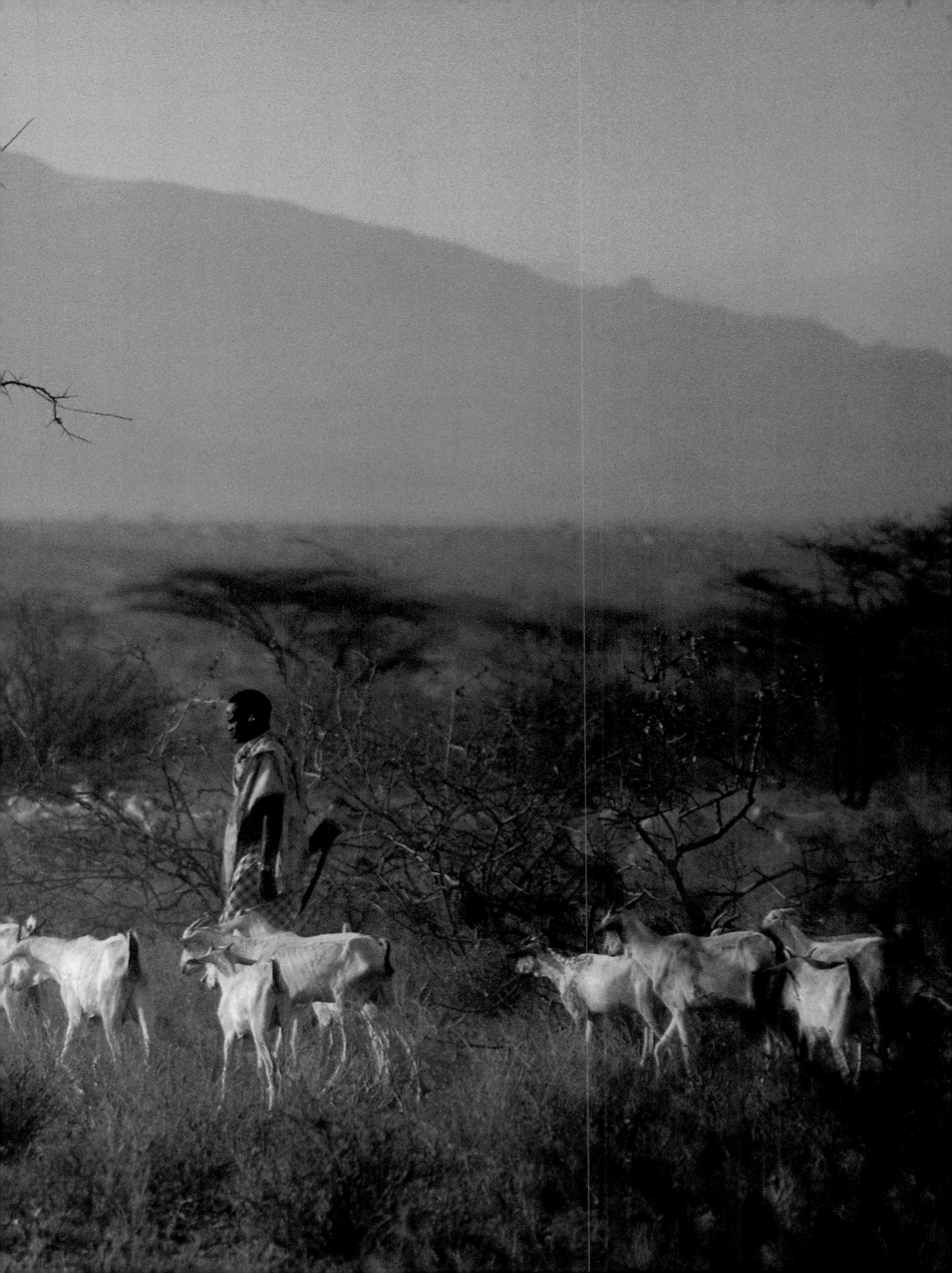

PRECEDING PAGE: Elders run a discerning eye over their flocks as they leave the *nkang* in the early morning to find pasture. In such hostile terrain their herds need constant supervision. The elders know each animal intimately and watch over them as they walk with them from dawn till dusk.

Every morning for part of the year Limo or Lakira le nkakenya, the morning star, appears and is the signal to lead the cattle out to graze; during the same months Lakira dorrop, the evening star, appears at about six o'clock and is the sign that the cattle and sheep must be brought back to the fold.

BELOW: Early morning, before the cattle have left for grazing with the men. Each family group usually has separate corrals for its cattle, which are always kept apart from the other livestock.

RIGHT: Some of the Samburu elders are enlisted in the home guard and armed by the government with Second World War .303 rifles to protect their herds and villages from marauding shifta (bandits).

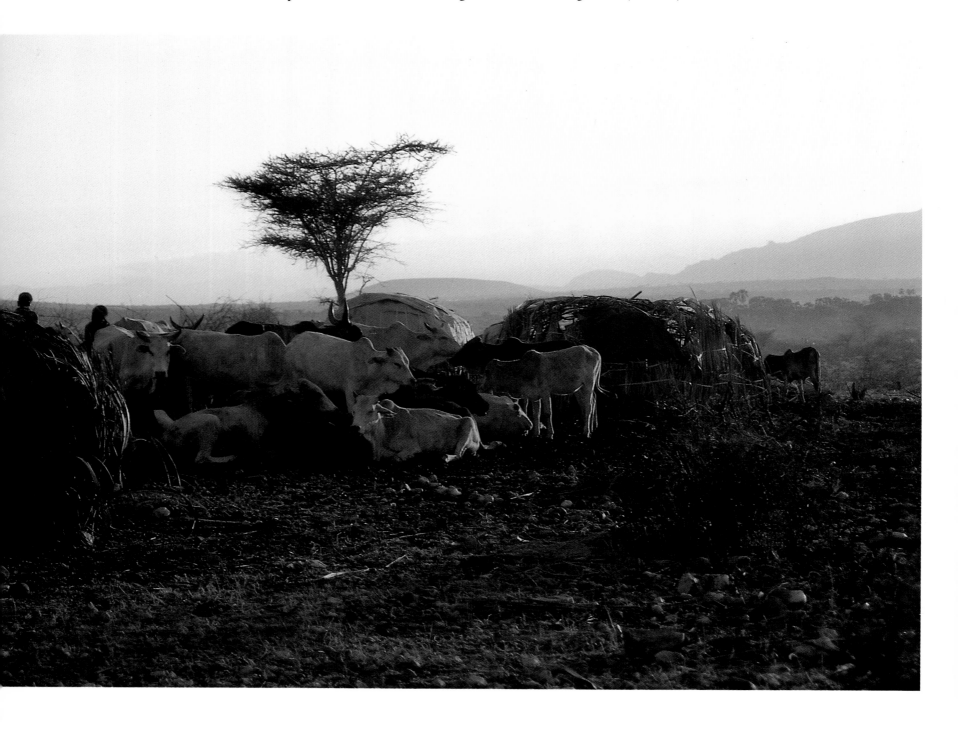

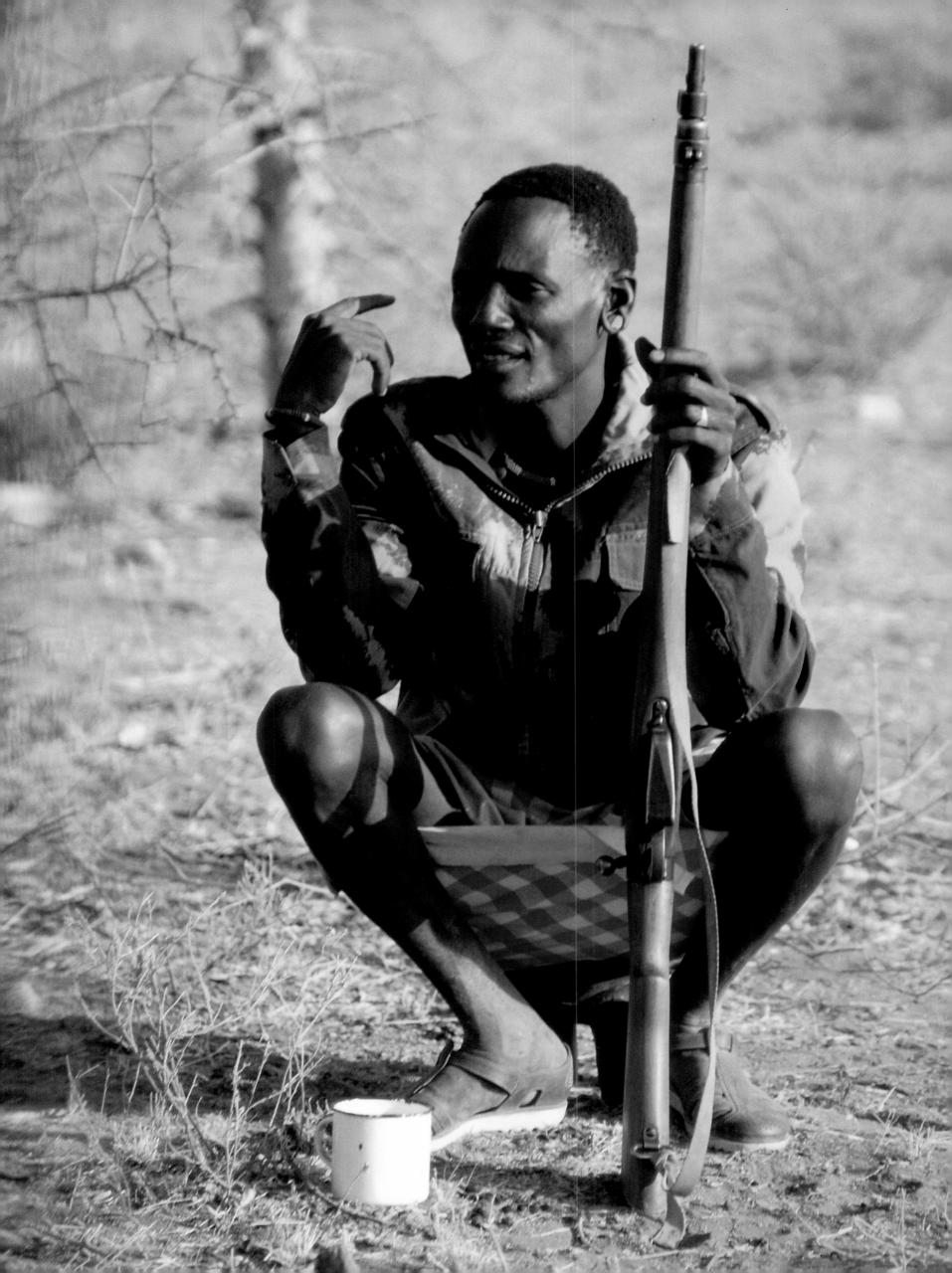

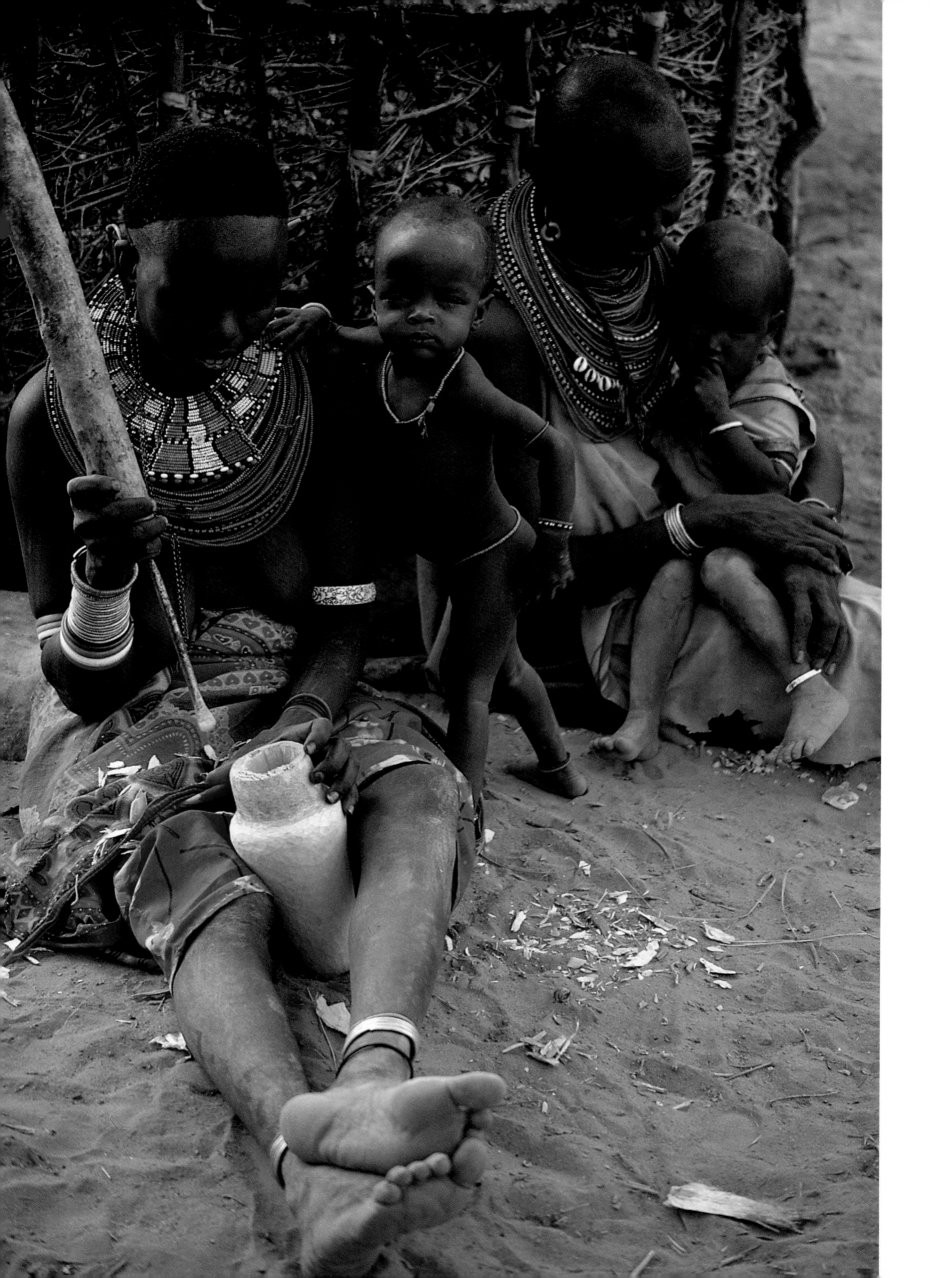

LEFT: A married woman uses a chiselling tool mounted on a long shaft to hollow out a lid for a wooden container, *nkarau*. Milk, dried meat and water are carried and stored in many differently shaped *nkarau* which are made by the women from wood, leather or gourds. The women also make small tube-like containers from hollowed branches, which they cap with goatskin and use to store tobacco, fat or a type of butter. Some families use hollowed animal horns, bones and ivory as containers for tobacco, which the elders wear around their necks.

BELOW: The villages are the focus of community life. During the day, once their chores are done, the women gather with their children while the men and young boys herd the animals.

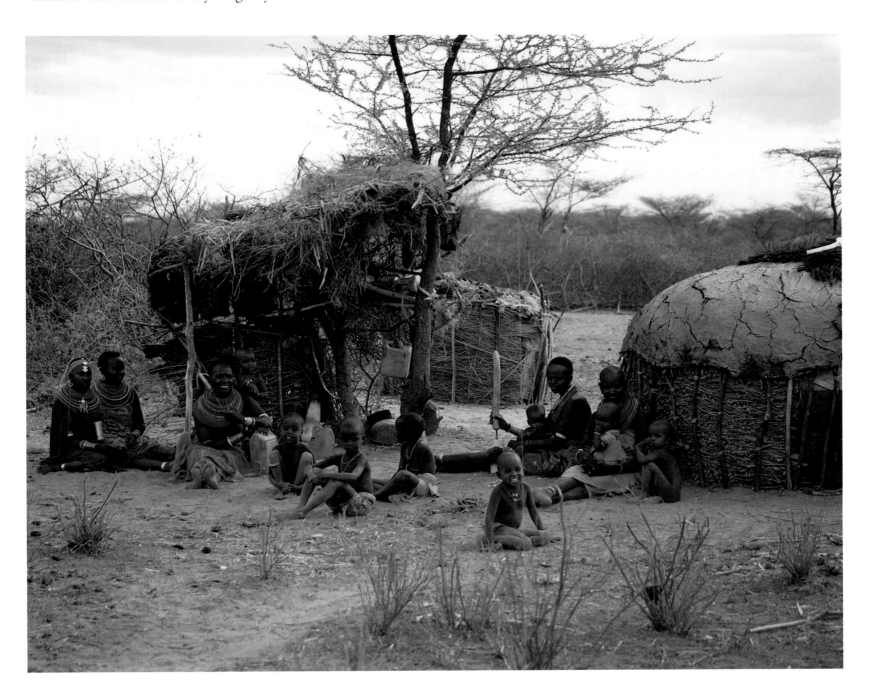

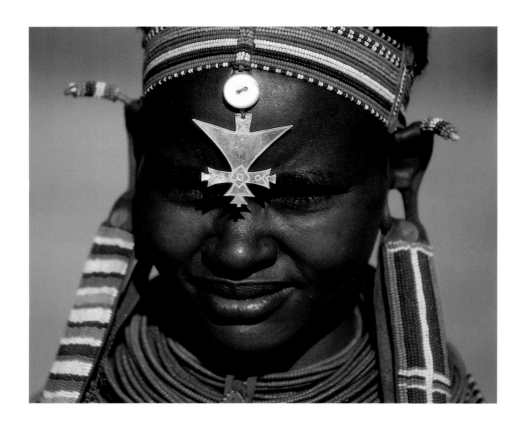

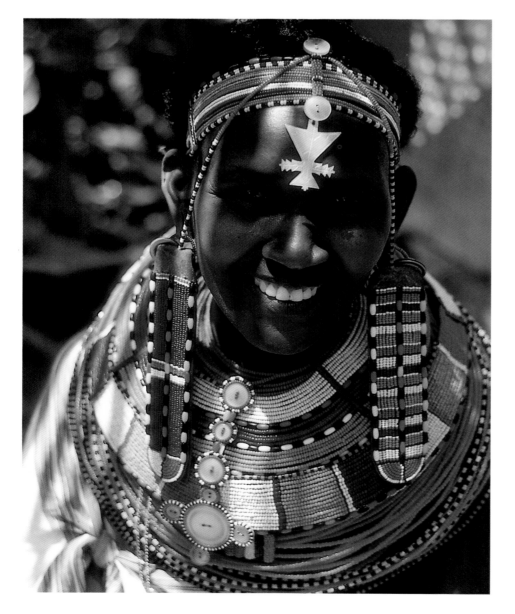

TOP, LEFT AND RIGHT: Many married women wear thin, metal ornamental crosses at the front of their beaded headbands. Although this decoration serves no purpose other than adornment, it would appear to have derived from the elaborate Christian crosses of Ethiopia. Some of the warriors also wear smaller versions of these crosses hanging from the visors of their headdresses.

Some women wear long beaded earrings which, in addition to the small circular brass earrings, denote married status. These are made of hide oversewn with beads and are threaded through the large holes in the earlobes made shortly before marriage.

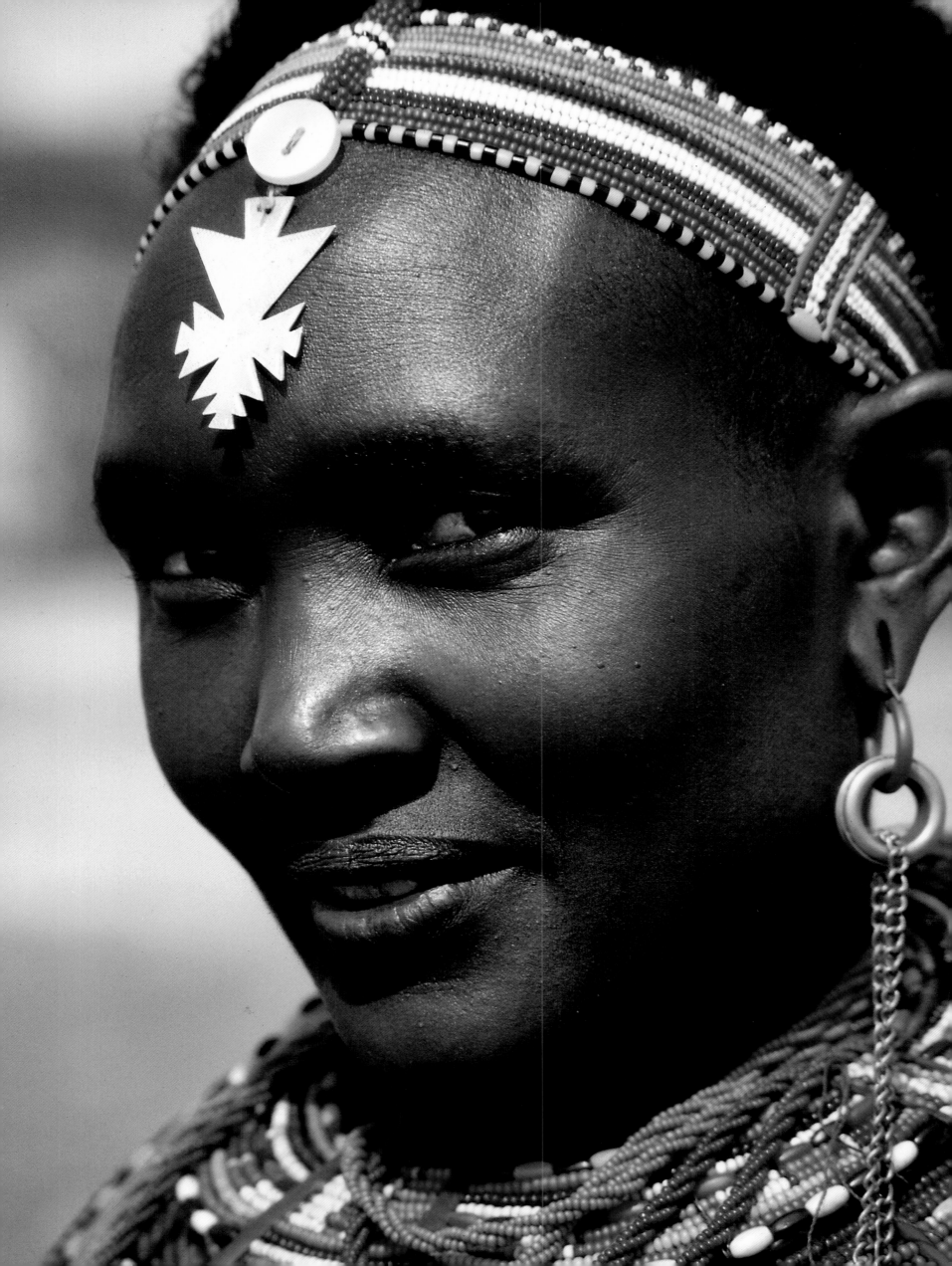

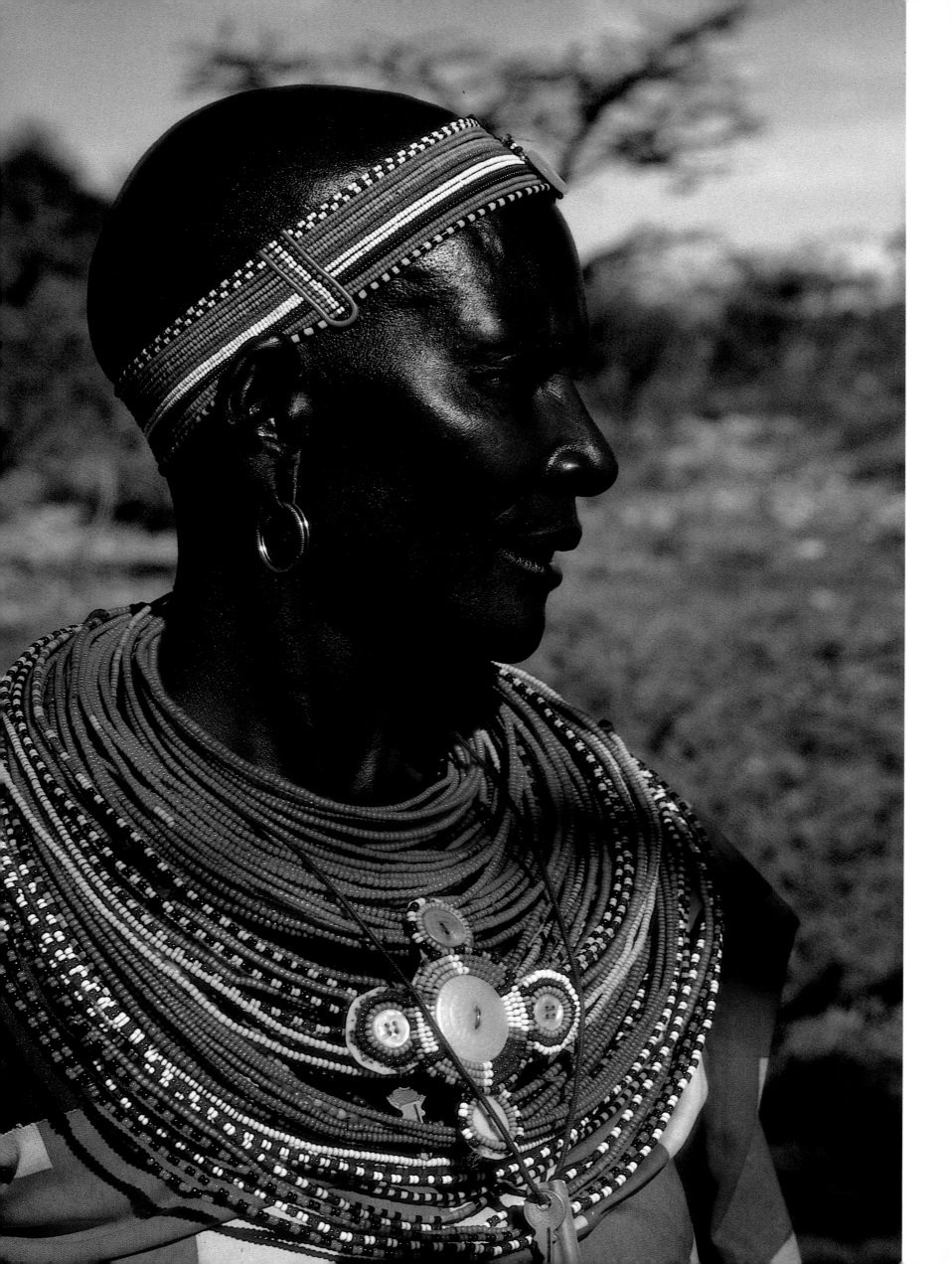

LEFT: Samburu women have stately carriage, strong faces with high cheek bones and aquiline noses. Their characters are equally powerful and they are the pivot of community life. Their many strands of beads are given to them by the warrior admirers of their girlhood or more recently by their husbands. Over the top of them they sometimes wear an additional striking decoration or pendant.

BELOW, LEFT AND RIGHT: A woman of the village chewing an *nkike*, a twig cut from an indigenous bush (*Salvadora persica*), which is used as a toothbrush by many of the East African tribes.

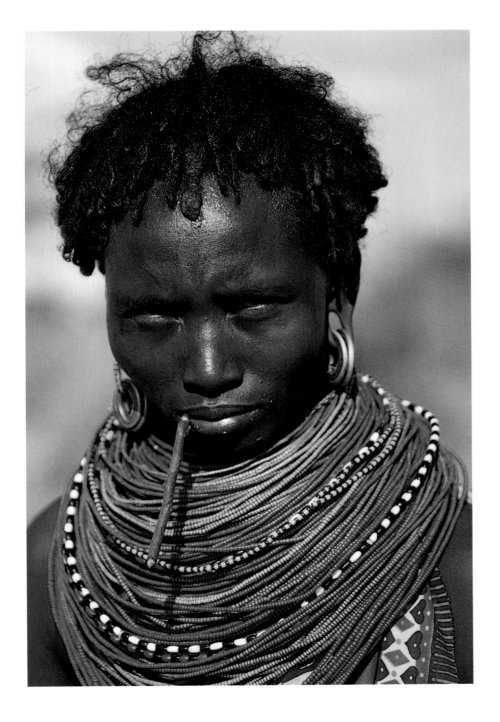

BELOW: A woman milks her cow in the calm of the early morning, before the first rays of sunlight have risen over the horizon. Each woman milks the cattle from her allotted herds. Standing, singing at the cow's right flank, she takes milk from the two right teats and leaves the two left teats for the calf. Comforted in this way, the animals stand easily and give their milk readily. Milk, along with blood and meat, is the Samburu staple diet. It is considered the essence of life, is never discarded and is held with such high regard that it is sprinkled at almost every blessing.

RIGHT: An old grandmother whose weathered face still reflects her youthful beauty.

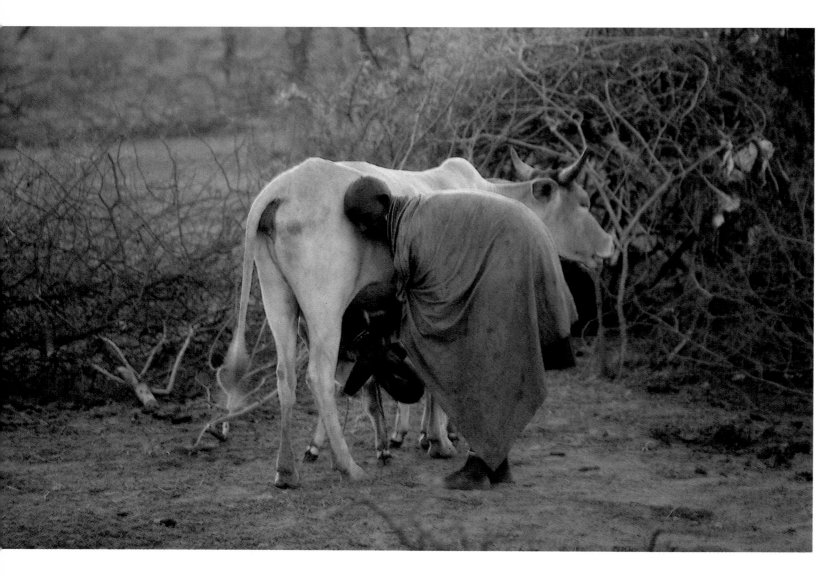

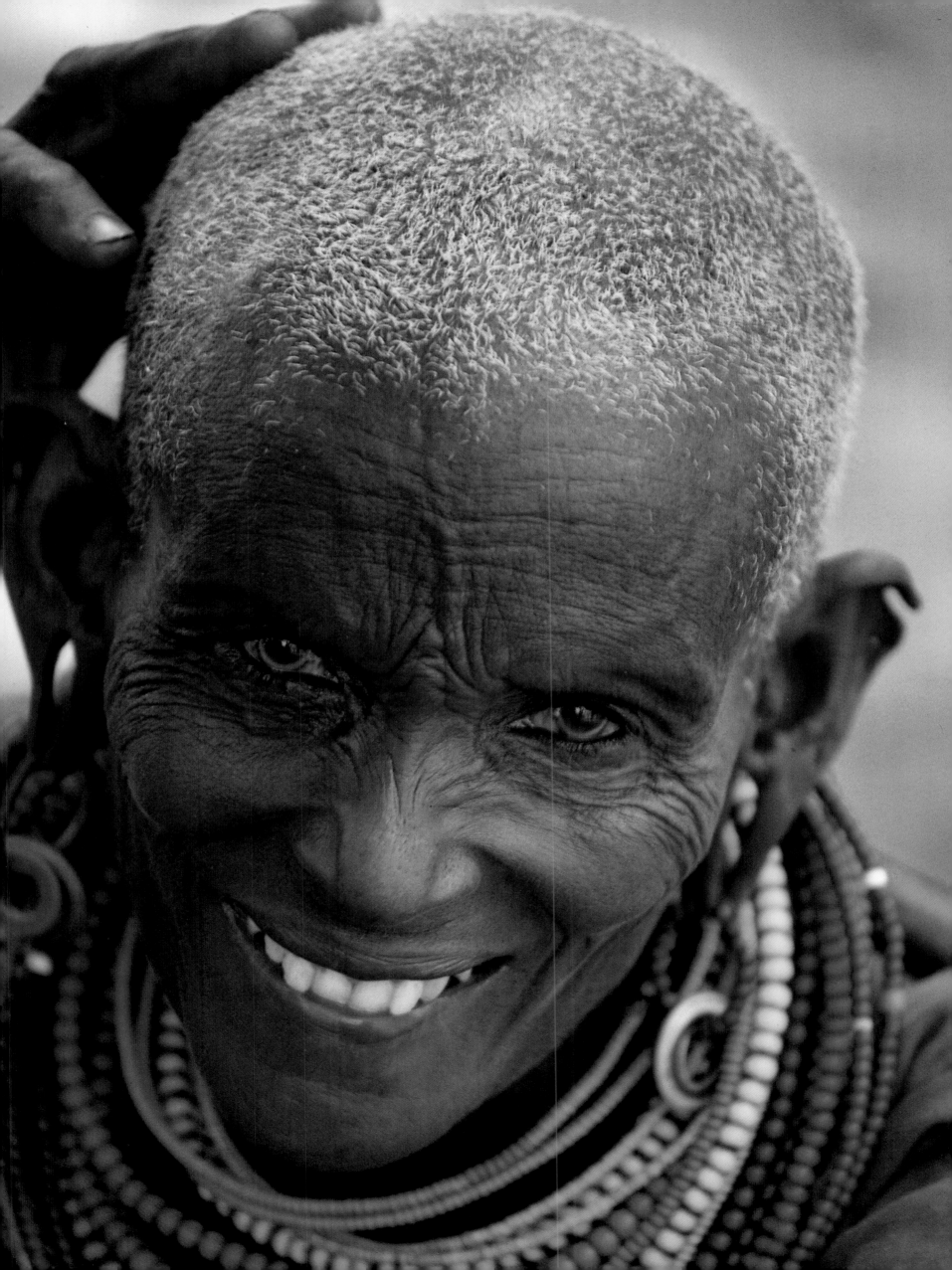

BELOW AND RIGHT: Women are cherished as the givers of life. Newborn Samburu babies are tiny, wrinkled and pink in colour, with straight black hair. The birth is attended by a sister, or another female relative, who remains with the mother for several weeks to care for her and to help look after the baby. The mother wears a wide leather belt for a couple of months after the birth, which the Samburu say helps their stomachs to return to shape.

When a child is born, blood is taken from a cow and given to the mother. The father makes tiny shoes for the baby out of cowskin, similar to the sandals made for a newly circumcised boy. A young, uncastrated goat is slaughtered, the blood is drained and then stirred with a stick to remove the fatty solids which coagulate and adhere to the stick. The goat's blood and meat is cooked and given to the mother to restore her strength. The coated stick is hardened in the fire and then suspended from the roof of the hut as a sign that a birth has occurred. Usually the mother will name the child, inventing a unique name for her offspring.

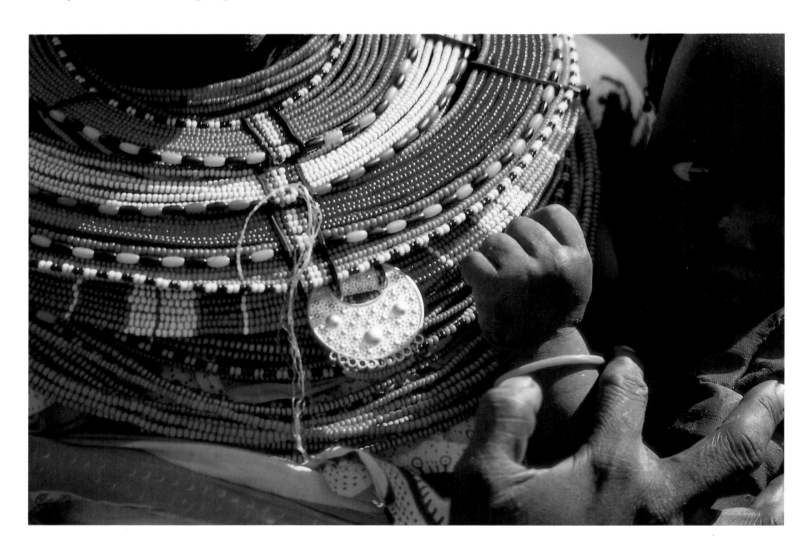

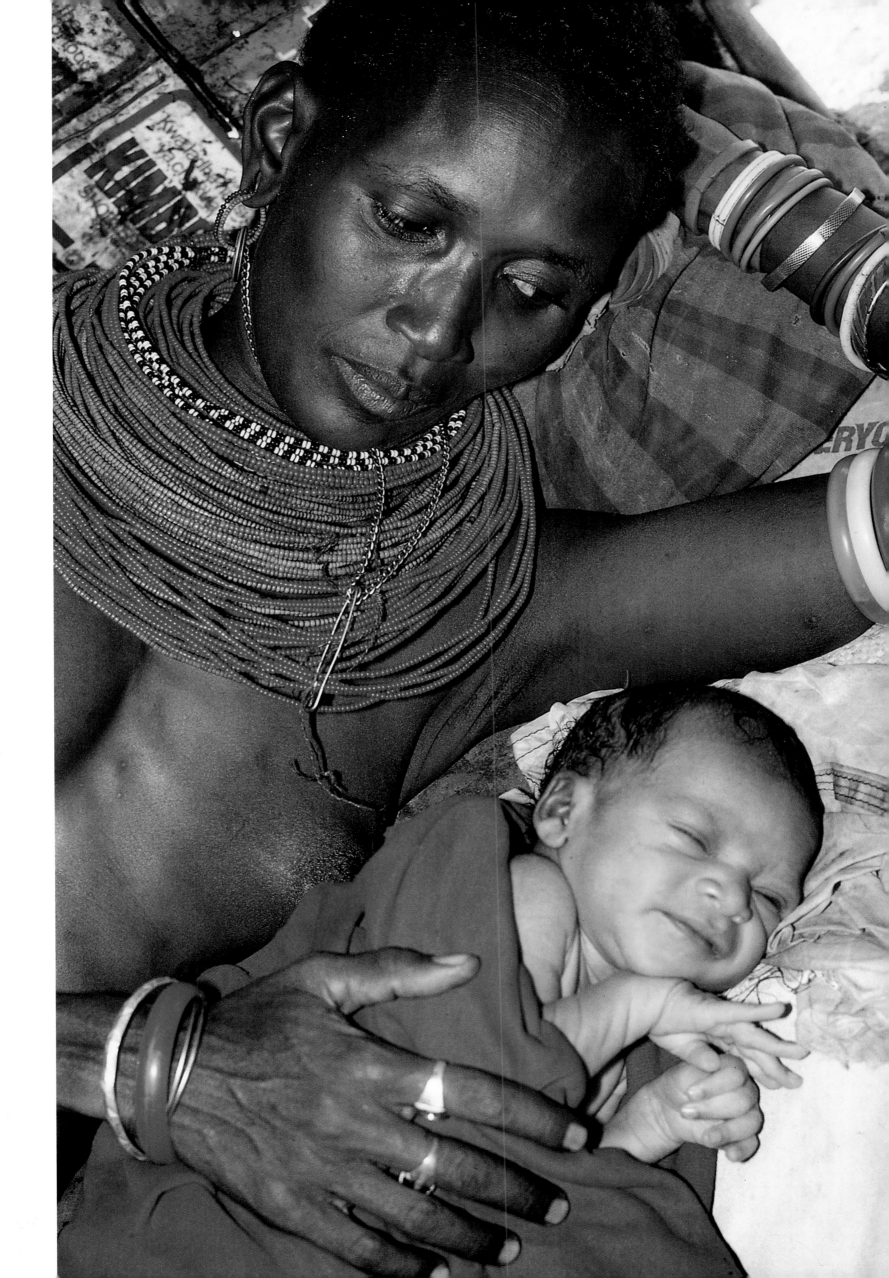

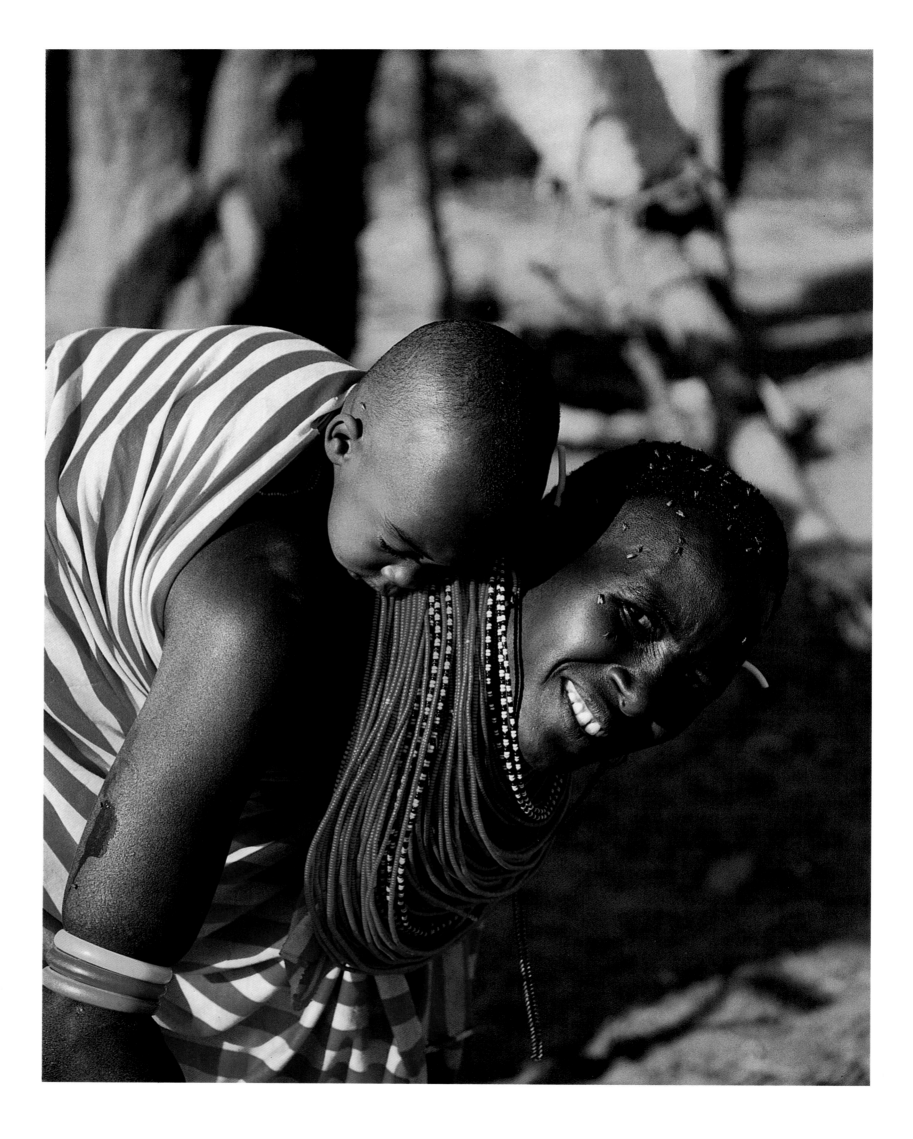

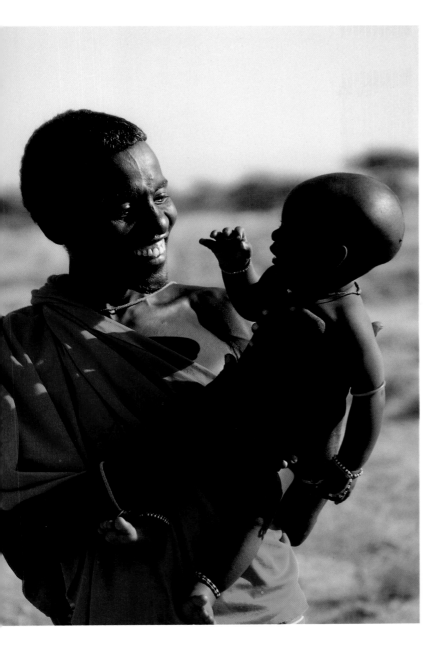

FAR LEFT: A mother carries her child strapped to her back while she busies herself with her daily chores. The Samburu tolerate the flies as legend says that the flies came first as a sign that the cattle would follow.

LEFT AND BELOW: Elders love their children and spend hours holding and playing with their babies.

OVERLEAF: Young children stand in the village compound, while their mothers enjoy the relative cool of an acacia's shade.

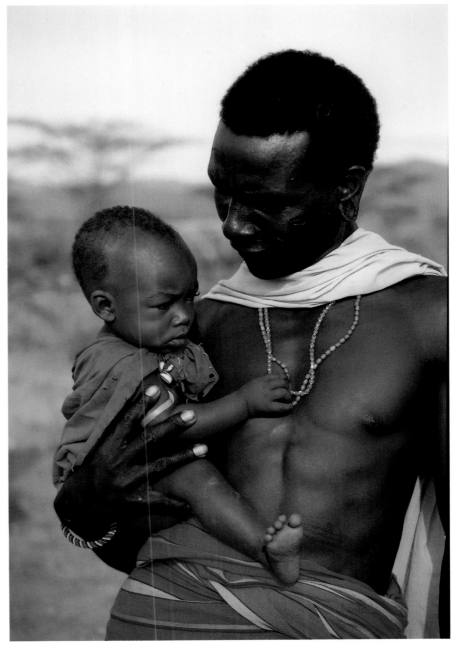

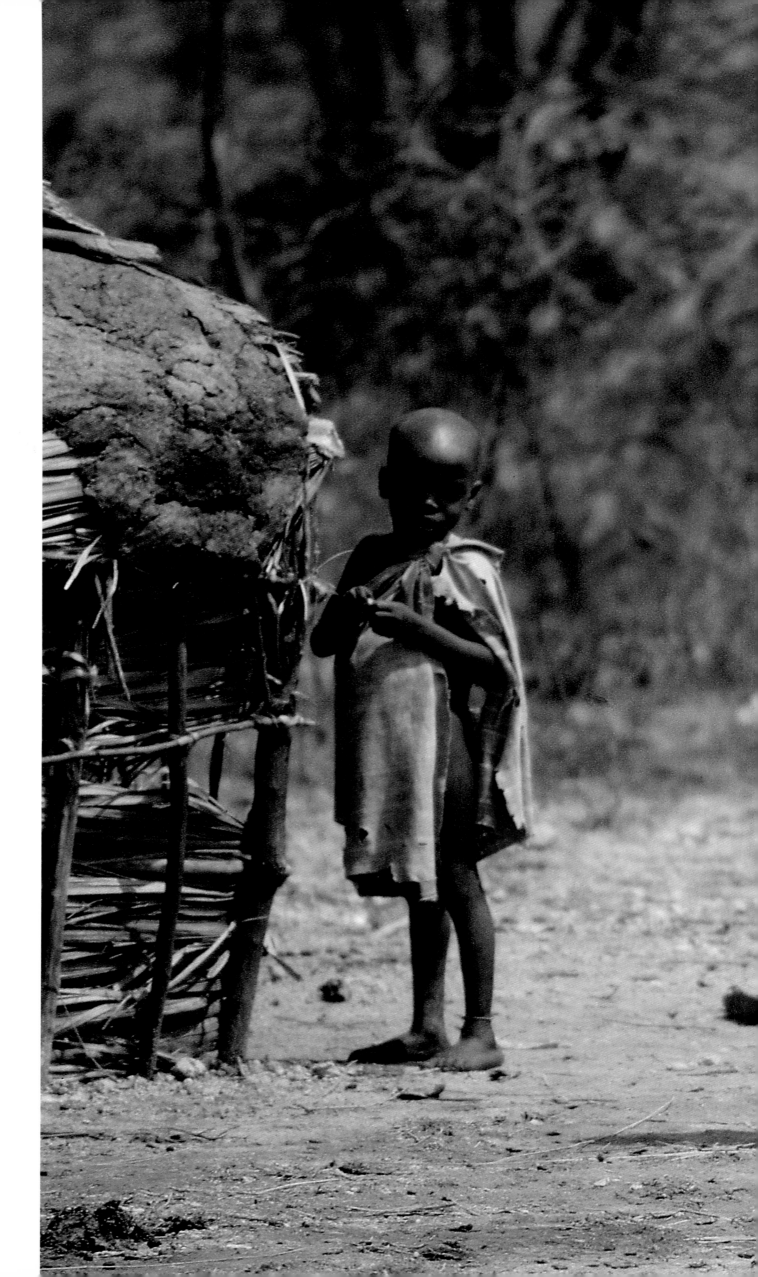

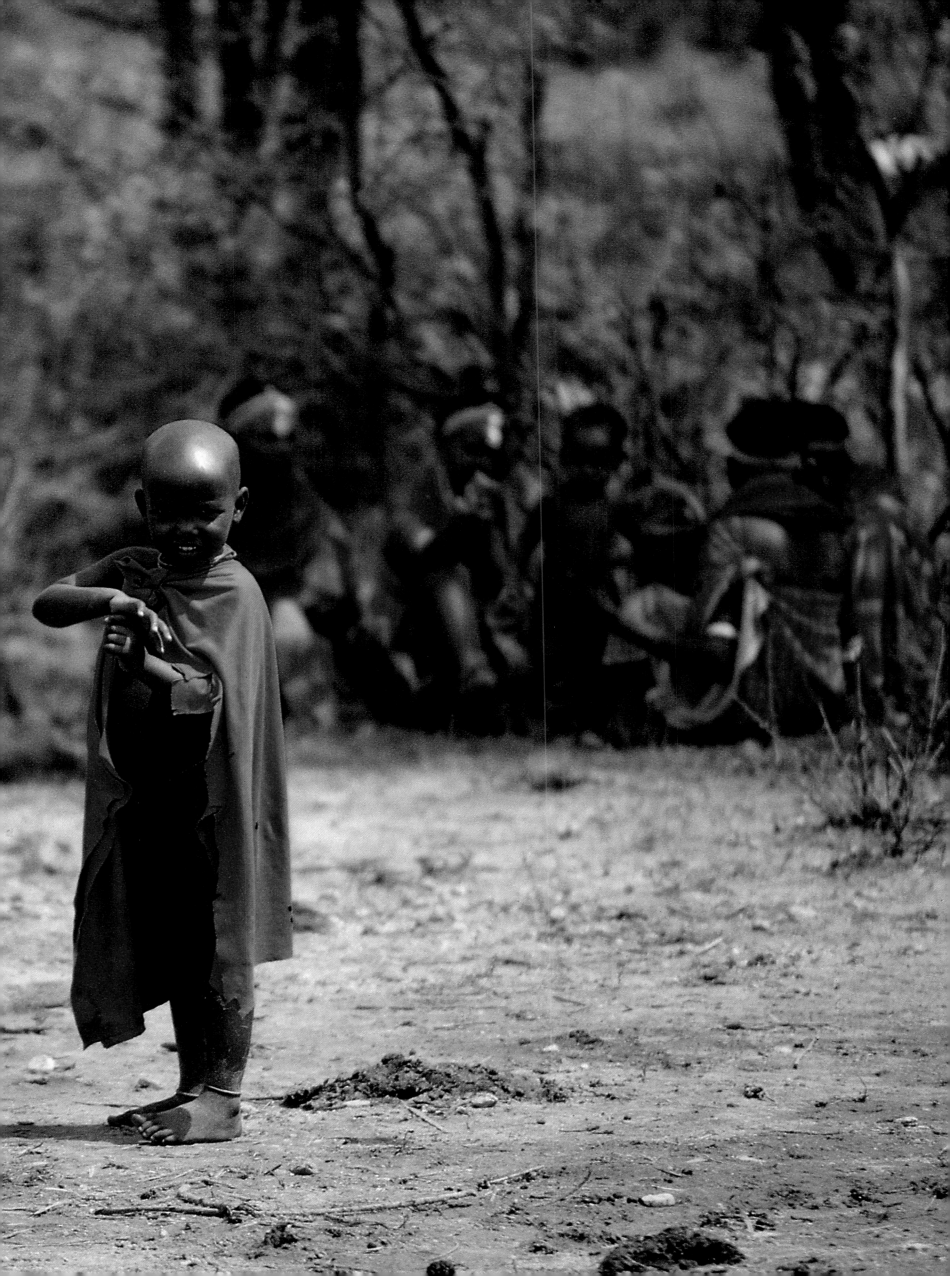

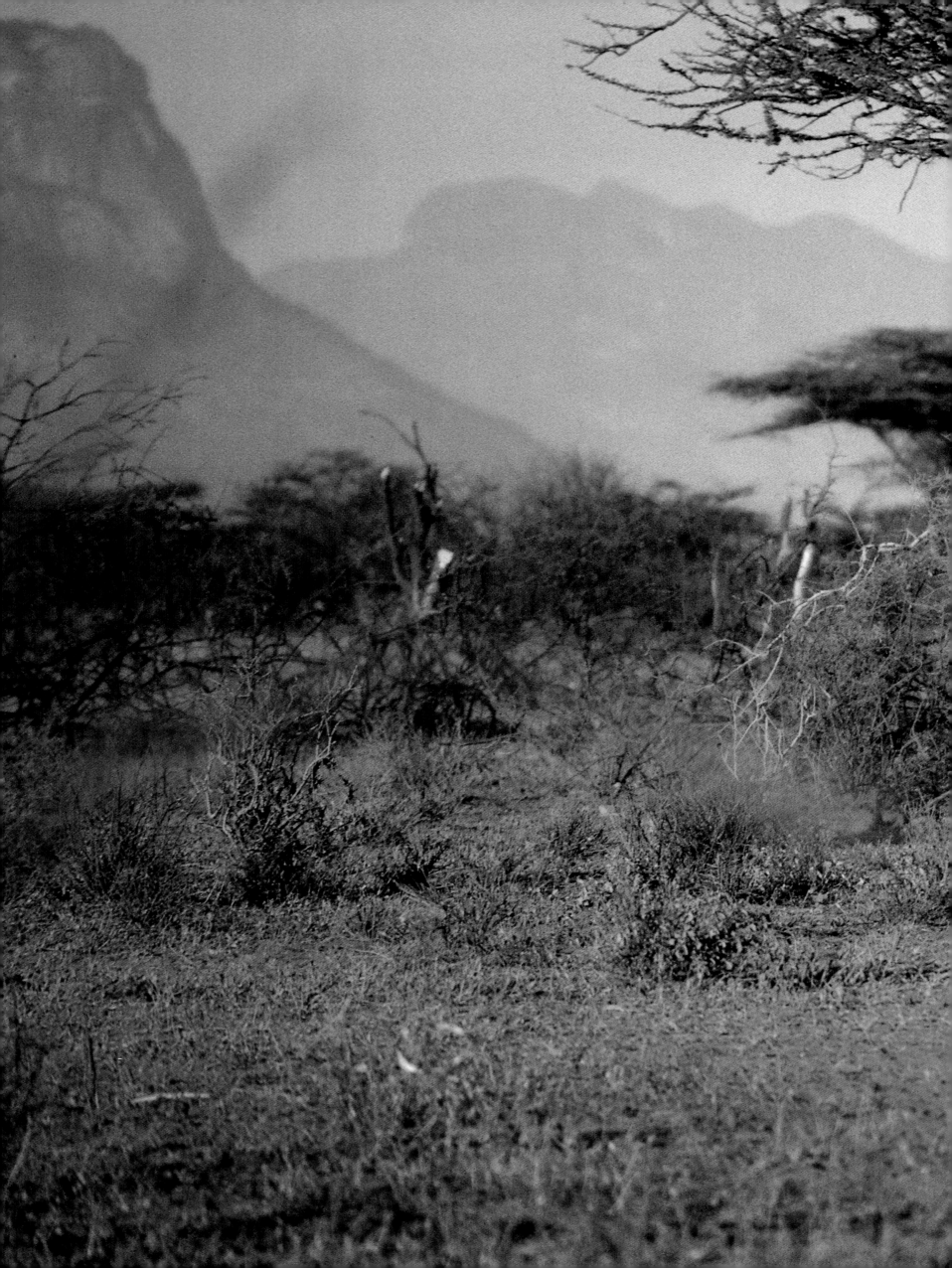

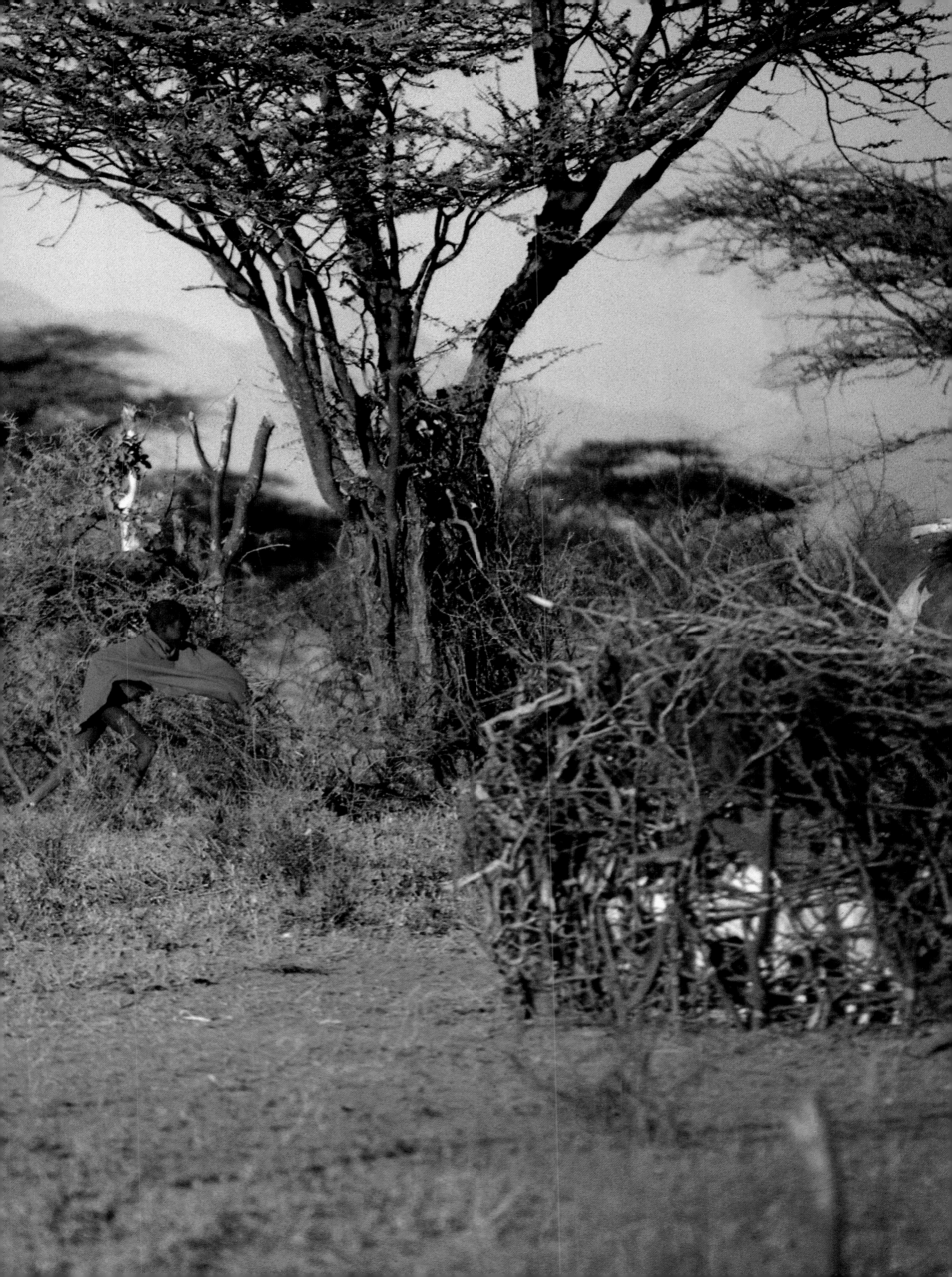

PRECEDING PAGE: A child runs through a dusty village. The Samburu lowlands are almost always dry and hot. Rainfall is unreliable and usually there is not a blade of green grass to be seen.

BELOW: Young children wander near an *nkang*.

RIGHT: A little boy mimics the stance of his father and older brothers. He leans on his staff and holds his *rungu* between his legs. Even though he is only about five years old he is quite capable of helping tend his family's flock of goats and sheep.

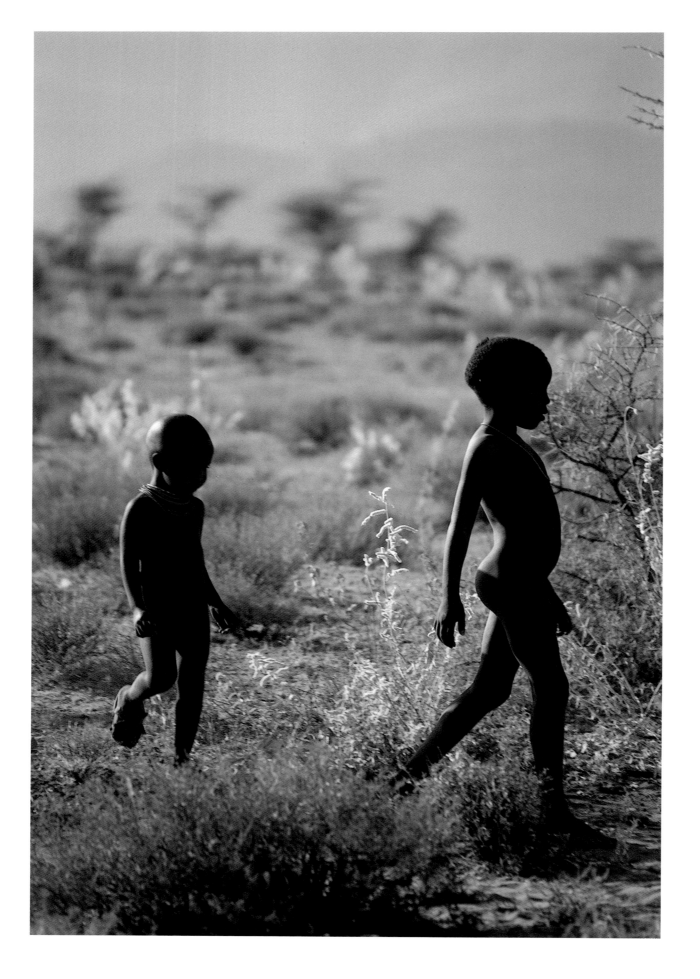

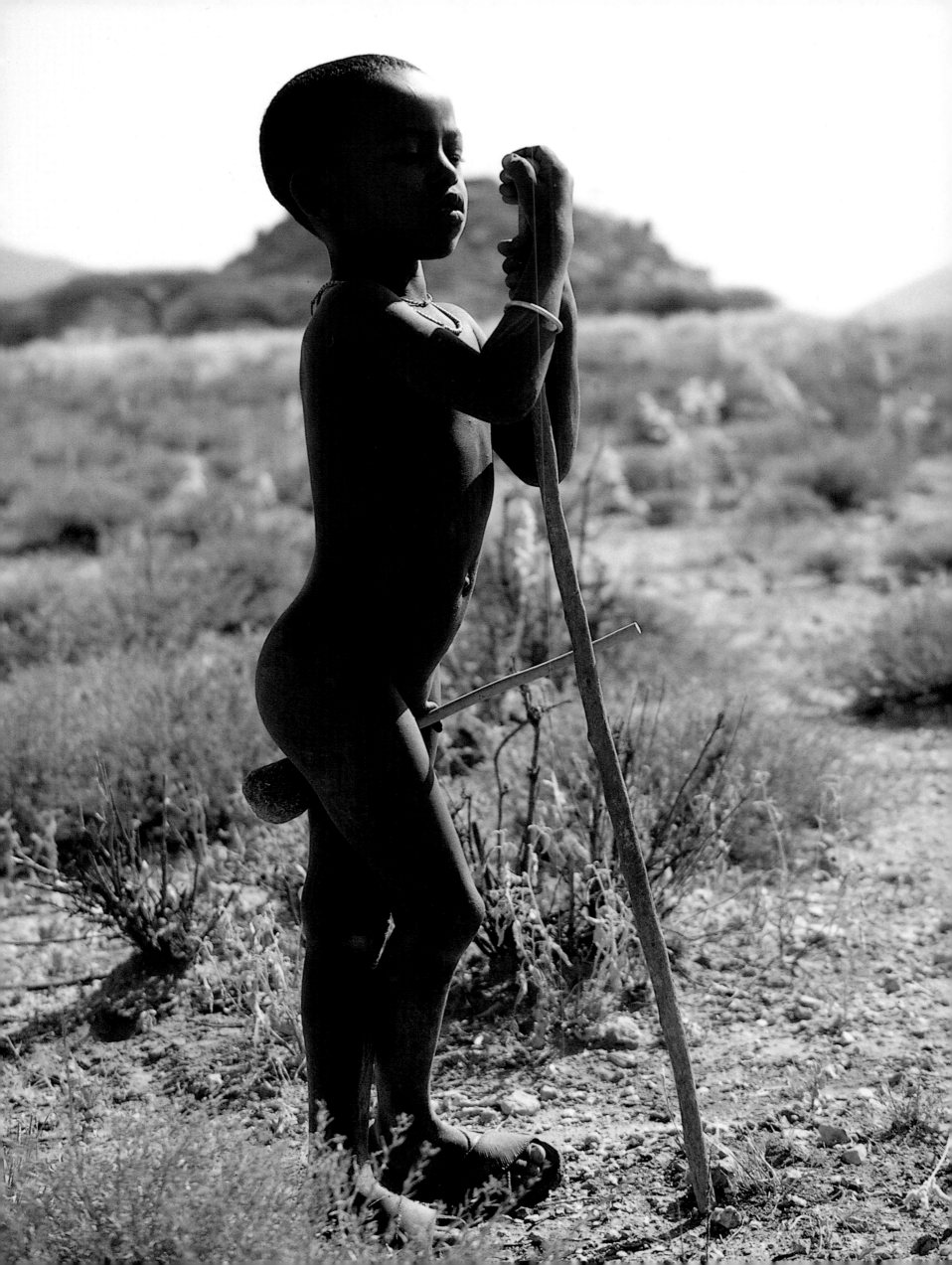

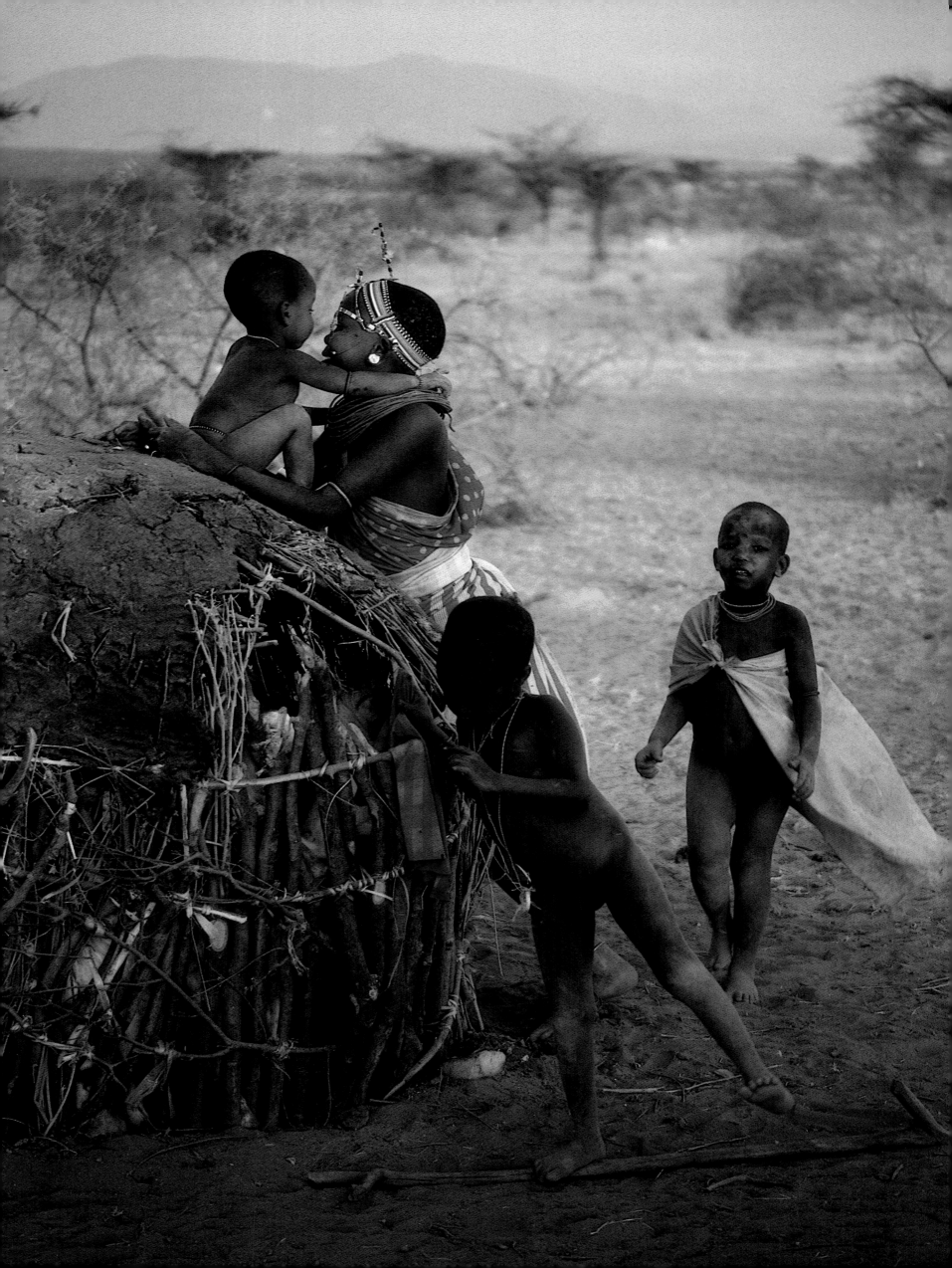

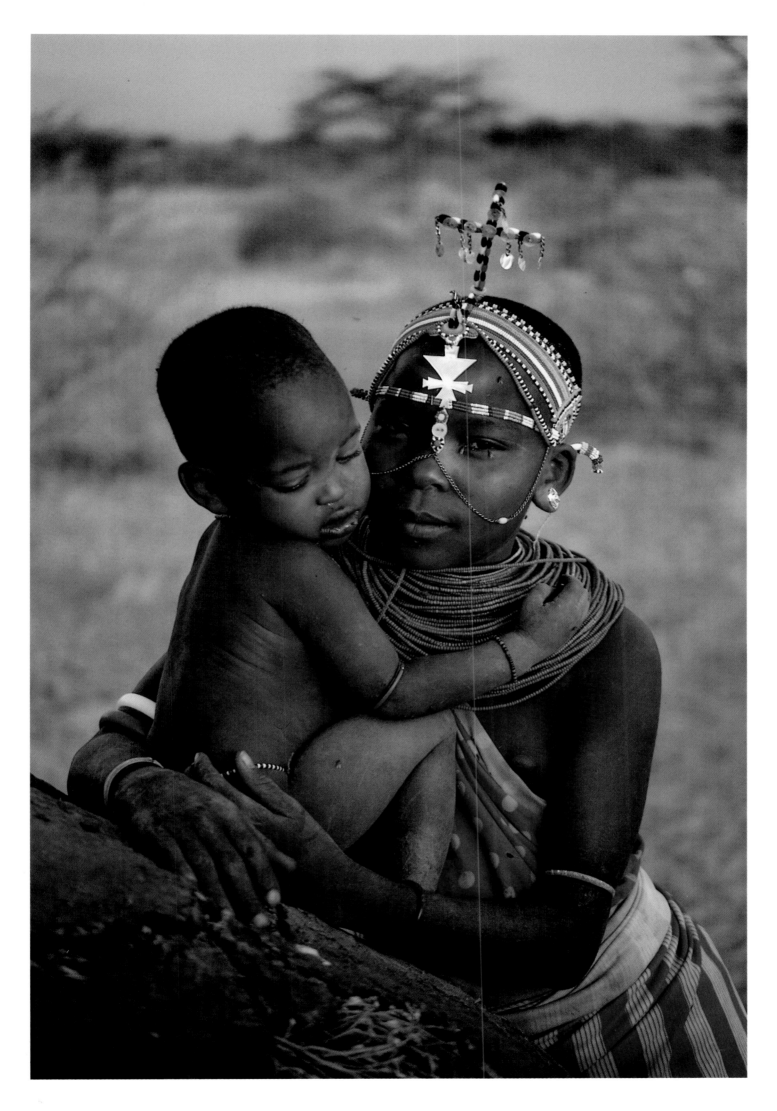

LEFT AND ABOVE: A young unmarried girl (*nkoliontoi*) plays with the children of the village near a covered enclosure used for penning young kids and lambs while their mothers are out grazing. She wears the distinctive jewellery of an unmarried girl; her earlobes have been pierced and plugged in preparation for adulthood.

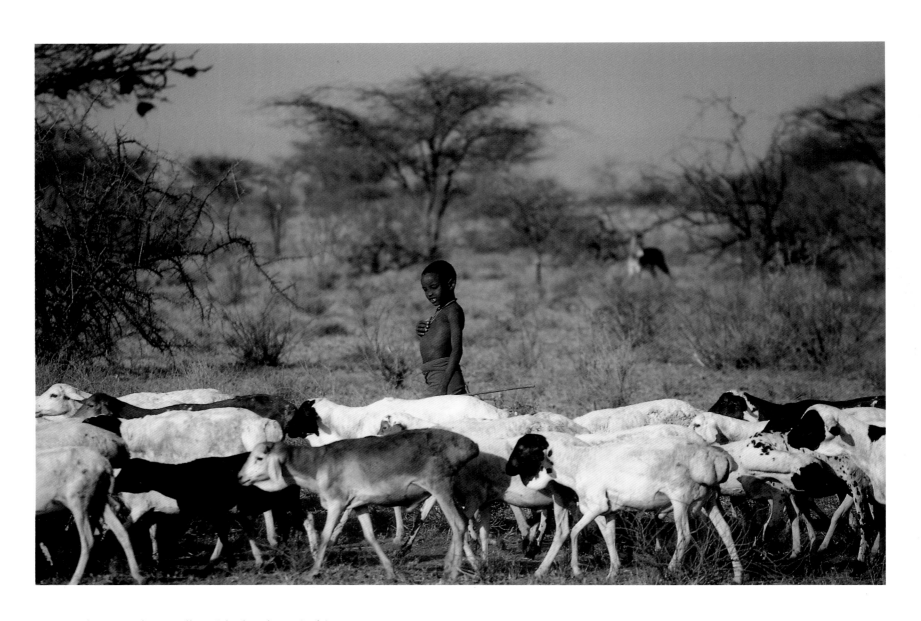

ABOVE: A young boy walks with the sheep in his care.

RIGHT: The boys are taught from an early age to tend the herds, and as they grow older they spend more and more time learning about the transient life of a warrior.

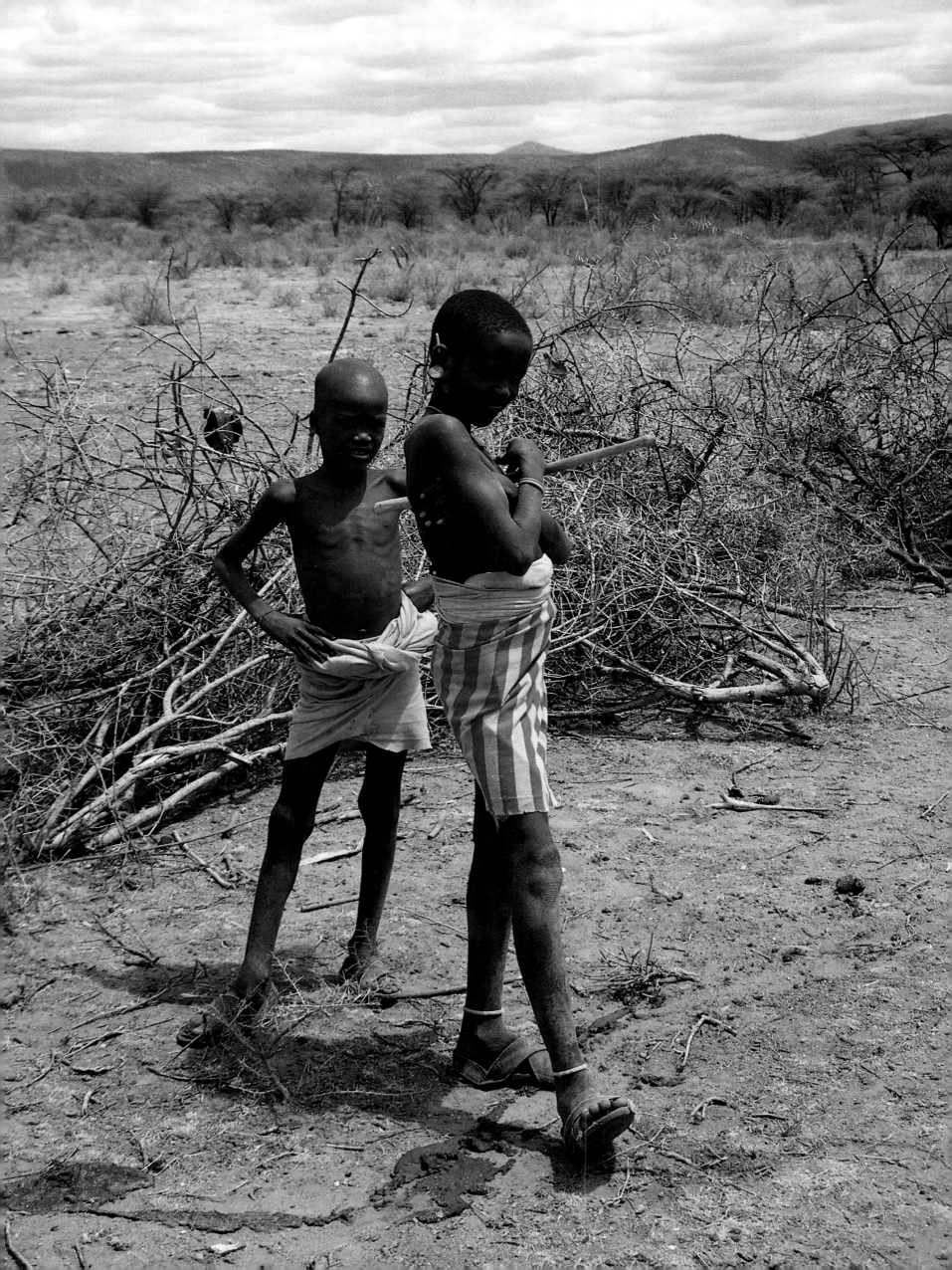

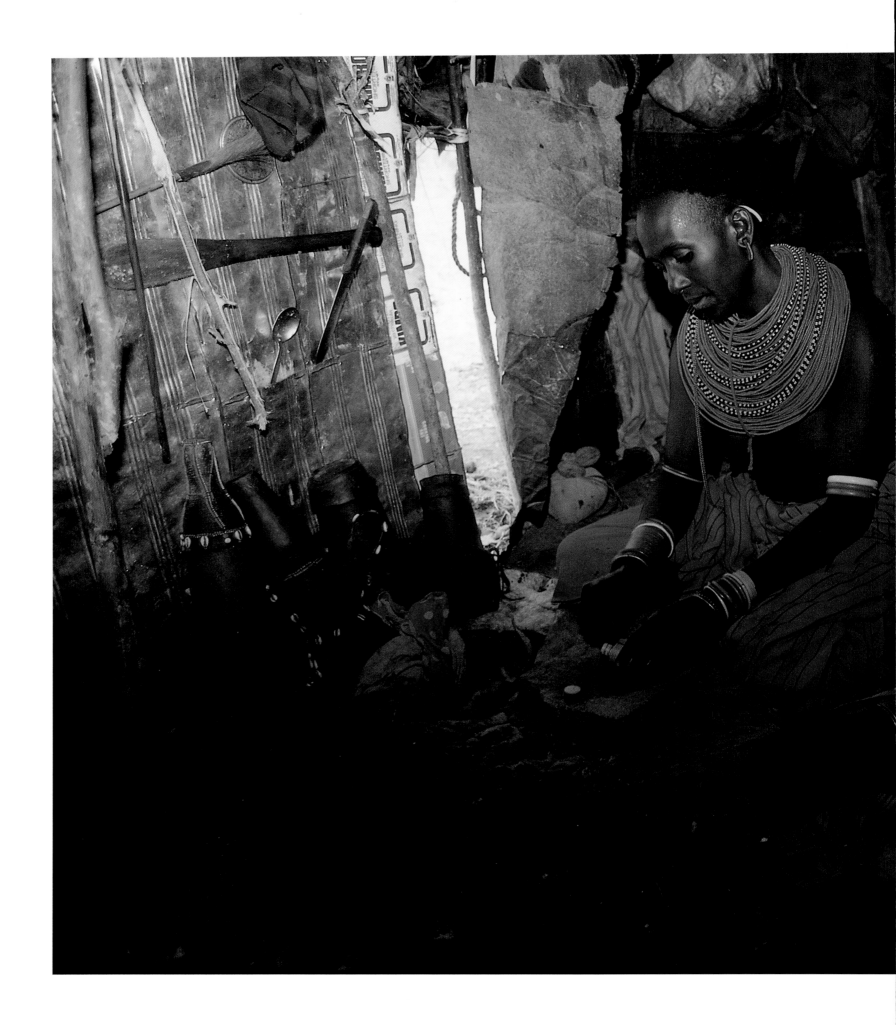

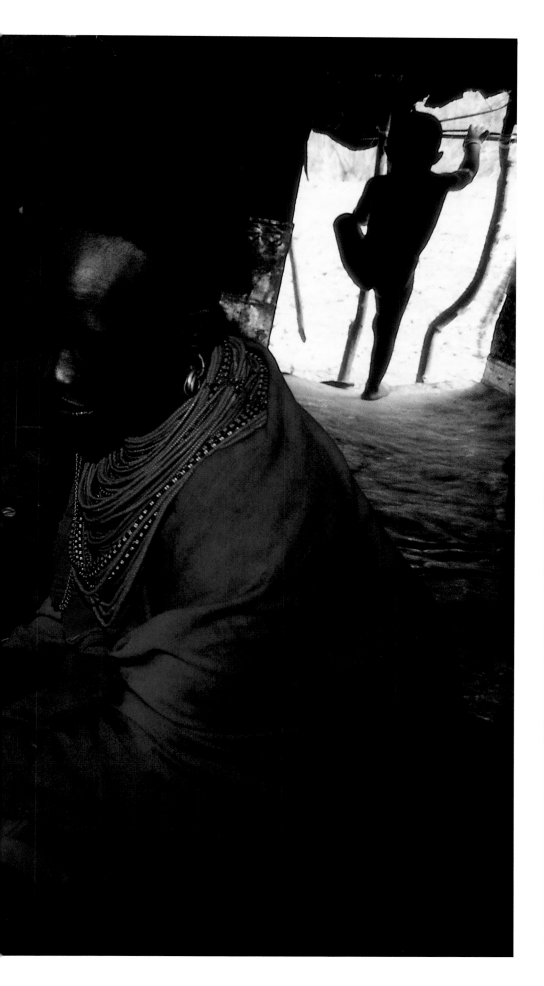

LEFT AND BELOW: A married woman inside her hut, accompanied by a friend, and with her child playing in the background, grinds tobacco between two stones. The ground tobacco (*naisugi*) is taken like snuff by the men and the older women.

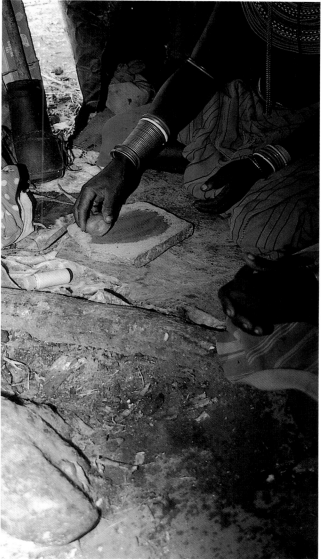

The building of each part of a village and the allocation of work within it is divided between the sexes: men choose the site and build the thorny stockade and women build the houses.

The women weave a type of thatch (*suuti*) for the roofs of their houses from spiny sansevieria (*oldupai*), which grows around the rocky outcrops that are a feature of the Samburu landscape. The women make long trips to gather the sansevieria, a plant similar to sisal, and carry it back to the village. On the perimeter of the village they dig shallow rectangular trenches, in which they light brushwood fires, laying the sansevieria on top of the glowing embers. The trenches are filled with earth and more fires are lit on top of the mound. The sansevieria is left under the slow-burning fires for about a week, and this prolonged baking breaks down the hard spikes into pliable fibres. The fibres are then dried in the sun and pummelled until they can be worked easily and woven into thatch.

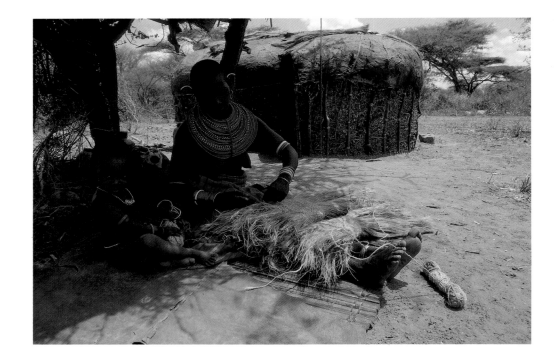

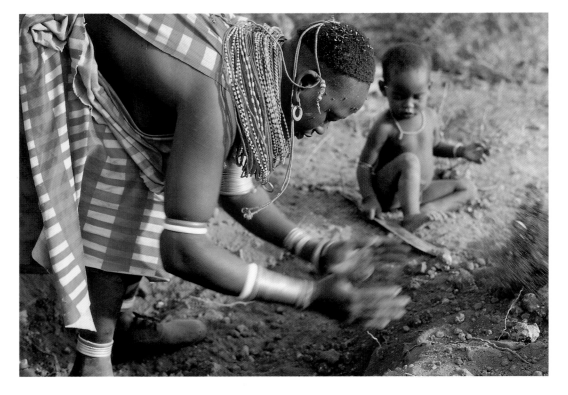

TOP: The framework of a hut roof before the thatch is laid.

CENTRE: A woman weaving pliable fibres into thatch.

LEFT: A woman digging a shallow trench in which to bake the sansevieria.

RIGHT: The worked fibres of sansevieria being woven into thatch.

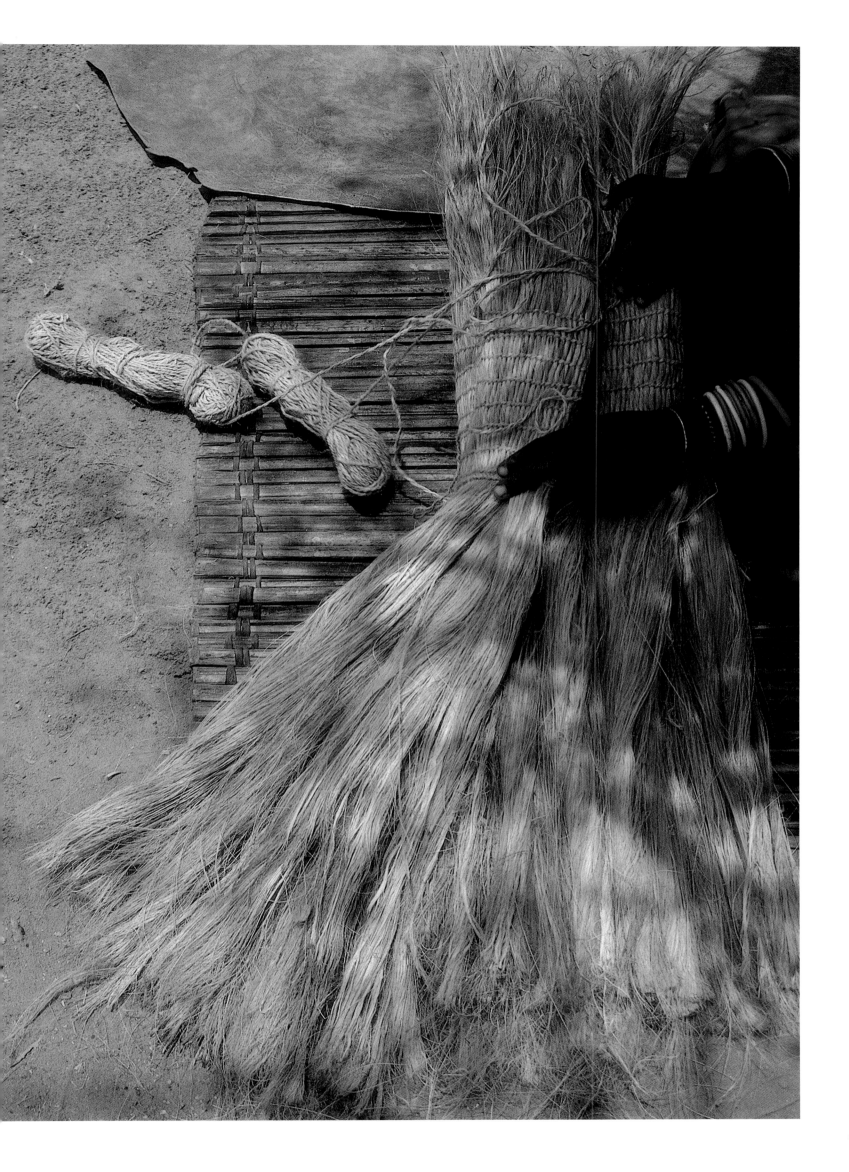

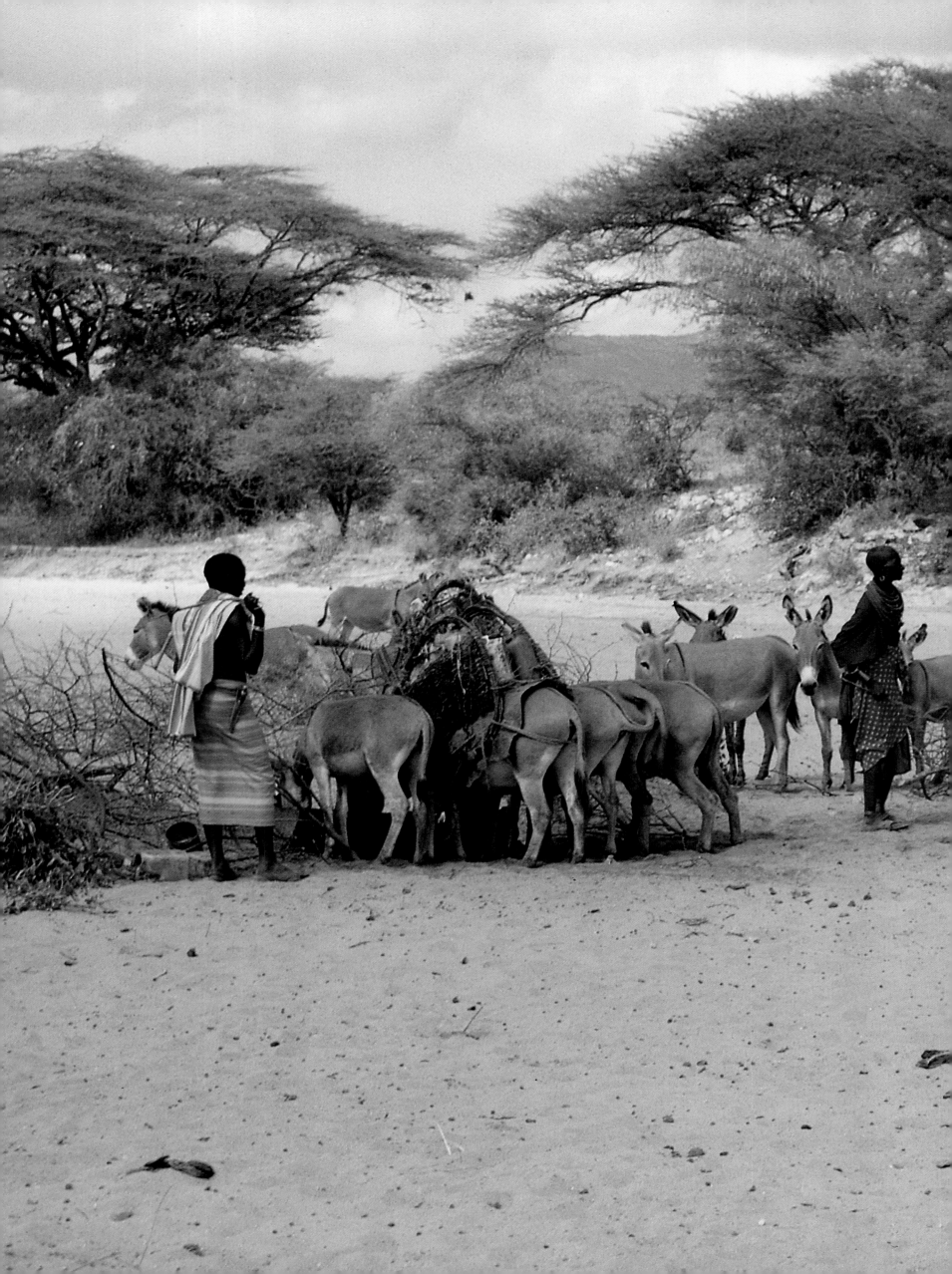

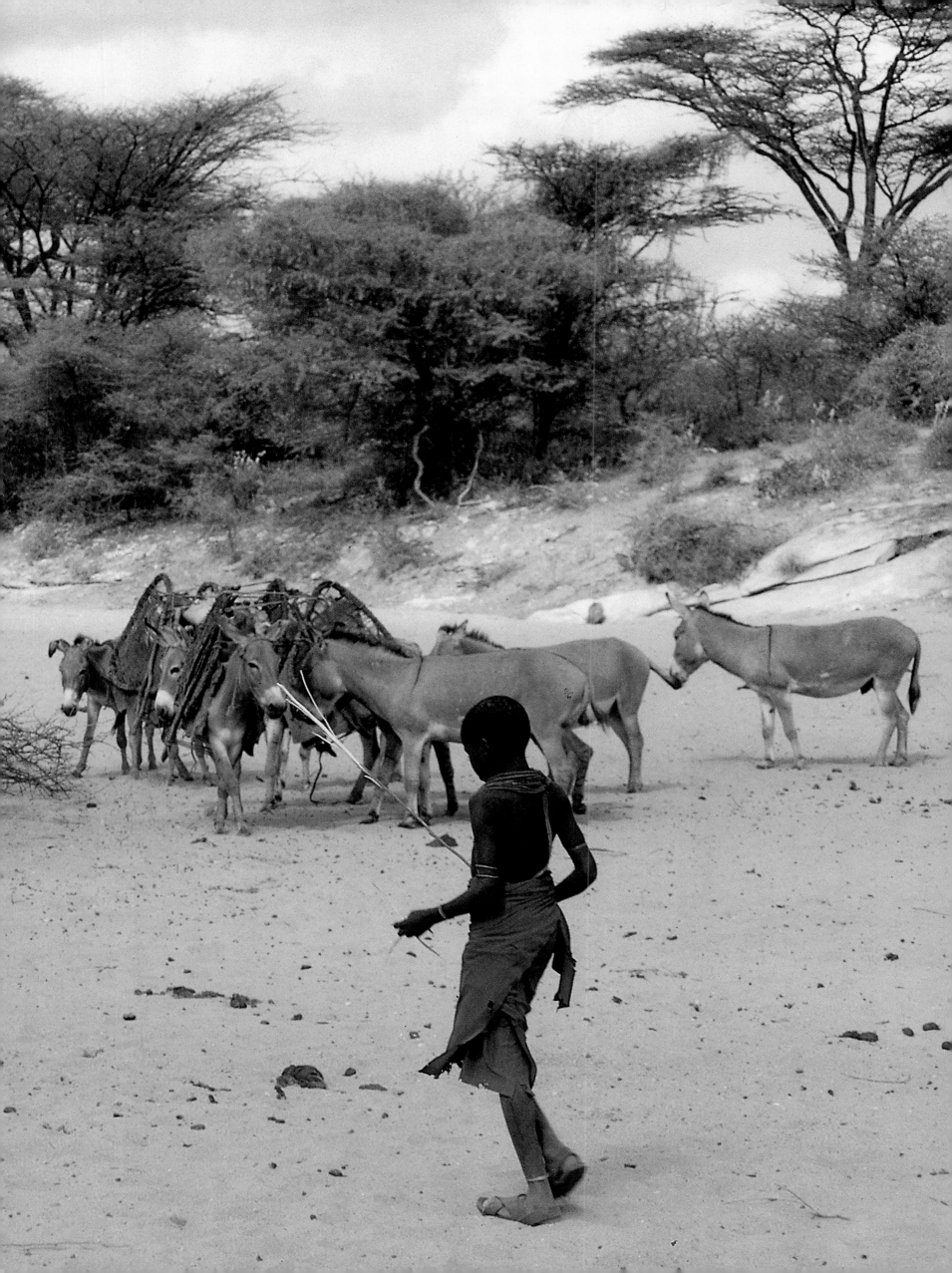

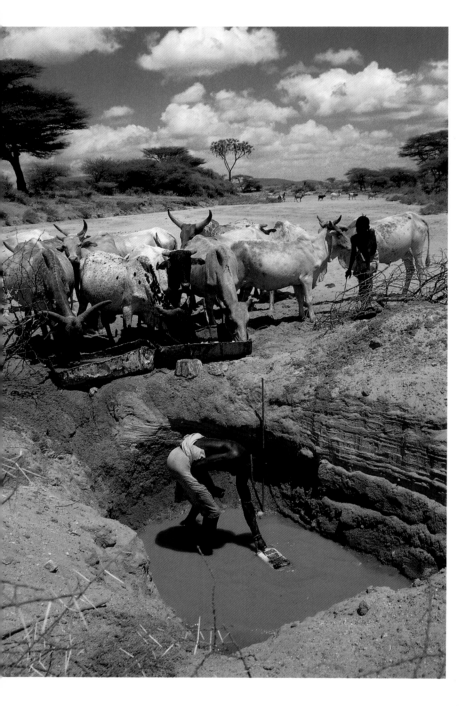

LEFT, BELOW AND RIGHT: Often, several wells will be dug quite close together. Each one is maintained by the men from specific sub-clans or villages. When not in use, they are enclosed with thorn branches to prevent wild animals from collapsing the sides.

Knowledge of where to find the springs is passed down from generation to generation. To draw water they stand in the wells and scoop up the water in leather bails, or nowadays tin cans or plastic containers and pour it into a trough made of a hollowed-out tree trunk. The wells may be as shallow as six feet deep, but sometimes, especially in very dry weather, they can be thirty feet deep; then it requires several men standing on stepped wooden platforms to pass the bails from hand to hand up to the trough. They sing as they draw the water and their movements synchronize with the steady rhythm of their voices.

Each group of animals drinks separately. The women stay with the goats as they are watered and the men oversee the cattle. When the rains come the dry river beds flood and the wells are filled in with sandy soil until the next dry season when they are re-dug by the men.

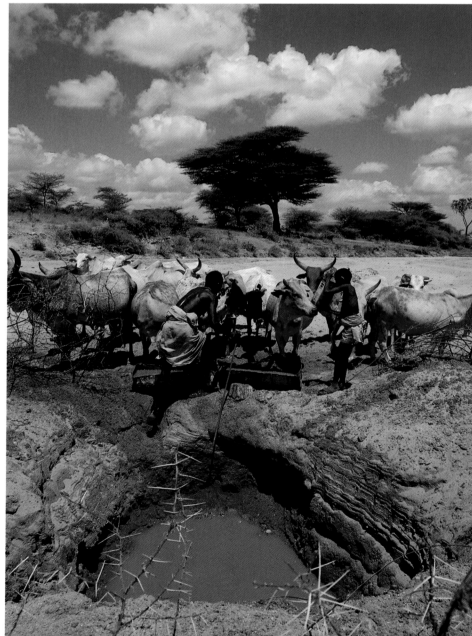

PRECEDING PAGE: Every few days the women herd their donkeys, often for many miles, to collect water for the village from the wells which have been dug in the dry river beds (*lbaan*). They pour the water into containers which they load onto their donkeys and this precious water will last them until their next journey. In the dry season there is no chance of remaining dust-free for more than a few minutes, yet the Samburu are a clean people and wash when the opportunity presents itself even though they have little water. They say that other peoples are dirty, and they refer to them with scorn.

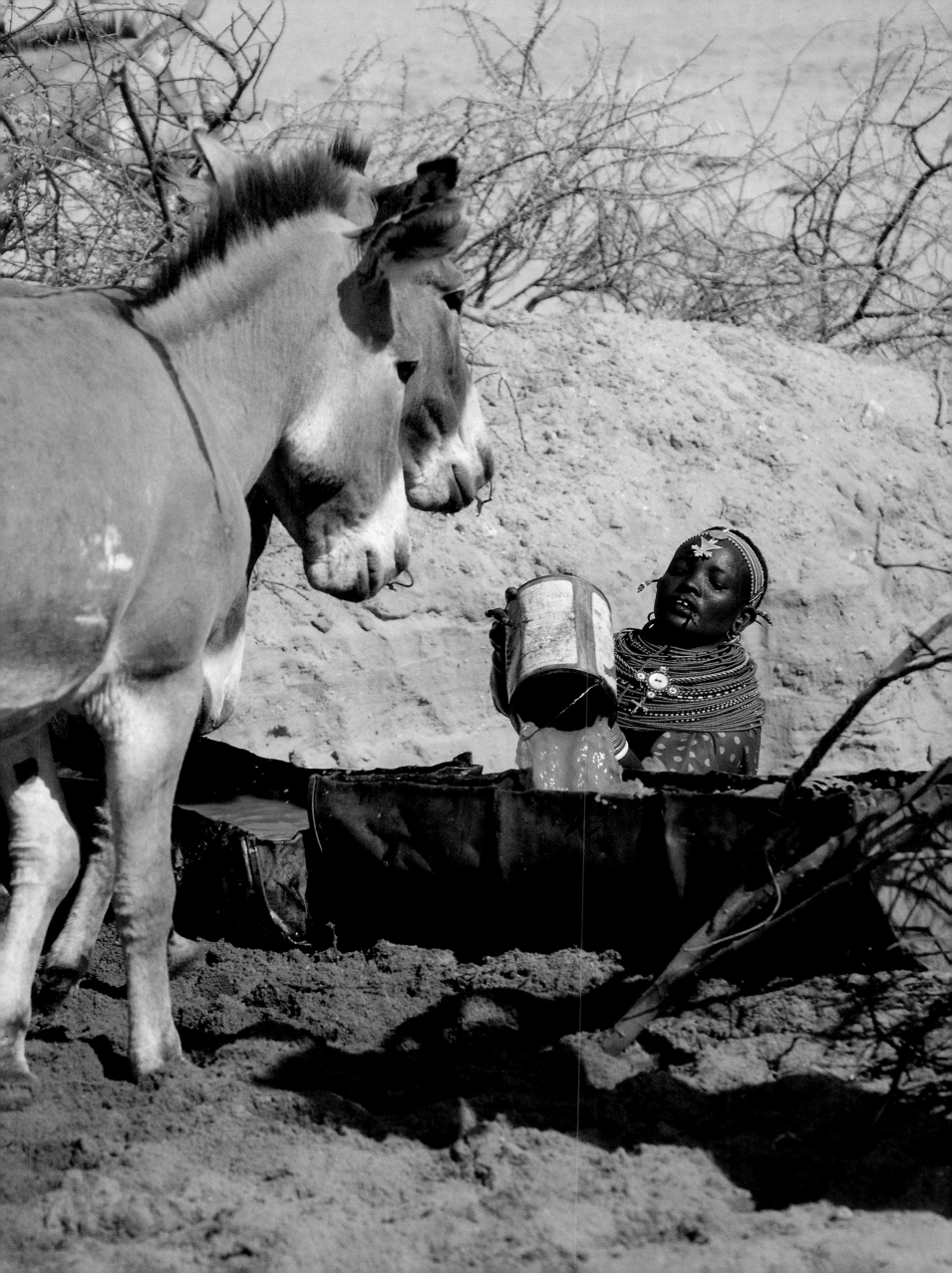

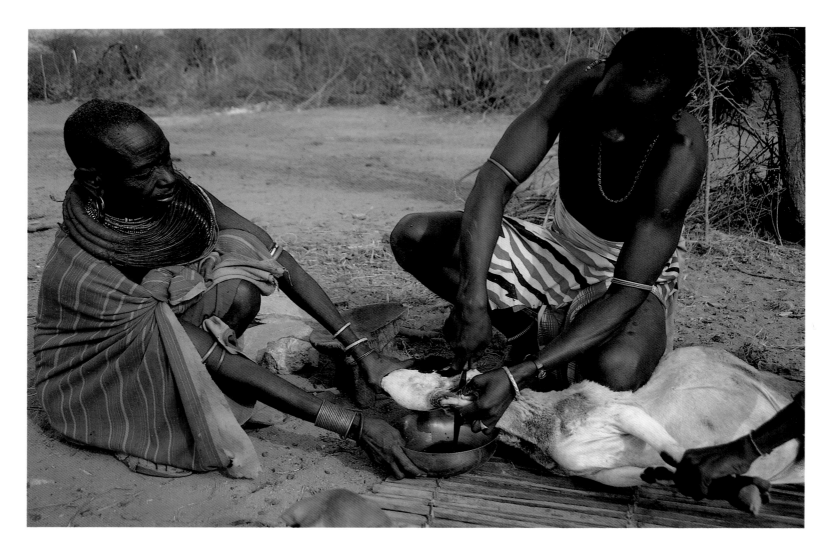

ABOVE AND RIGHT: A senior warrior slaughters a goat for his mother, who catches its blood in a bowl, while a small dog eagerly waits for any discarded scraps. Although dogs are not uncommon among the Samburu, they are regarded as unclean and are never handled.

Men do most of the slaughtering for the village, although a woman may slaughter a goat or sheep by cutting its throat, if her men are absent. Cattle and usually camels are killed only by the men by driving a knife or a spear into the base of the skull. Then the animal's throat is cut and the blood collected in a container or bowl. It is then either drunk by the men, or cooked by the women. The skin is removed in one piece and given to the women to peg out to dry. The men divide up the meat according to strict custom. For goats and sheep the right hindleg, right side and head are eaten by the elders; the stomach, the right foreleg and throat are eaten by the women; the back is eaten by the uncircumcised girls; the ribs and belly meat are eaten by the uncircumcised boys. The left hindleg, left foreleg and left side are distributed or eaten by the family who owned the animal.

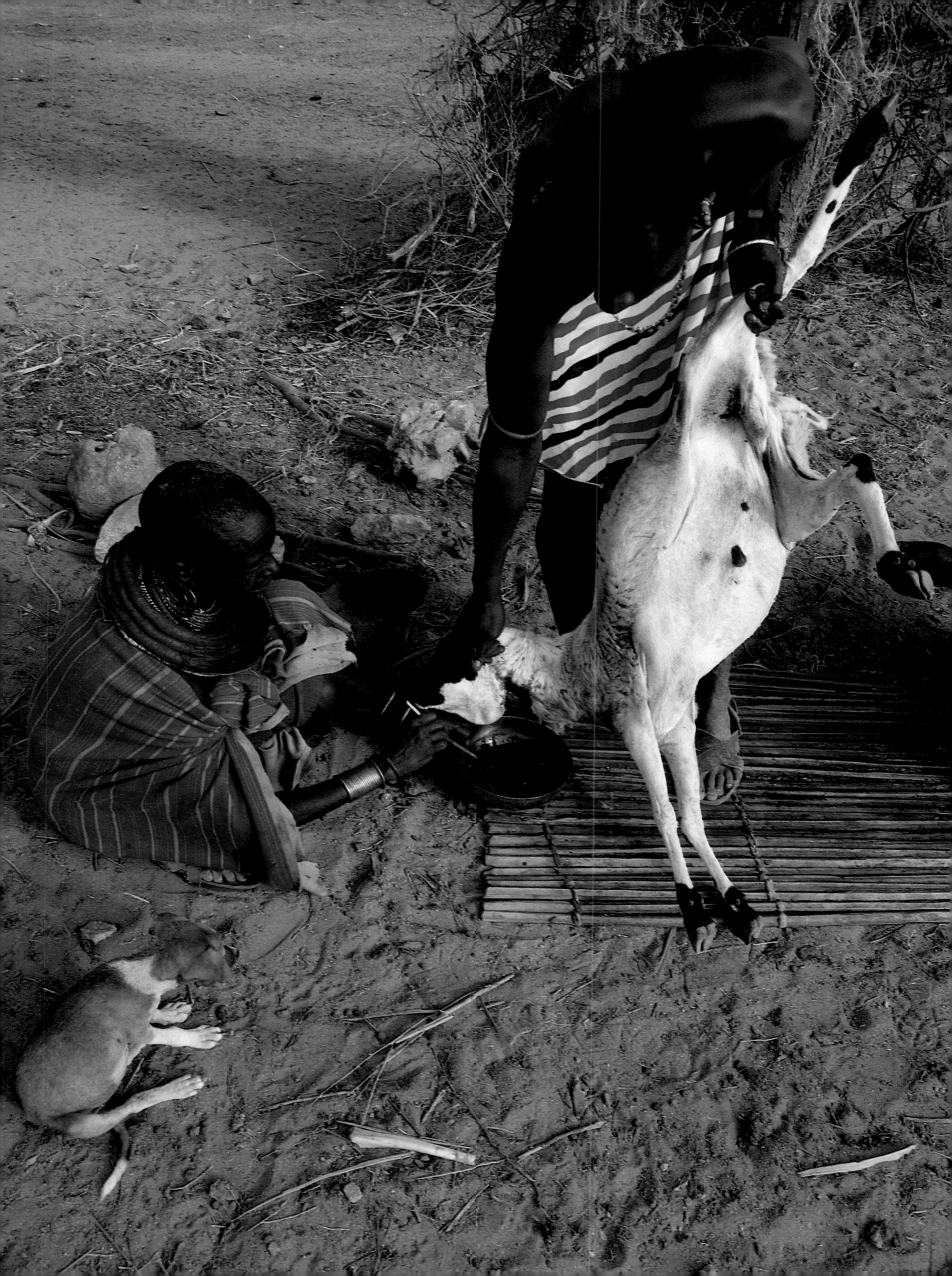

BELOW AND RIGHT: Goats are milked in the early morning before they go out to graze and then again in the evening when they return. Milk is taken from each of the two teats, but a proportion is left for the offspring.

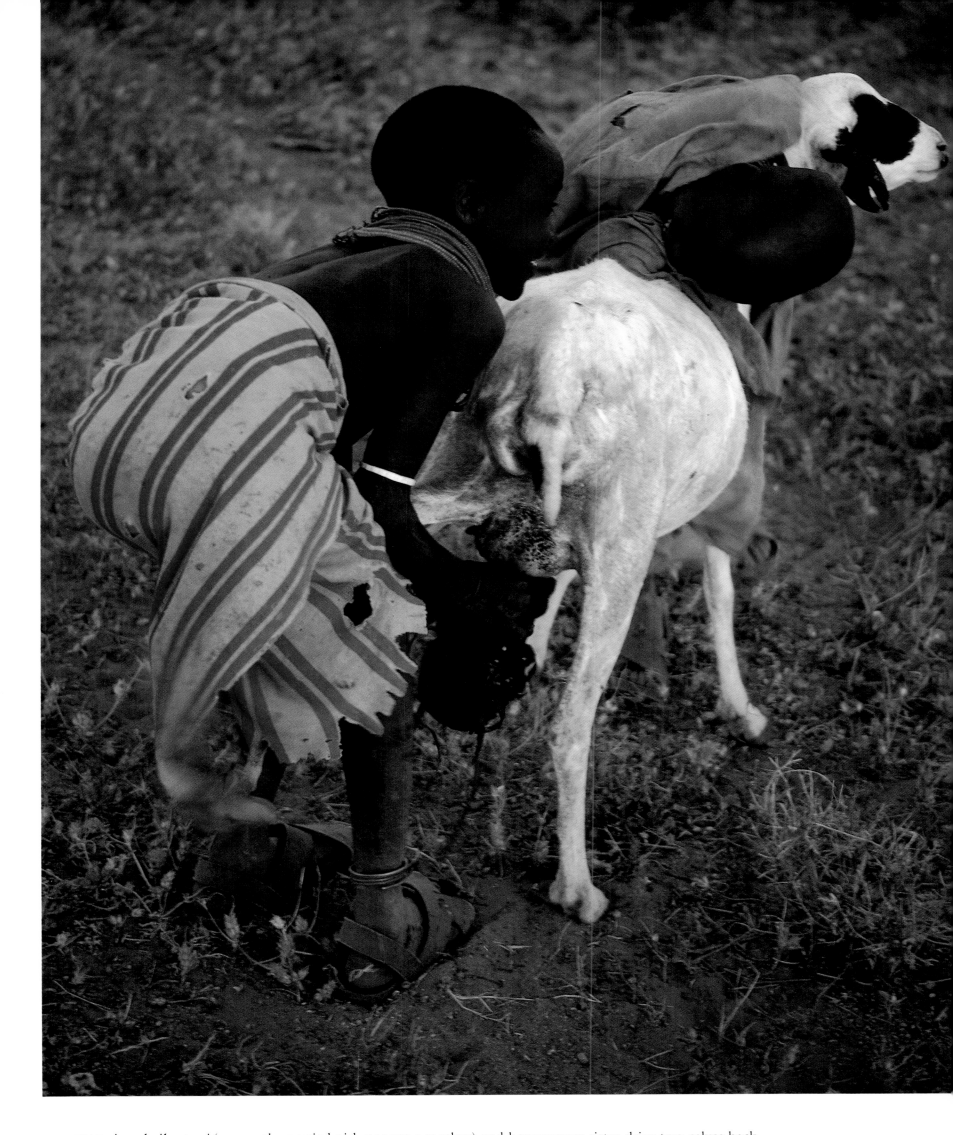

OVERLEAF: An *nkaibartani* (a recently married girl, not yet a mother) and her younger sister drive two calves back to the village as the herds of cattle go out to pasture. An *nkaibartani* is considered pure and held in high regard.

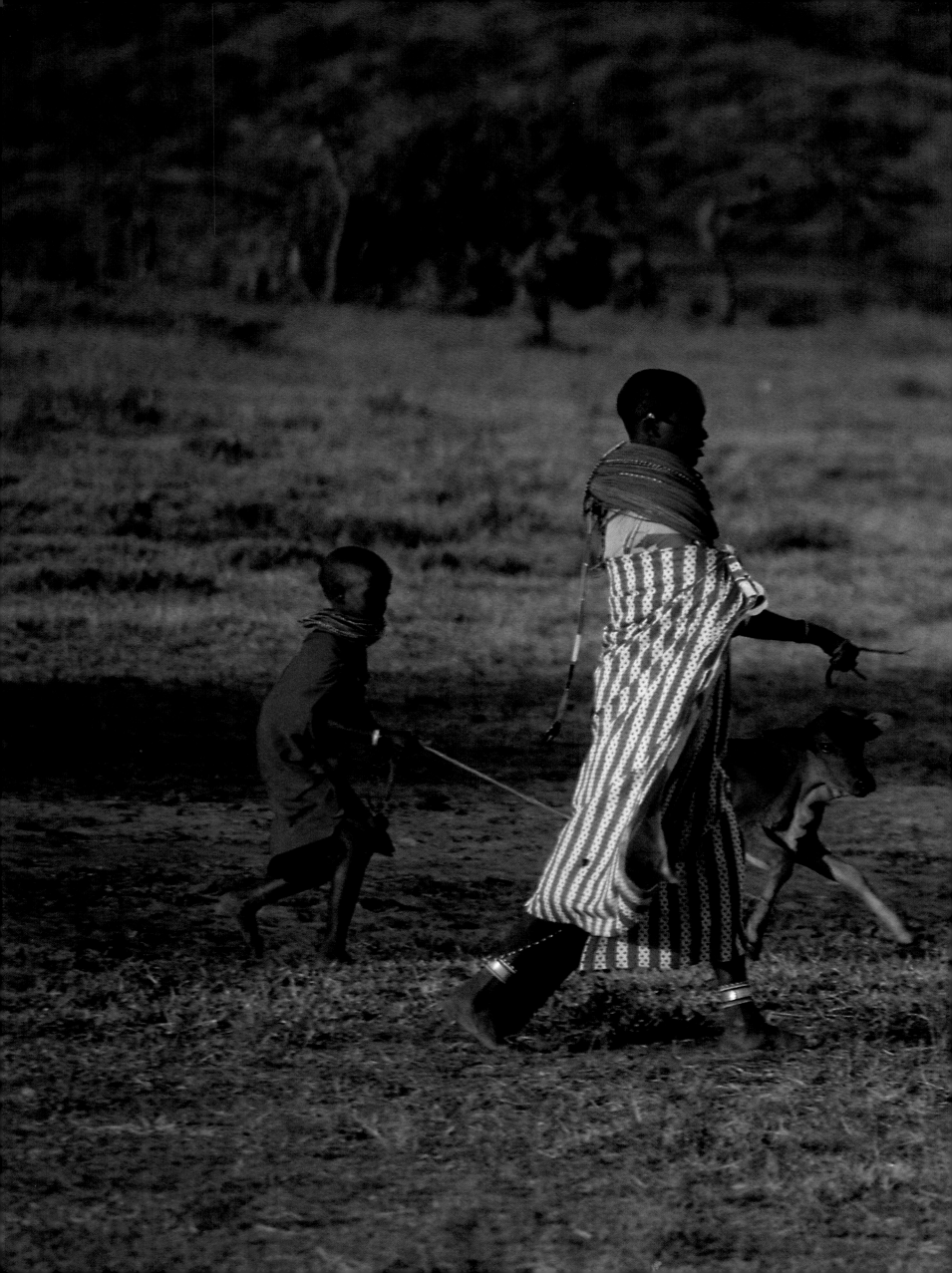

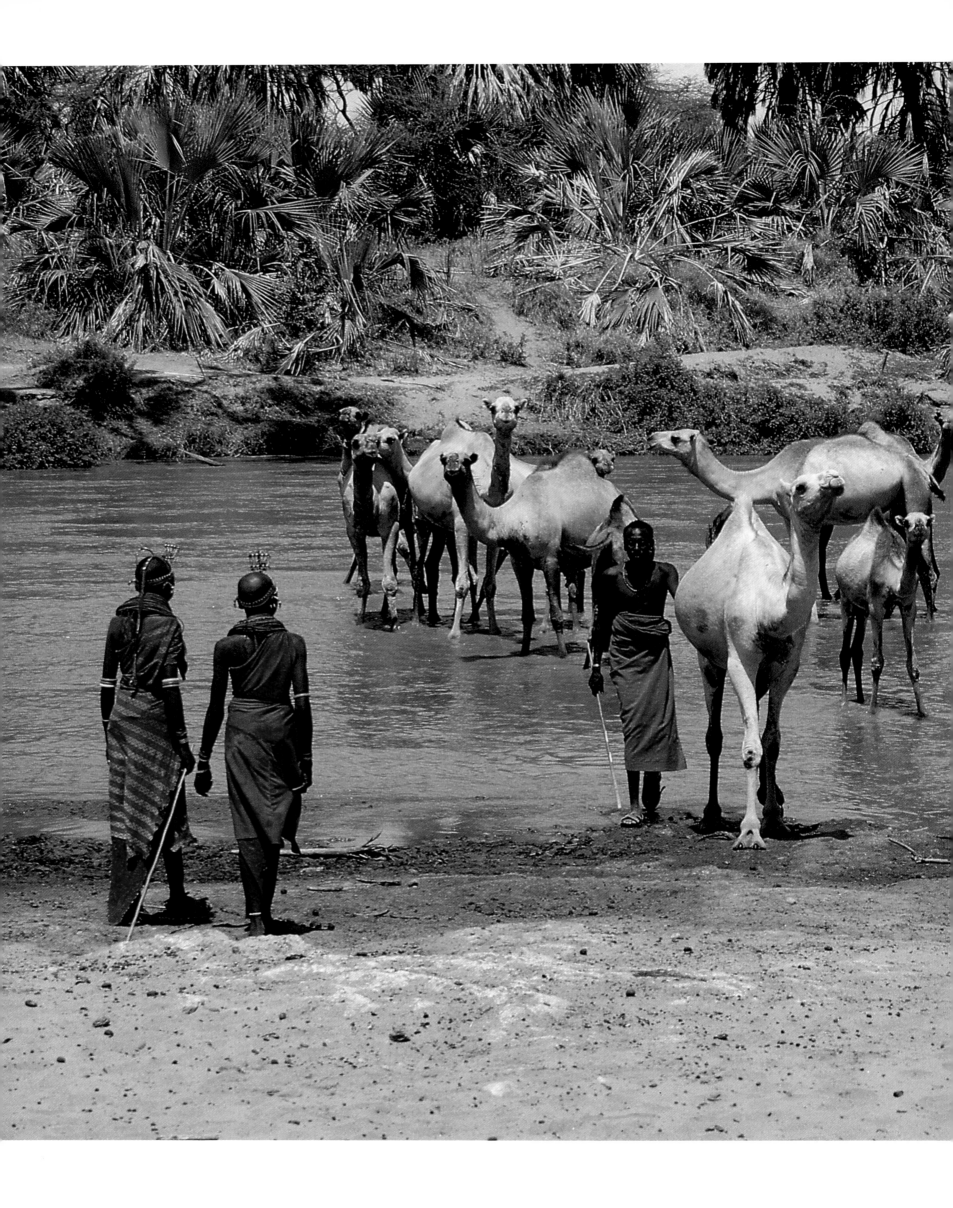

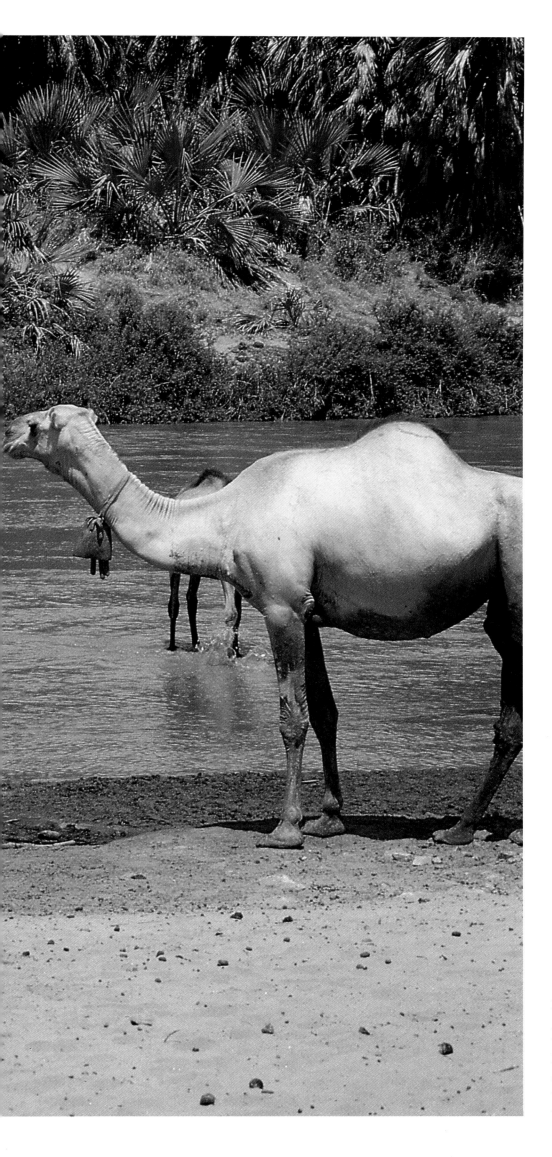

LEFT: Camels, tended by an elder and two girls, drink at the Ewaso Ngiro river. Traditionally it was only the neighbouring Rendille, slightly to the north, who kept camels, but recently the Samburu have taken to herding camels as they are hardier than cattle in times of drought.

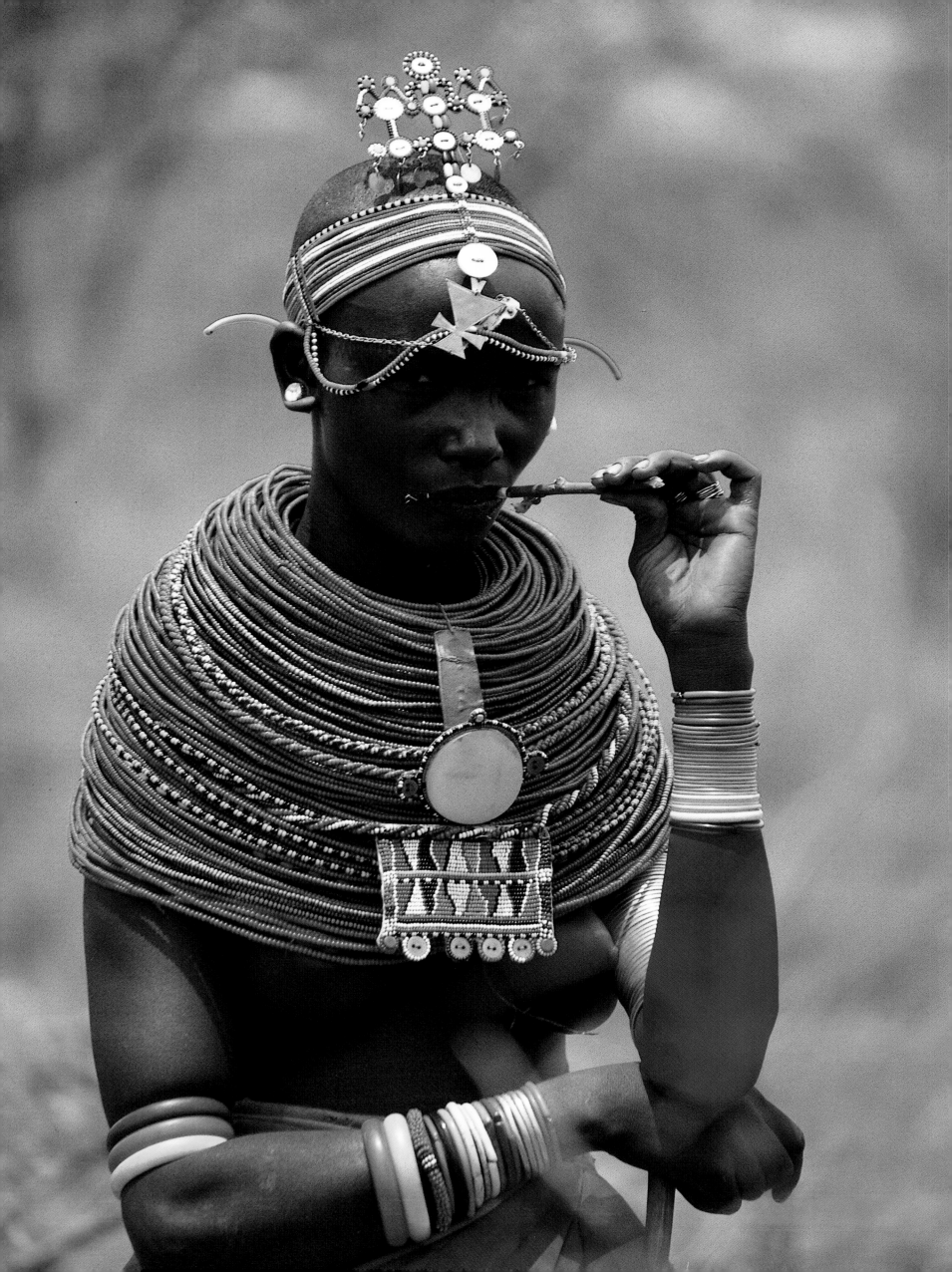

LATIM

Marriage and Female Circumcision

Once the older warriors, that is those who were circumcised in their late teens, have reached a certain maturity, the elders decide to hold the *ilmugit lnkarna*. By this stage, about six years after circumcision, the older warriors are at their most splendid: their long, braided hair now falls below their shoulders, they carry themselves with grace and poise, and they have begun to earn the respect of the elders and the community as a whole. At the *ilmugit lnkarna* the *laji* is named. Then, three to four years later, after the *ilmugit lolaingwani*, the warriors are permitted to marry. However, only the oldest *lmurran* enter into marriage, which ends their warriorhood and starts the gradual progression into elderhood. The majority of the warriors continue to fulfil the role of the warriors until the new *laji* of adolescents has passed through circumcision.

When seeking a wife a man will go to the girl's uncle or a close friend of her father and state his wish to marry. The elder must give his approval before the *murrani* approaches the girl's father; this prevents the father from manipulating his daughter's future in his own interest. It is regarded as desirable to marry outside the larger clan, though it is not obligatory.

A girl is considered old enough to be married just before she reaches puberty. Girls may only be married to *lmurran* at the end of their term of warriorhood or to an elder as his second wife. Thus if a girl is eligible for marriage before the warriors have performed the *ilmugit lolaingwani* she may be married to a man much older than she is. No girl is married into her father's *laji*, although she can be married into the one above, as the men of the father's *laji* regard her as if she were their own daughter. A father usually tries to make a suitable match for his daughter and the girl will not generally dispute her father's word. However, if she is adamant that she does not want to marry her suitor and her father accepts his daughter's plea, the marriage will not take place. It is only very occasionally that a father will insist that the marriage goes ahead and even more rarely that the girl will drink poison to escape her fate.

Once a father has agreed to a marriage, a bride wealth, which varies from five to seven cattle, is arranged and preparations for the wedding are made. The exchange of cattle need not take place all at once; it is not so much a payment for the bride as an exchange for the children she will bear. The bride wealth usually comprises a sacrificial ox for the marriage feast; two cows for the father; one cow in milk for the mother of the bride, along with a lamb, presented with the words, "This is for the milk you gave your daughter"; and one cow for each of the elders the man first approached when asking to marry the girl. Two castrated young bulls are usually given to elders of the same *laji* and sub-clan as the father. This is the customary exchange, although the father and sub-clan may ask for additional gifts.

The warriors spend the day before the marriage preening themselves, dressing their hair and painting themselves with ochre. The groom will have obtained a sack of sugar, some tea, cloths for the bride, *miraa* and chewing tobacco for the elders and such gifts as the bride's sub-clan may demand, and these are taken to the girl's *nkang*.

The groom is now accompanied by a *chapulkerra*, a close friend and age-mate. The two men wear *ou-raurri*, special earrings made from copper wire wound in a tight circle. They tie *munken*, thongs of lionskin, around the top of their calves and wear specially made leather sandals, called *namuke*. They also carry ceremonial wooden staffs made from *lngweta cordia*, and sometimes they will carry a hard-wood staff of *siteti*. Once all the preparations have been completed, the groom and his companion herd the cattle, the lamb and the sheep for the bride

LEFT: An *nkoliontoi* (an unmarried girl) wears jewellery appropriate to her status: a beaded cross in her headdress, a metal chain across her face, earplugs and a large ornate band with pendant beadwork which loops her necklaces.

wealth to the bride's village. While they are still some way off they start to sing. It is a moving moment when the two warriors become visible, striding through the bush, singing their haunting song of celebration. They drive the bride-wealth livestock before them into the *nkang* through the entrance opposite to that of the bride's mother.

All girls are circumcised before marriage. That evening, the girl's hair is completely shaved by her mother and her head is smeared with ochre in preparation. A close friend of the girl's father slaughters a male lamb belonging to the girl's father. It is skinned and the meat is divided and eaten in the usual manner. The nose-skin is placed as a ring on the girl's middle finger by the elder who slaughters the lamb, and in some clans the girl's mother will wear a portion of the lamb's skin over her beads. The following morning, just before dawn, the mother, wearing a ceremonial leather cloak under which the girl crouches, milks her cows. The ritual symbolizes the time the mother carried her daughter as a baby on her back, and the milk will be used later in the ceremony for ritual washing. Then, as the first rays of sunlight flood over the horizon, the girl is circumcised.

Only circumcised women are present at the circumcision of a girl, which is performed by an older woman who was traditionally given tobacco, but today is paid a fee. The girl stands at the entrance to her mother's house while her mother remains inside. The leather skins she wears are removed and milk from the ceremonial milking is poured over her head in a ritual cleansing. She then sits on the lambskin placed on top of a cow hide. One woman will hold her right leg and another her back. These two women become as mothers to the girl and they are expected to give her gifts: the one who holds her back gives thatch for her house, two leather hides and a cooking pot; the one who holds her right leg, a leather cape and shoes. Another woman will hold the girl's left leg, but no importance is attached to this role.

Most of the married women of the village gather around and see that the circumcision is performed correctly. There is no shame involved if the girl shows pain, flinches or cries out. Some of the younger women who have gathered round start to shake and sob as they remember the pain of their own circumcision. It is a time of intense emotion.

The girl is then carried into the hut and laid close to the fire on a raised bed specially built by the women the previous afternoon. Once the girl leaves her mother's settlement with her husband, the bed will be dismantled and burnt. She lies with her legs apart and often quivering. Yet by late afternoon most newly circumcised girls will have left their huts to watch the dancing. Sometimes they stand on the edge gently participating in the celebratory dances, standing out from the rest of the women with their shaved and ochred heads.

The Samburu are convinced of the importance of female circumcision; for them it is a deeply rooted ritual, symbolizing a girl's purity and readiness for marriage. A newly circumcised girl is called *nkaibartani* (lit. shaved by God), meaning a good and pure person. The name derives from Nkaibartak, the constellation we know as Orion's Belt. According to the Samburu, these four stars symbolize the groom, the companion and the bride, walking one behind the other as they leave the bride's *nkang*; the smallest, faintest and most southerly of the stars symbolizes the groom's companion's dog.

After the bride's circumcision, the groom and his companion drive the bride-wealth livestock in through the bride's mother's entrance. They remove their leather sandals and give them to the bride's mother as a sign of humility. The groom gives the lamb to his mother-in-law, who leads it into her house. To show that she approves the marriage she tethers it under the bride's circumcision bed, where it will remain until the next day. The groom and his companion follow the mother into her house, where the bride is resting. The men sit for a while and the mother sprinkles milk on their feet as a final blessing and sign of approval.

Immediately after this blessing the sacrificial bull is slaughtered outside the mother of the bride's house, the animal is skinned and the meat divided among the wedding guests.

The spilling of blood marks the actual marriage contract, and all who are present at the slaughter are witness to the marriage.

Meanwhile, the bride's father sits on his stool in the doorway of the hut and another elder of the same age-set fits the ceremonial coiled earrings into the father's ears, ties the lion thongs around his calves, green beads around his head and smears fat across his forehead. The father then hands out tobacco to all present and everyone separates to feast with his or her own age group until the dancing starts in the late afternoon.

The next day the groom and his companion lead the bride away to the father of the groom's village. Before they leave, their sandals are returned and the bride's mother hands the groom soft leather capes smeared with ochre. The men stand and wait while a woman from the groom's *nkang* and the one who held the bride's back during circumcision dress the bride within the hut. She wears two leather capes also smeared with ochre and a marriage necklace made of doum palm fibres over her beads. Tucked into the cape on her back are gourds she will use in her new home. She emerges from the hut glistening with wet red ochre and is handed a long staff of *nkweta* by her father, who solemnly instructs her to go with his blessing and to care for her husband's cattle.

The elders stand in two lines outside the father's entrance to the *nkang*. The groom, then his companion and lastly the bride leave the *nkang* in single file and walk between the two lines of elders who hold their staffs high in the air and chant a blessing. The bridal procession walks a short distance, then stops. The companion places handfuls of leaves for the girl to rest on, or gives her some milk to drink, symbolizing that the bride will be well looked after in her new home. They move off and repeat the action three more times. The trio does not look back while walking away, but silently prays to Ngai and asks for his help and protection.

Once they reach the groom's village, the couple are greeted by his mother, who sprinkles milk over them as they enter through her gateway. The girl stands at her mother-in-law's doorway, and will not enter until she is promised a cow. The new wife is given animals by most of the groom's family soon after she arrives. *Pa-tawo* is the name used to refer to those who give and receive a heiffer, *Pa-che* for those that give and receive a calf, *Pa-nkerra* for those who give and receive a sheep, and *Pa-kini* for those that give and receive a goat.

Initially, the bride and groom will sleep in the groom's mother's house, but they will only consummate the marriage once the girl has healed, and usually not until she has physically matured and made her own house. If the girl is very young, the mother of the groom will see that she is sheltered as one of her own children until she is mature enough to take up the responsibilities of a wife and married woman.

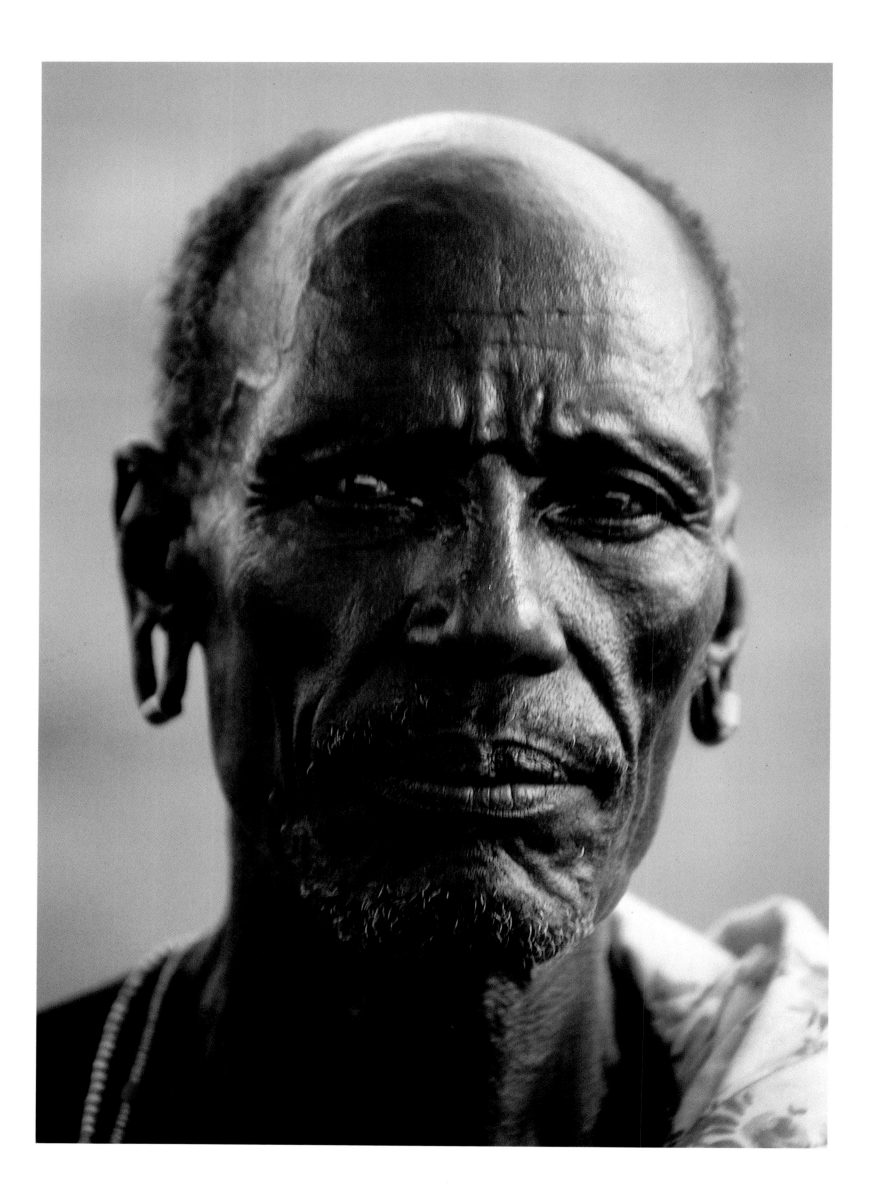

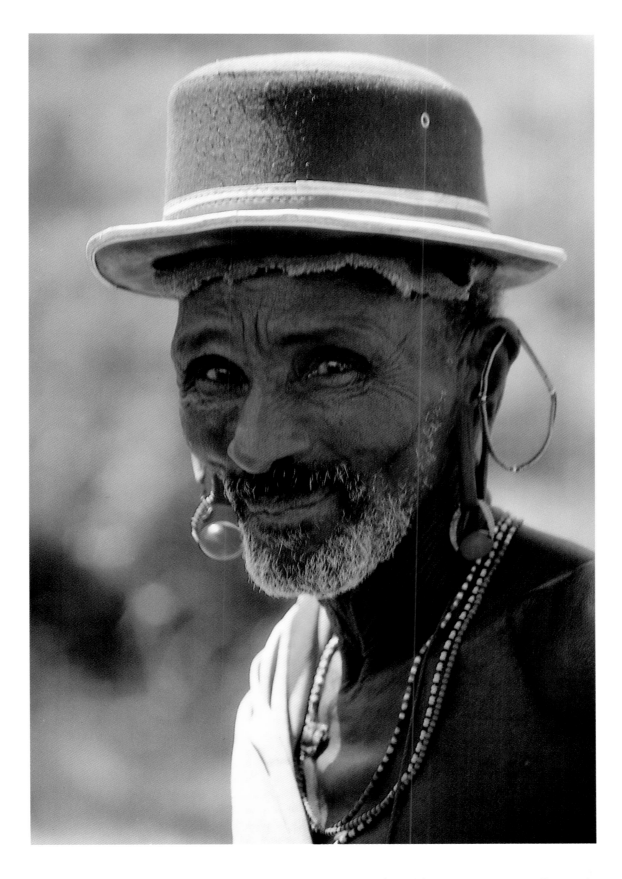

ABOVE: Marriages are overseen by the elders. A warrior who wishes to marry must first seek the consent of a friend or close relative of the father of his desired bride. This prevents a father from manipulating his daughter's destiny in his own interest. The groom gives cattle and sometimes camels as bride wealth to the bride's father and to her older male relatives.

LEFT: Elders often wear small metal earrings which are attached to their ears by their wives. Only a wife is permitted to touch a man's ear, and if a man's ear lobe is broken by another man the offending party has to pay a fine, usually a camel or a cow.

TOP: Clear, clean water tumbles down its rocky course on the higher ground where the warriors take their cattle for the lush grazing.

RIGHT: The warriors may take a whole day to prepare themselves for a marriage ceremony. They dress their hair and paint themselves with ochre.

LEFT: Sometimes the warriors mark the rocks where they have made their preparations, before descending to the villages below to deliver the bride wealth. They sing a special song, *n-tera*, as they herd the cattle through the bush to the bride's father's village.

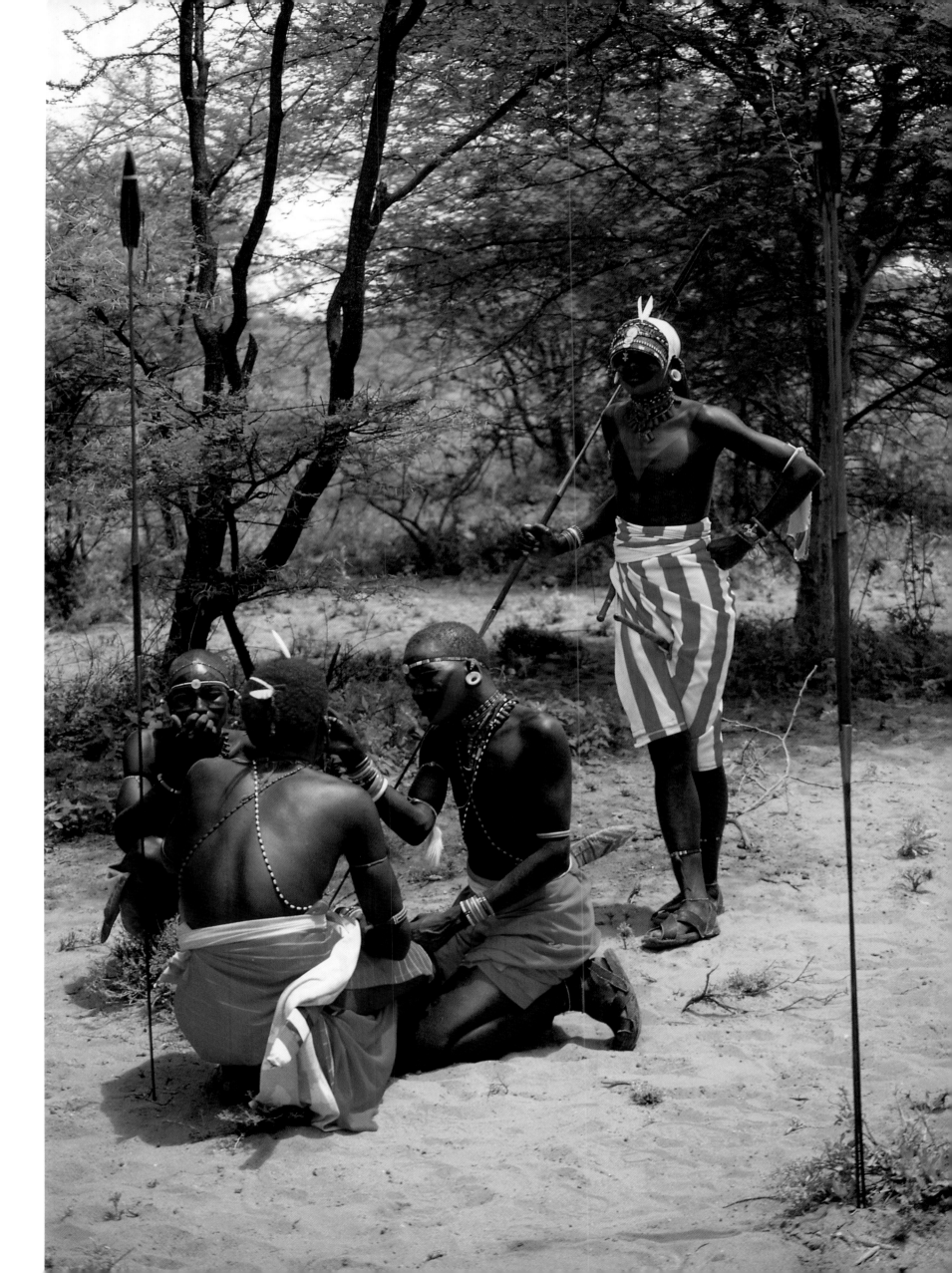

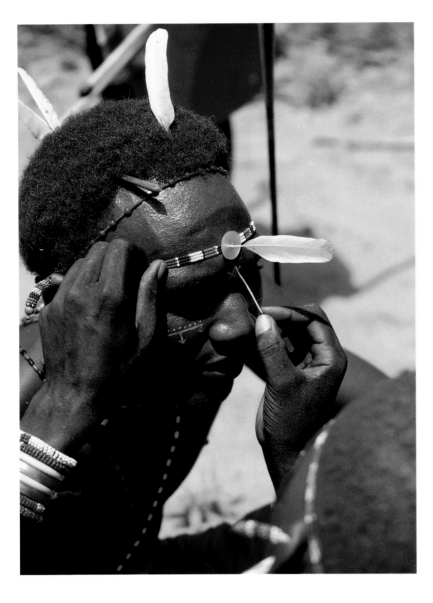

LEFT, BELOW AND RIGHT: The warriors take great pride in their elaborate face-painting and braided hair styles. The straight edges to the blocks of red ochre on their chests and cheeks are made with a small wooden spatula, which they often carry tucked behind one ear. The fine lines on their eyebrows and cheekbones are drawn using a thin, whittled stick. The ochre is carried in a pouch attached to their belts.

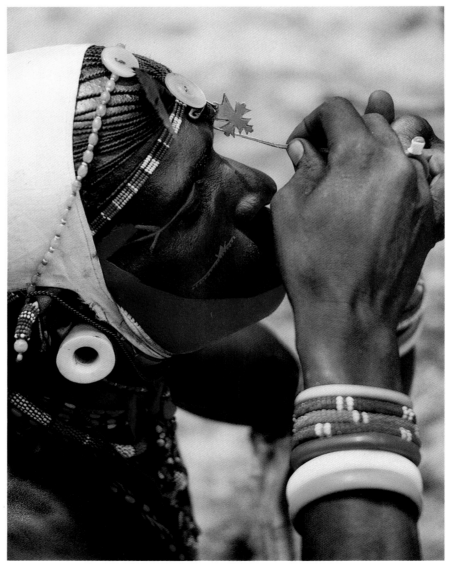

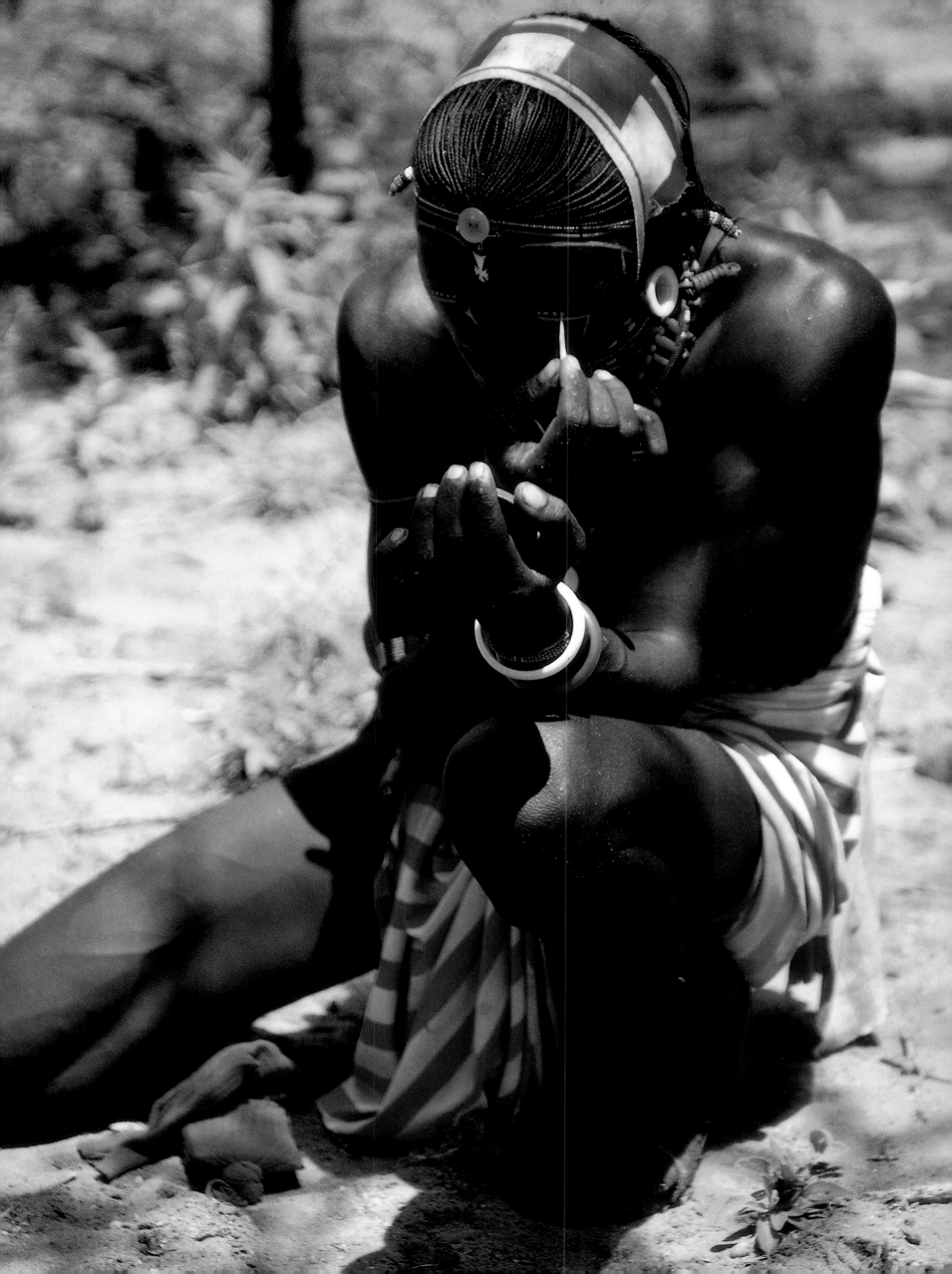

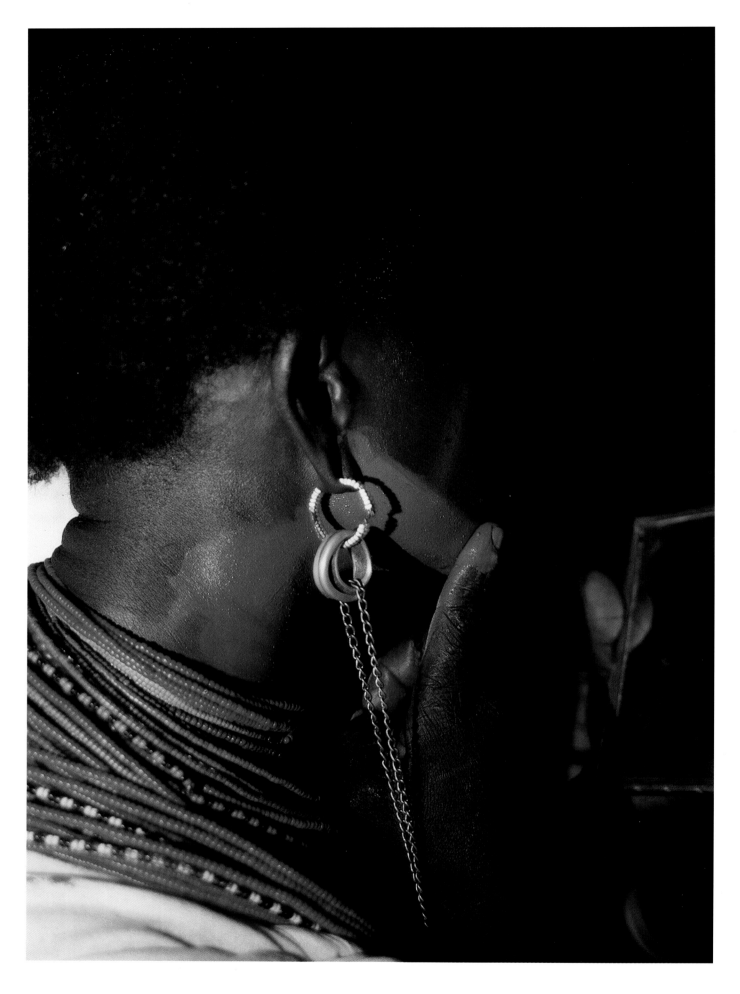

ABOVE AND RIGHT: In the privacy of their huts the women also decorate themselves with ochre, but the designs they use are much simpler than those of the warriors.

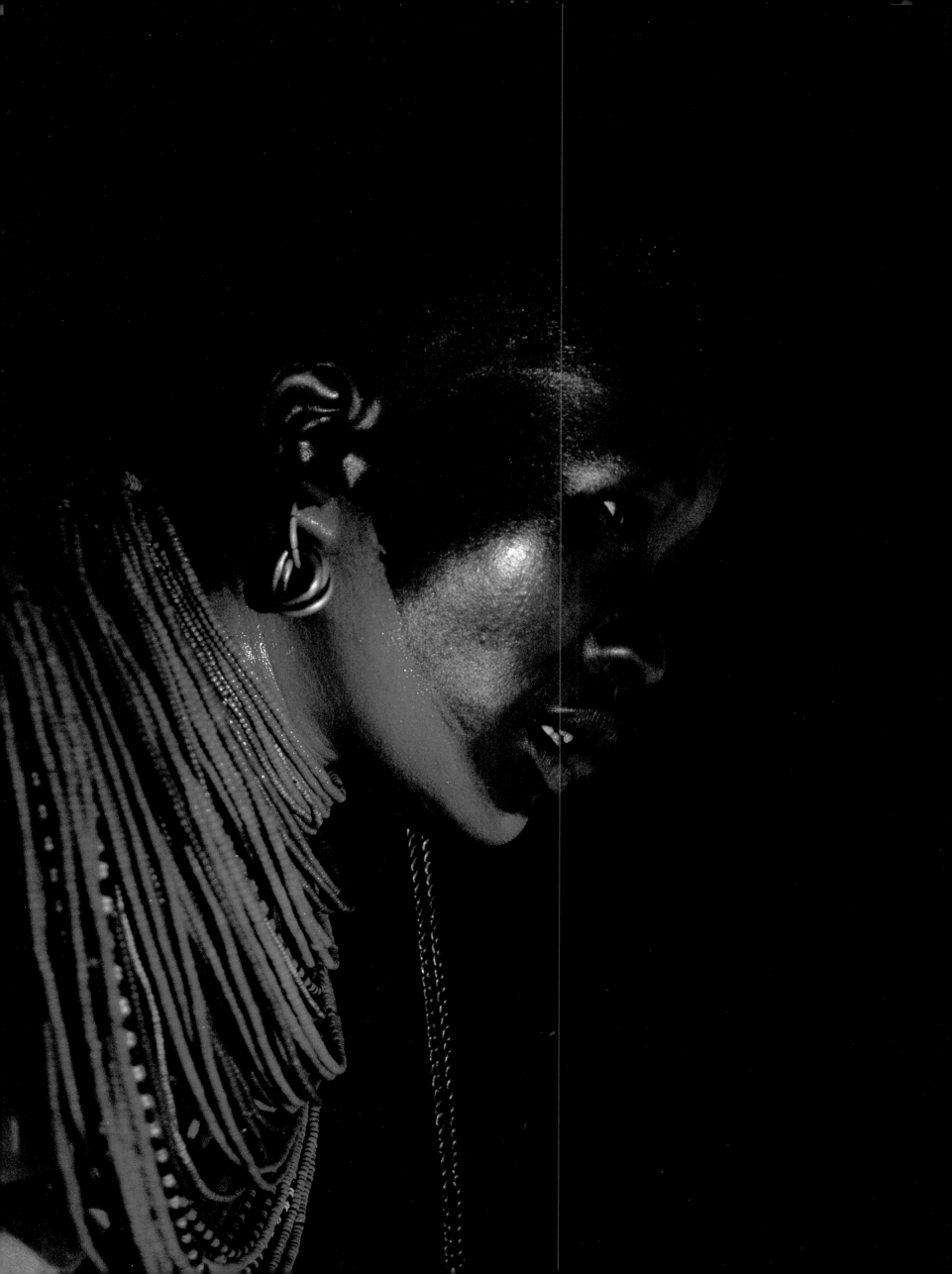

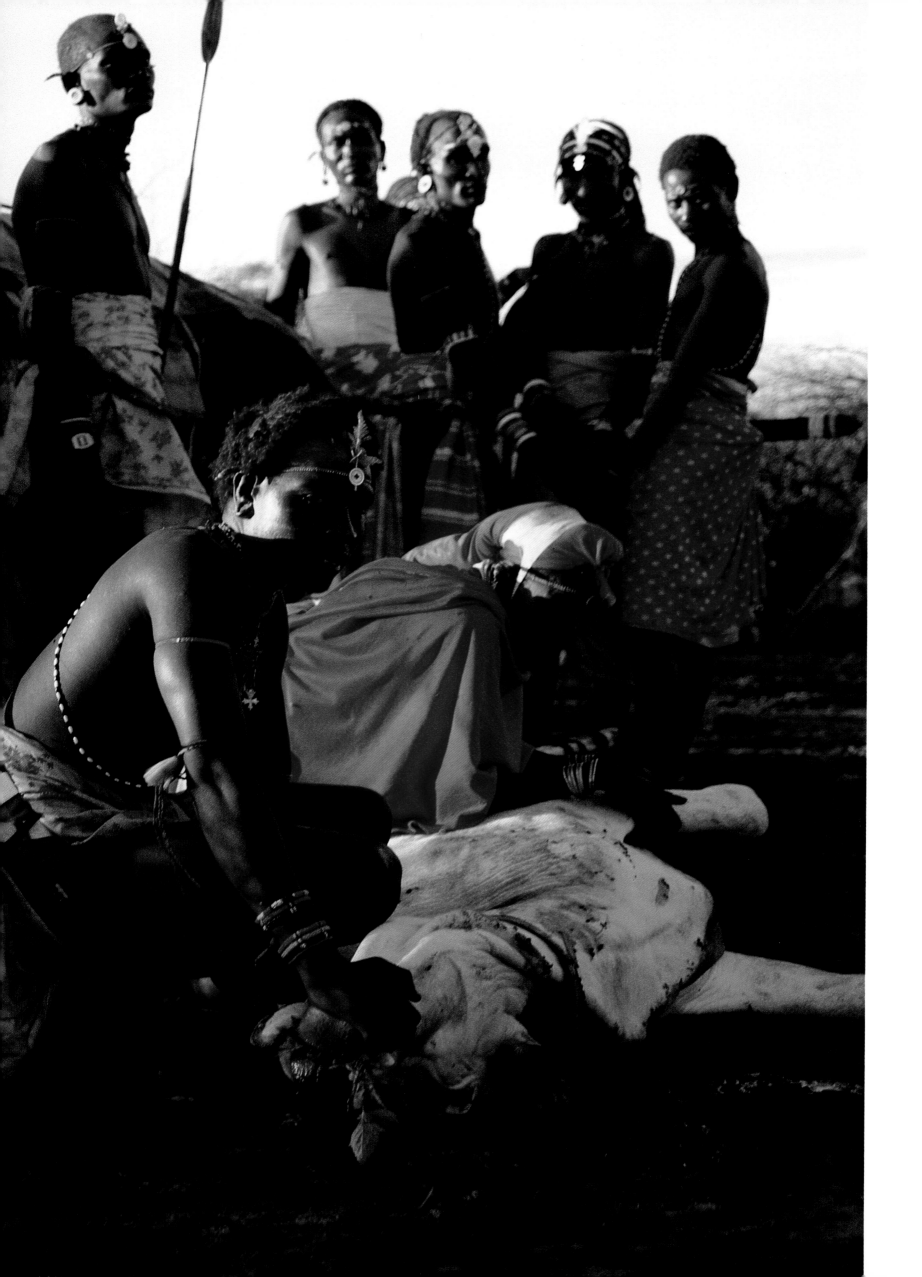

LEFT: Warriors ceremonially slaughter a castrated bull for the marriage feast outside the mother of the bride's house. The blood is drained by slitting the dewlap under the bull's neck and piercing the jugular vein. The blood is collected in the bowl of skin and drunk still warm by the men or given to the women to cook. The spilling of the bull's blood seals the marriage contract of which the elders are witnesses. No vows are exchanged, but as with almost all Samburu ceremonies, duly witnessed ritual acts and visual symbols have the force of a written contract.

BELOW: An elder with token face decoration, the vestiges of his warriorhood. The motif of white dots is unusual for a Samburu, being more typical of the Rendille.

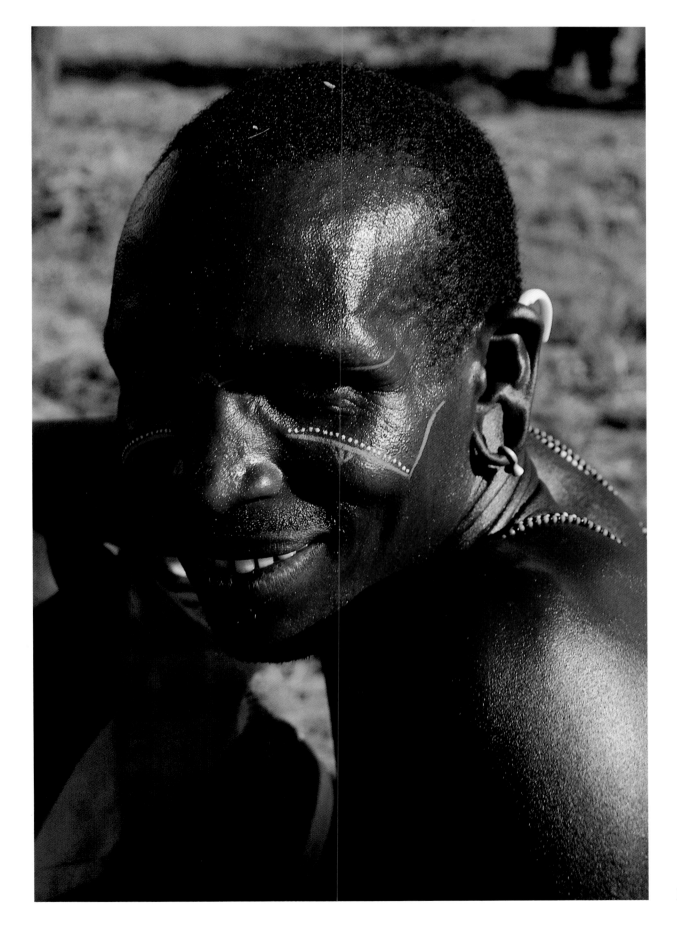

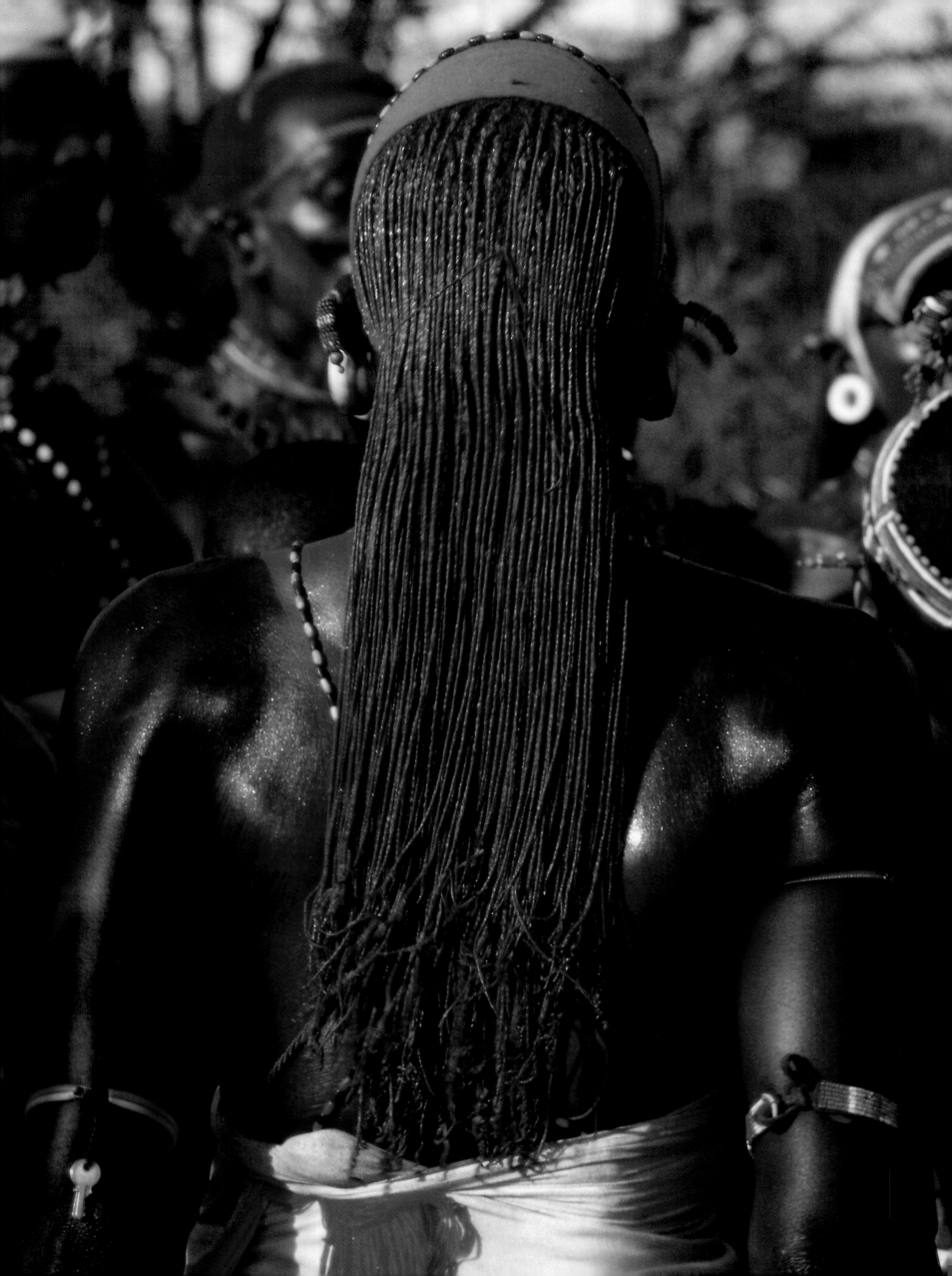

LEFT: A warrior, with hair braided to his waist, gathers with other warriors of the same age-set to dance in celebration of a marriage. The dancing starts in the relative cool of the late afternoon and may last far into the night.

BELOW AND OVERLEAF: The first of the warriors' dances always consists of one warrior skipping forward from the chanting group and leaping high into the air before returning, as the next dancer advances. These warlike dances are both a demonstration of comradeship and a chance for the warriors to show off their strength and stamina to the girls and to each other.

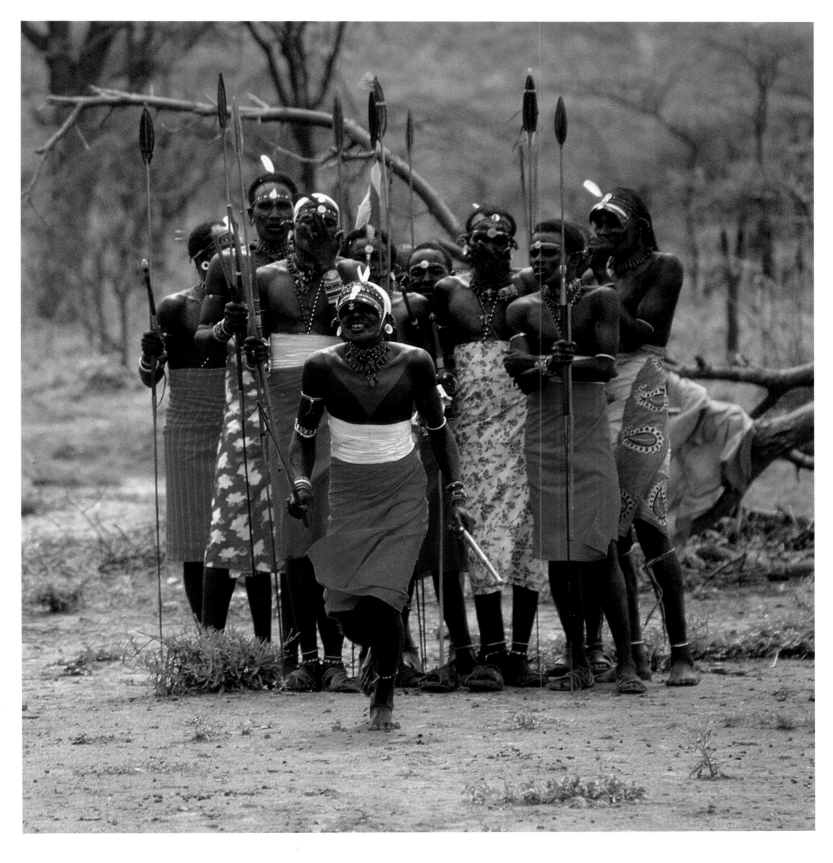

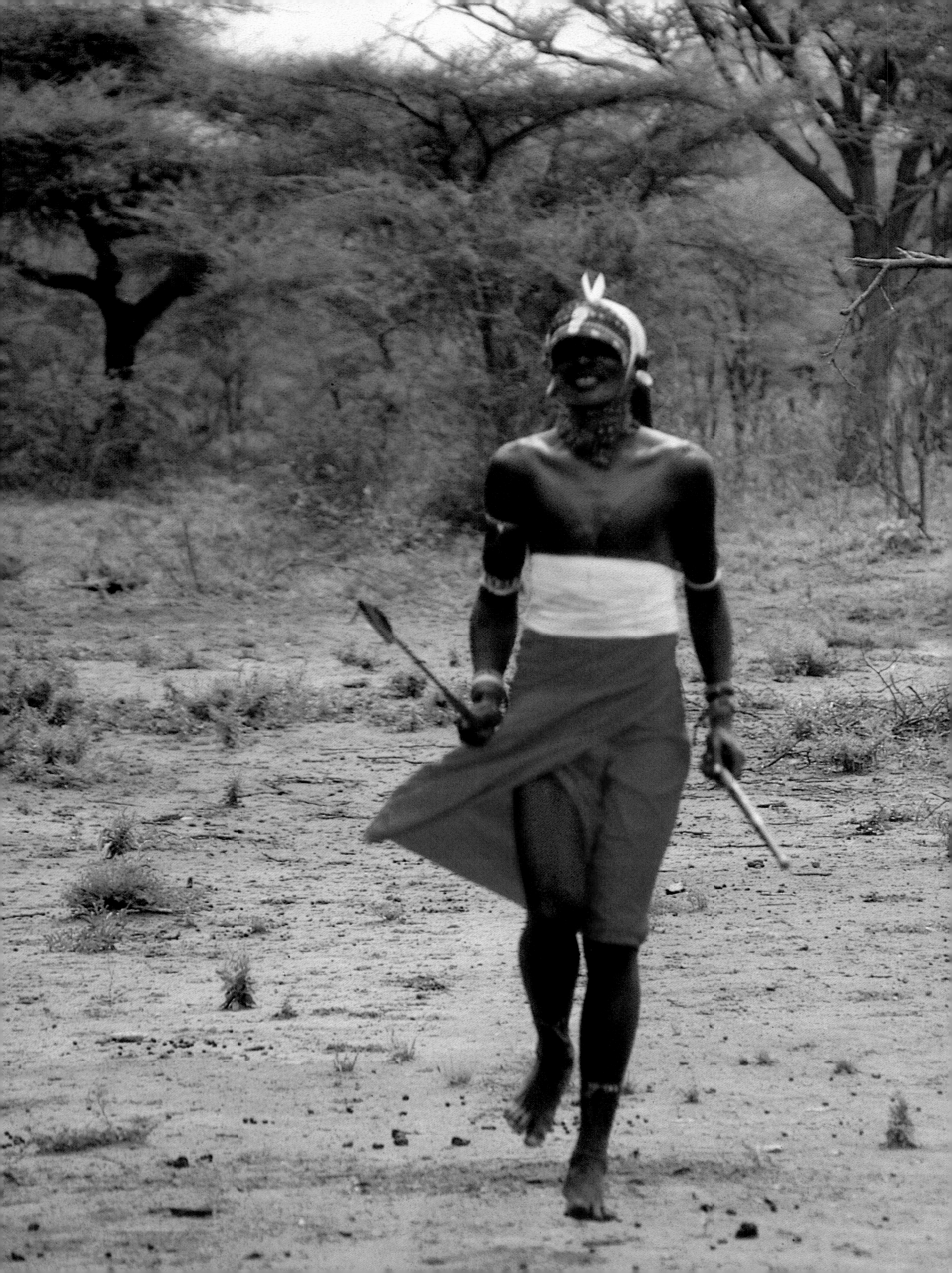

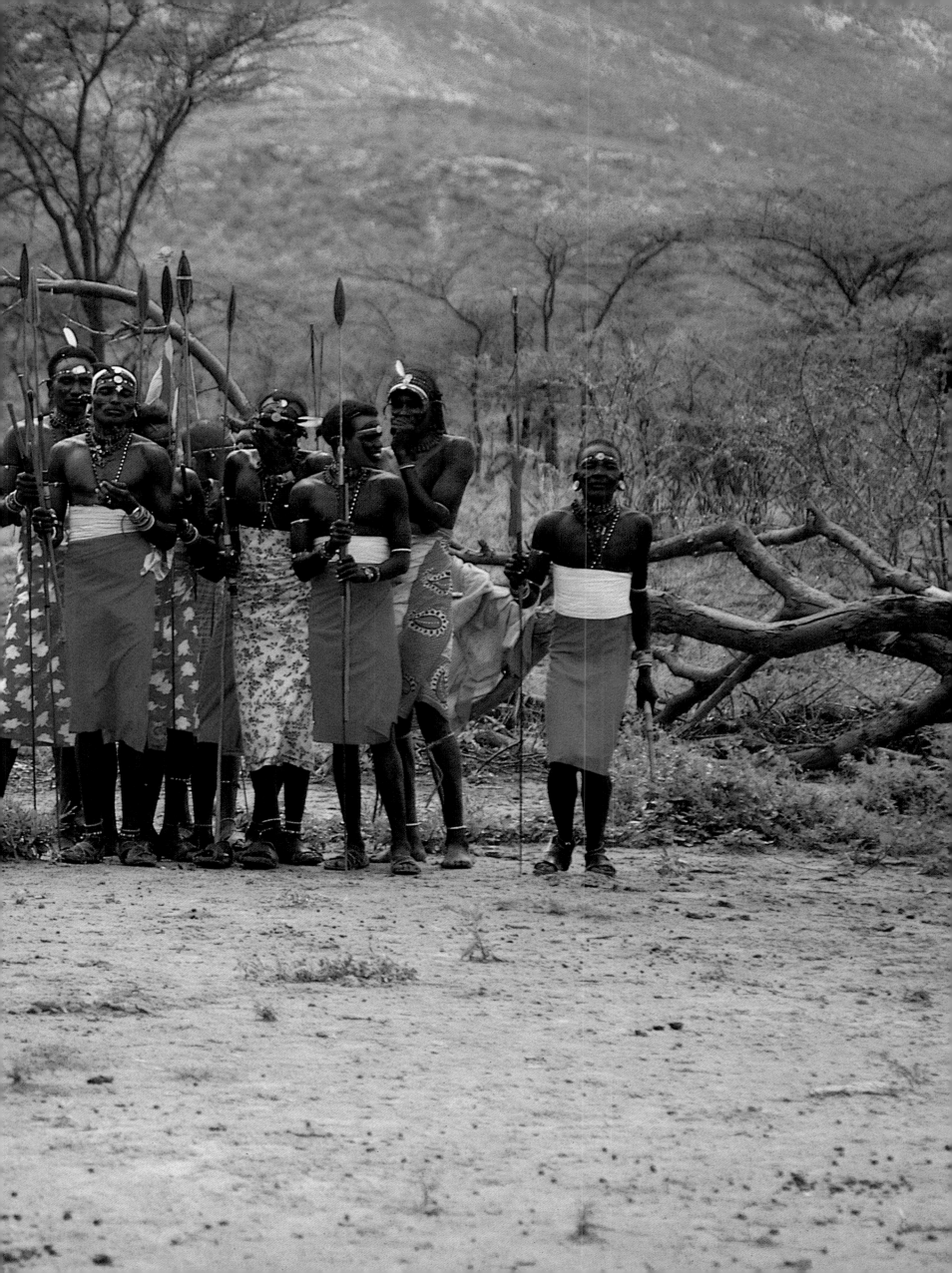

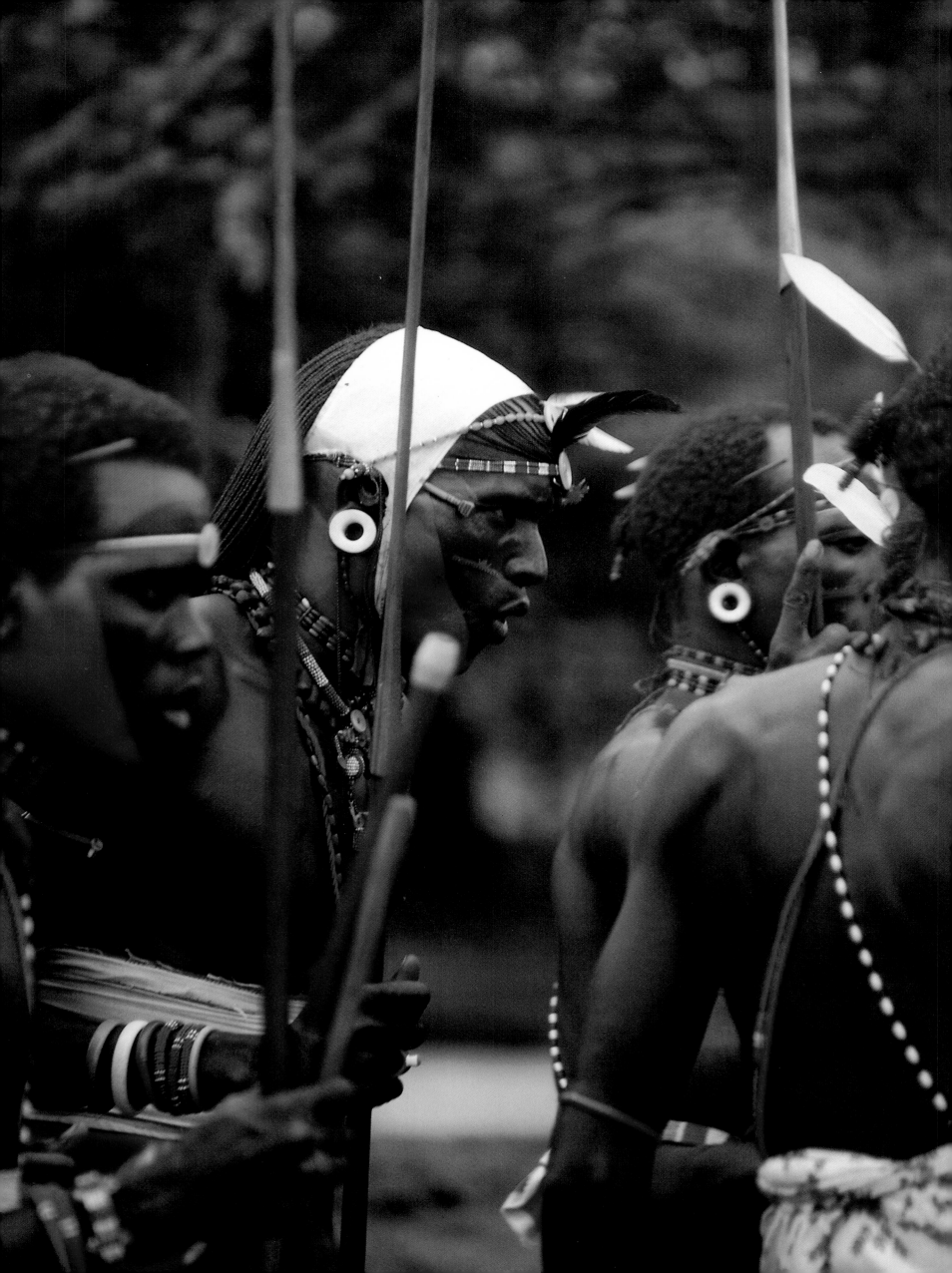

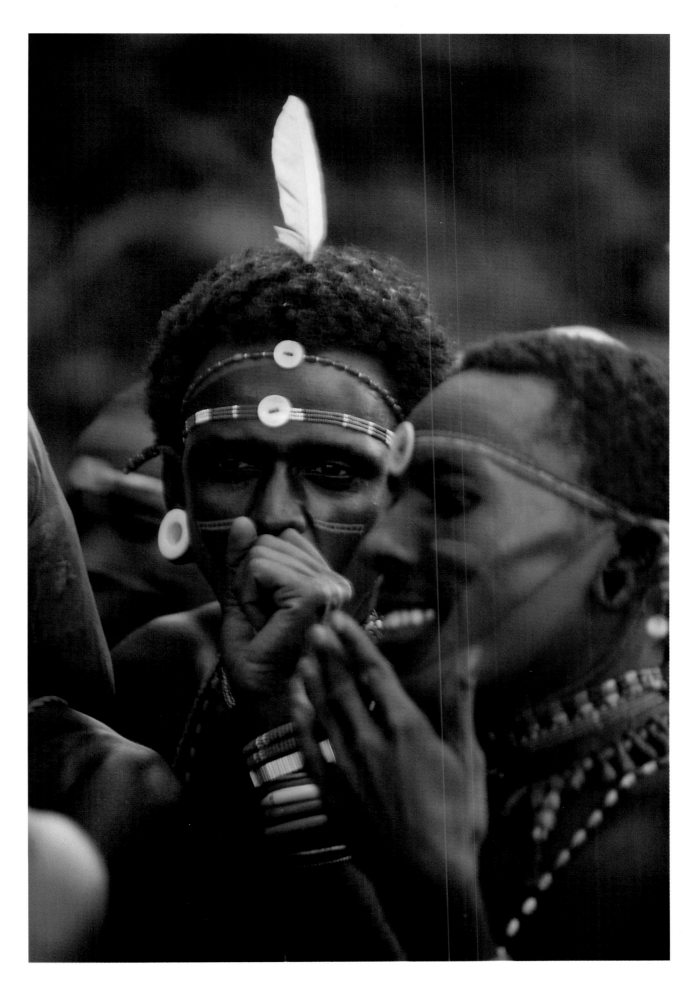

LEFT AND ABOVE: The warriors play no musical instruments but create music with their voices and a rhythm beaten out in handclaps and with their *rungu* on their spears or staffs. One lead singer chants his song above the chorus of the other warriors, who create a powerful, harmonized and rhythmic warbling, varying the pitch by partially covering their mouths with their hands.

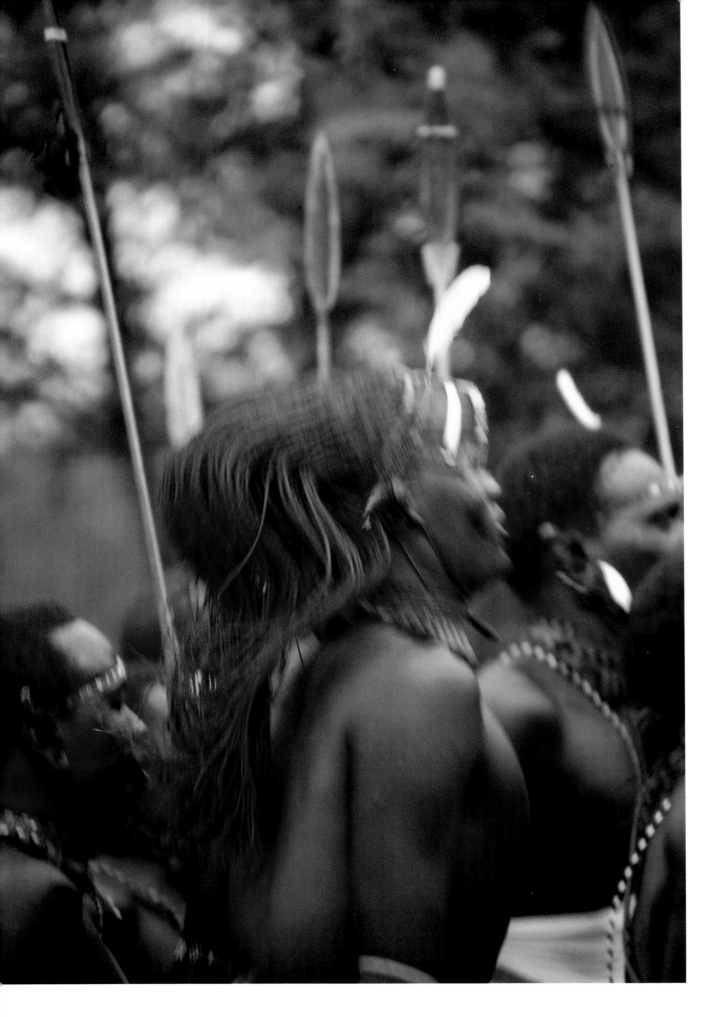

ABOVE AND RIGHT: The warriors become engrossed in their dance and compete with each other to leap high into the air.

OVERLEAF: A married woman absorbed in the rhythm of the dance.

130

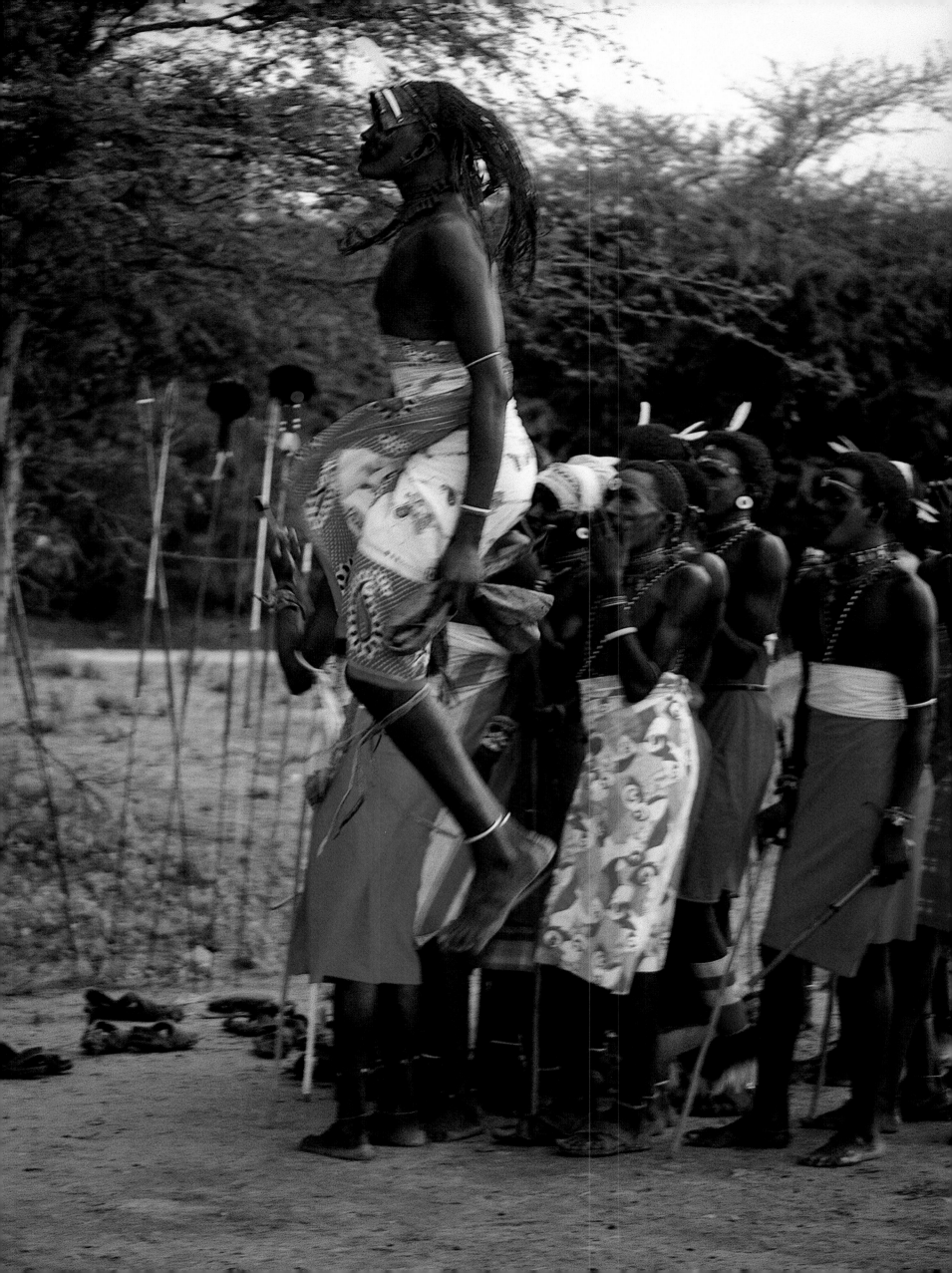

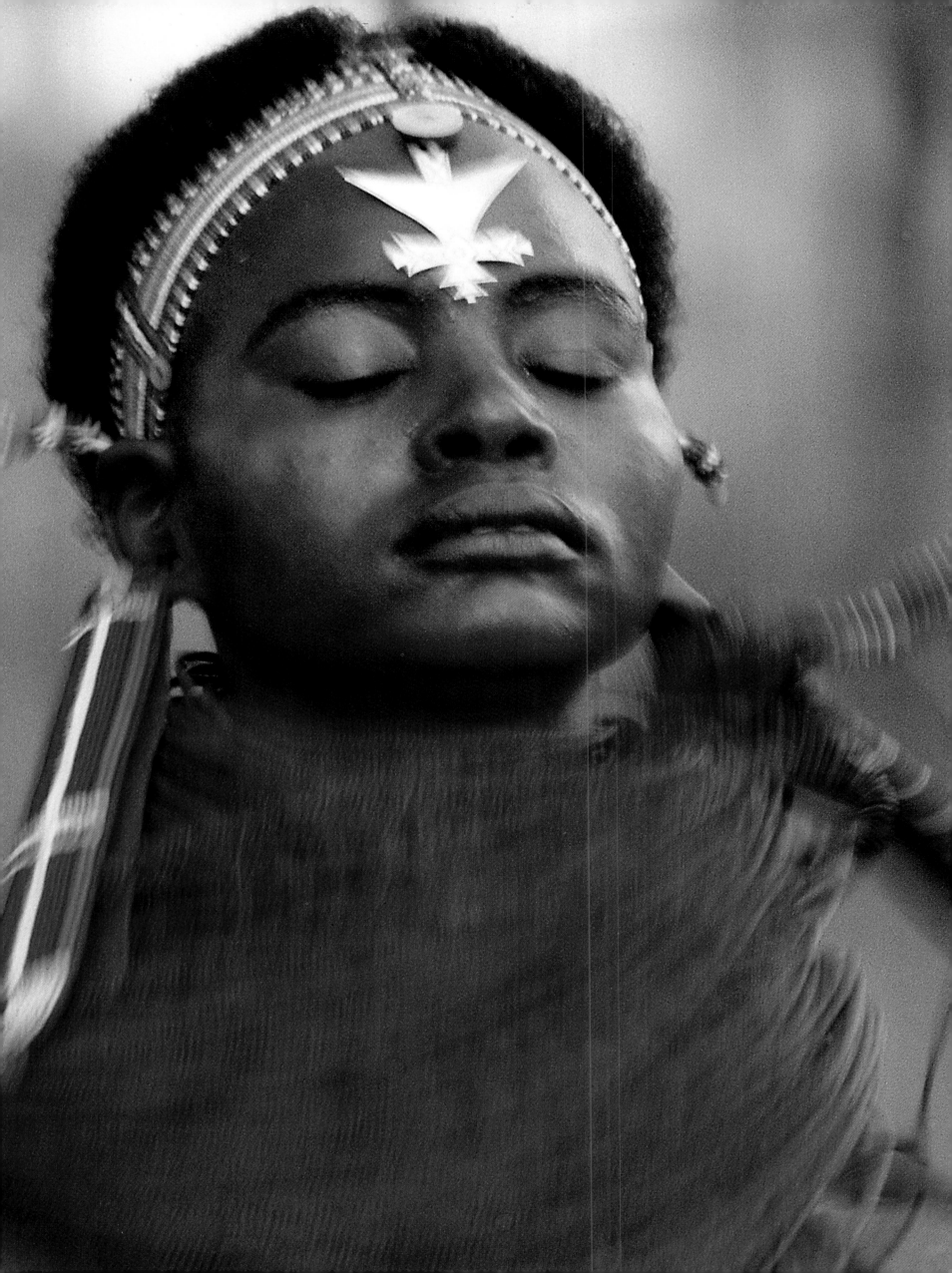

ABOVE: An uncircumcised youth moves serenely, with the air of a novice, among the dancing warriors.

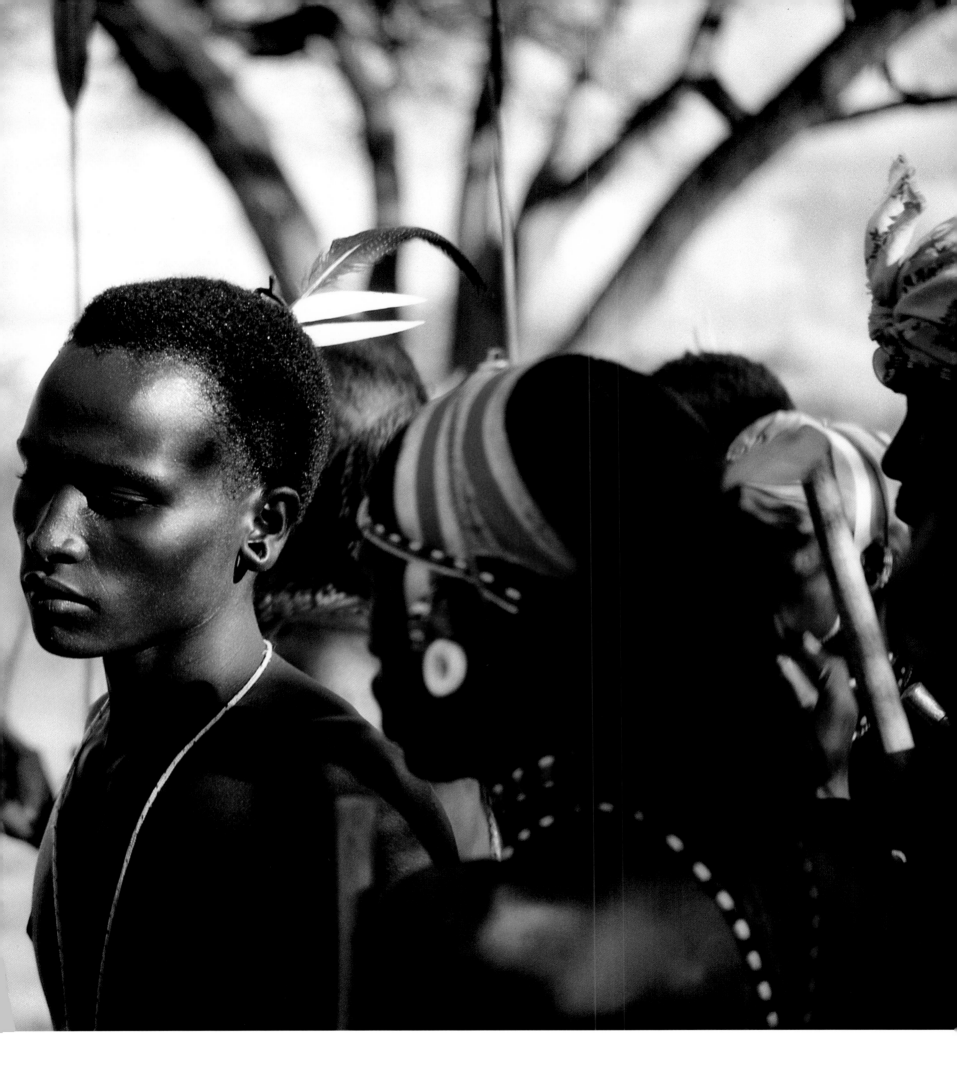

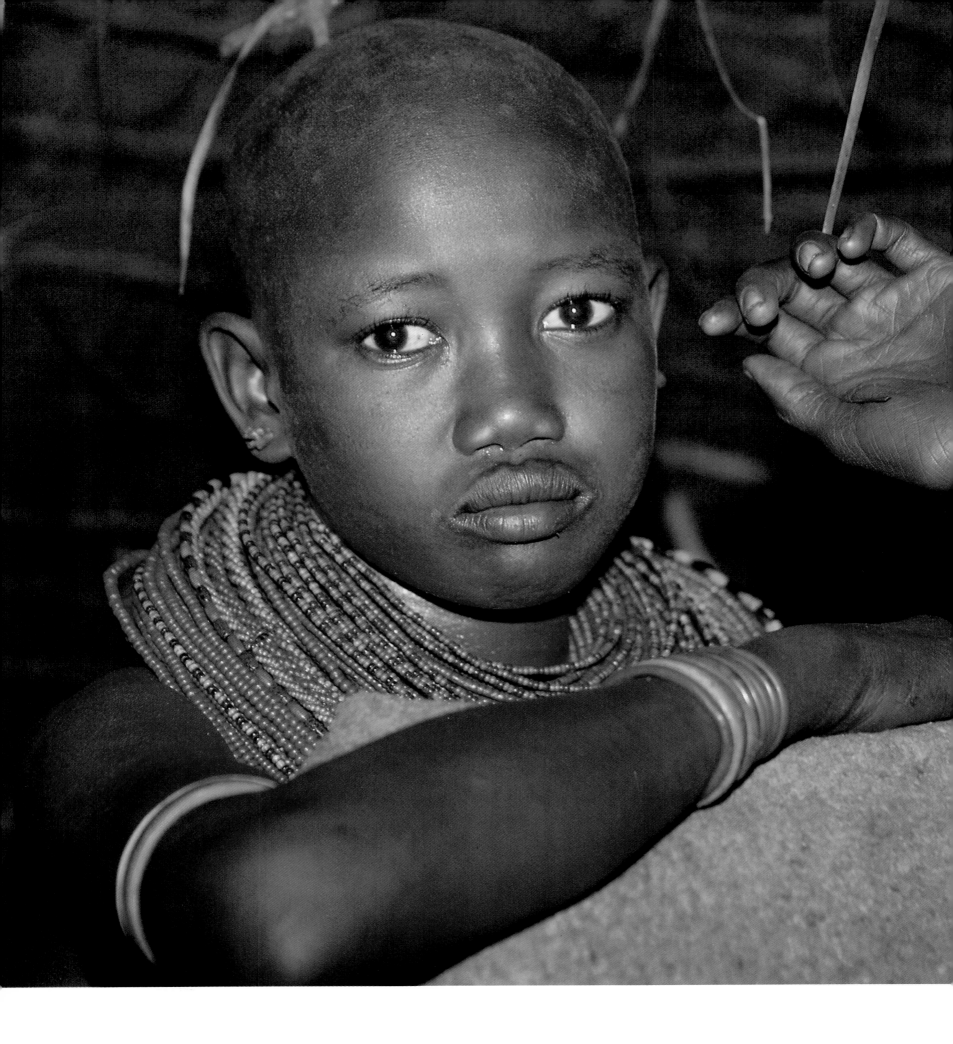

LEFT: A young bride sits in her mother's hut after circumcision. An older sister will always be married before a younger sibling. However, if there are two sisters very close in age then they will be circumcised together, even though the younger girl may not be married for up to a month or more.

BELOW AND RIGHT: A bride wearing a leather cape glistens with wet red ochre as she leaves her mother's village and sets out to walk into the next phase of her life. She carries her father's staff together with an *nkarau* for milk and another for meat, tucked into the back of her leather cape. She wears her marriage earrings and her marriage necklace, which is made from strands of fibre from the doum palm tree. She wears or carries all the possessions she will take with her to her new home.

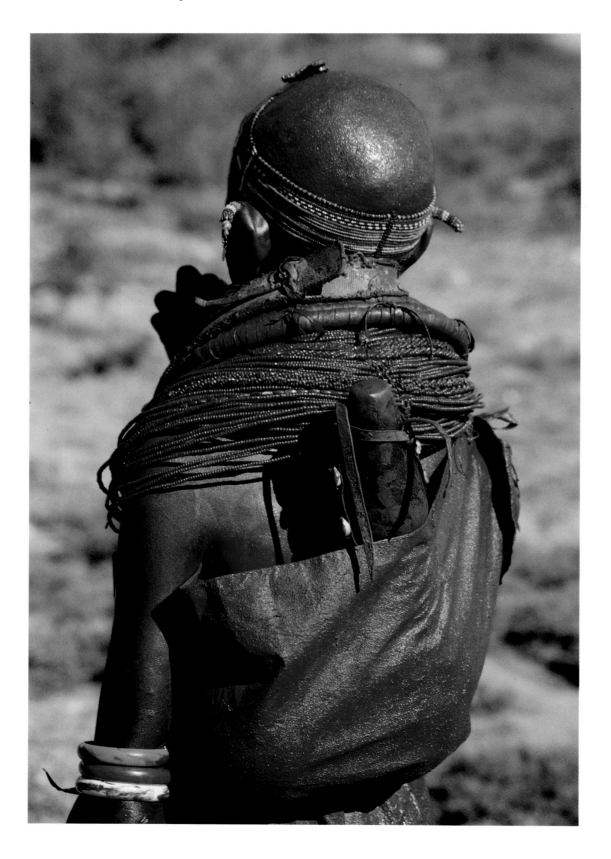

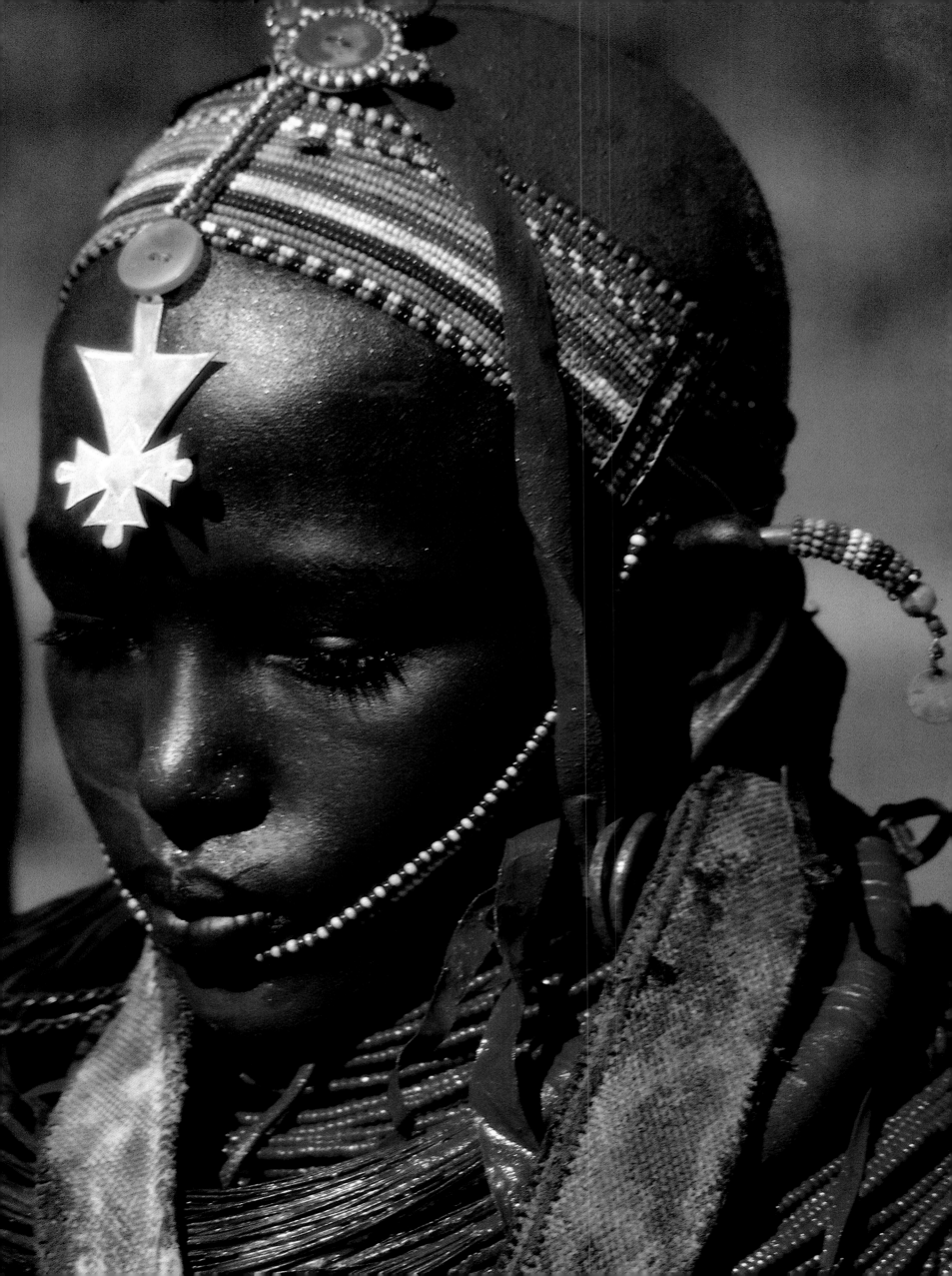

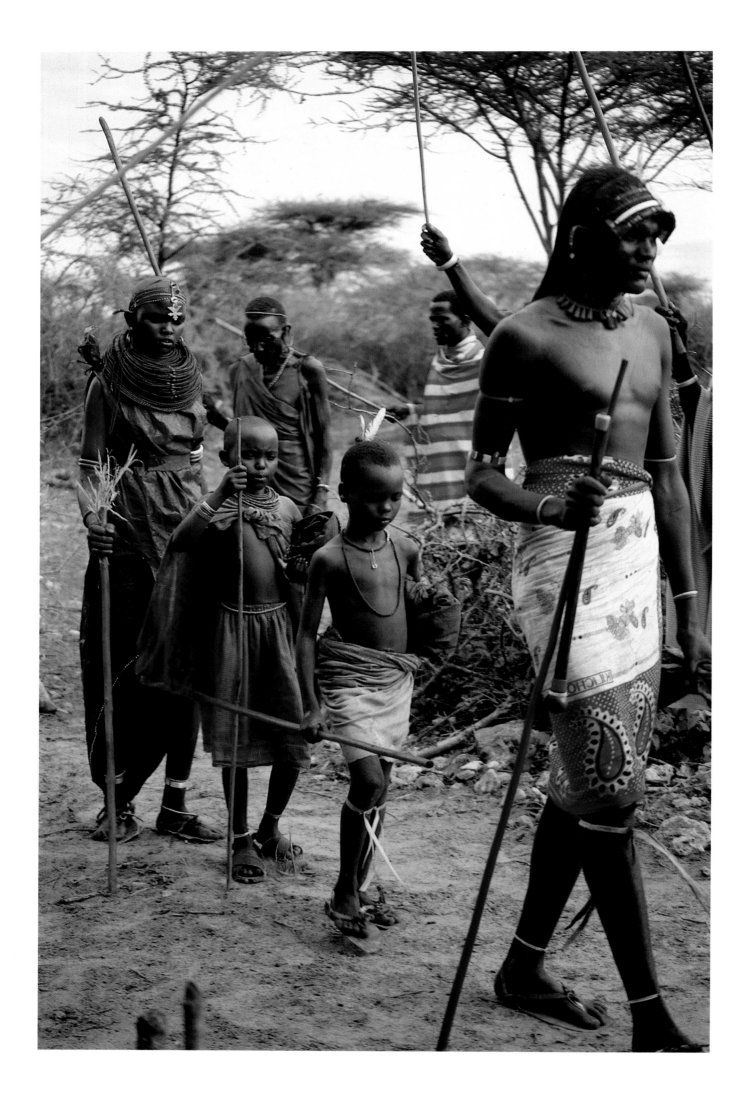

140

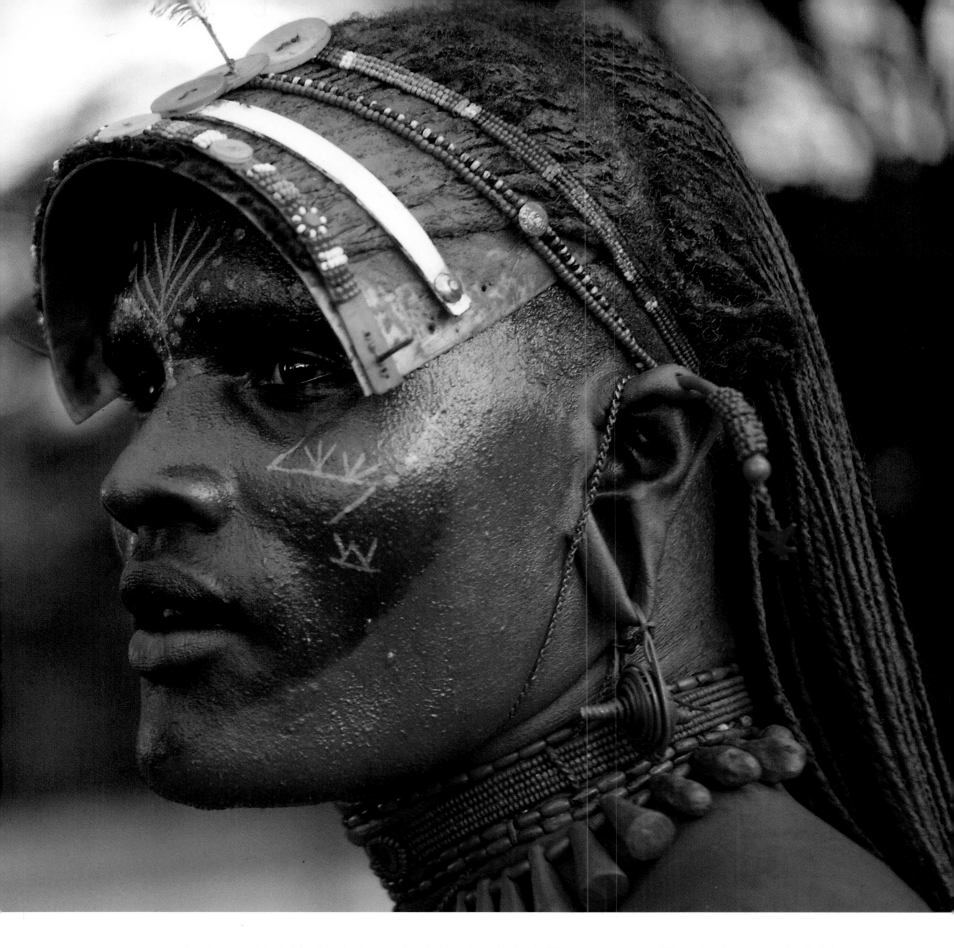

LEFT: A groom leads away his bride. Each clan and sub-clan has slightly different customs. Here, for instance, the bride and groom are attended by an age-mate companion and a young girl and boy, who carry small replicas of the staff and *nkela* carried by the groom's companion. Also in this clan the bride's father hands the bride a tuft of green grass as a symbol of good pasture, that is to say prosperity, fertility and good fortune.

ABOVE: A groom with extremely elaborate designs on his cheekbones and forehead. He wears the coiled earrings which he first wore at his circumcision. Throughout his warriorhood his mother keeps the earrings, returning them to him at the time of his marriage. He wears them at his wedding and again at his son's or his daughter's circumcision.

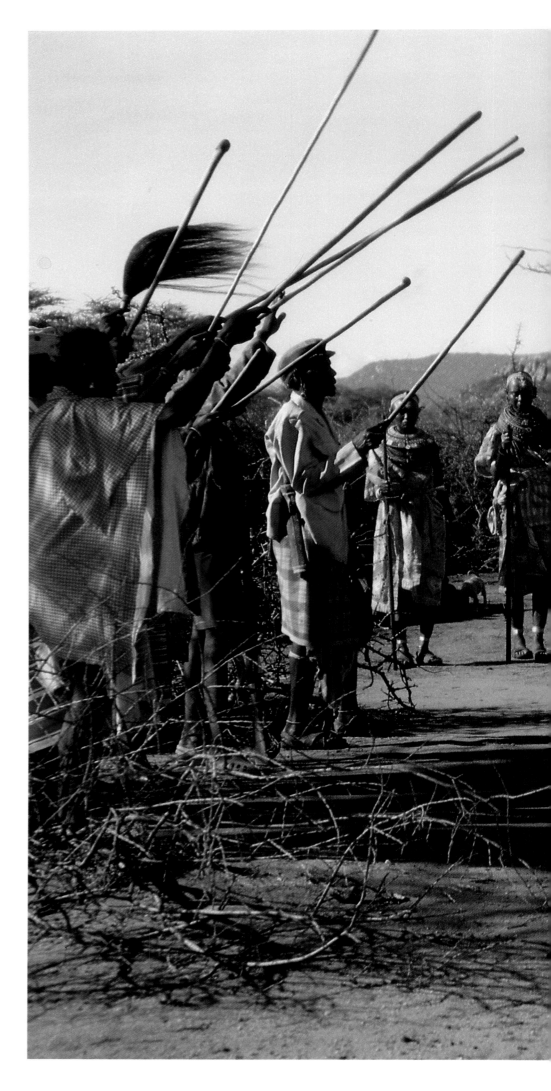

RIGHT: A wedding procession leaves the bride's village and the girl's mother watches her daughter leave with her husband and his companion. The bride will now live in her mother-in-law's house, which may be several days' walk away. The elders line the path and raise their staffs, the symbols of their status, and chant a blessing as the wedding party passes. The groom carries two skins which have been smeared with ochre and specially softened; one a present from his mother-in-law, the other a gift from his own family.

OVERLEAF: The bride, the groom and his companion, do not look back toward the village as they walk away. After a short distance, they stop and rest for a while. Here, the groom's companion hands the bride milk to drink to symbolize his concern for her welfare; more usually he will place branches or leaves on the ground for her to sit on. This responsibility continues until, using firesticks, he lights the first fire in the house the bride will eventually build in her husband's village in about a year's time.

142

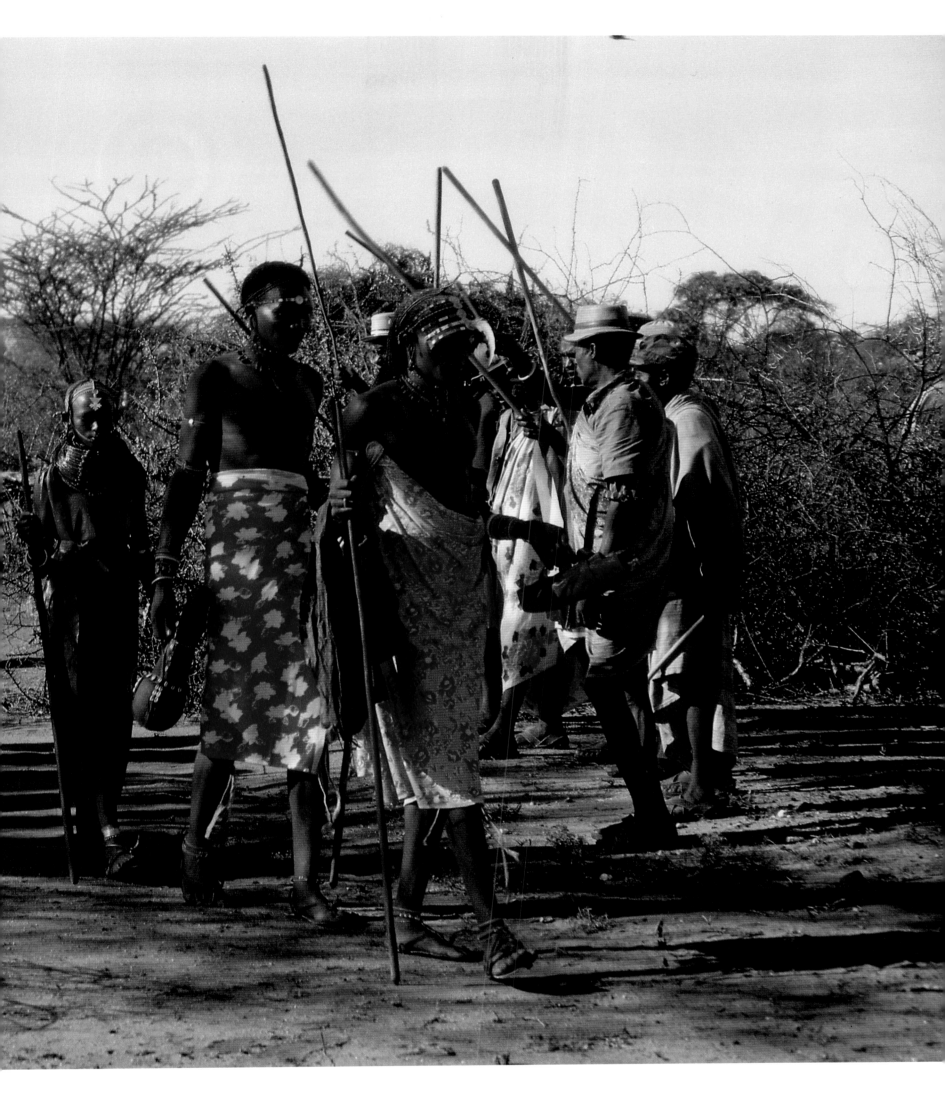

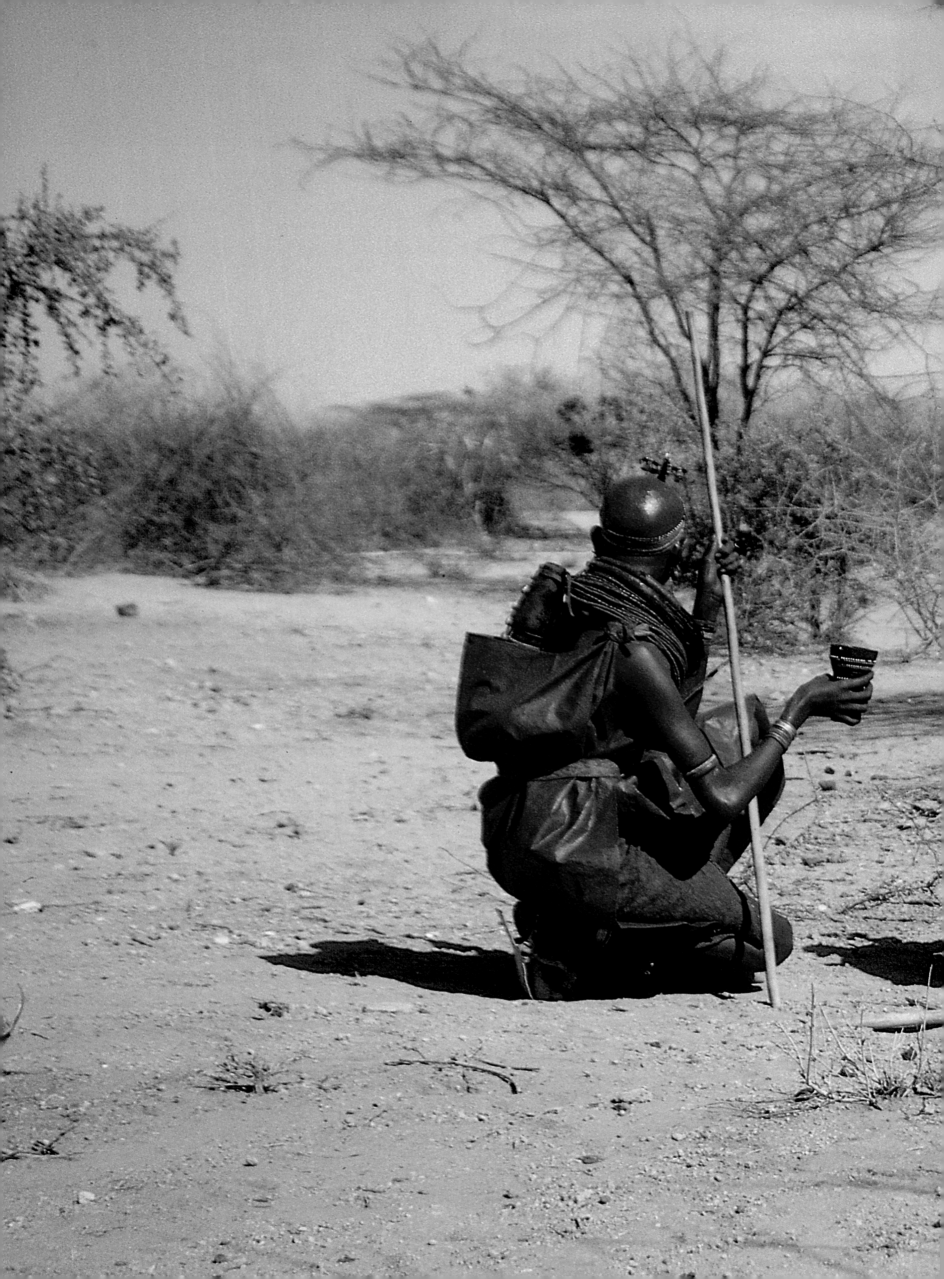

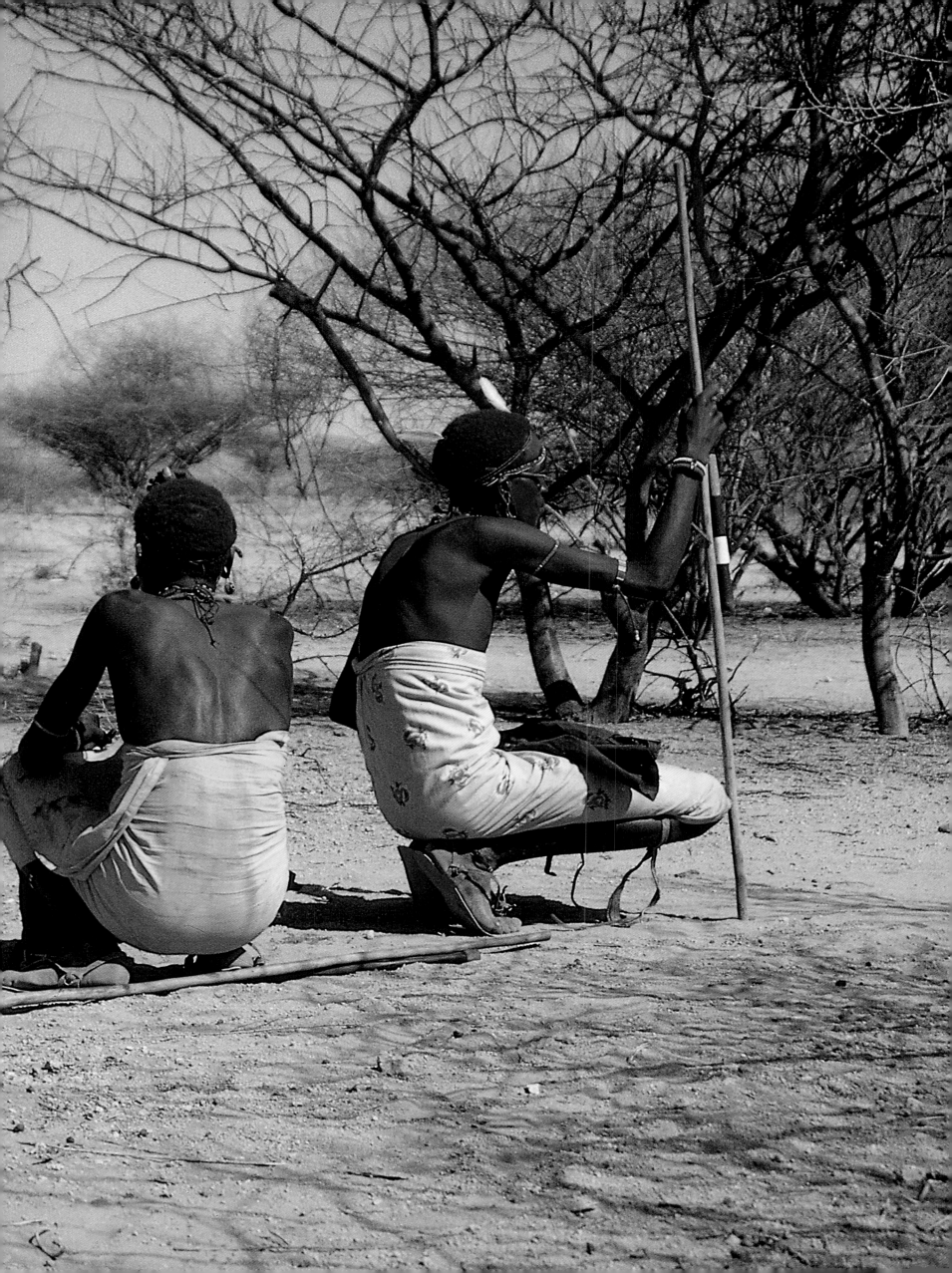

BELOW AND RIGHT: As well as the symbols of their married status newly married women may wear the jewellery and adornments of their girlhood for a while before discarding them altogether. In all other clans, married women wear their marriage necklaces whenever they wish, but among some of the Lpisikishu, the women only wear them on ceremonial occasions. These differing customs arise because once a man took a bride and she died, so he took another and she died too, but when he married a third time the usual custom governing the wearing of marriage necklaces was varied. This seemed to break the pattern of bad luck. The man's descendants followed the practice which in time became a tradition.

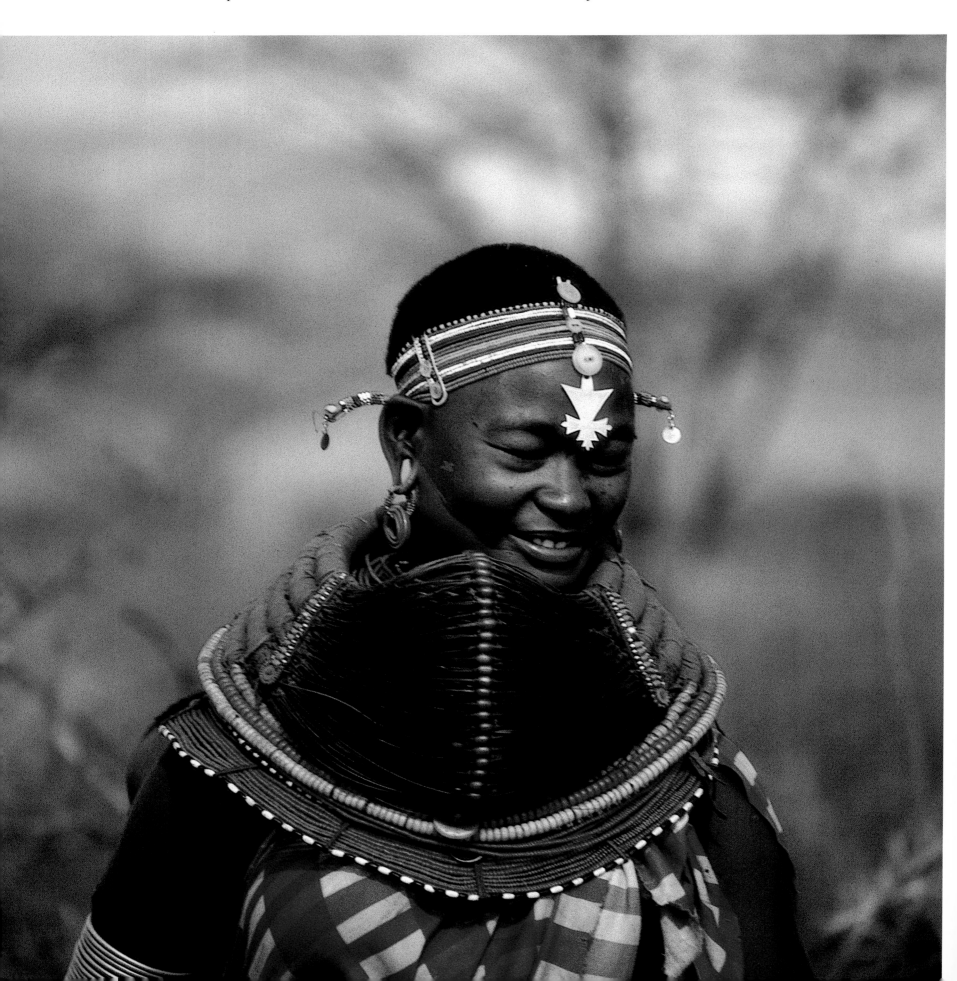

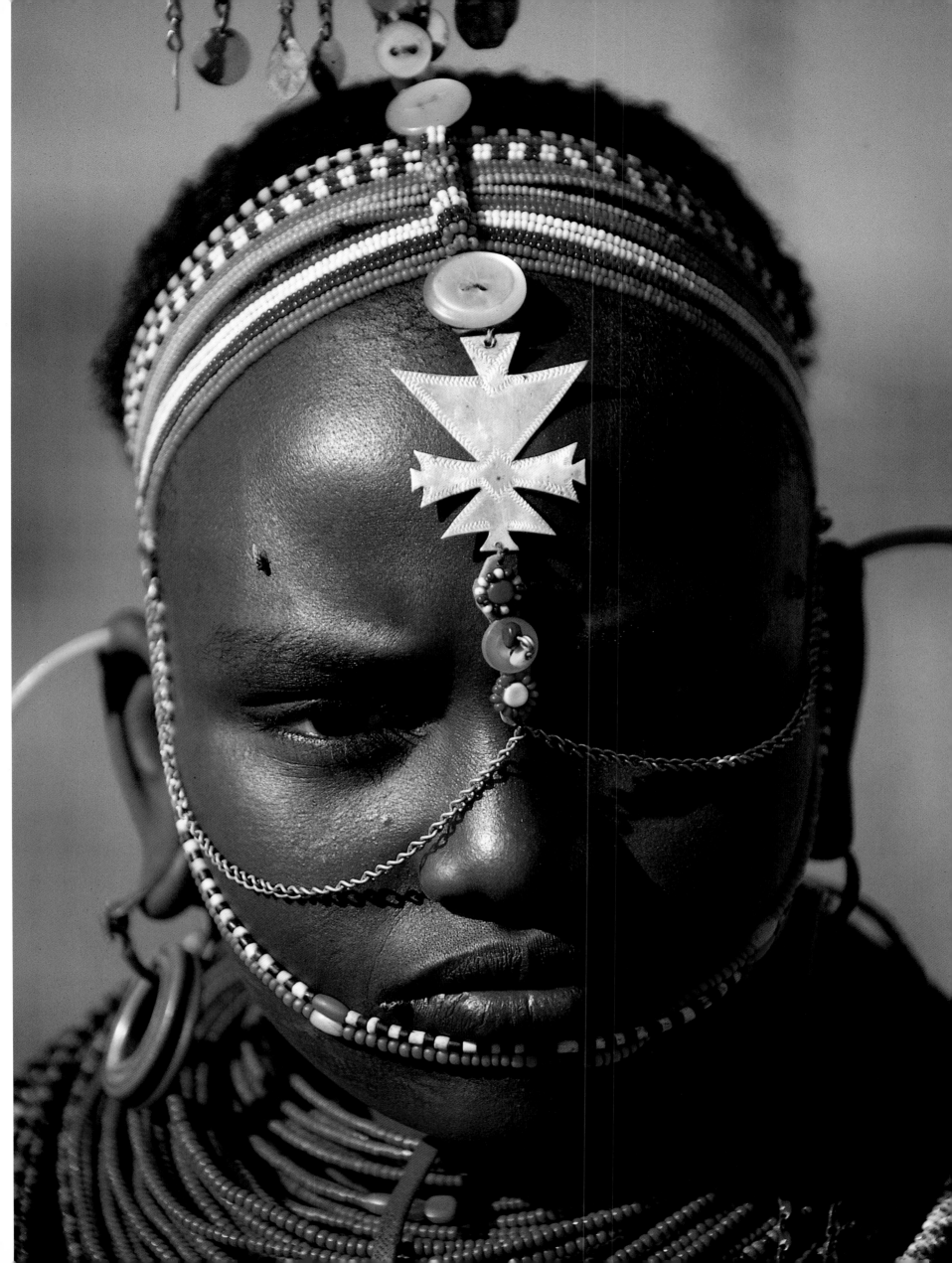

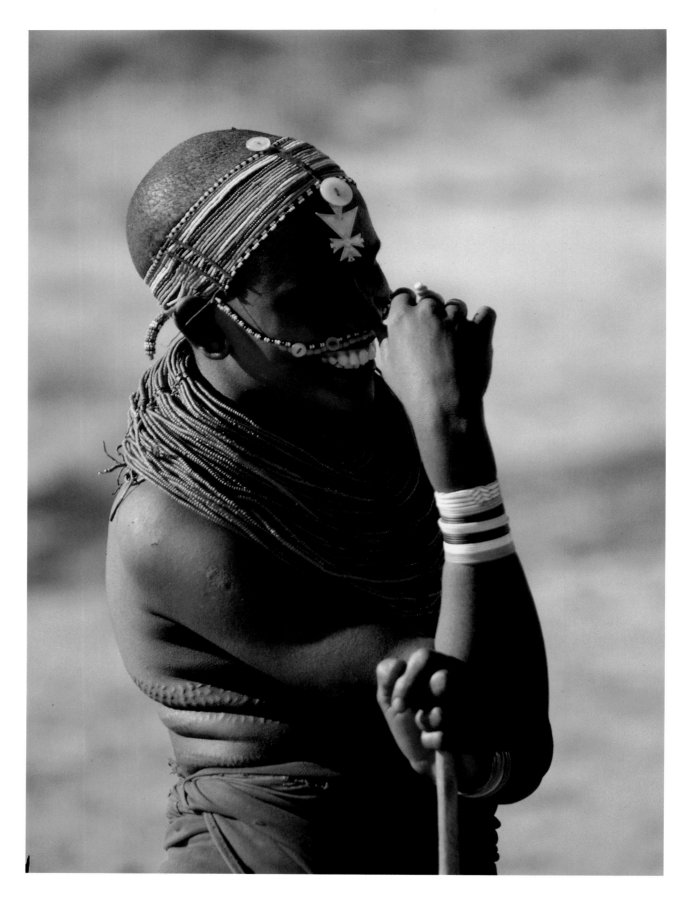

ABOVE: A married woman with scarification around her waist. Such scarification used to be common and was carried out simply for decorative purposes, although nowadays the custom is dying out.

RIGHT: A newly married woman, wearing marriage earrings; her layers of red beads glisten with ochre.

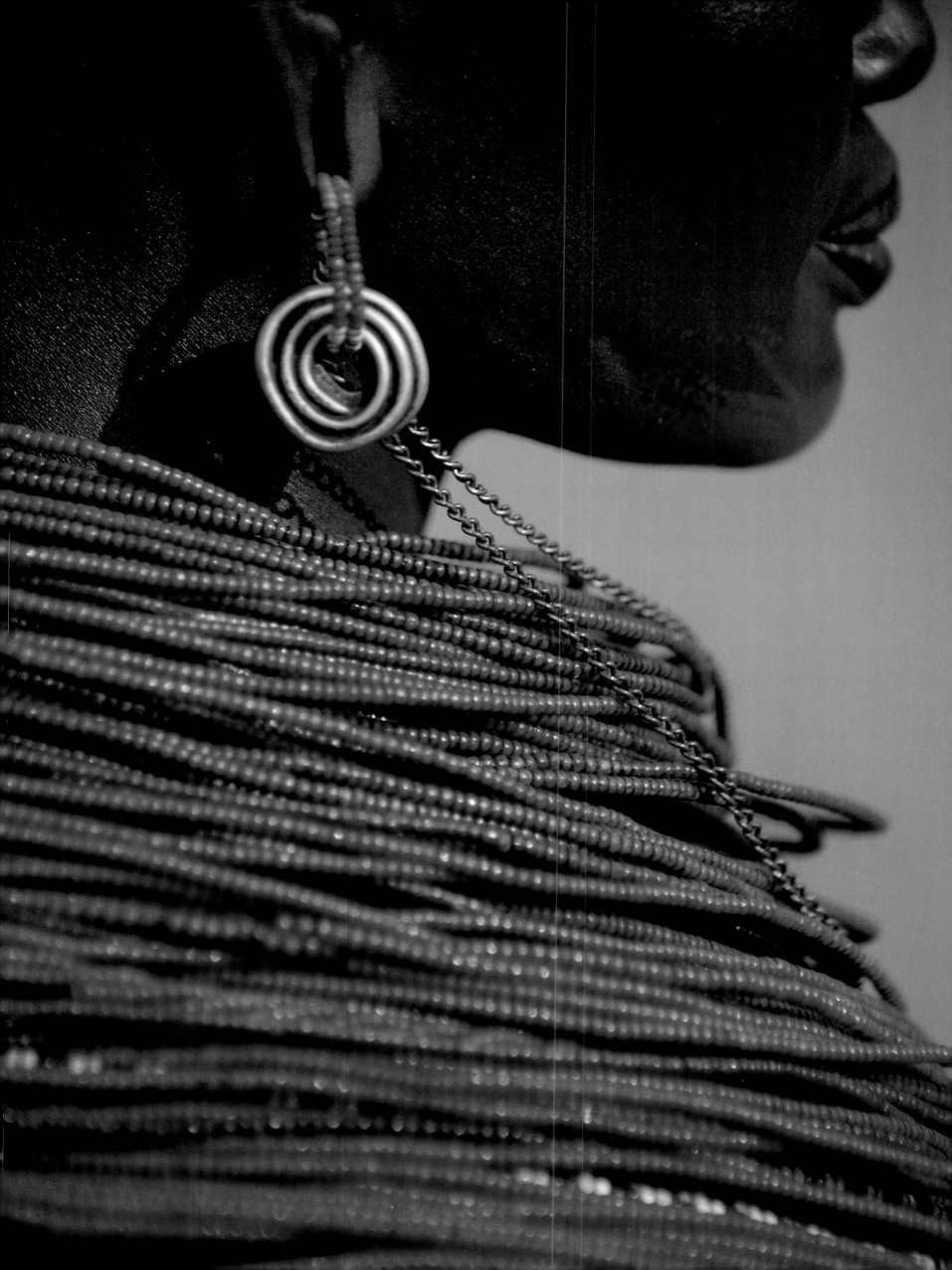

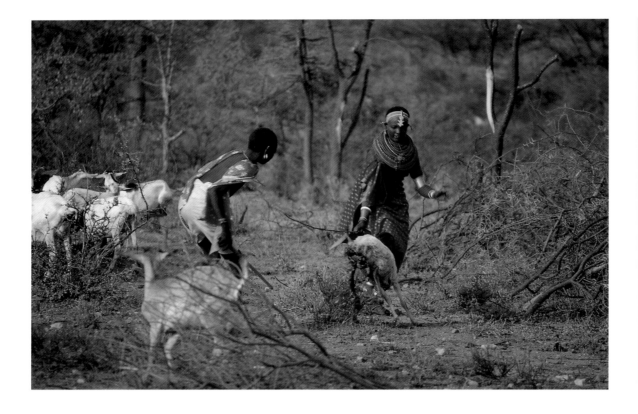

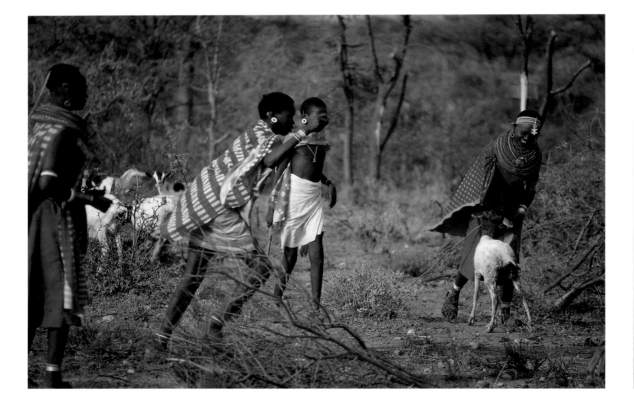

ABOVE AND RIGHT: The newly married girls begin to take up their roles within their husband's village. Aided by a young boy, an *nkaibartani* separates out the sick and the young animals before the main herds go out to graze.

When a new wife first arrives at her husband's village she will be given a cow by her mother-in-law, and various other animals by most of her husband's family. *Pa-tawo* is the name used to refer to those who give and receive a heiffer; *Pa-che* for those who give and receive a calf; *Pa-nkera* for those who give and receive a sheep; and *Pa-ki-ne* for those who give and receive a goat.

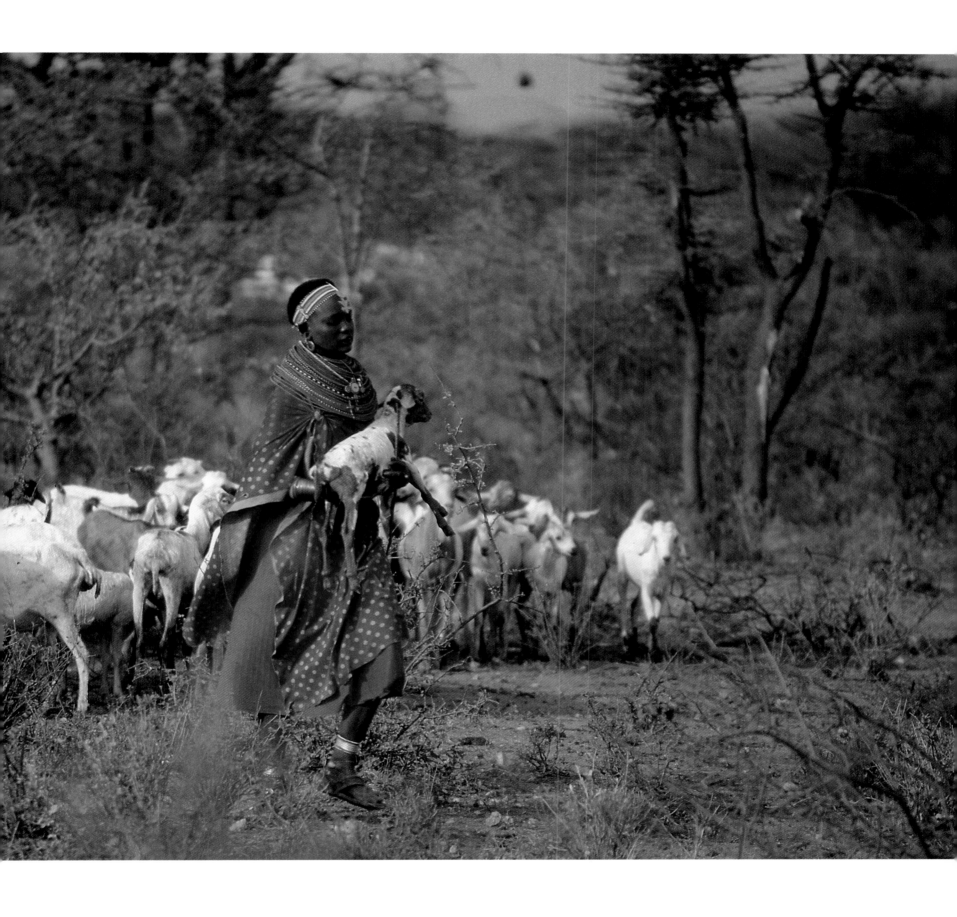

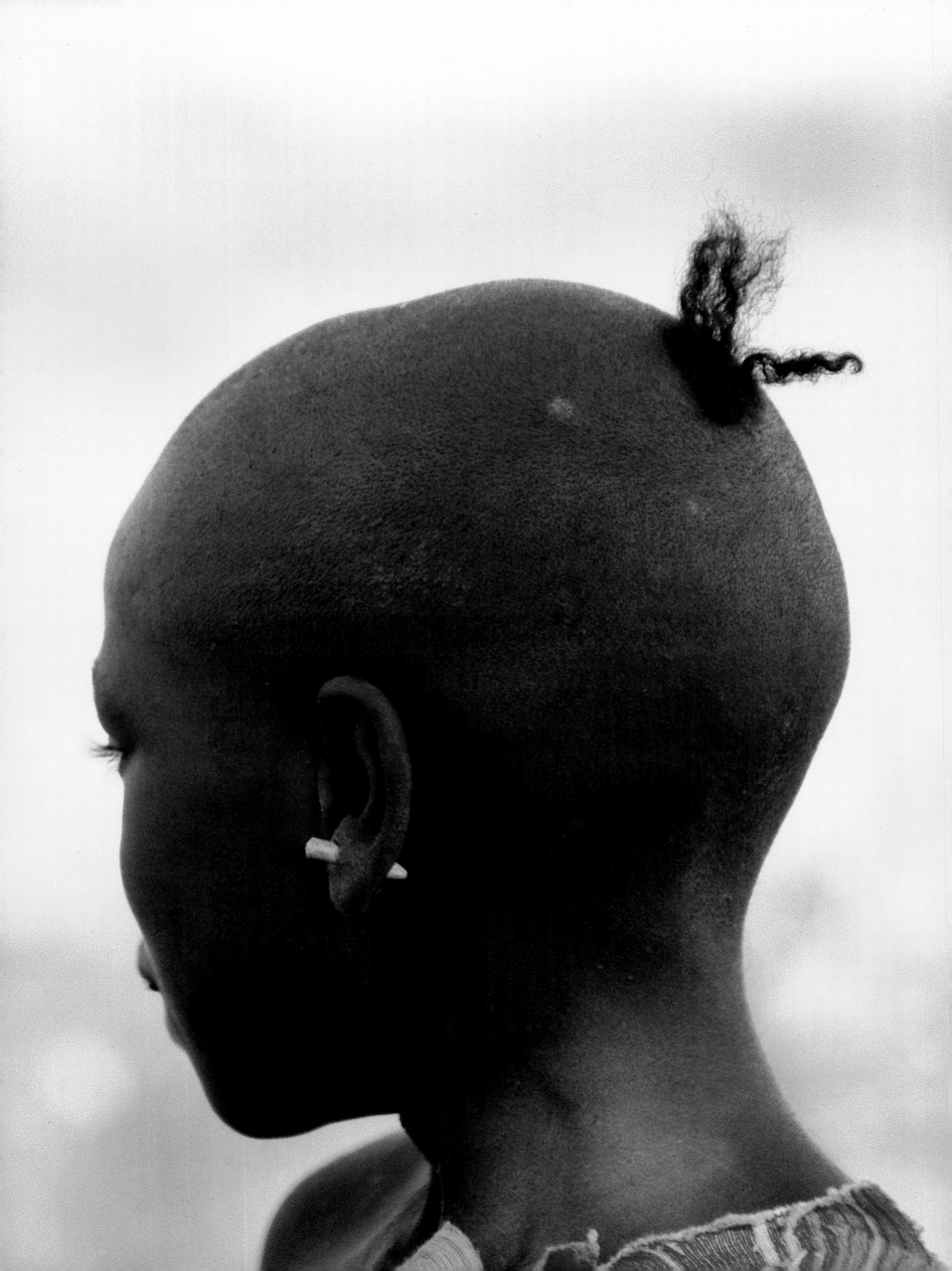

E·MURATARE

Circumcision Ceremonies

E-*muratare*, the days of circumcision, is the most important Samburu life-stage ceremony. Not only does it ensure the continuity of the age-set system and mark the time at which the new generation of *lmurran* begins to take the place of the previous *laji*, but it unites the whole Samburu people and re-establishes clan bonds and the hierarchy of elders.

The most senior elders name the time when the young boys are to be circumcised and, a year or more before the ceremony is due to take place, call a wider meeting of elders with representatives from each sub-clan. The elders gather together in the open to discuss and plan the ceremony. They pray to Ngai, chew *miraa* and eat the meat of the cattle and goats they bring with them. They confirm the order in which the clans are to be circumcised. It follows the hierarchical clan order, with the Lmasula preceding the Lpisikishu, which the Lpisikishu say is because their sons frequently died when they were circumcised first.

After this meeting, six or more firestick elders, representatives from the Lmasula, Lpisikishu and Nyaparai families, escort eight or so chosen boys to Mount Nyiru to collect moss and foliage from the trees near the summit. All mountains are revered by the Samburu, who believe that on the peaks Ngai is near, and the pilgrimage to Mount Nyiru symbolizes seeking and obtaining Ngai's blessing for their circumcision. Firestick elders are so named because they must use firesticks, rather than an ember, to create a new fire at specific times during the circumcision ceremonies. Their task is to guide the novices through their initiation. They are selected from the *laji* above the *laji* of *lmurran* because they will not have sons old enough to be circumcised, and therefore will treat the boys in their charge impartially.

The boys wear black capes made from sheepskin darkened with burnt cow dung mixed with sheep fat, and their heads are shaved except for a tuft of hair on the crown. Leather thongs are passed through the holes in their earlobes and joined behind their heads by two vulture or greater bustard quills, from which hang six long strands of thick blue beads with beetle wing-cases attached to the ends. These headdresses are called *nchipi*, and, like the capes, are made by the boys' mothers. The *laiyok* (sing. *laioni*, the name by which all the boys ready for circumcision are known) wear black as a sign that they are leaving their childhood and are ready to take their place as the new generation of warriors.

The group descends Mount Nyiru and returns to a ceremonial *nkang*, called a *lorora*, where many of the sub-clan elders are gathered. Within the *lorora* an inner enclosure is constructed, which the chief *laibon*, the elders and all the boys enter. The *laibon* calls the boys to come before him, but states that those who have slept with a circumcised woman or made a girl pregnant must not come forward. A curse of death is said to befall any boy who lies. The *laiyok* are not expected to be virgins, but they are expected to have associated only with young girls. To have slept with a circumcised woman is considered a serious breach of *nkanyit*.

The eldest son of the most senior elder approaches the *laibon* first and the others follow in hierarchical order. As each boy comes forward, the *laibon* smears his forehead with blessed white powder. The *laiyok* then force a white bull, given for this specific ceremony by the Nyaparai clan, to drink a brew of milk and honey. They lift the animal off the ground and suffocate it with a soft, well-oiled lambskin wrapped tightly round its nostrils. As the bull dies it is lain on its right side on a bed of grass with its head to the north, facing Mount Nyiru's summit, Gus Gusi.

The elders circle around the bull, raising their staffs in the air, sprinkling milk and asking

LEFT: The tuft of hair on the crown of this boy's otherwise shaved head signifies that he has not yet been circumcised, although his ears have been pierced and his two lower front teeth have been removed in preparation for warriorhood.

153

for Ngai's blessing. The bull's throat is slit along the dewlap and the blood is collected in the bowl of skin and may be drunk by any of the boys and men within the central enclosure. The *laiyok* skin the bull under the direction of the elders and every boy smeared with powder is given a strip of hide to wear around his calf or in his cloak. The moss and cedar sprigs, collected from Mount Nyiru, are placed on the roasting fires. This gives the meat, which is eaten by all present, a distinctive flavour. The sacrifice marks the beginning of the time of circumcision. Once the Lmasula clan has begun its initiations, all other clans will proceed to circumcise their boys within the next few months.

Meanwhile, all the other boys ready for circumcision begin to gather. Dressed in blackened capes, they move from one *nkang* to another, singing special songs called *lebarta,* a sad sort of warbling lament, which call the boys of the new group to be circumcised. At this stage the warriors usually accompany the novices, helping them and teaching them to sing. The boys approach an *nkang* from afar, singing as they move forward. Grouped close together they walk a short distance, then stand continuing their song, then move on a further short distance until they reach the entrance of the most senior elder's wife. The wife takes an *nkarau* of milk, pours a little into its lid and splashes it over the boys as a blessing and a sign of approval, signifying that they may enter the *nkang.*

The boys will sleep a night or two in the village before moving on to gather up more initiates. They are given milk to drink and goats are slaughtered for them to eat. At first there may only be six or seven boys, but slowly, over several months, the groups grow until they number perhaps a hundred boys or more.

When the time for circumcision is only a couple of months away, the initiates leave their villages between two rows of elders, who bless them as they set out on the journey to collect resin from a *silale* tree (comifera), one firestick elder from each sub-clan going with them as a guide. Once every boy has collected enough resin, the firestick elder makes a new fire with firesticks. Each boy heats his resin in the fire and moulds it into a large ball on the end of a stick. The resin will be used to tip the arrows the boys use during the month after their circumcision, known as the "month of birds", when they shoot the birds which they use to decorate their headdresses.

By this stage the fathers of all the initiates are gathering in specially constructed *lorora* with their wives and offspring and direct kinsmen. A *lorora* is built only for *e-muratare* and the following *ilmugit.* It is usually rather larger than a normal *nkang.* Some of the *lorora* contain many hundreds of people and others only about a hundred.

In the *lorora,* the houses of the mothers of the *laiyok* are rectangular rather than oval. These houses are placed in a large circle, similar to a normal *nkang,* with the house of the wife of the most senior elder on the eastern side, while the houses of those without an initiate are built nearer the centre. The huts' entrance walls are made of vertical sticks topped with compacted cow dung. The doorways are rectangular and open directly into the interior rather than via the usual tunnel entrance. The entrances face the nearest mountain, but never the rising or the setting sun.

Throughout the preparations for *e-muratare* and for the month following, a kudu horn, made from the long spiralled horn of a large antelope called a greater kudu, is blown by the firestick elder of the *lorora* to summon all the sub-clan's elders to meetings in a specially constructed inner enclosure. Here a fire is kept constantly burning with wood brought by the firestick elder. The meetings continue for hours, as the elders squat or sit on their *lorika* in a circle and discuss every aspect of the proceedings in detail.

The kudu horns are held in high regard. They are the property of the most senior elder within a clan and are always kept within his wife's hut. On ceremonial occasions the long curled horn appears from within the hidden depths of the senior elder's wife's house, to be cleaned

with milk and water and then covered with ochre by the elders. Kudu horns are blown only by the elders to summon special meetings such as those held at all *ilmugit* ceremonies, by the *laiyok* on the day they become warriors, and by the warriors themselves in times of danger.

The days for circumcision are dictated by the moon. The elders study the moon's cycle and number the days from the sighting of the new moon. They call the evening when the new moon appears the first evening, the following morning the first morning, the next evening the second evening and so on. As a general rule, during the time that the moon is waxing the days which can be divided by two or three are considered auspicious. After the twenty-first morning and until the moon is no longer seen any day may be used for circumcision as all boys within one *lorora* must be circumcised within one lunar month.*

The firestick elders spend hours lecturing the boys and preparing them for their time as *lmurran*. They are told to look after themselves and to build up their strength in the period leading up to circumcision. They are told not to sleep with girls and to conduct themselves well within society; and once again they are questioned as to whether they have slept with circumcised women or have fathered a child. If a boy has made a girl pregnant or has slept with a circumcised woman he has to pay a fine of a female calf to the one who will hold his back during circumcision, and a male calf to the one who holds his leg. Later, his father will not be blessed by the other elders and the boy will not be given cow's blood. Neither will he be allowed to eat with the other new warriors for the following month.

Once the month of circumcision has arrived, the *laiyok* sing the *lebarta* early every morning and evening. They slaughter cattle in a nearby *lbaan* and feast during the early days of the month. While the boys are wearing black it is considered unlucky not to give them food and everyone will readily slaughter stock for them. They eat large quantities of meat, sometimes several cattle at one sitting. On about the sixth or seventh day they return to the *lorora* and enter by the entrance of the most senior elder's wife. They stand in the middle of the *lorora*, singing, then pass through two rows of elders, who bless the boys as they run off to collect sticks of *siteti* for the bows and arrows they will use after circumcision.

The next day all the boys again pass between two rows of elders, who bless them as this time they run off to collect grass for their circumcision beds. Meanwhile their mothers collect wood to make the frames for their sons' beds. The elders bless with sprinkled milk the cowhides, pangas and *nkarau*, which will be used during circumcision.

Later the same day, or perhaps the next, depending on the favourable lunar days, the boys who will be circumcised first go off to wash in flowing water, each blood washing together. Every boy carries a staff and a gourd with him which he fills with water and brings back to the *lorora*. Each sub-clan's customs vary; for instance, some boys place four small river pebbles in their *nkarau*, and in others they tuck fresh green river grasses into the shoulder knots of their black capes as a sign for all to see that they are clean. While the boys are washing, a lamb is slaughtered. The skin from the nose is removed and made into a ring, which an elder puts on the boy's right middle finger when he returns from washing. The skin of the lamb is folded and left with the stomach on top of the house.

If the boys are to be circumcised early in the morning, the sandals worn by the initiates are made the night before, and just prior to circumcision if they are circumcised in the

* Each sub-clan within a *lorora* favours different times of day for circumcision, either early in the morning, around 6 a.m., or in the afternoon, around 4 p.m. Also, those with different blood are circumcised on different days. Therefore in any *lorora* those with Turkana blood are circumcised first, then those with Ndorobo blood, then those of pure Samburu blood. (For these purposes the Rendille are considered as Samburu.) After one blood has been circumcised, a night must pass before another blood is circumcised. Thus boys with Turkana blood will wash and prepare themselves and if their sub-clan's circumcision time is in the evening they are circumcised when they return from washing. If there are more Turkana boys whose sub-clans' time is in the morning or when the cattle return (around 4 p.m.) they will be circumcised the following day. A night must then pass before those with Ndorobo blood go to wash and can be circumcised and so forth.

afternoon. The boy's father and the two men who hold the boy during the circumcision make the sandals, using the hide of a cow which belonged to the father. They use a ceremonial knife shaped like a spearhead and set in a stout handle. The men cut soles for the sandals and measure the boy's feet. They attach thin strips for thongs and dexterously tie and knot them into sandals. When making the sandals, they retrieve all the waste leather and burn it on the fire within their hut, for fear that the scraps could be used to put a curse on the boy.

While their fathers are making the sandals, the boys remove their blue beads and give them to their mothers to wear until the ceremonies are complete, at which time the women will incorporate them back into their own beads. The mothers wet their sons' hair with a little milk and completely shave their heads. All the hair is collected, just as the scraps of sandal leather were, and hidden by the mothers. Once the boys have been shaved they are said to have cut the hair of boyhood; their heads will be shaved again at the end of the "month of birds", leaving them free to grow the hair of a warrior.

Every clan and sub-clan has slightly different customs. For instance, all the sub-clans whose time for circumcision is in the afternoon can only begin their ceremonies once the cattle have returned from grazing. In some sub-clans the herdsmen stampede the returning cattle through the *lorora*, whereupon the *laiyok* run among the cattle and the men who are to hold them chase after them. As one mother said to me: "The *lorora* gets hot!" There are excited shouts as the boys run after the cattle and the men run after the boys. Dust is kicked up and swirls in the air and there is general pandemonium. Once caught, they are led to stand in front of their mothers' houses. The atmosphere is now highly charged and the boys sing through their tears of emotion, their bodies quivering.

As the circumcision begins, the boys awaiting their turn sing to keep their spirits up. They stand outside their mothers' house, chant their songs and prepare themselves not to flinch or cry out while they are being cut. Each boy is then led without objection to stand directly in front of the doorway of his mother's hut on the cowhide from which his sandals have been cut. The men remove the boy's cape and splash his face with the milk and water from his *nkarau* in another action symbolizing the boy's purity. The milk comes from the mother's morning milking, when the boys, just like the girls before their circumcision, crouched in the shelter of their mothers' cloaks; the water comes from the river where they washed earlier.

The initiates fall into a trancelike state and drop into a sitting position with their legs outstretched before them. Their sandals are removed. Their eyes glaze over, at times becoming almost creamy white. One elder holds one leg, another the other and a third holds the boy's back and head. No woman ever holds a boy during circumcision. The one who holds his back pays the circumcisor and also pays for the ceremonial knife used to make the sandals, and at the end of the month will give the boy a cloth and a spear or a *lalema*. The one who holds the boy's right leg will give him shoes. The bond between the initiate and these two men is now complete and they become as fathers to the boy.

The circumcisor (*lakitoni*) is an elder chosen by the council of elders. He uses a small, sharp knife, which he rinses with the water from each boy's *nkarau* before each operation. As the circumcision is about to begin, all the women retreat inside their huts, and the men quickly crowd round, jostling each other to see that the operation is performed correctly and, most important of all, to see whether or not the boy flinches. The fathers of the *laiyok* stand nearby, concerned and often quivering, anxious that their sons should not show any pain. The boys' older male relatives secretly fear that the new generation may disgrace them, though they try not to reveal their misgivings.

Many of the elders have shaking fits (*ndokuna*) and some throw off their loosely wrapped cloths and leap into the thorn stockades. Most of the warriors, who are brothers or cousins to the initiates experience *ndokuna*, and many of the boys go into semi-fits. Sometimes it seems as

if every man is either having a fit or holding another who is having a fit. Many of the women, before they retreat into their huts, openly cry and wail as the moment for their sons to be circumcised approaches; only rarely do any of the women throw a fit.

Once the circumcision is over the boys break into song. The two who held the boy replace his sandals and cape and carry him inside the hut where his mother waits. The cowhide is also taken inside the hut and placed on the boy's raised bed where he will sleep every night for the following month, after which it is dismantled and burnt. No one else must lie or sit on the bed.

After circumcision, the boys can often be heard breaking into a fit, which with the younger ones sometimes sounds more like a sob. The boys try to make themselves comfortable on their beds, lying on their backs with their legs wide apart and their feet resting on the hut wall above them. The man who held the boy's back supervises the taking of blood from a cow, which he mixes with yoghurt and fresh milk, then gives it to the boy to drink.

After the ceremony the father is blessed by the elders, who smear butter fat on the crown of his head and his temples. He wears lionskin thongs around his calves, the green beads his son wore before circumcision around his head, special coiled earrings, and he carries an *nkela* and a herding stick with him for three days. Also at this time the eldest son of a deceased man, who is an older brother of an initiate, is blessed and officially enters the council of elders.

A few hours after the boy has been circumcised and while he is still within his mother's hut, the women erect two long branches on either side of the door as a sign that a son of that house has been circumcised. Again, there are differences in each sub-clan's practices. Some put long herding sticks either side of the doorway instead of tall sticks, others place thin small sticks. They sing a short joyful song and dance, proud and happy that their sons have been circumcised. Once the "month of birds" is over and their sons have become *lmurran*, the mothers take down the branches, cut them into small pieces and burn them together with the circumcision bed.

The morning after a boy's circumcision, the men who held the boy make a bow, and eight arrows out of the sticks the boy collected before his circumcision. The bowstring is made from a cord of sinew from a cow's back and the arrows are tipped with the gum also collected previously; the remaining gum is wrapped around a stout stick, which the boys carry like a *rungu*. Four spare arrows remain in their mother's house.

The *laibartok*, as circumcised boys who are not yet warriors are known, now only wear their black leather capes, raw-hide sandals, and the curled brass ceremonial earrings. They rest for a day and then, using their bows and blunt arrows, they start to shoot small birds for their ceremonial headdresses. At first they walk rather gingerly, holding their capes in front of them, then, as they heal, great fun is had leaping around and stalking the birds which hide in the bushes. The initiates also shoot their arrows at young girls. It becomes a game; the girls run and hide from the boys, and if a boy manages to hit a girl she will have to give him a cowrie shell, which he ties around his waist.

The women weave bands of doum palm twine, sometimes decorated with cowrie shells, which the men tie around the boys' heads to form the basis of the ceremonial headdresses; two ostrich feathers are then inserted into the headband on either side above the ears. The birds the boys shoot are gutted and their capes are attached by the beak to the headband, and hung at the nape of the boy's neck. A maximum of twenty birds may be hung from two headbands, but usually about ten are hung from a single band. Strings of thick green-and-white beads are also attached to the back of the headband.

During the "month of birds" the *laibartok* are forbidden to cross water. Nor must they hold or touch metal, for instance a spear or a knife, during this time. They do not drink water for about fourteen days after circumcision; only milk and blood, as this reduces their need to urinate. One or two weeks into the month the *laibartok* slaughter sheep with much rump fat

and drink the liquid fat, which is said to give them strength. The initiates must never wander too far from their *lorora* and be within its stockade by nightfall.

Approximately one month after circumcision, at a time dictated by the lunar cycle, the first *ilmugit** of the initiates' *lmurrano* is performed at the circumcision *lorora*. The *ilmugit loungwen* (feast of birds) marks the completion of the passage from boyhood to *lmurrano*. It is so named because on the morning of the feast day the *laibartok* wake and leave their bird head-dresses within their huts. Their mothers then wear them and give some of the birds to the other married women of their close family.

For each circumcised boy a cow or a big male goat, depending on the state of the *nkang*'s herds, is slaughtered. The animal is led by the initiate from the livestock stockade to the *ilmugit* site. The animals are tethered in a line with the eldest son of the most senior elder at the east end of the line. The boys carry hot embers, the ceremonial knife and a panga from their mother's house to the site. Then they each collect firewood and make a small fire with the embers close to their tethered animal. Next to this they make a pile of brush wood, on which the meat will be placed. It is a happy occasion and there is a light air of festivity, and even relief, that the initiation is nearly complete and that all has gone smoothly. If the *lorora* is large then the slaughtering and feasting may take place over a number of days.

The animals are slaughtered by two male friends of the boy, but not those that held him. The men hold the animal down and slaughter it with the ceremonial knife. They slit the dewlap lengthways and then puncture the jugular vein. The warriors and the elders kneel down and drink the blood as it collects in the bowl of skin. The animal is skinned by the men, not the *laibartok*, who merely observe. When they have finished, the men cut two strips of hide from the belly, which the boys tie around their right calves. The meat is divided according to the usual custom, except that the elder who held the boy's right leg receives the right leg joint of the animal, and the elder who held the boy's back receives the back.

The firestick elder of the sub-clan then makes a new fire some distance away from the slaughter site using two firesticks rubbed together. He places the first stick (*ndane*) flat on the ground; he then rubs the second stick (*lpiron*) rapidly between his hands so that its point causes friction against the bottom stick, generating heat that ignites the tinder. Only a fire made in this manner is used to cook the initiates' meat. The initiates collect firewood and make a frame of wood to cover the coals on which they roast their meat. The ceremonial kudu horn, previously used by the elders to call their meetings is now blown almost continually by the initiates throughout the time of feasting.

Once the men have taken their share of the meat to the feasting site the women come from the *lorora* and collect their portion. They wear their marriage necklaces and sort the meat, discarding the undigested contents from the stomach and intestines. On the original fire made by the *laibartok* the women cook the liver and kidneys which they eat immediately. The mothers of the initiates pack some of their meat into a leather bag (*sampurr*), which they wrap in a hide with the rest of their share, and carry it back to the *lorora* on their backs.

* ILMUGIT CEREMONIES

E-muratare	days of circumcision	*Ilmugit lo-laingwani* (*laingwani* = bull)	hair below the shoulders (same *lorora* a month later) older warriors may marry and become junior elders
Ilmugit loungwen (*n-gwen* = bird)	of the birds (one lunar month later) become *lmurran*	[Circumcision of the next *laji*]	
Ilmugit lowatanta	of the roasting sticks (same *lorora* a month later)	*Ilmugit ade-lemowo* (*mo-wo* = animal horn)	of the kudu horn (junior elders become firestick elders)
Ilmugit lnkarna (*nkarna* = name)	of the name (recognized as fully fledged warriors; elders name the *laji*)	*Ilmugit lesekeya* (smell of meat)	held at any time; *lorora not required;* designed to raise morale (e.g. if a number of warriors have died)

If a boy has made a girl pregnant then the mother of the girl carries the meat back to the village, not the boy's mother. If a boy has slept with a circumcised woman it is considered an even greater disgrace. Not only will no one hold his back while he is being circumcised, but the woman carries the meat back to the *lorora*, where most will not deign to eat the boy's meat for he has betrayed the social codes of the Samburu.

The initiates and the men remain eating their meat until about midday when each *laibartani* returns to his mother's house with two companions. They carry a piece of cooked meat on the ceremonial knife. They go inside, drink water and handing the meat to his mother, the son says: "This is in return for all the food you have given me." From this moment onward the initiates will not eat within an *nkang*, in front of women or elders, or without another *laji* member being present, until they themselves become elders a decade or so later.

Later that day the initiates' heads are shaved by their mothers and they forsake their capes of blackened skin for new white cloths to symbolize their pure status. For the first time they smear ochre on their heads and over their bodies and are permitted to decorate themselves with the adornments of a warrior. The previous warriors give their younger brothers and relatives pieces of beaded jewellery, and the initiates' mothers and sisters also give the new warriors jewellery.

The boys now place the thong from their calf on an *nkarau* made by their mothers. Every warrior has such an *nkarau*, which his mother will always keep full so that there is milk for him to drink whenever he visits the *nkang*. Milk and water are all that *lmurran* are permitted to consume in the presence of their families.

Once all the initiates who have slaughtered an animal that morning are wearing their warrior clothing and jewellery, they sit on their father's stools at the entrance to their mother's huts and fire their gummed arrows into the air. Once again the son of the most senior elder fires his arrows first and the rest of the new warriors follow in order. The young children gleefully scramble to retrieve the arrows which they play with for a time. All the new warriors will now sleep in the open near the feasting site until the end of the *ilmugit*.

In the afternoon of the last day of slaughtering, when all the boys have fired off their arrows, the dancing begins. At first, the previous *laji* of warriors starts to dance, then the new warriors begin to dance in their own group and to one side. The women dance with the former *laji* and the girls dance with the new warriors. To mark the end of the *ilmugit*, early in the morning the initiates move in a singing group towards the *nkang*. Now in their white cloths and with shaved, ochre-reddened heads, they blow the kudu horn and enter the *lorora* for the first time as *lmurran*.

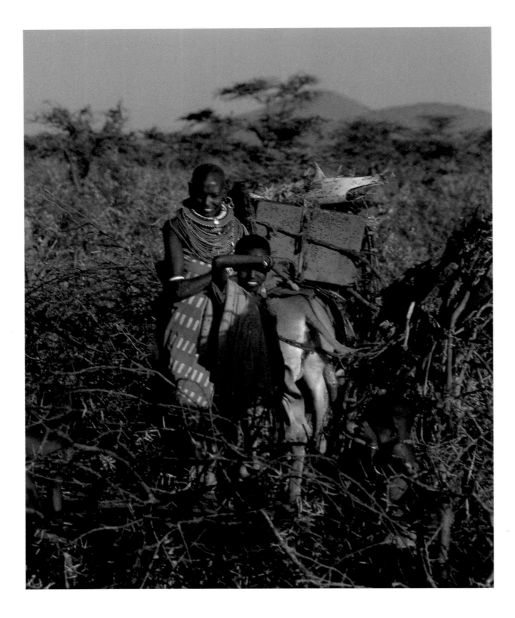

LEFT AND BELOW: Prior to the circumcision *ilmugit* (feasts) each clan and sub-clan gathers in specially constructed villages called *lorora*. The women pack their possessions on donkeys and move to the *lorora* site under the supervision of the firestick elder.

Ilmugit bring all the members of a clan together. They serve to maintain clan ties and to reassert the elders' hierarchical order, allowing the elders to supervise the progress of the whole community.

RIGHT: A firestick elder, chewing a long *nkike*, used by the Samburu as a toothbrush.

OVERLEAF: Early morning in a *lorora*, before the cattle have been taken out to graze.

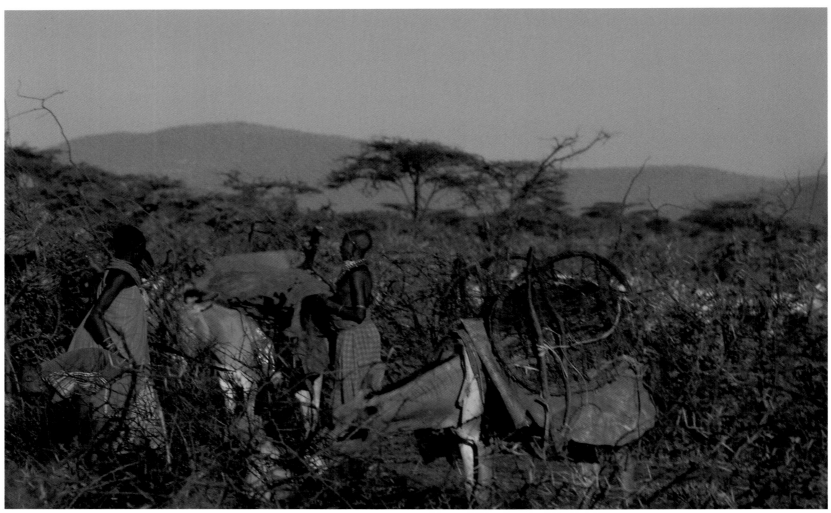

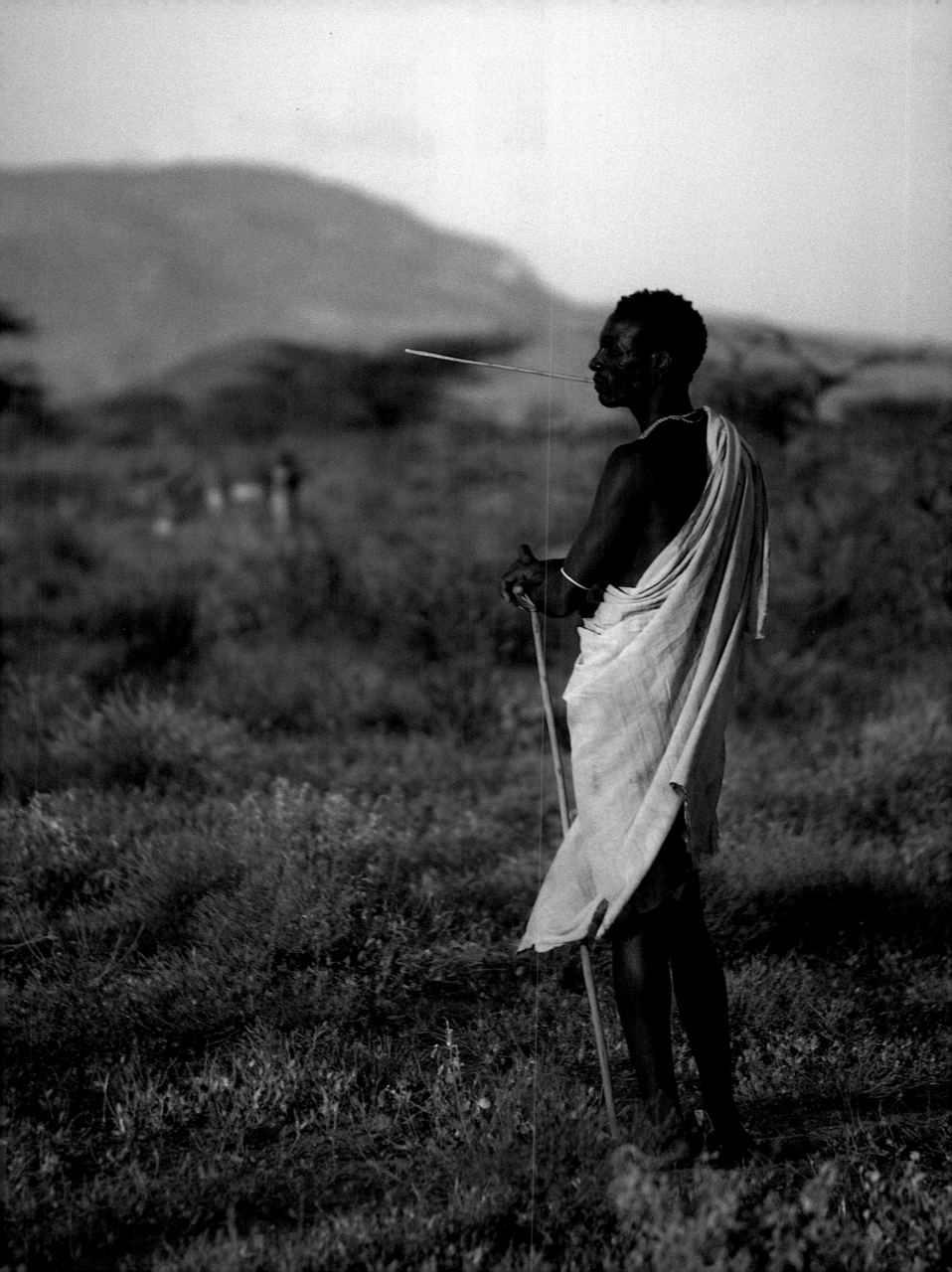

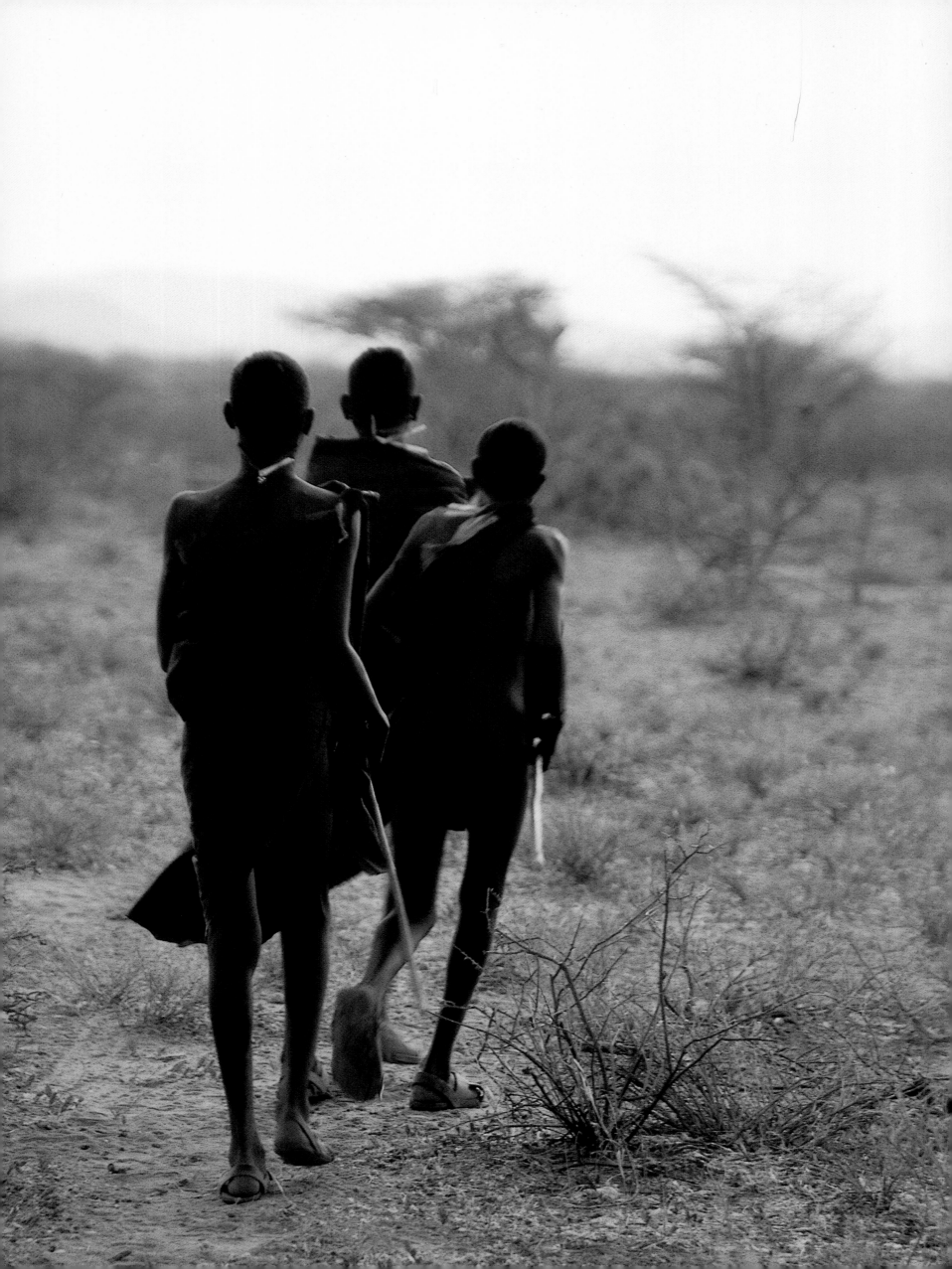

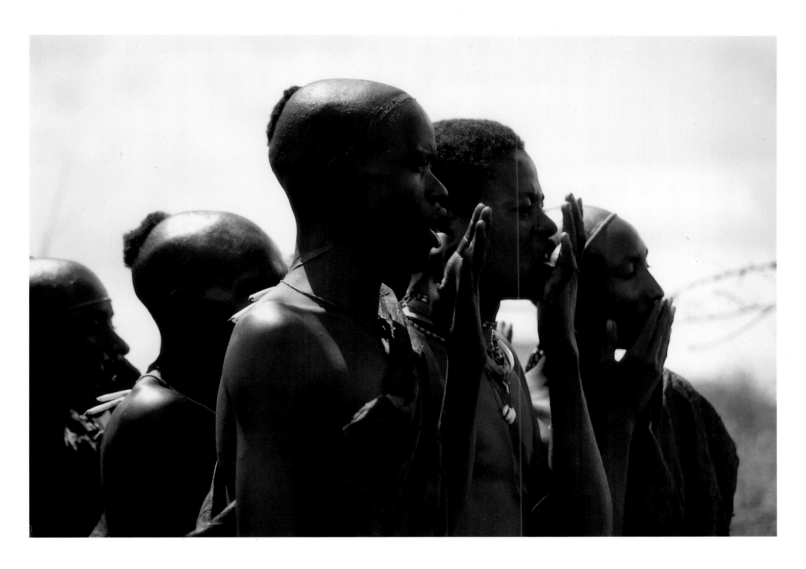

LEFT AND ABOVE: The boys approaching circumcision begin to gather together, wearing capes of sheepskin blackened with cow dung mixed with sheep fat. They walk from village to village in an ever increasing group, warbling the haunting songs of the *lebarta* to announce their arrival and to call their contemporaries to join them.

BELOW: Two long, spiralled horns (from a large antelope called a greater kudu), covered with dust, and stored in the roof of the most senior elder's wife's hut. As the time of circumcision approaches, these kudu horns are cleaned with milk and smeared with ochre by the firestick elder, who will blow them to summon the *lorora* elders to meetings throughout the circumcision ceremonies.

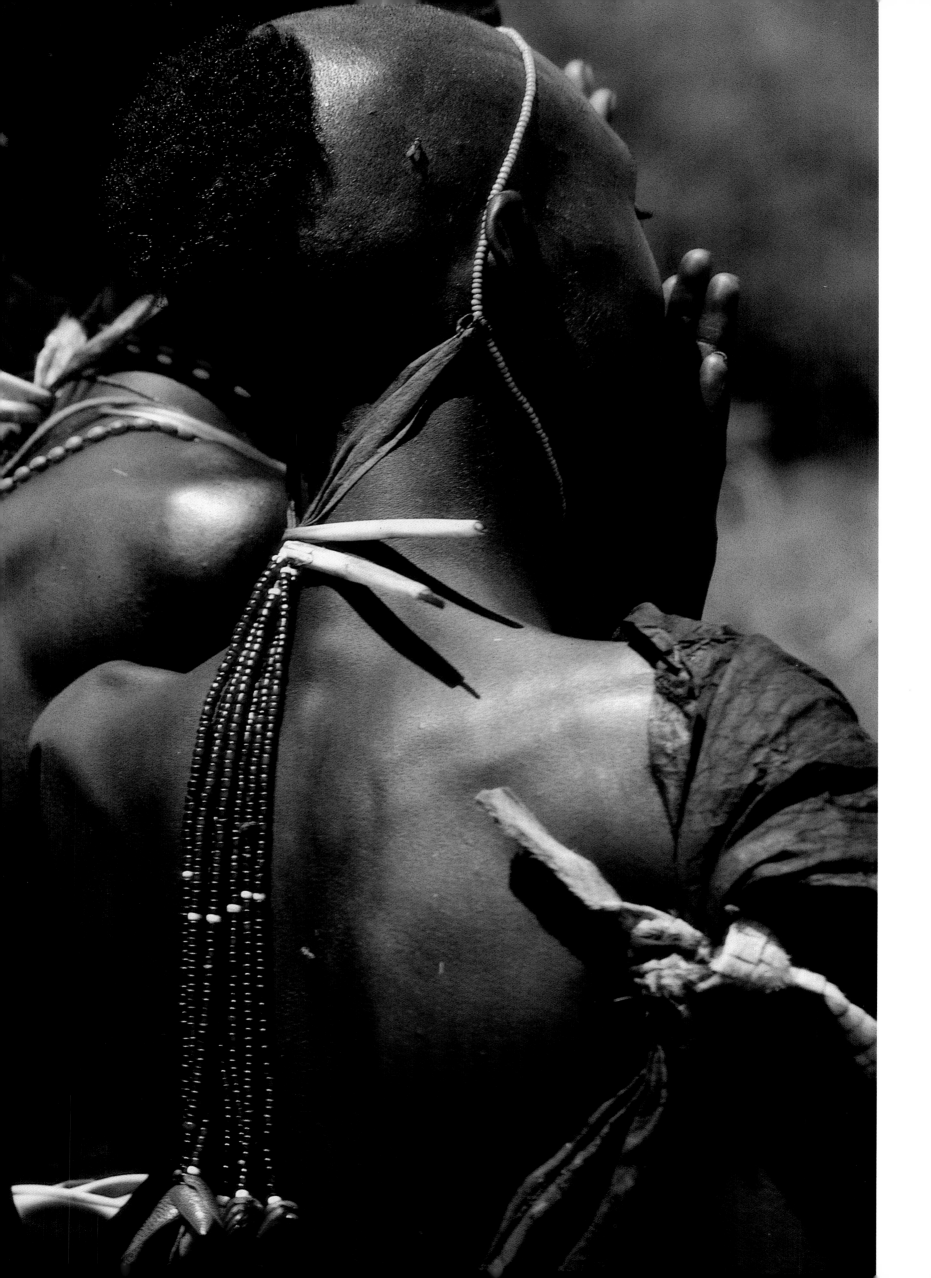

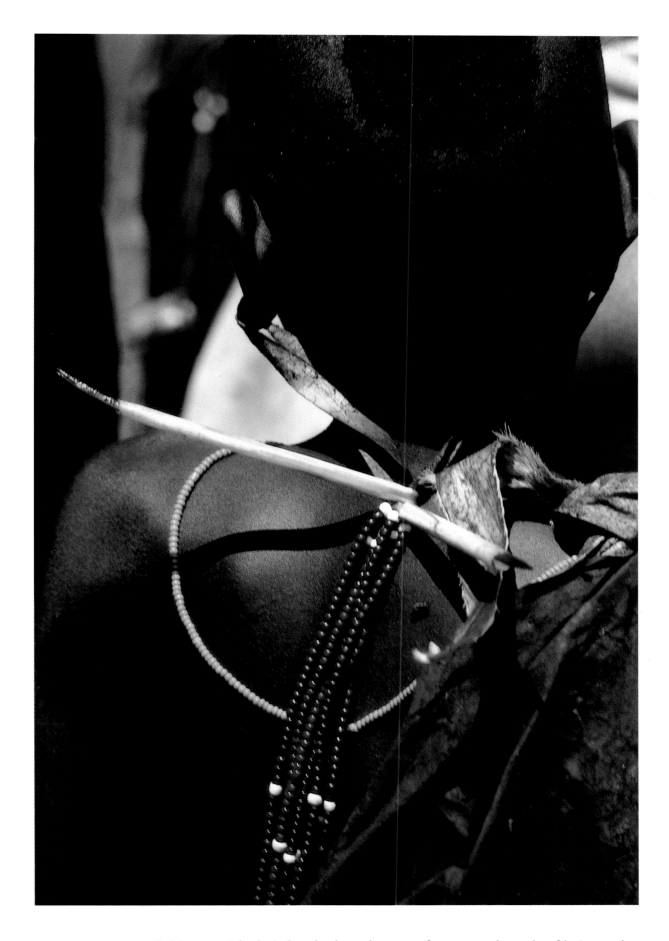

LEFT AND ABOVE: Initiates, with their heads shaved except for a round patch of hair on the crown. Leather thongs are passed through the holes in their earlobes or attached to the green beads of boyhood and joined at the back of their heads by two vulture or greater bustard quills, from which hang six or eight long strands of thick blue beads trimmed with beetle wing-cases.

OVERLEAF: The boys are happy to be leaving boyhood behind and eagerly await their initiation and the time when they will become the new *laji* of warriors. Several generations ago the Samburu did not circumcise their sons until they had started to grow facial hair, but nowadays all boys between the ages of about nine and twenty years old are circumcised. The double cowrie-shell necklace worn by the boy on the left signifies that he is a twin. Twins (*ilmau*) are considered very special, and the mothers of twins are revered.

167

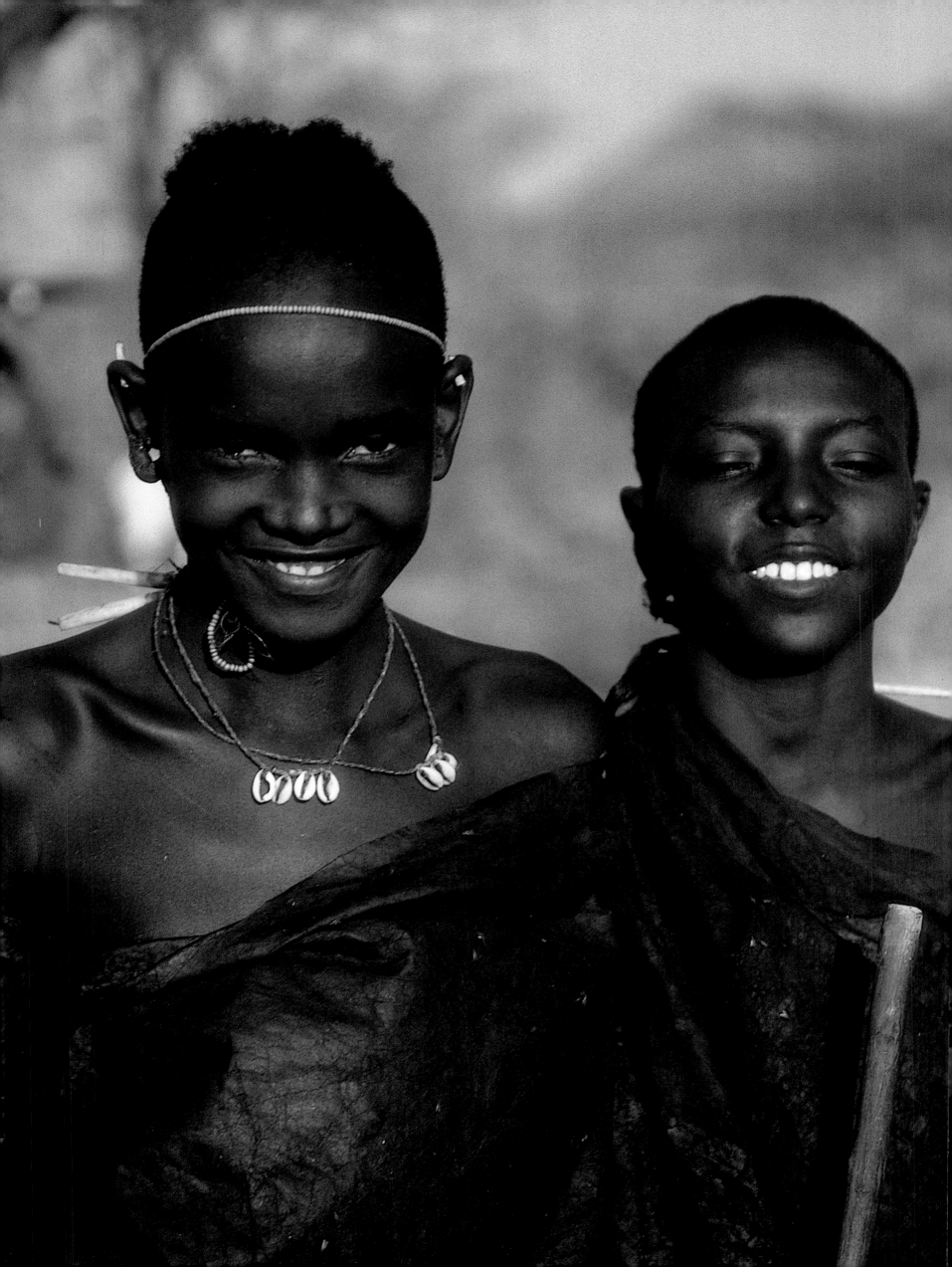

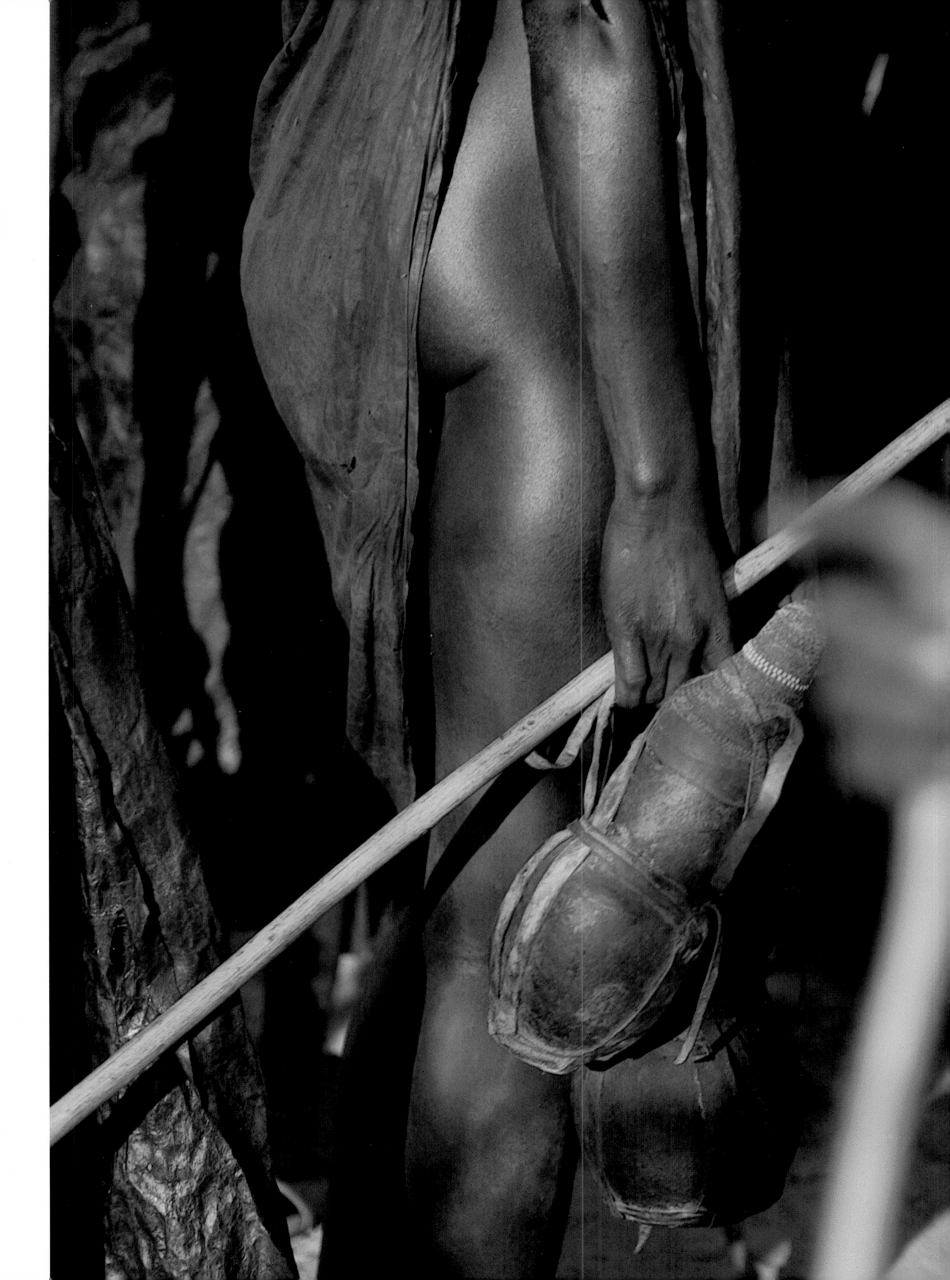

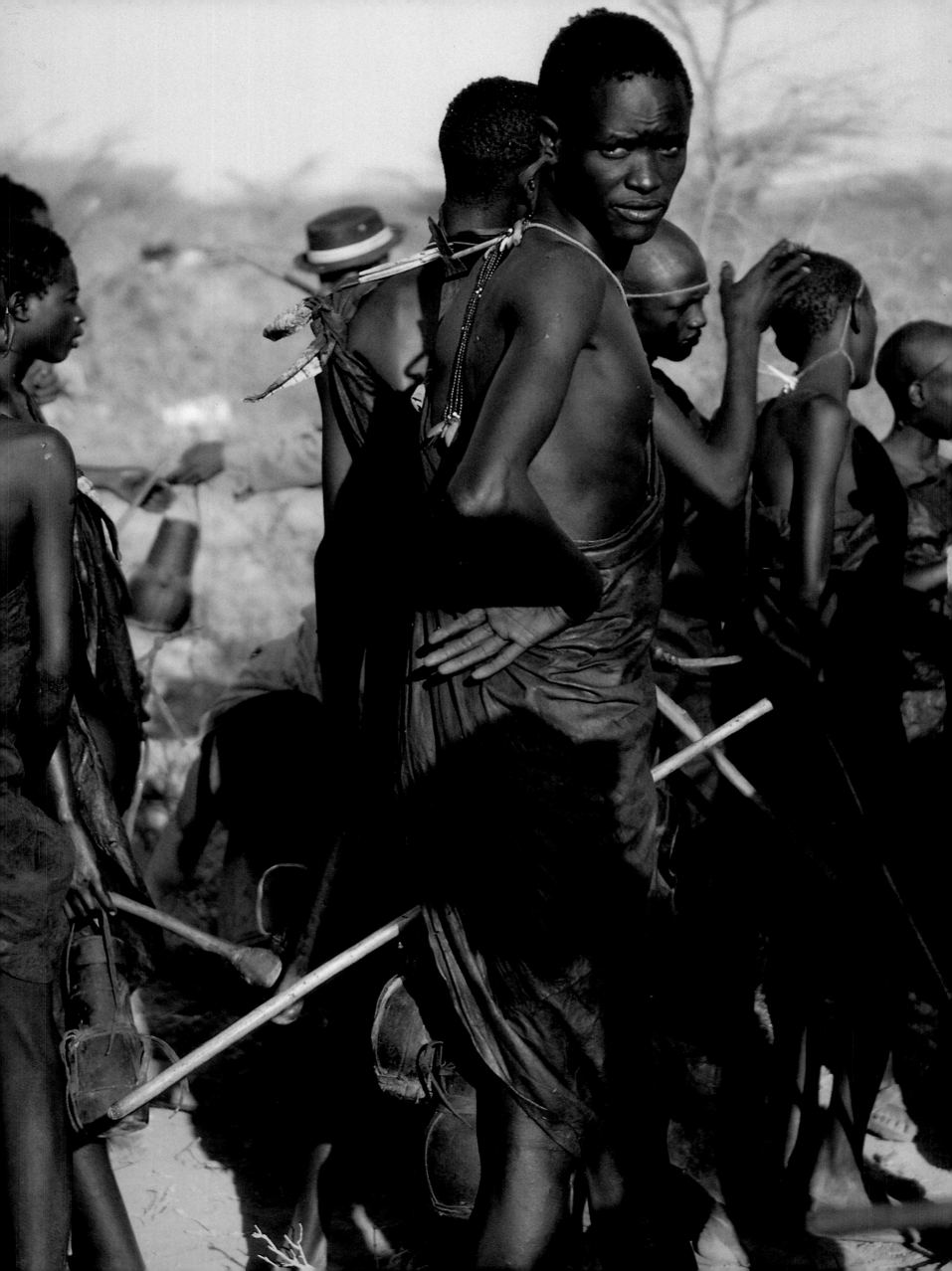

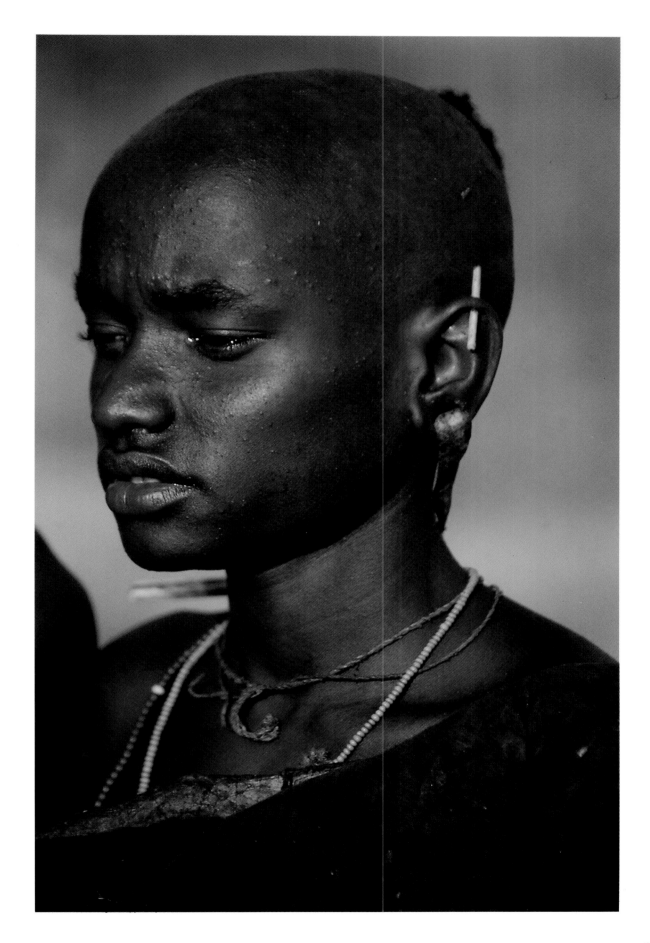

PRECEDING PAGE, LEFT AND ABOVE: Carrying the staffs of their fathers and the *nkarau* of their mothers, the boys congregate before leaving the villages to wash in flowing water in preparation for their circumcision. The *nkarau* contain a little milk, which the boys will cast into the river as a blessing. Then they will rinse out the *nkarau* and use them to bring back fresh water, which later will be used in a ritual washing immediately before circumcision.

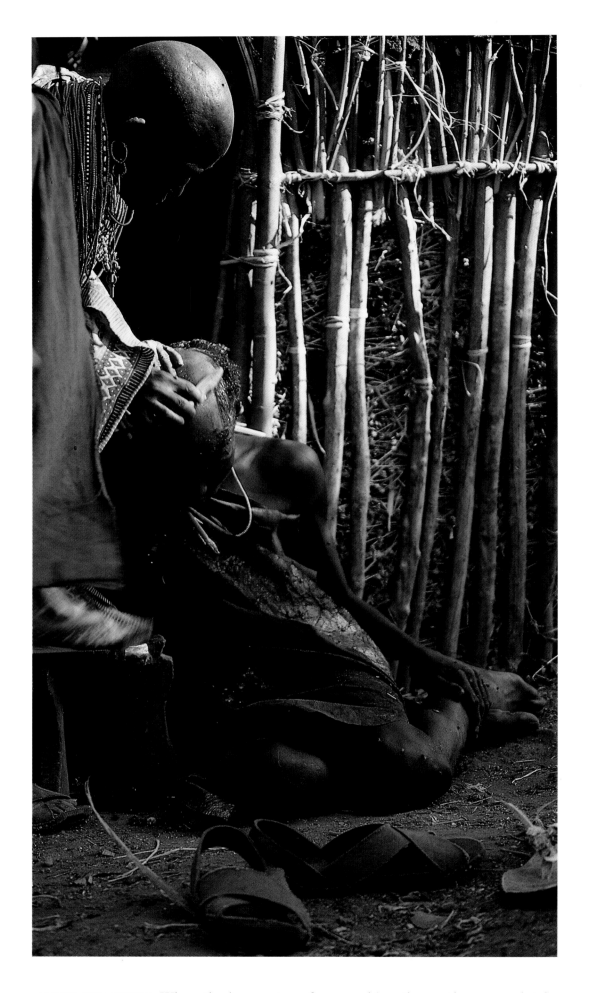

ABOVE AND RIGHT: When the boys return from washing the mothers completely shave their sons' heads. The boys wear green grass in their blackened capes as a sign that they have washed and are ready for circumcision.

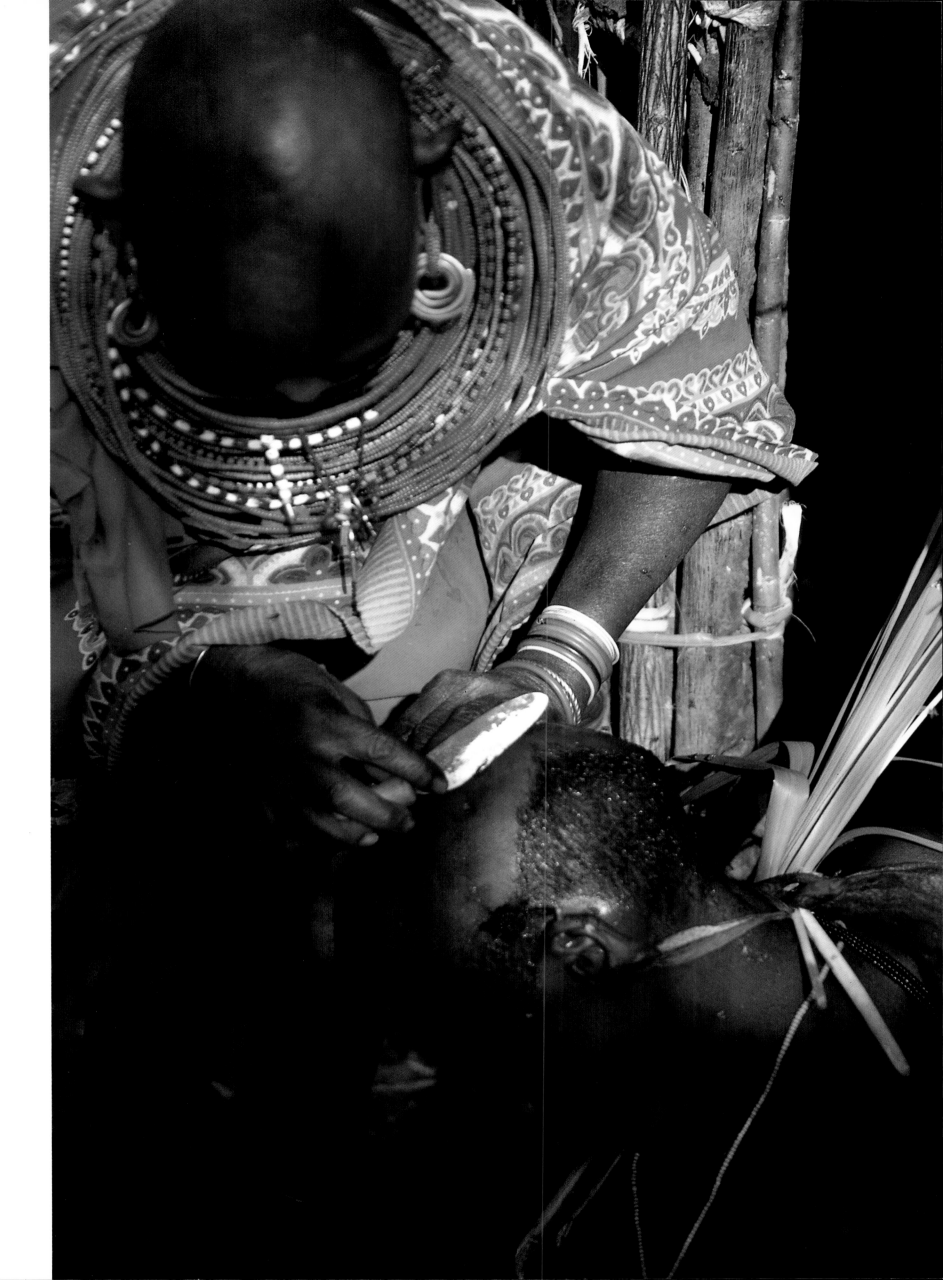

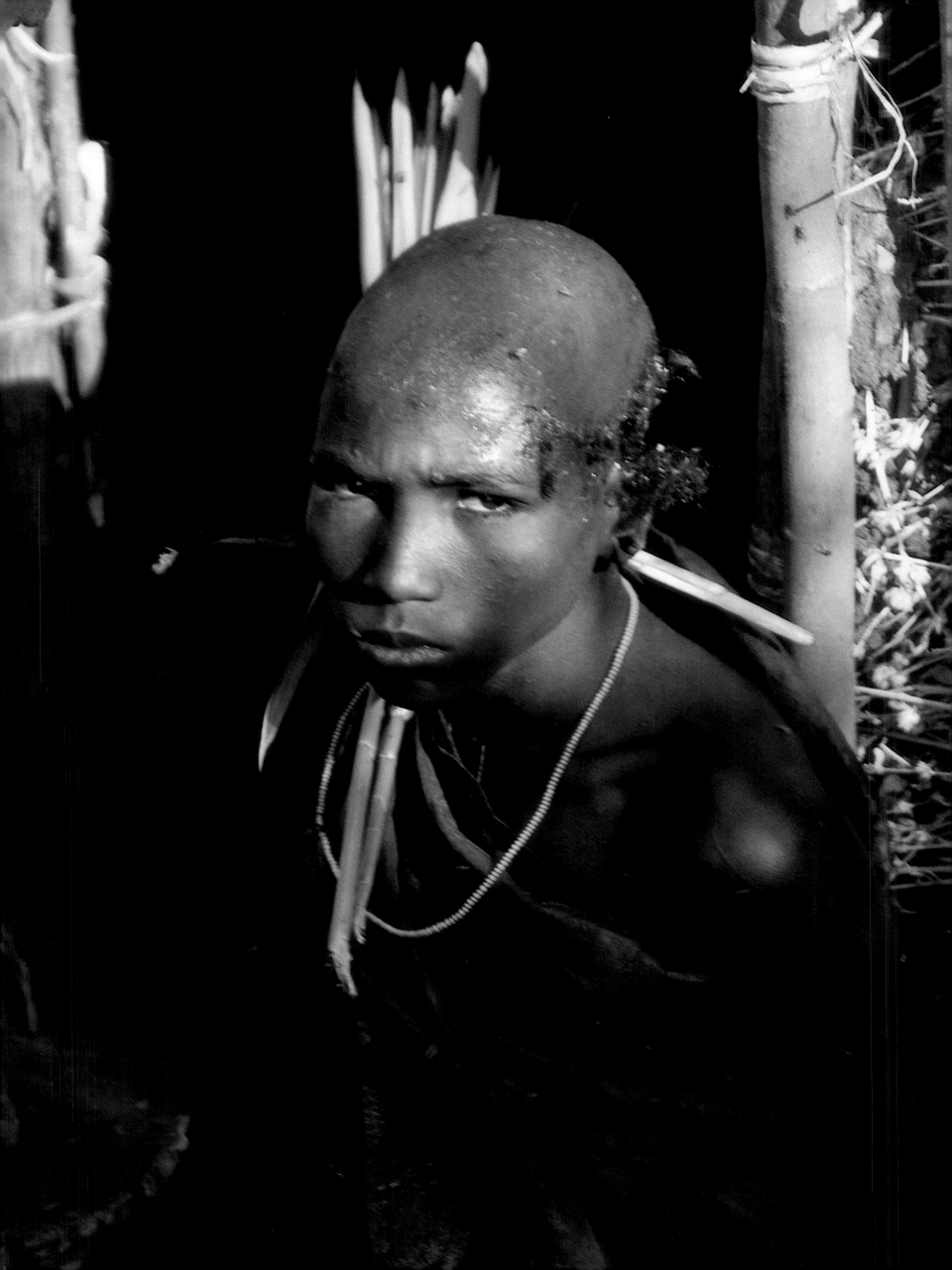

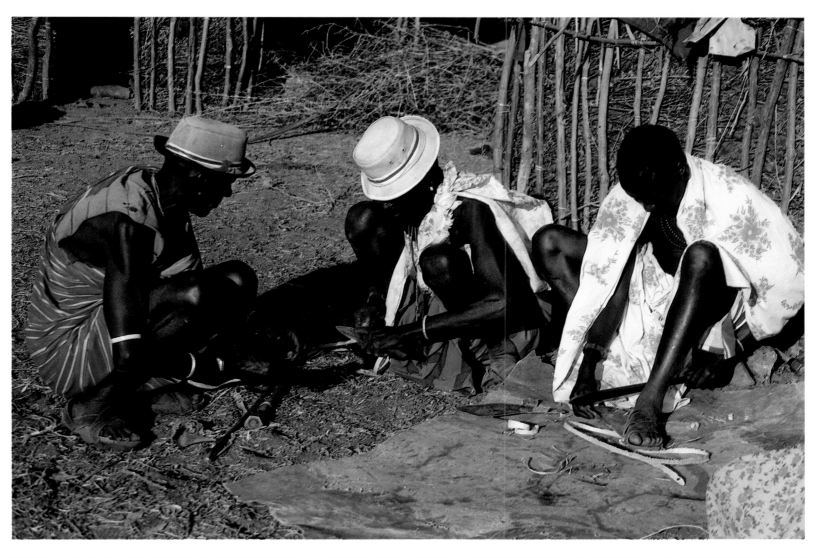

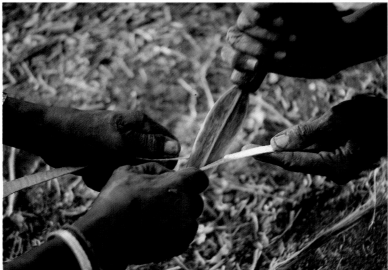

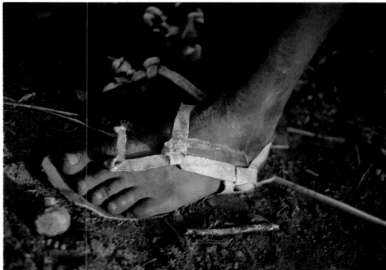

LEFT: An initiate at the entrance of his mother's house with his hair half shaved.

ABOVE: The fathers of the initiates and the two men who will hold the boys during their circumcision make ceremonial sandals out of cowhide for the boys to wear for the duration of the ceremonies. They cut the hide with a ceremonial knife made especially for *e-muratare*, which is given to the mothers once the boys become warriors.

175

ABOVE: At first light the boys stand outside their mothers' huts and sing as they await their turn to be circumcised. It is considered a great disgrace for a boy to flinch or cry out during his circumcision; if any boy so shames his family his mother will have to enter her hut backwards and his father's cattle will be driven from the *nkang*. This has not happened within living memory.

RIGHT: Moments before his circumcision, a tear of emotion, not pain or fear, rolls down an initiate's cheek as he stands and sings with his head freshly shaved.

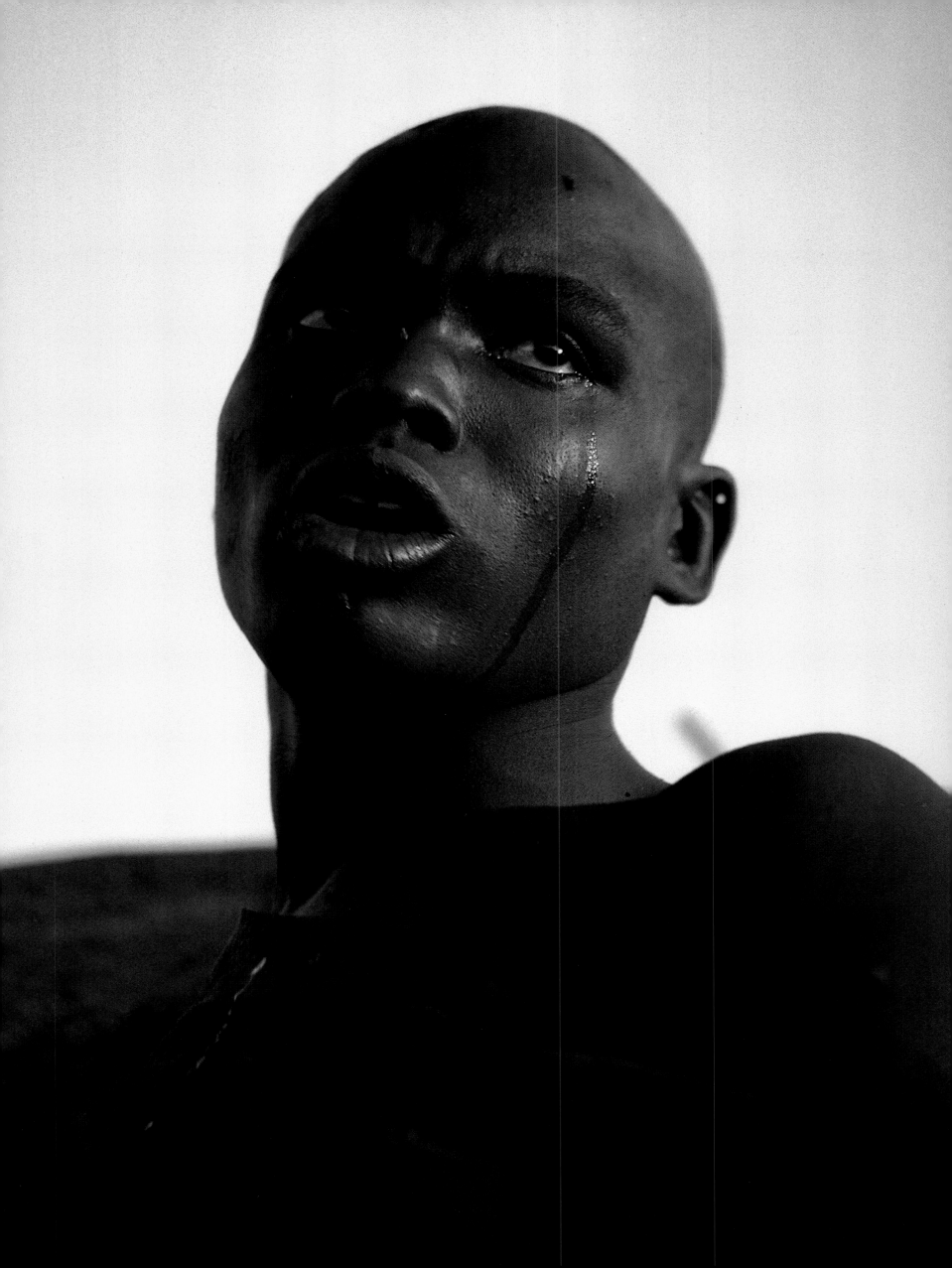

ABOVE: The eldest sons of the most senior elders within a *lorora* are circumcised first. The men who hold the boys as they are circumcised become as fathers to the boy.

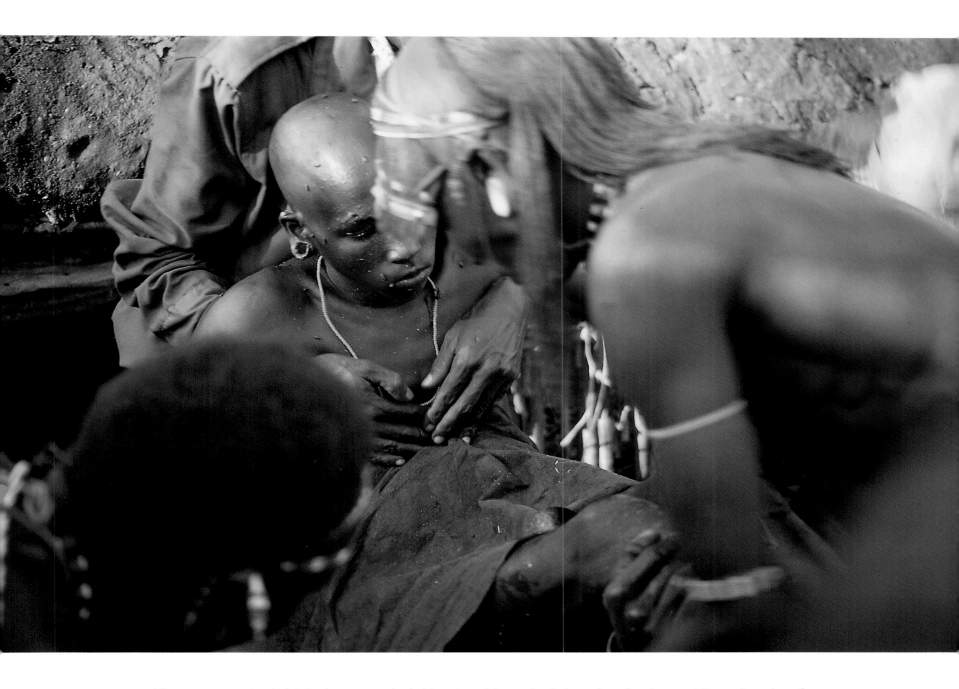

ABOVE: The two men who held the boy carry the initiate into his mother's hut after the circumcision, where he often breaks into song, as a release of emotion.

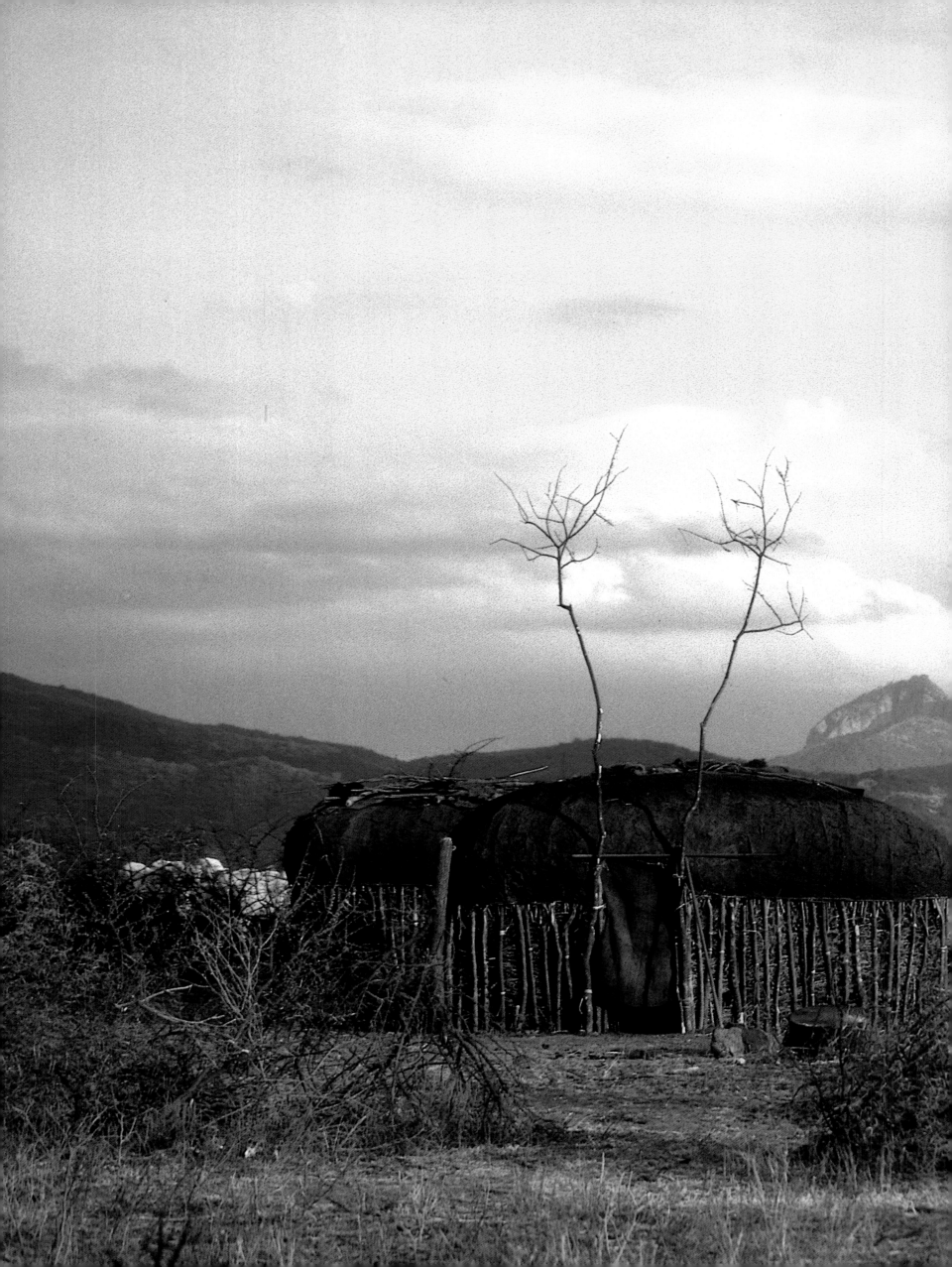

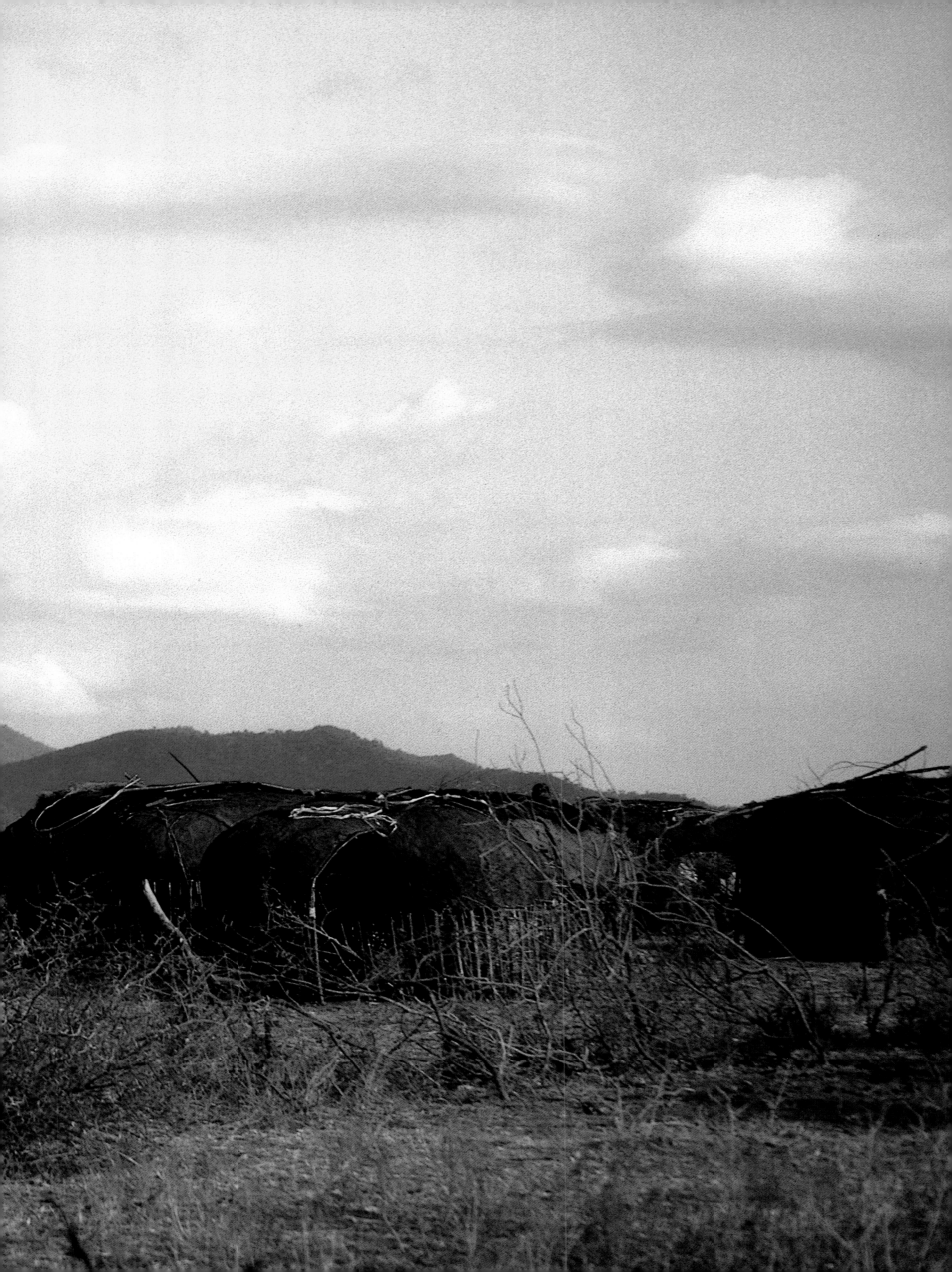

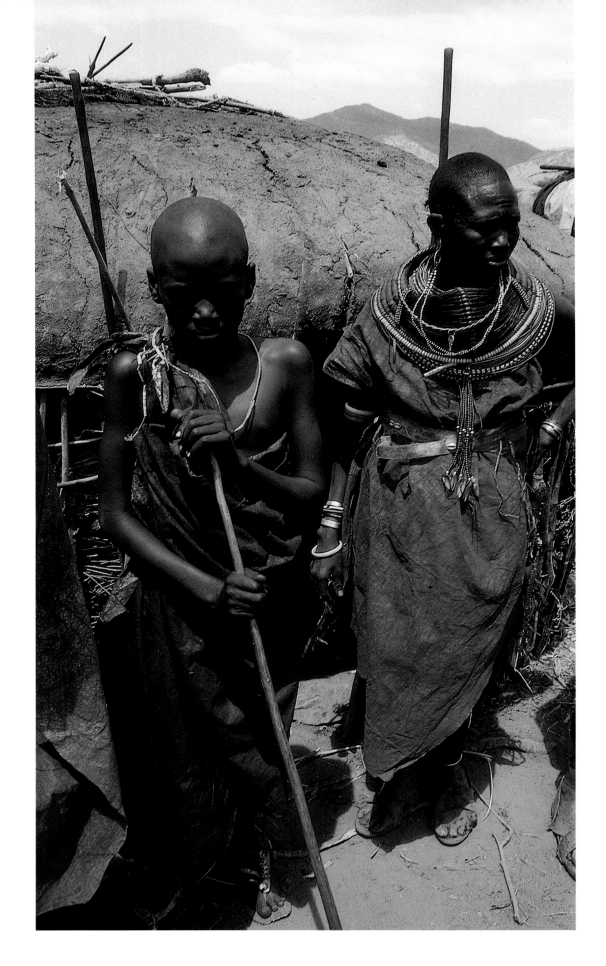

PRECEDING PAGE: The mothers of the *laibartok* (newly circumcised boys) place two branches on either side of their doorway as a sign that their sons have been circumcised.

ABOVE: Soon after the women have performed a small dance to celebrate the boys' transition into manhood, the *laibartok* emerge from their mothers' huts. Some mothers wear their wedding necklaces and all Samburu mothers wear the *nchipi*, the blue beads their sons wore before their circumcision.

RIGHT: For the following month, the *laibartok* wear the ceremonial earrings and carry with them their bow and arrows, which the men who held them during their circumcison made for them. While they are in this transitional state between boyhood and warriorhood the *laibartok* are considered especially vulnerable, and must follow a number of customs designed to protect them: they must not cross or use water, nor must they touch metal, and they must return to their mothers' huts by nightfall.

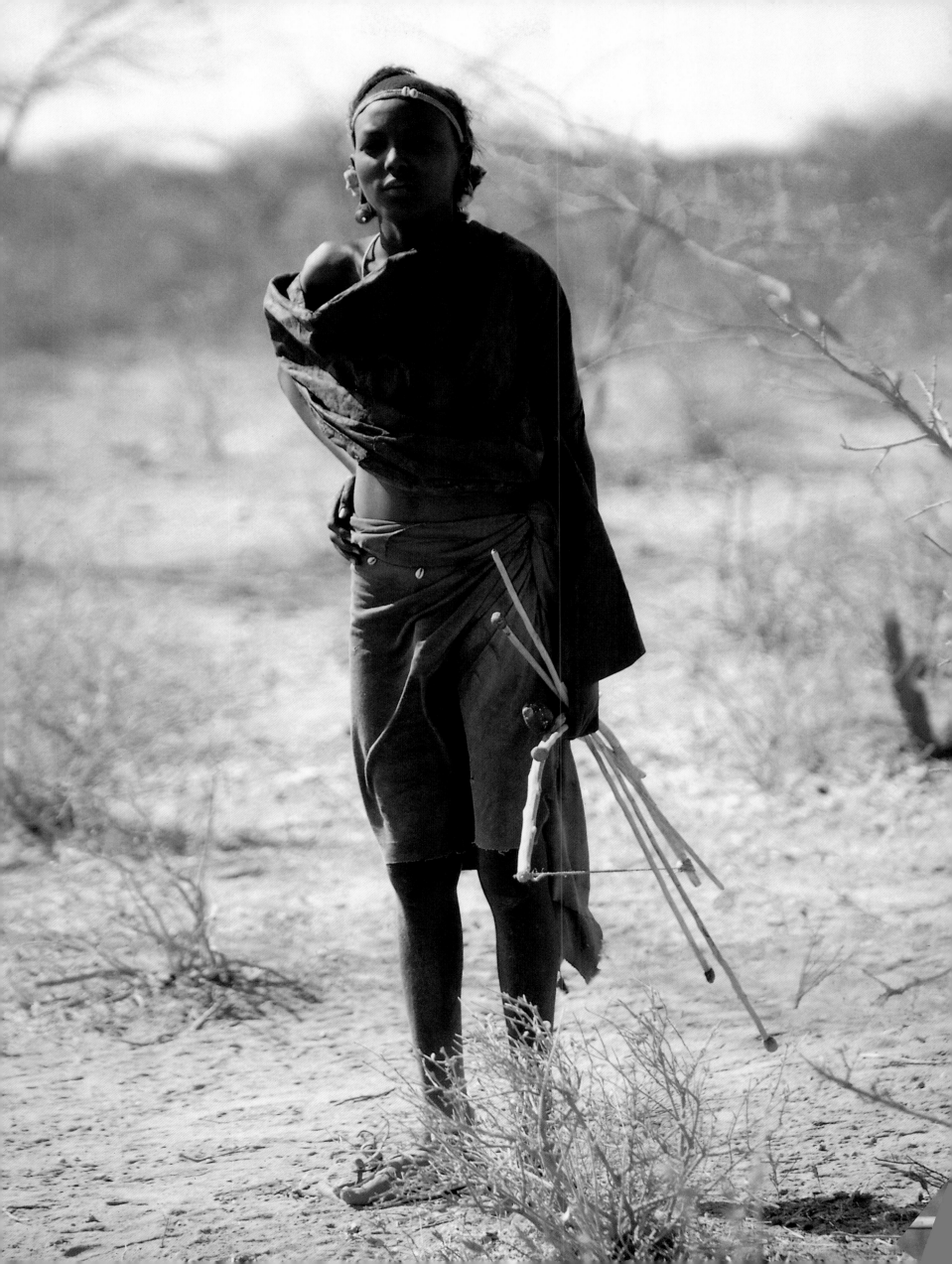

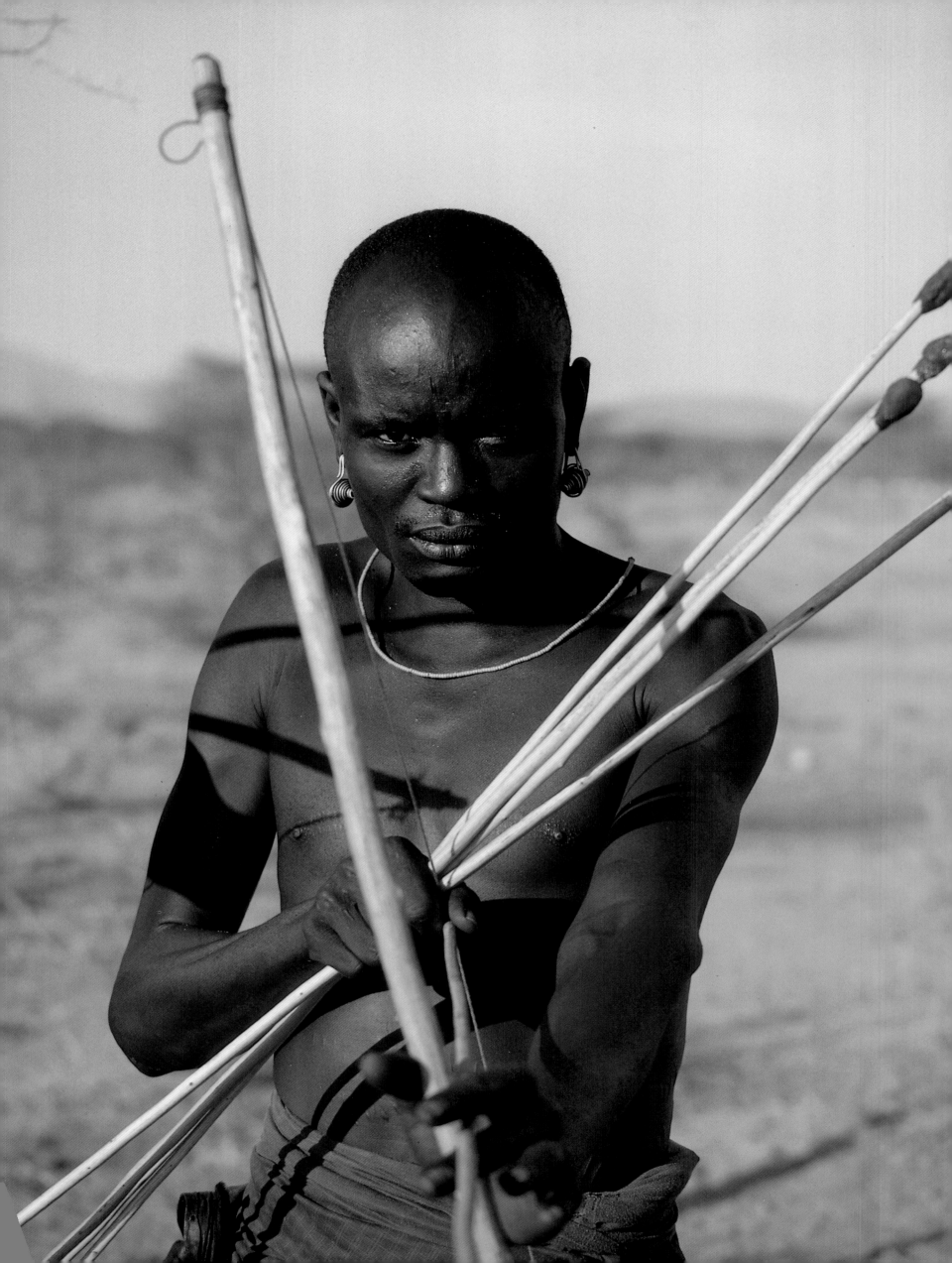

LEFT AND BELOW: At one time when the Samburu hunted game and did not keep herds of animals for food, the use of bow and arrow must have been an important skill for the boys to learn as they approached manhood. Nowadays, with the exception of taking blood from a cow, the month following circumcision is the only time the Samburu use a bow and arrow. The boys take great delight in stalking through the bush around the *lorora* in search of small birds to shoot with their bows and arrows tipped with sticky gum. It is the first proof of their abilities and marks the beginning of their progress toward manhood. They shoot mainly weavers, finches and starlings. However, it is considered very bad luck indeed to kill certain birds, especially doves, but also pigeons or hornbills, as the Samburu say that a dove's coo is like the cry of a girl, that the pigeon calls like their mothers and that the hornbill is like the old men. These birds, they say, hold the souls of their parents and lovers in their calls.

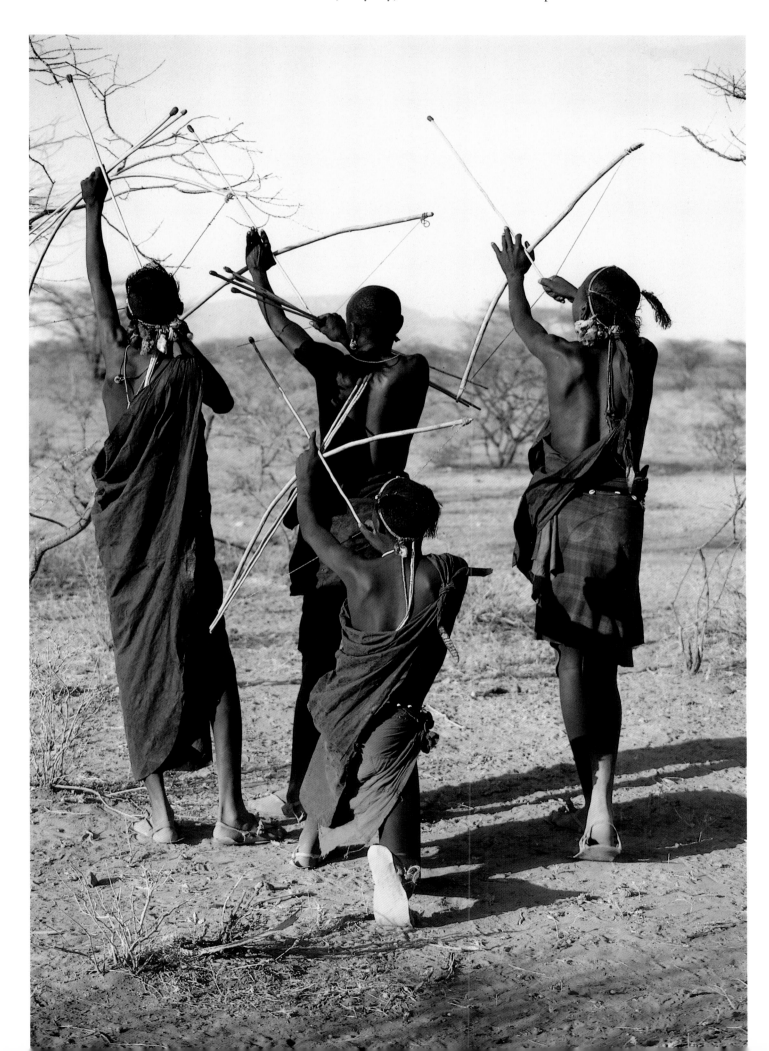

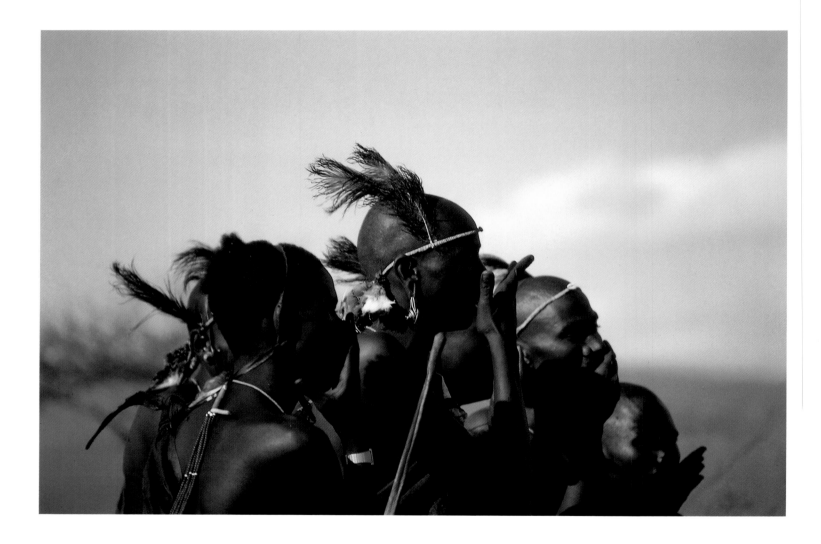

ABOVE: The *laibartok* continue to sing the *lebarta* until all the boys within the *lorora* have been circumcised. Here a boy who has yet to be circumcised and still has his top knot stands with his age-mates, who have already been circumcised and have begun to wear the headdress of the "month of birds".

RIGHT AND OVERLEAF: A circumcised boy on the threshold of warriorhood, wearing the headdress of the "month of birds" and the earrings he wore at his circumcision. The women plait the cord for the initiates' headdresses, the initiates gut the birds, stuff the capes with grass and the men attach the birds to the cord by their bills. They then fix two ostrich feathers on either side of the headdress which the boys wear for the month following circumcision.

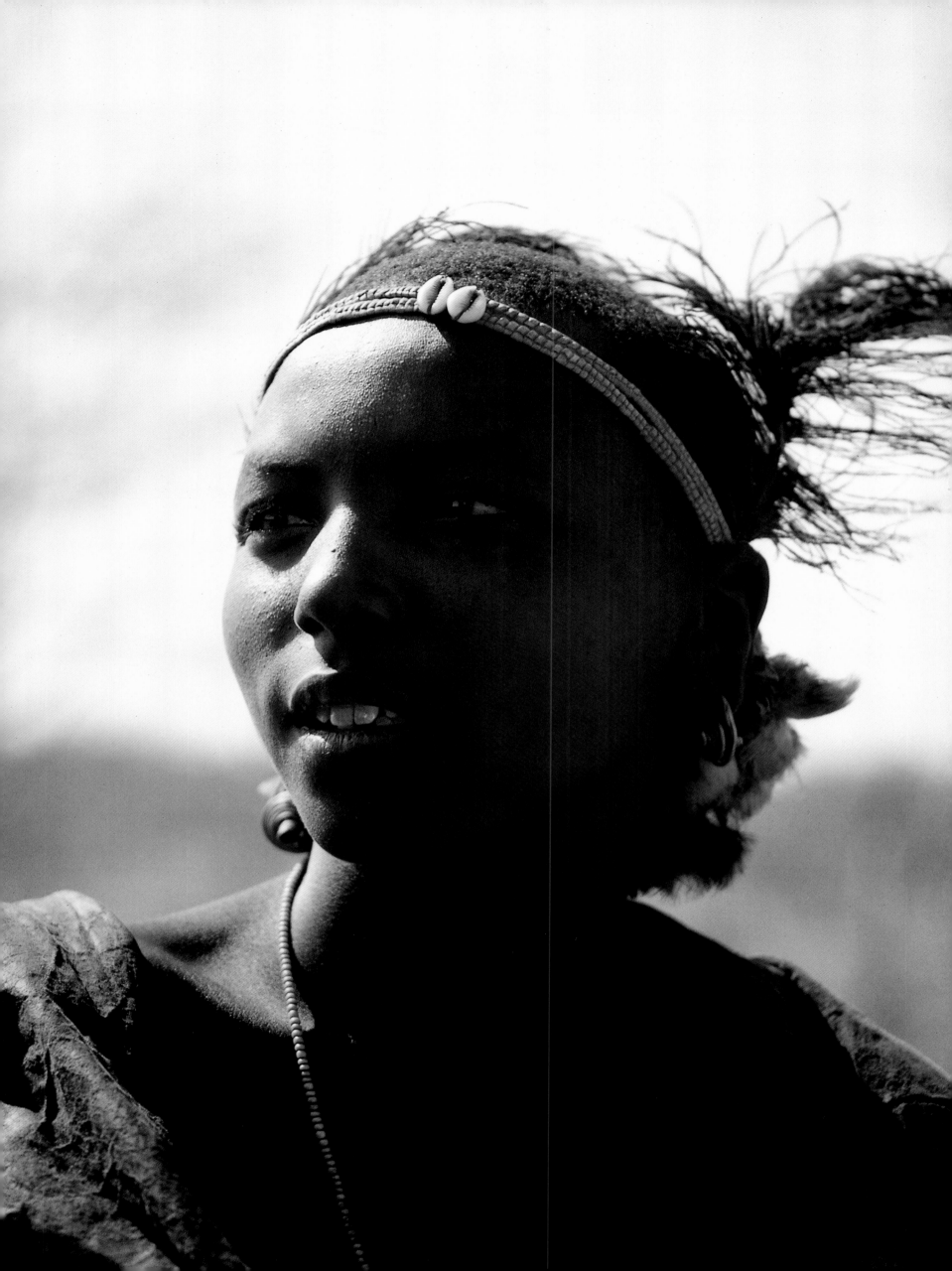

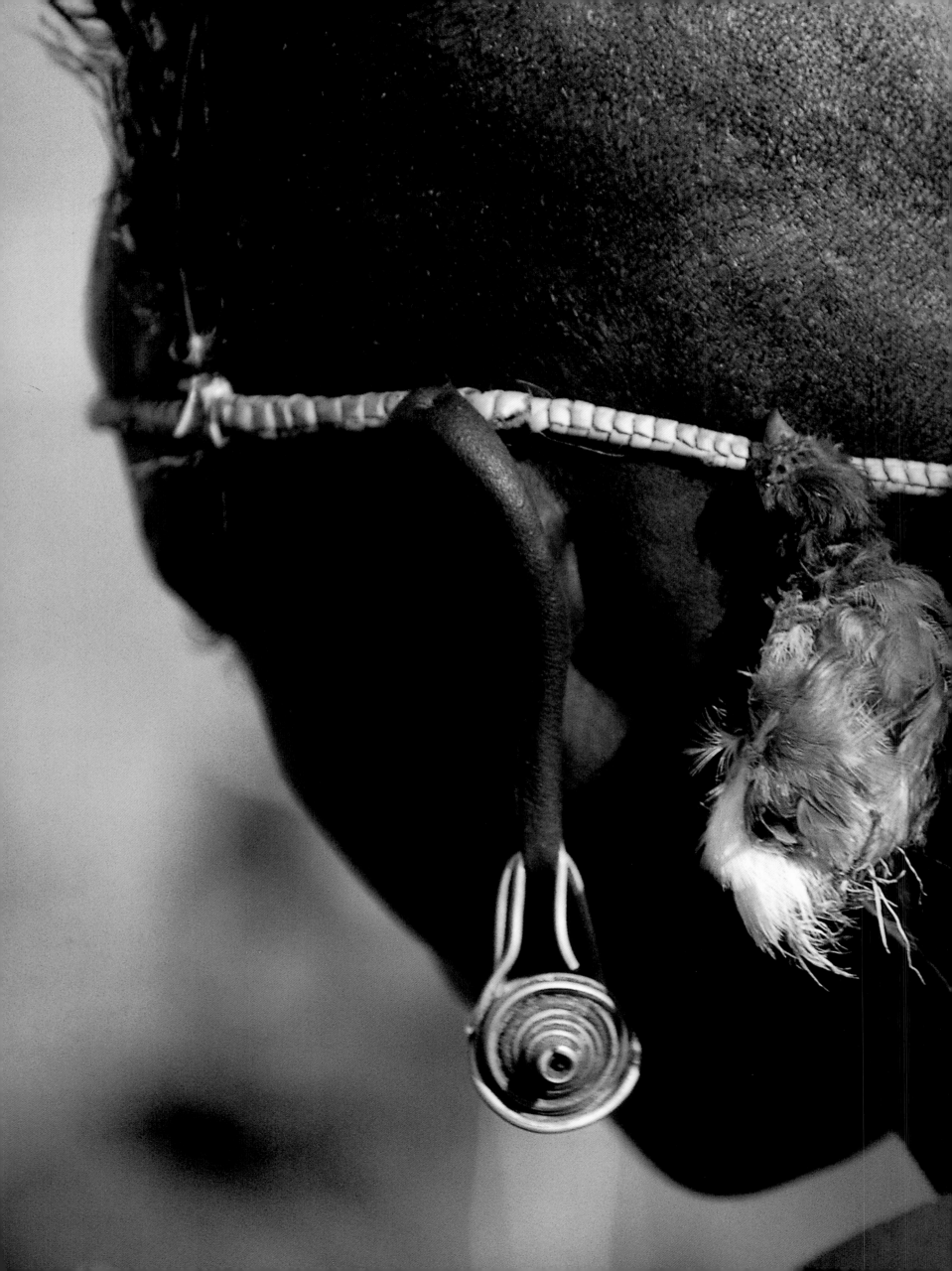

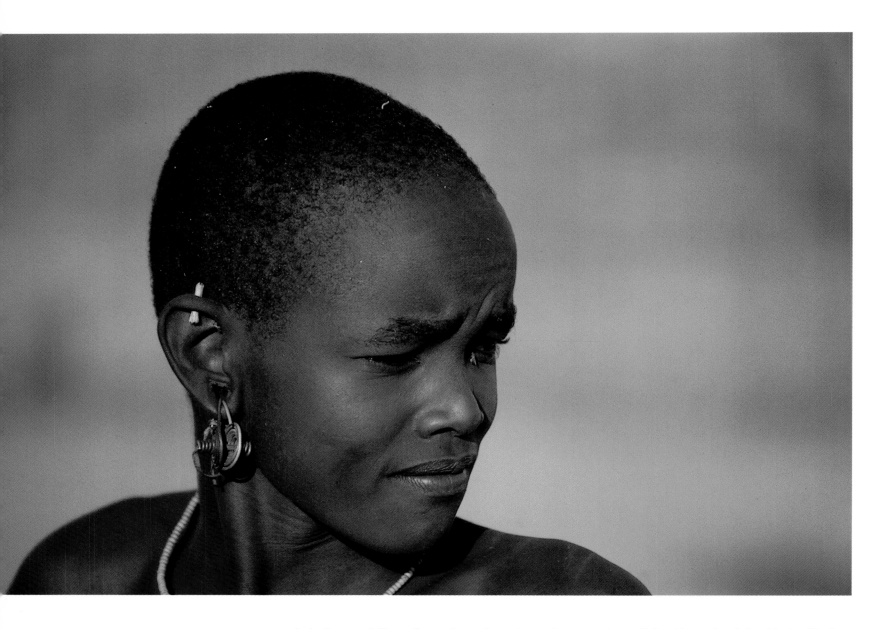

ABOVE AND RIGHT: A *laibartani* (literally, a shaved one) on the morning of the *ilmugit* of the birds. He has discarded his bird headdress and later in the day will start to wear red ochre for the first time. For every initiate a fatted animal is slaughtered. Within one *lorora* there may be several slaughterings, depending upon the number of initiates within that sub-clan. For instance, if there are ten boys in a village, then the five sons of the fathers highest in the hierarchy of the council of elders will slaughter on the first day, and the rest will wait until the following day, for otherwise there would be more food than could be eaten in one sitting and it would soon become putrid.

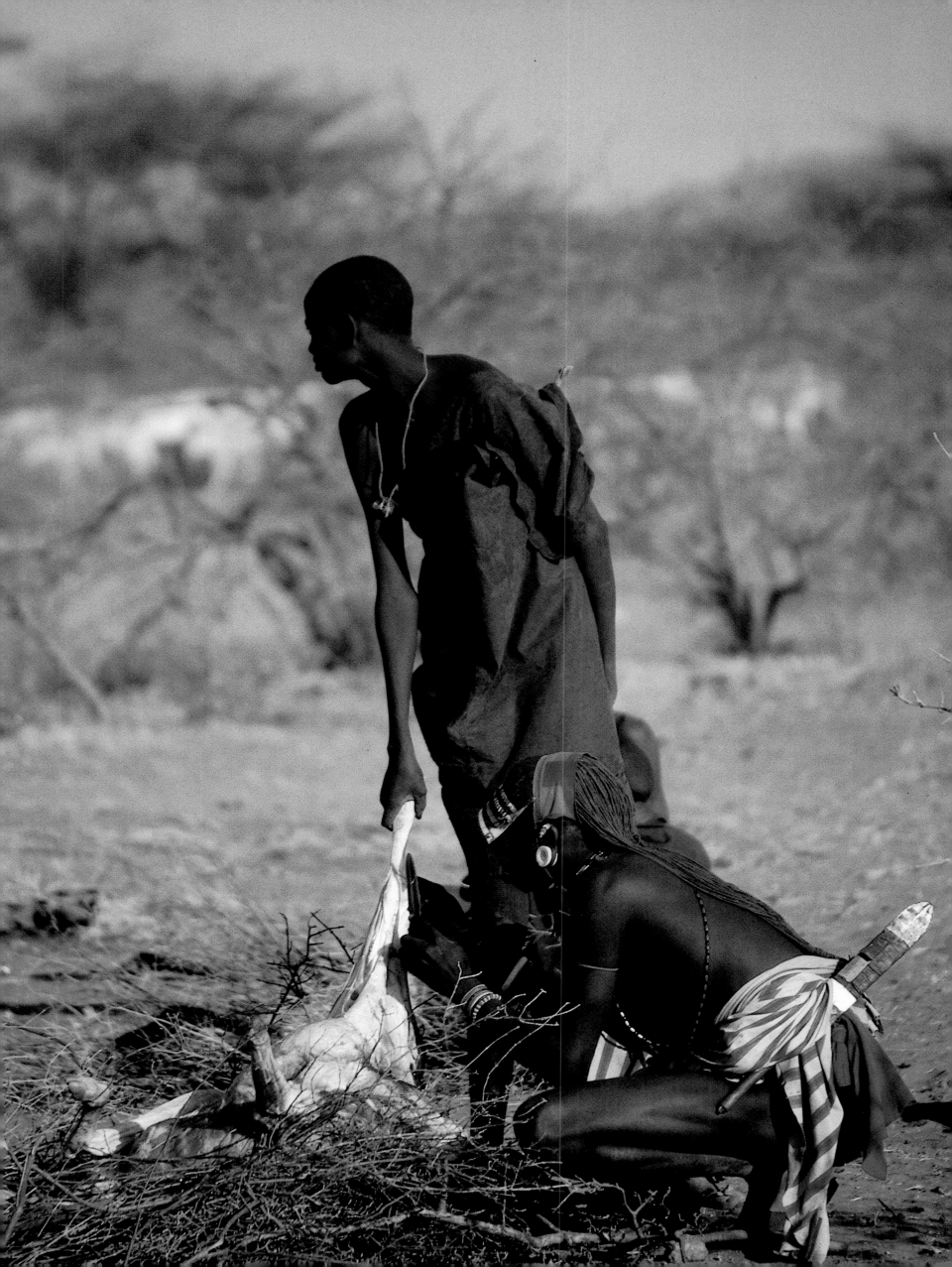

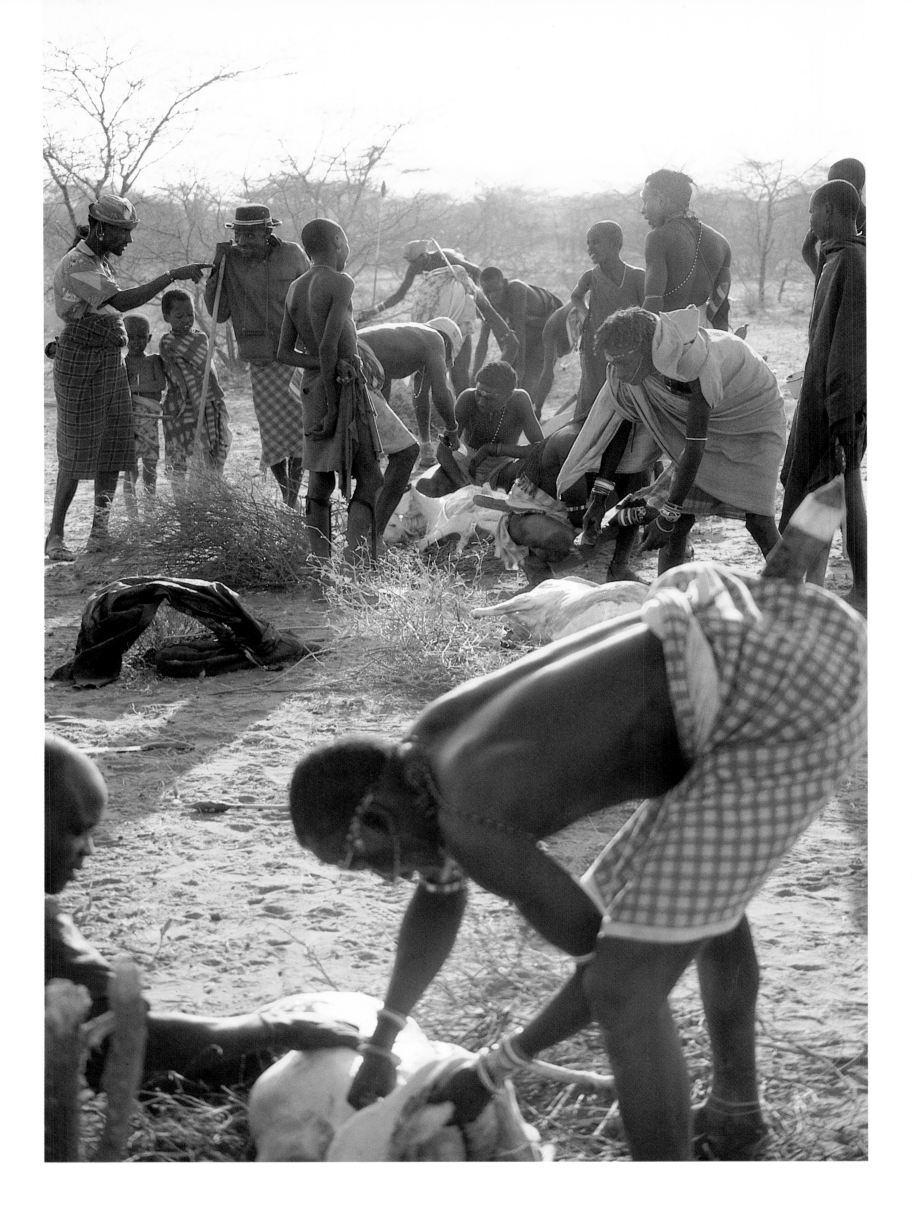

LEFT AND BELOW: The men cut up the meat for the *ilmugit*. There is an air of festivity and relief that the ceremonies have gone well. The man who held the initiate's right leg is given the right leg joint of the animal, and the man who held the initiate's back is given meat from the animal's back.

OVERLEAF: A senior warrior at the end of his term of *lmurrano*. Soon he will shave his braids and make way for the new generation of warriors.

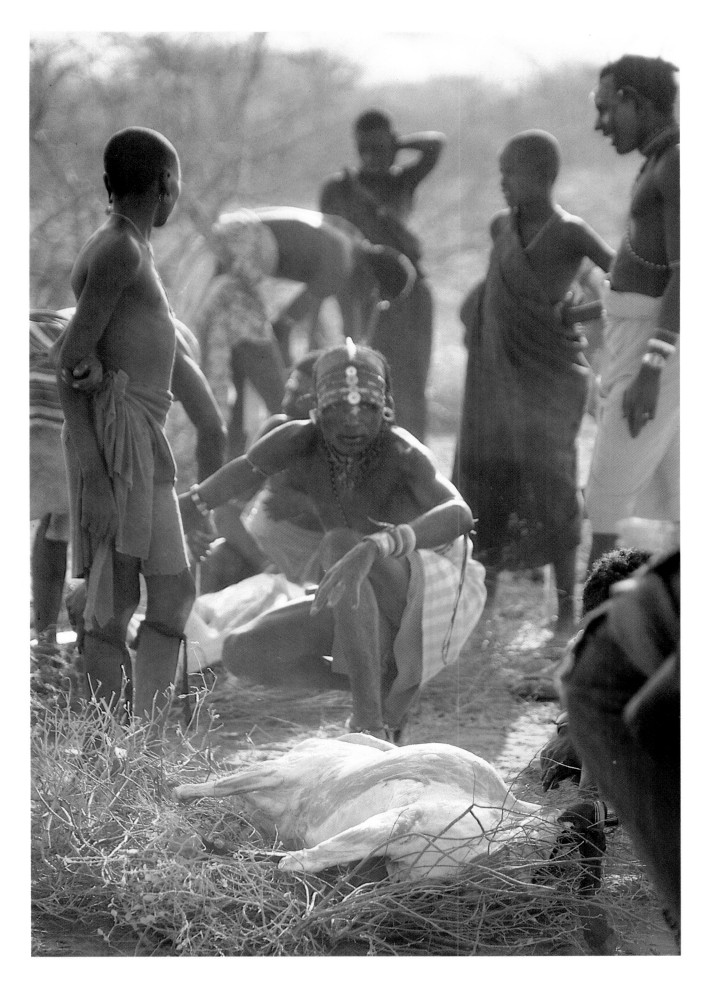

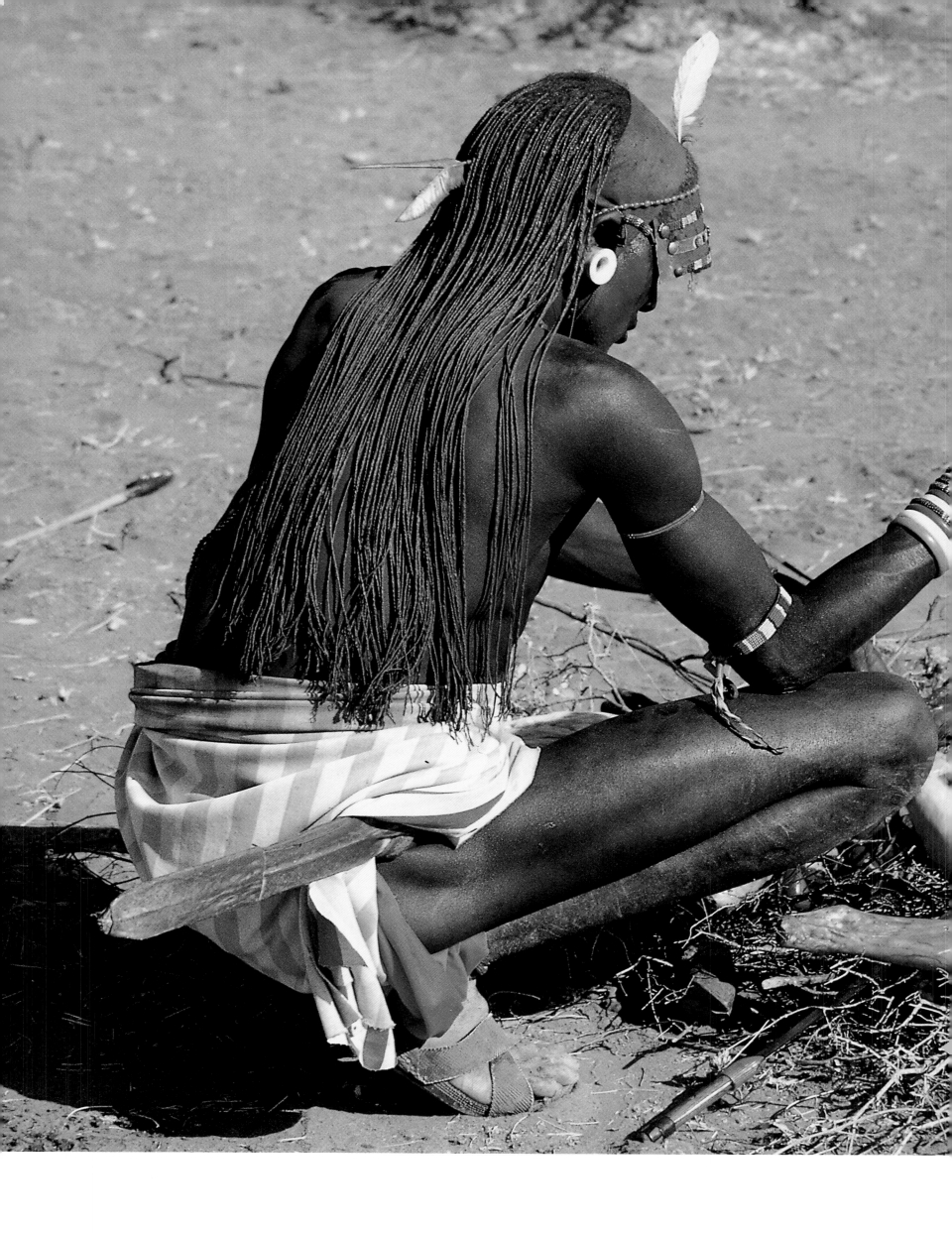

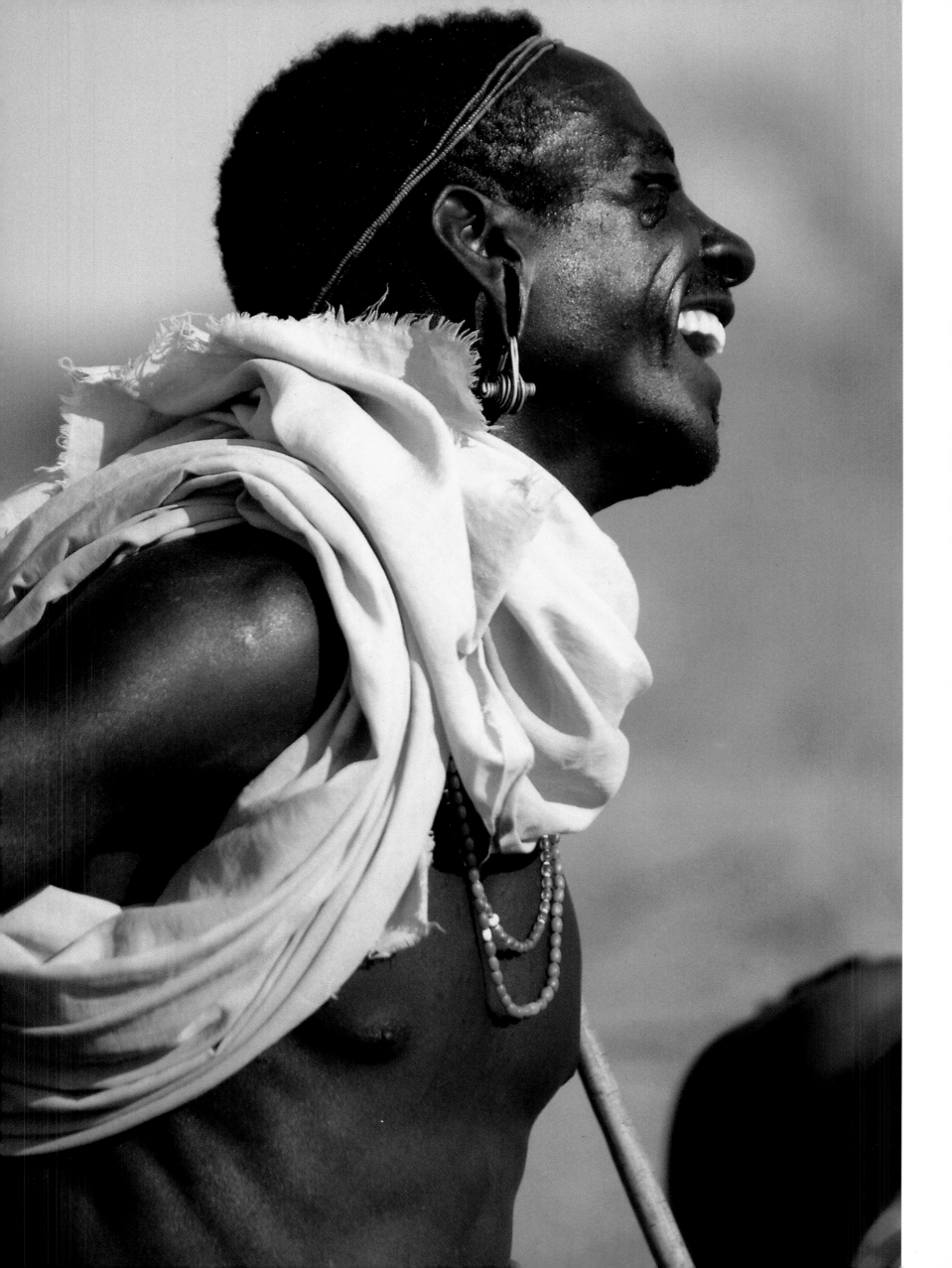

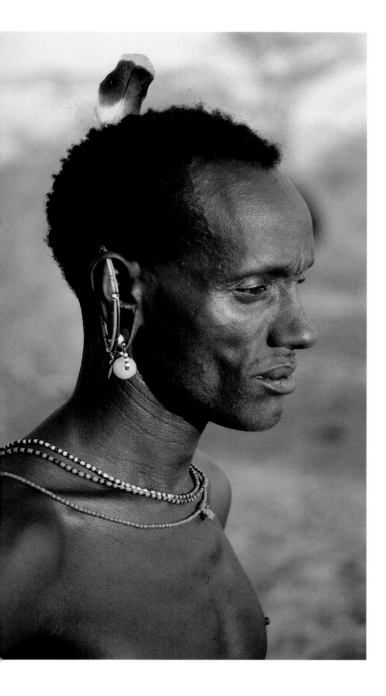

FAR LEFT, LEFT AND BELOW: The fathers of the new warriors wear their sons' ceremonial earrings. If an elder dies, the eldest son, on the day of circumcision of either a brother or a sister, has fat smeared on his head, is blessed by the elders and takes over his father's seat in the elders' council.

The elders brew a mead made from honey fermented with the fibrous aloe root (*sugurai*), which they drink in celebration. The honey is collected with the help of the honey bird (greater honeyguide, *Indicator indicator*) which calls to the hunter and leads him to a hive. Once the hive has been broken open and the honey collected, the bird is able to eat the larvae. Legend has it that if a hunter is greedy and does not leave anything for the bird, next time the bird will lead the man to a buffalo.

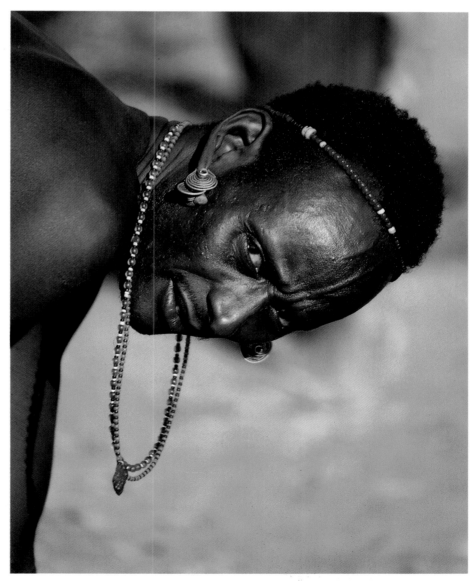

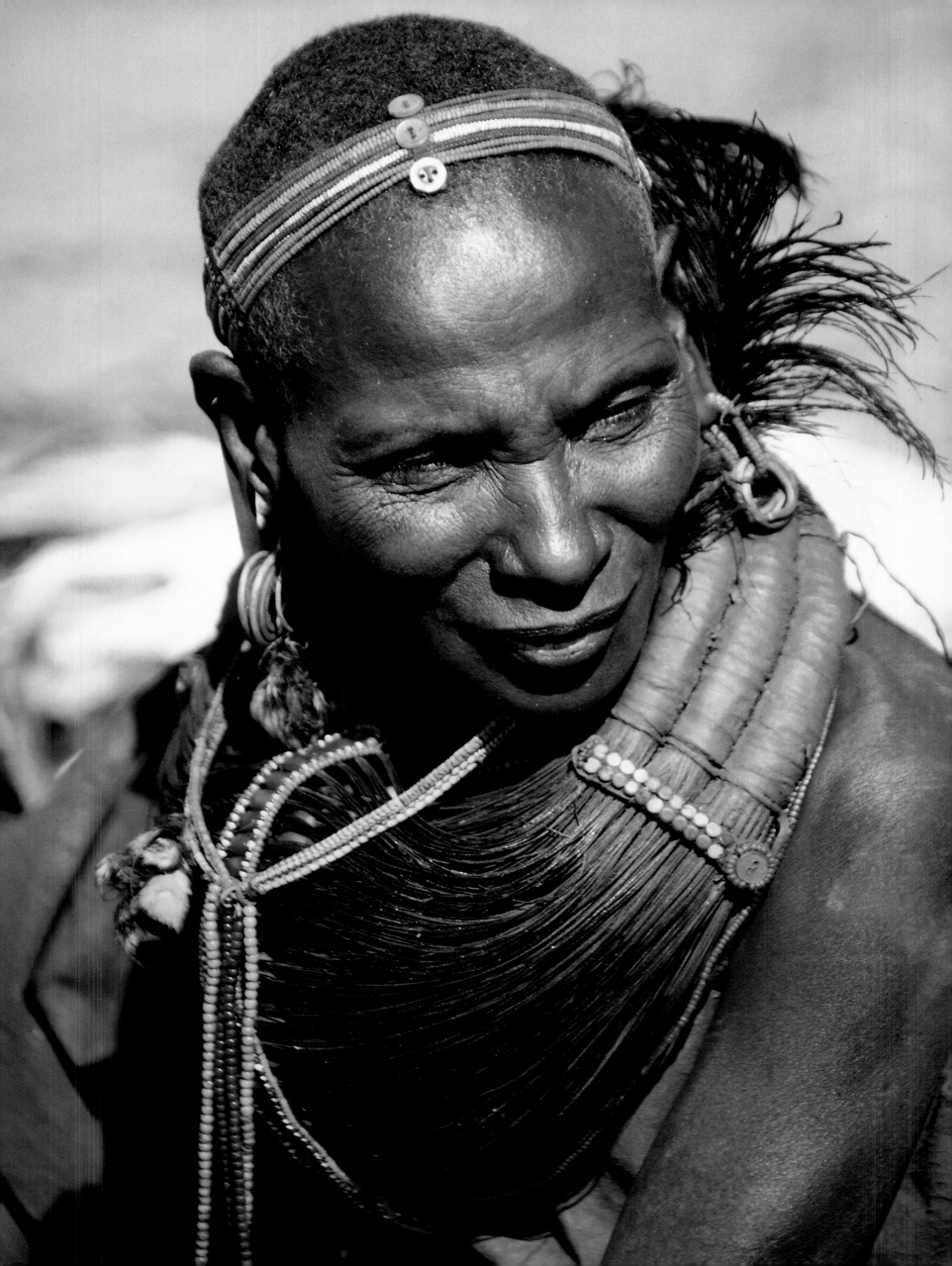

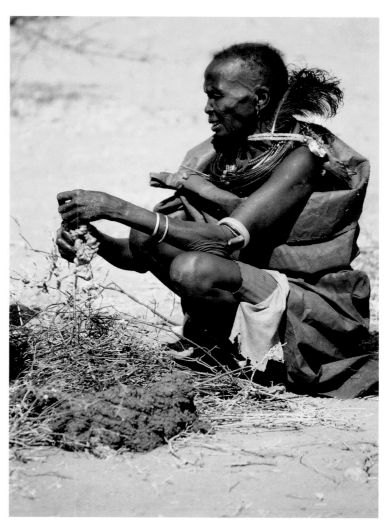

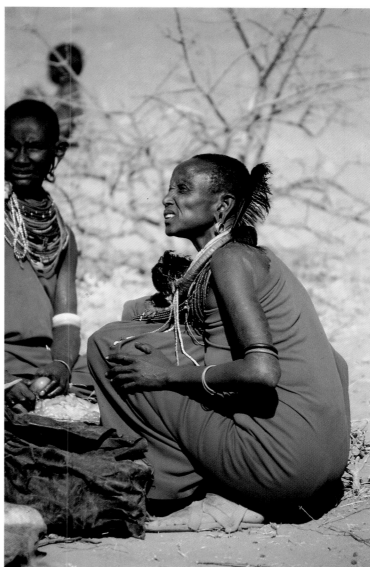

LEFT: The mother of an initiate wears her marriage necklace, and her son's headdress which he gives to her at the end of the "month of birds".

TOP: A mother cleans the intestines of a fatted animal.

RIGHT: A mother with her *sampurr* beside her in which she will carry her share of the meat back to the *lorora*.

OVERLEAF: The women sort their share of the meat for the feast once the men have taken their portion.

199

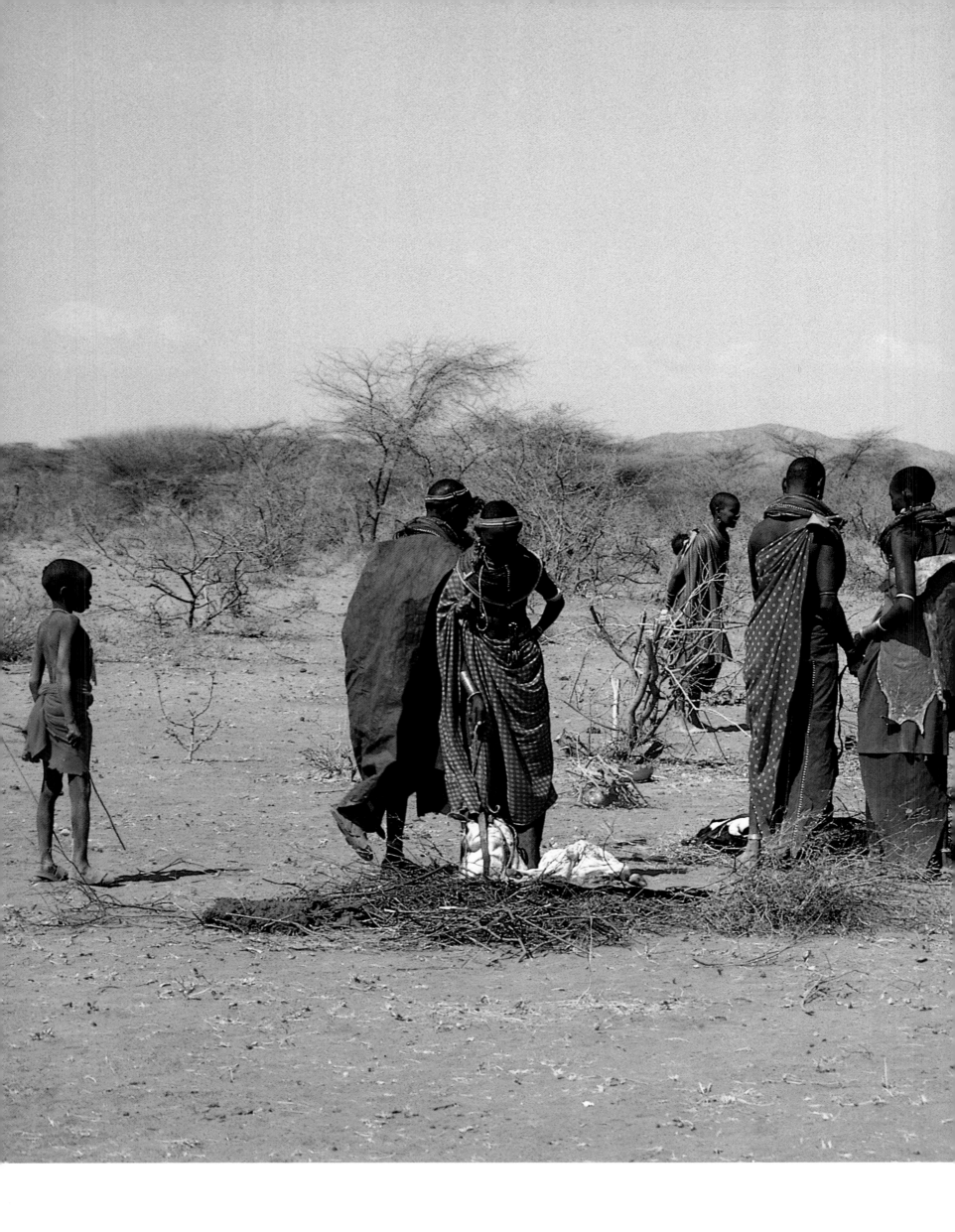

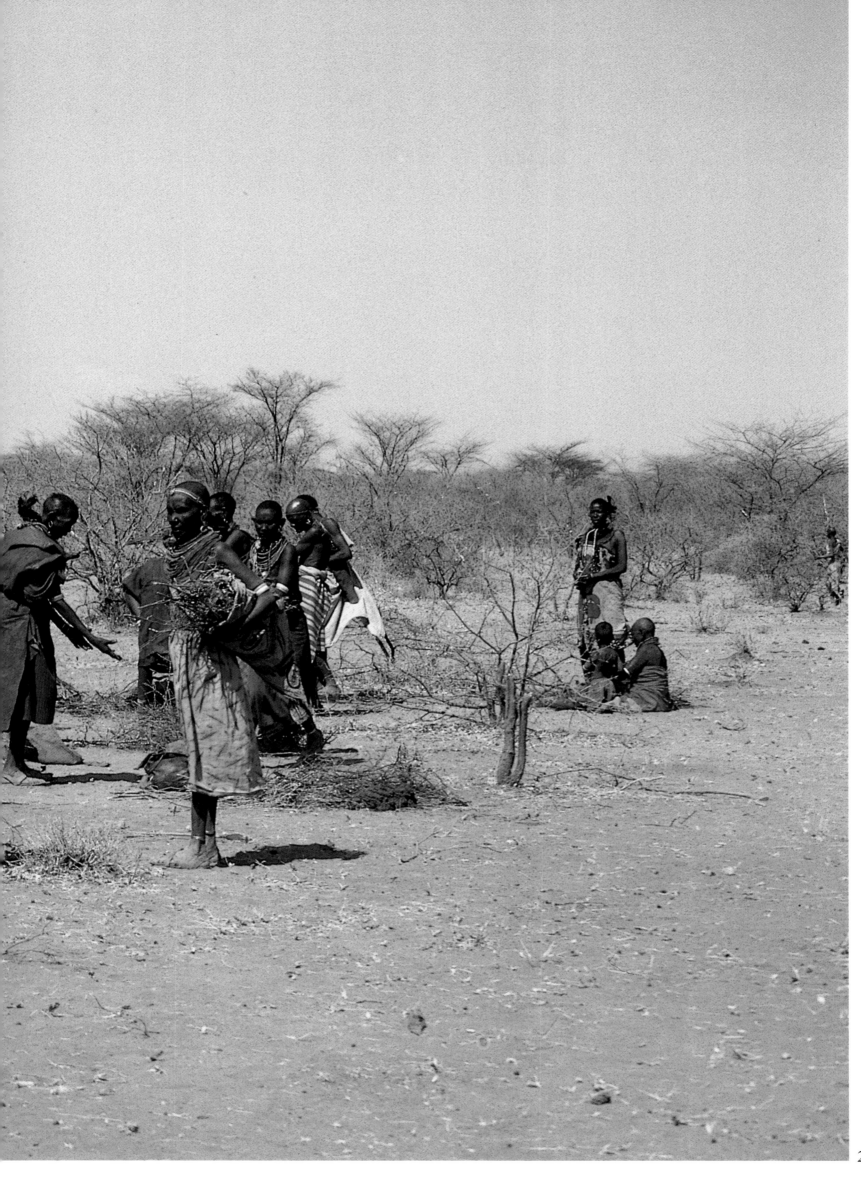

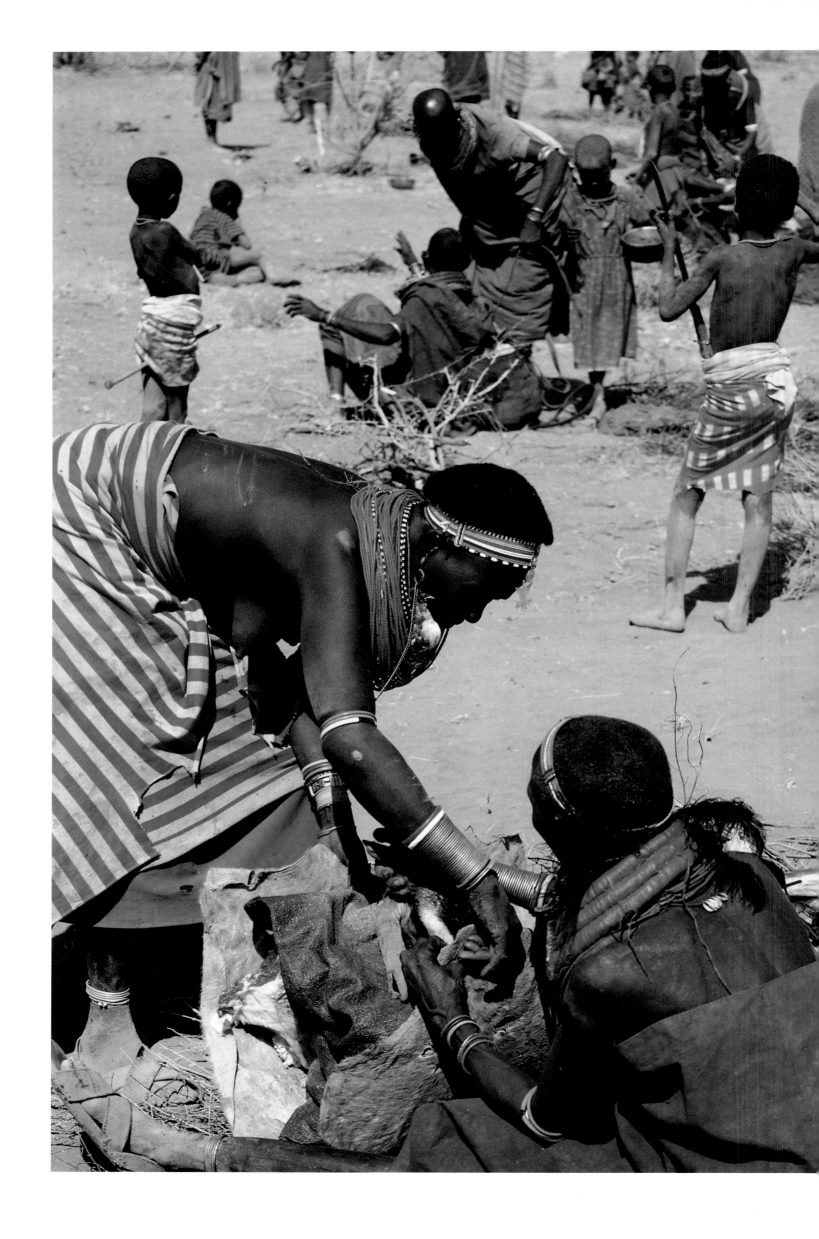

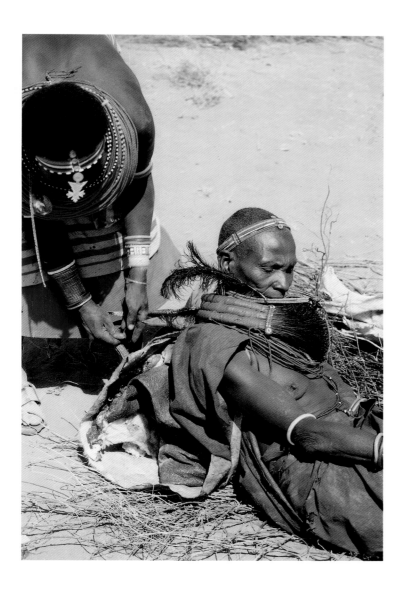

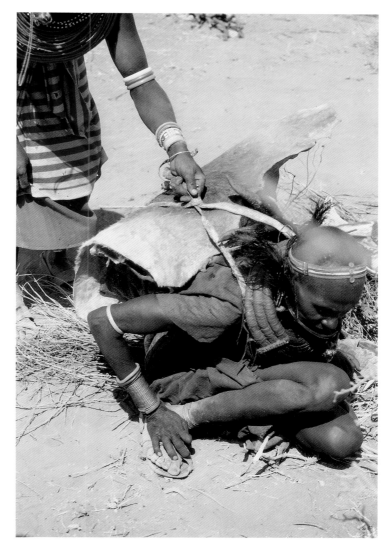

LEFT, ABOVE AND RIGHT: A mother of a new warrior prepares to carry her share of the meat back to the *lorora*. A younger woman helps her lift the full *sampurr* and any extra meat wrapped in a hide onto her back. If a mother has two or more sons, other women will help her to carry the meat back to the *lorora*.

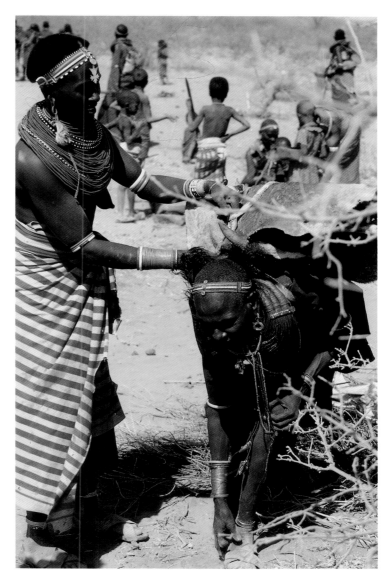

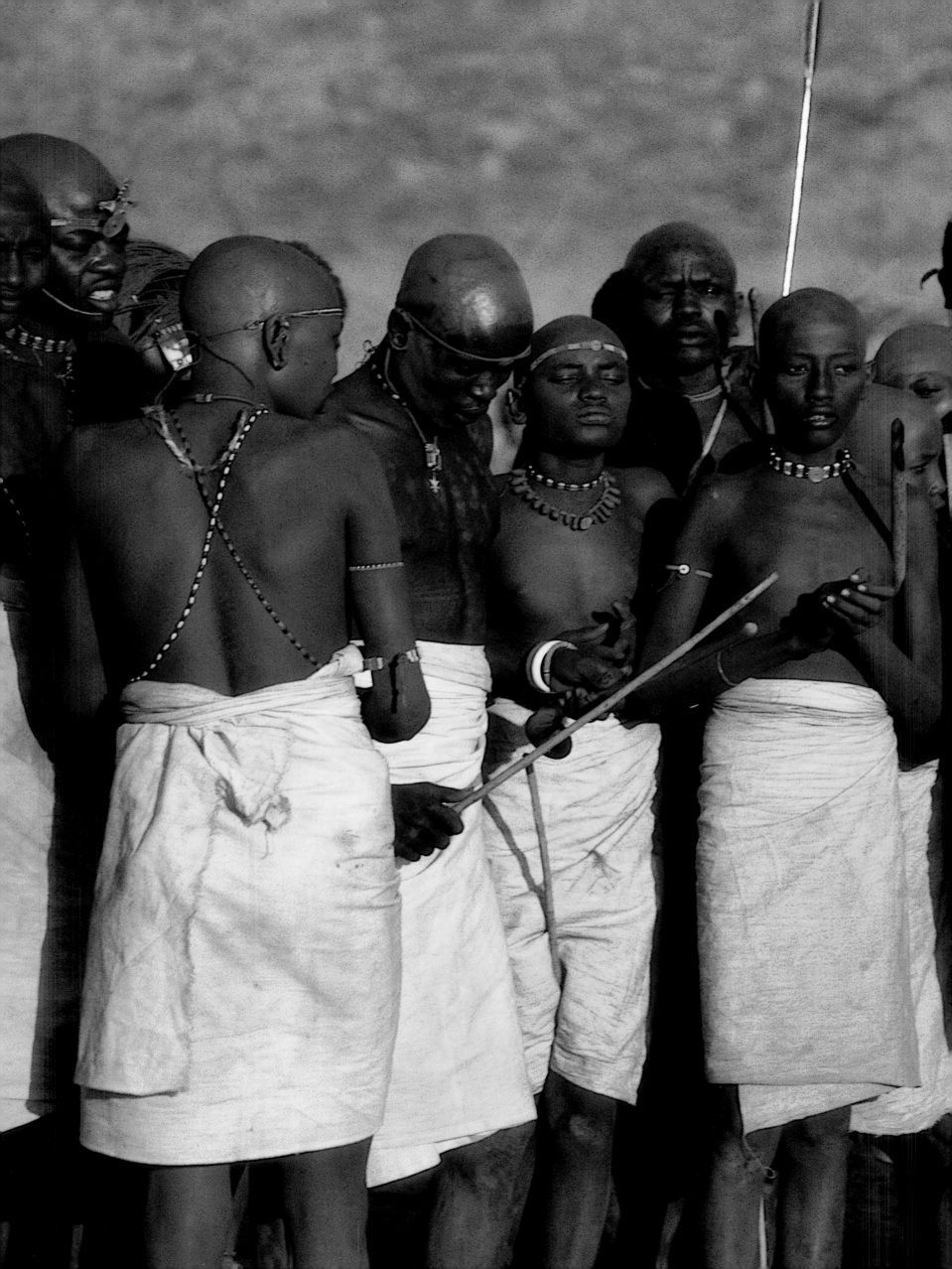

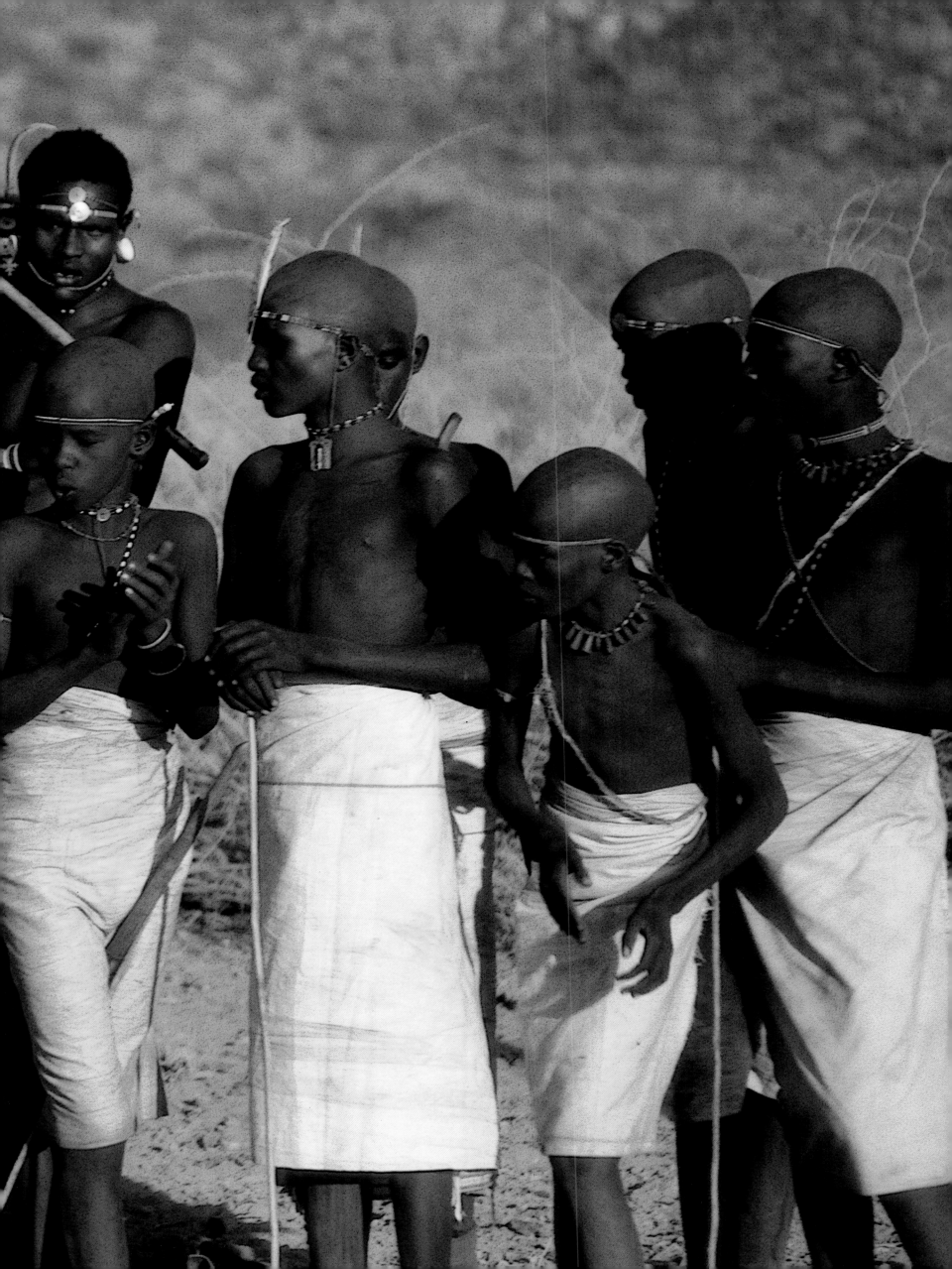

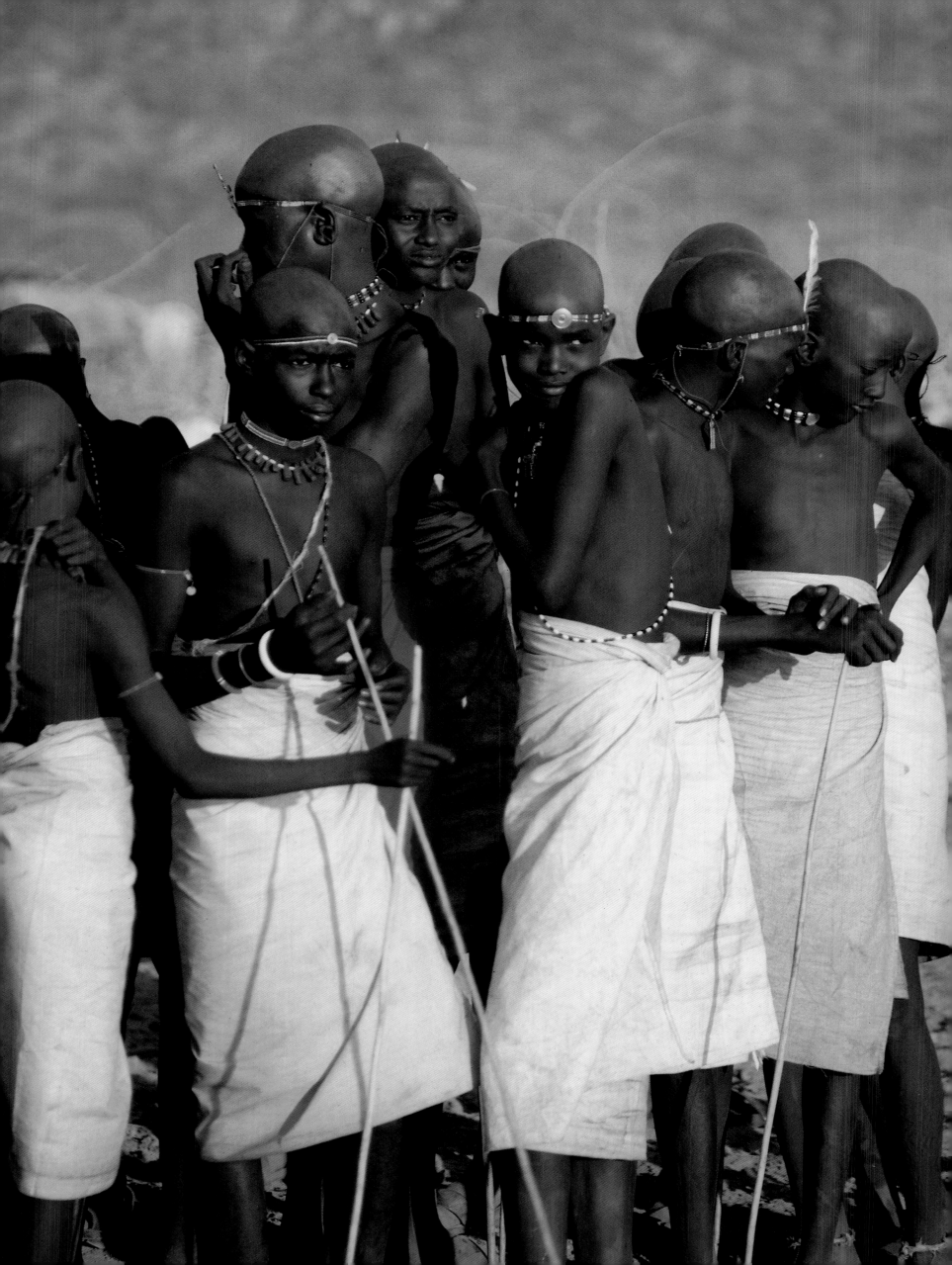

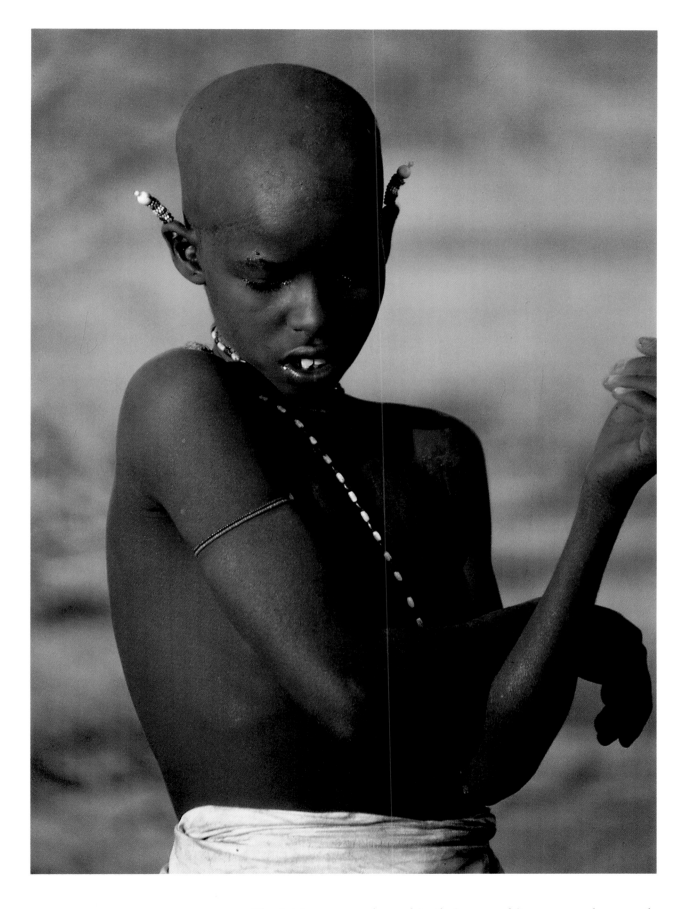

PRECEDING PAGE, LEFT AND ABOVE: The initiates, now dressed in their new white capes and smeared with ochre for the first time, gather to sing and dance on the day they become warriors. They now also start to wear the distinctive beaded jewellery of *lmurrano*. Some of the boys appear shy in their new role and are encouraged by the older generation of warriors.

RIGHT: A boy begins his *lmurrano*. He wears some beaded jewellery, which will probably have been given to him by an older warrior, who, in his turn, will have begun the slow transition to elderhood.

OVERLEAF: The senior warriors dance together, slightly apart from the new warriors, thus affirming each generation's separate identity.

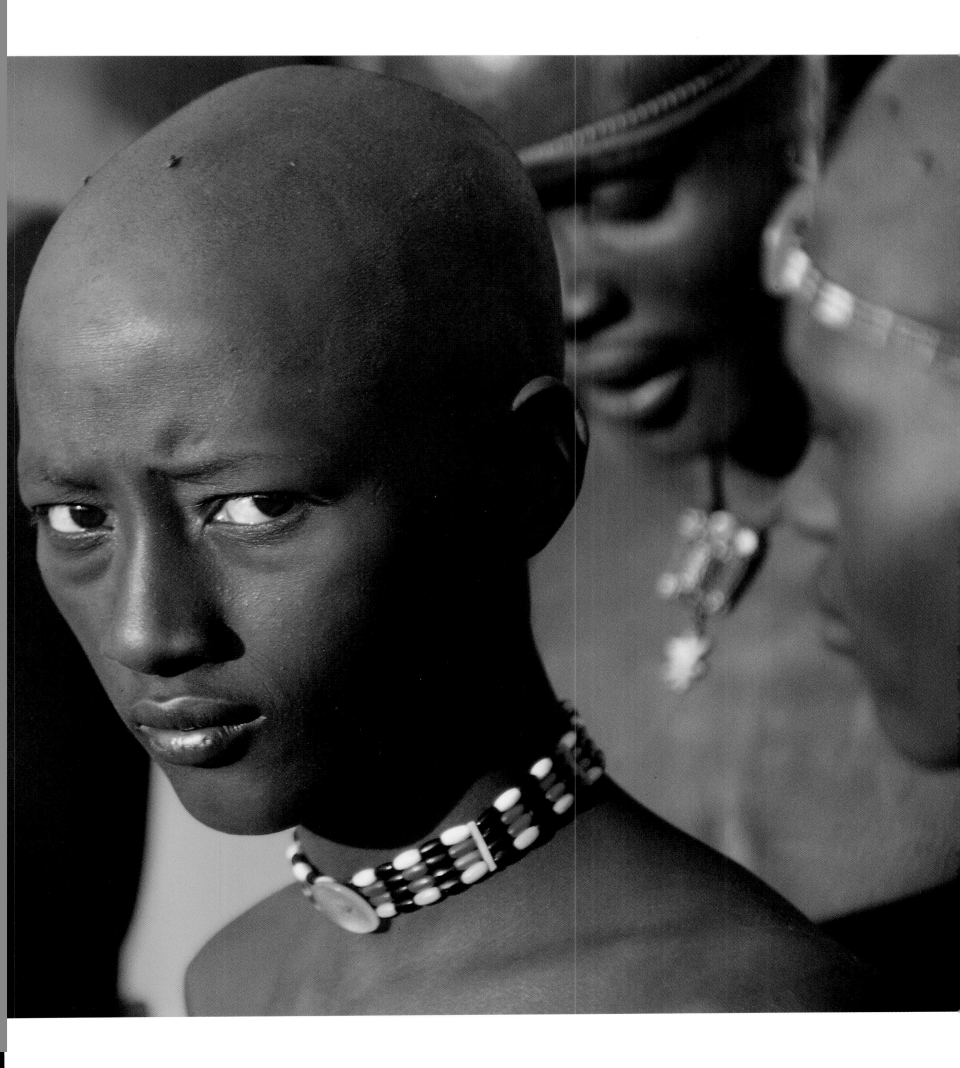

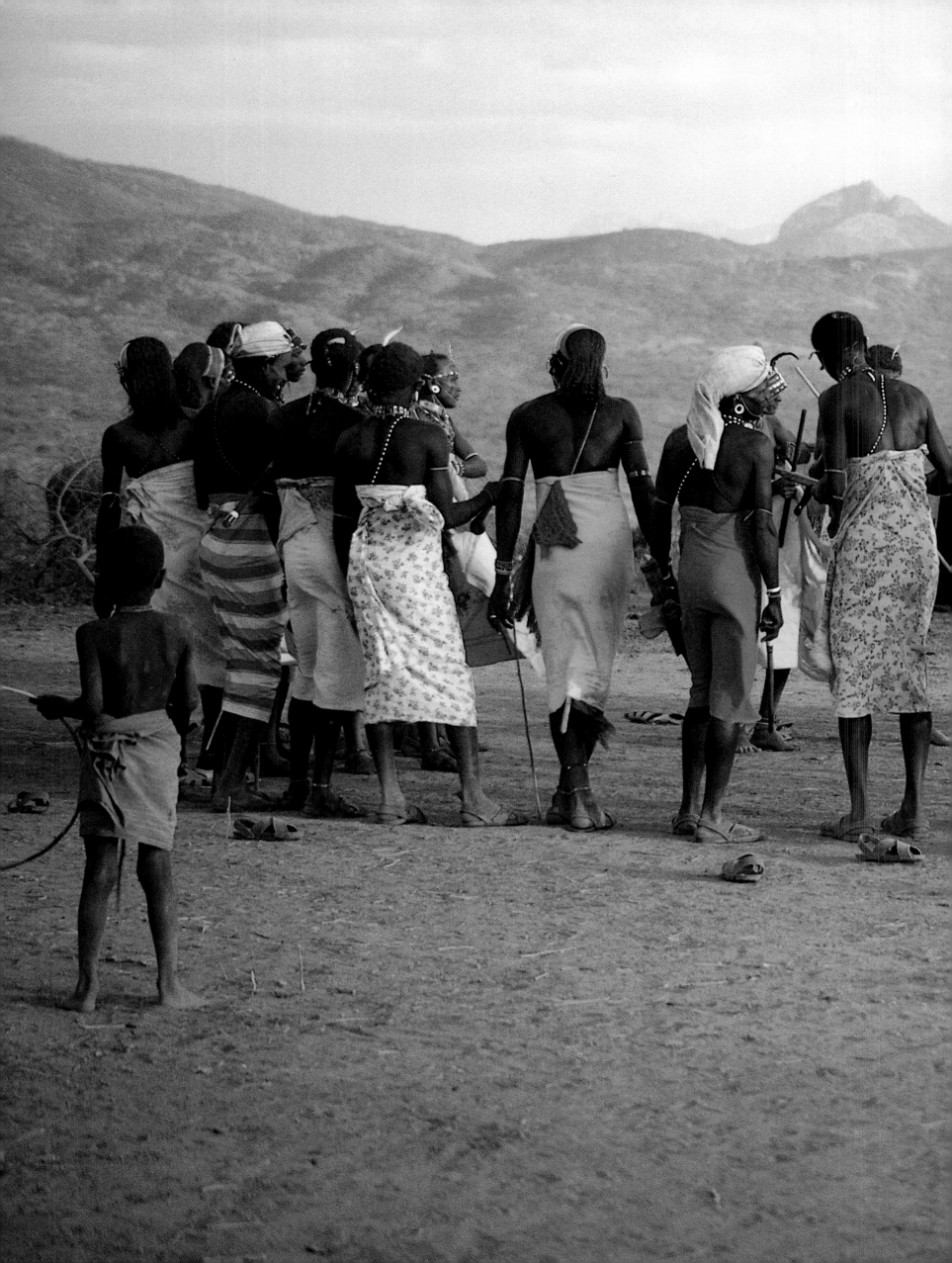

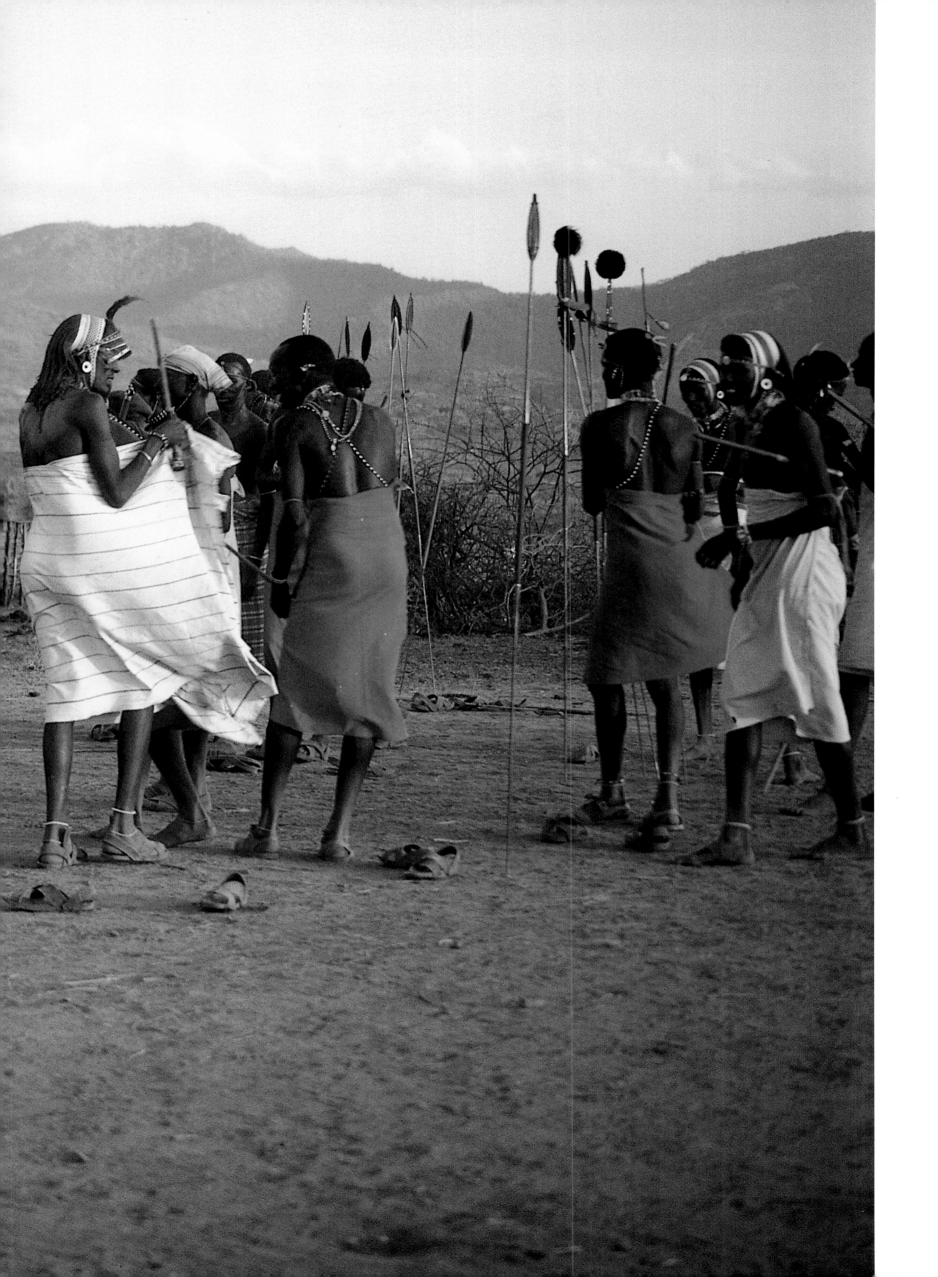

ABOVE: The sticks used to support the meat roasted at the *ilmugit* are stacked against a tree at the feasting site and will never be disturbed. Once again a visual sign marks the arrival of a new generation.

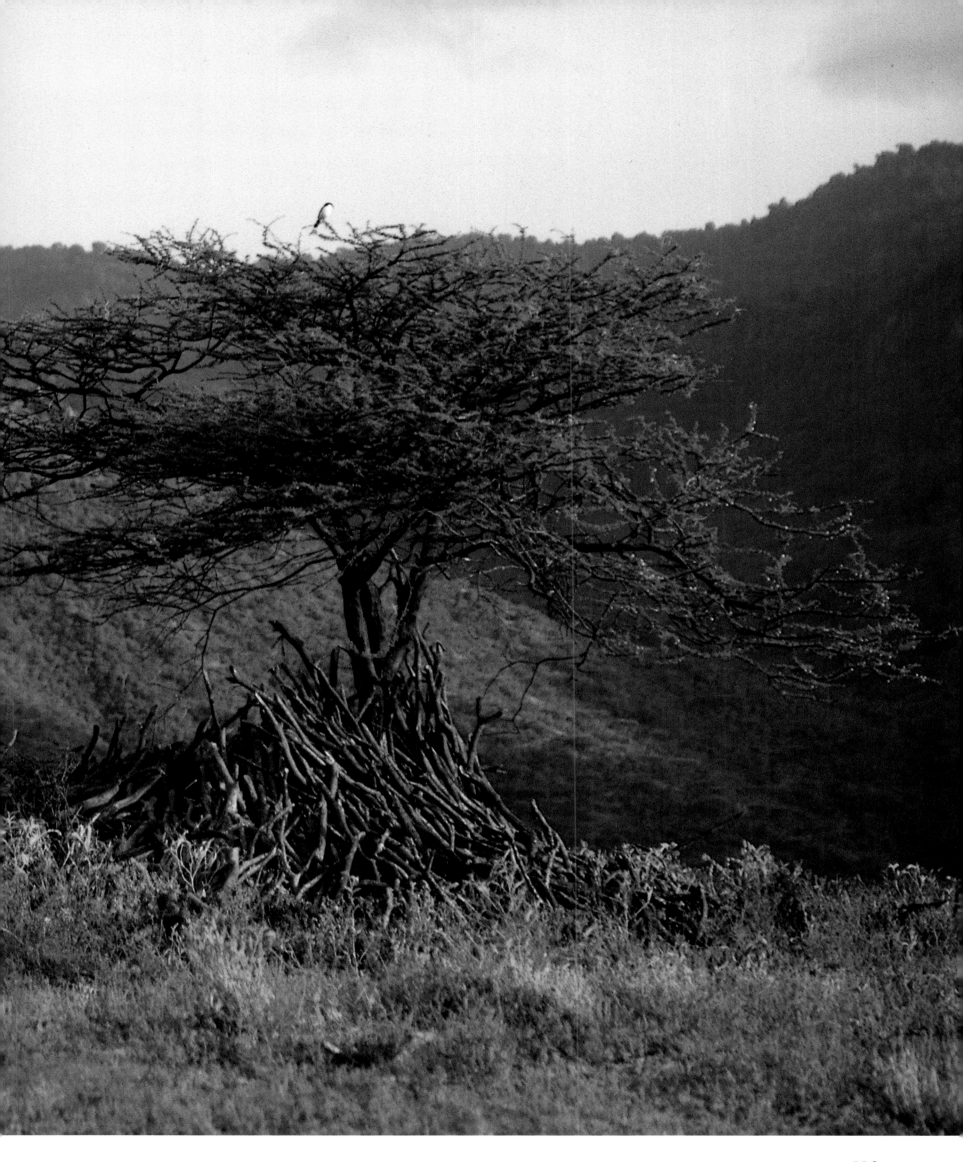

RIGHT: Having shaved their heads at the beginning of *lmurrano*, the new warriors, will now leave their hair to grow into long braided strands. This young warrior's hair will not be cut again until it is waist length, at about which time the next *laji* of warrior will be ready to be initiated.

214

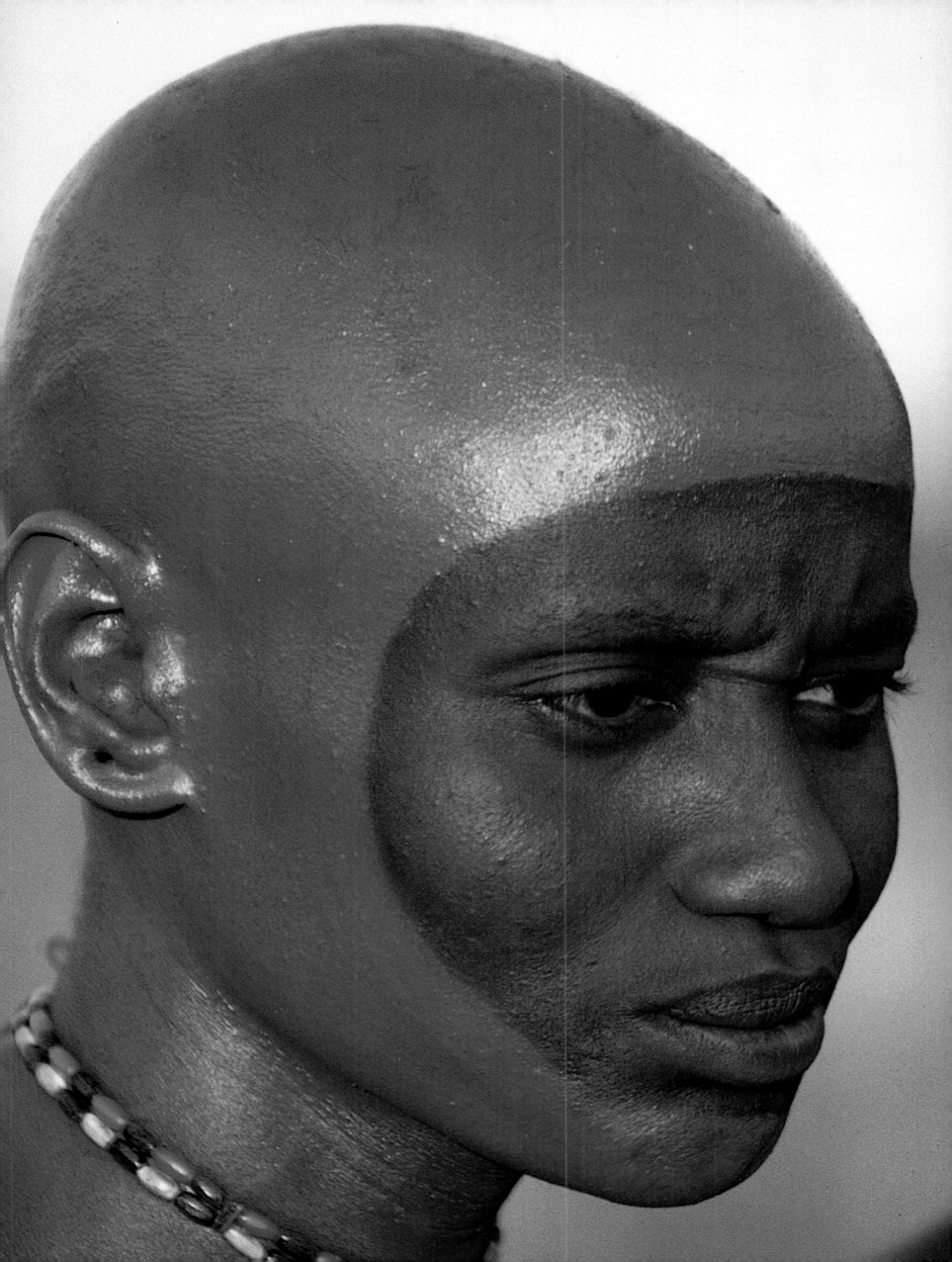

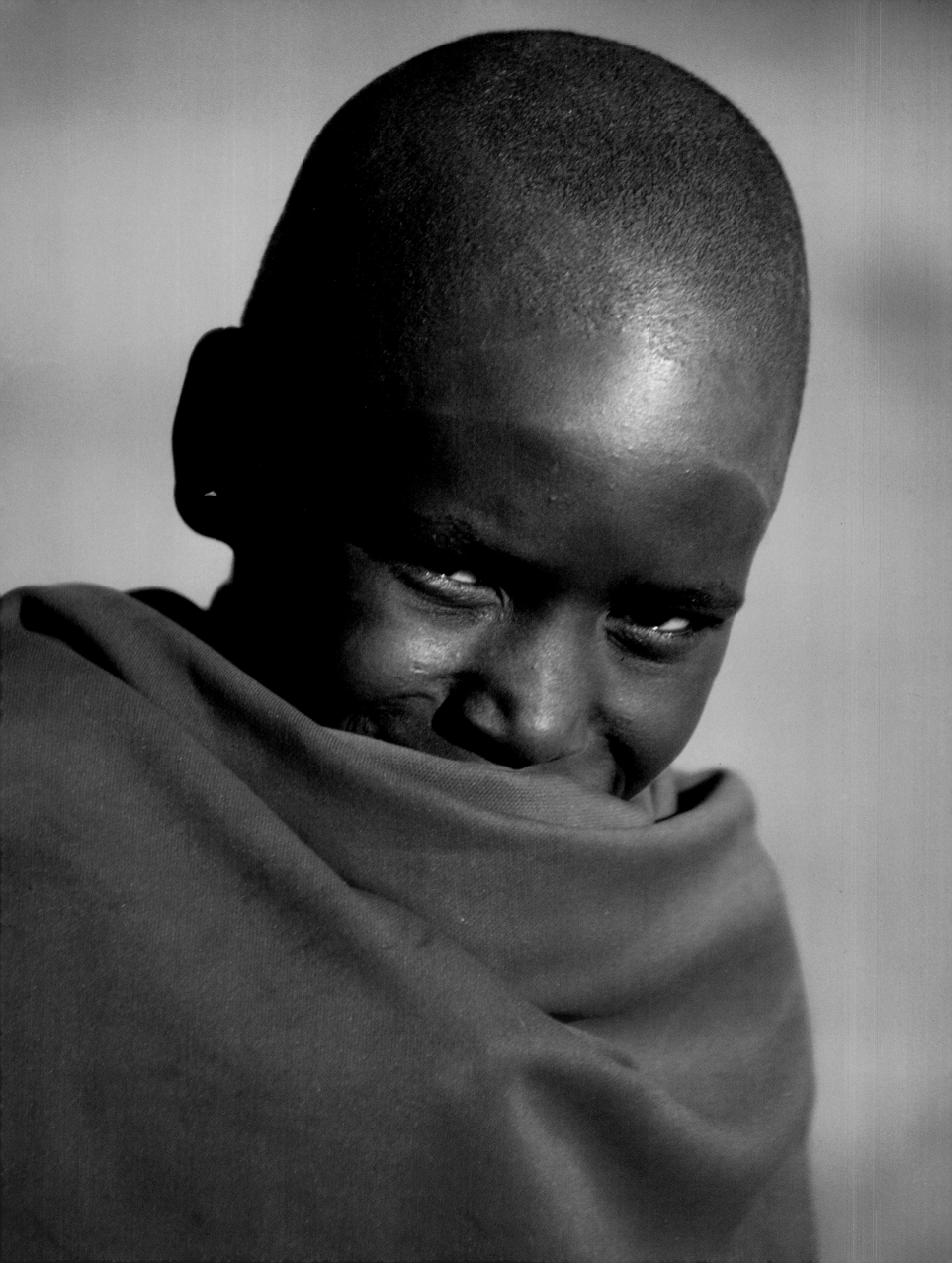

LODO

New Warriors and New Elders

During the months leading up to *e-muratare*, the whole community works itself up into a state of nervous tension. In the following months the *lorora* slowly disperses and the feverish tension subsides. The atmosphere changes, the air becomes light and life returns to the calmer rhythms of waking, tending the livestock, eating and sleeping.

By now the newly circumcised boys have discarded their black capes and bird head-dresses and are becoming fully fledged warriors. Some of the youngest alternate between the shyness of boyhood and the pride of a warrior. They wear long loops of beads over their shoulders, but often their shoulders are not broad enough to keep the beads in place, and the boys have to keep pushing them towards their necks to stop them slipping off. Gradually, they learn to pace about, their hair begins to grow and little by little the new warriors slowly change from boys into men.

A few of the new warriors boast of lion kills and wear with pride a claw around their necks. Sometimes they purposefully scar their legs or arms, often as the result of a dare, and consider the marks with manly pride and considerable vanity. To be held in the highest regard by their peers is important, and thus they relentlessly and arrogantly compete for honour. They also continually test the elders. However, if they go too far they are quickly put in their place. For example, occasionally a young warrior will slaughter and eat an elder's goat without the elder's permission. As soon as the transgression is discovered, the elders call a meeting and discuss for hours the penalty the young warrior must pay. As they try to find their place in Samburu society, the new warriors tread a fine line between seeking recognition for their strength of limb, their noble character and their valour, and taking every possible advantage. The elders in turn calmly do as was done to them: they enforce discipline and keep the young warriors in hand.

Thus the Samburu cycle continues and the whole community moves on to new roles. The girls become brides and the married women move on to become mothers of *lmurran*; the circumcised boys assume their role as warriors and the older warriors move on to become junior elders.

The transition from warrior to elder is a gradual process. After a warrior has taken a bride, the girl remains for a while in his mother's house. Then in her own time she will build her own house and have her own entrance to the village and begin to establish her status as a married woman, even though her husband does not yet eat or drink in her presence. It is usually only when she has given birth to one or two children that her warrior husband will cut his hair and perform the *lodo* ceremony at which he drinks milk and eats meat in his wife's presence for the first time in the manner of an elder. Elders marrying for a second or third time will not perform the *lodo* ceremony with their new wife.

The decision to cut off the long braids of warriorhood is made by the individual. If he feels in his heart that the time to leave *lmurrano* has come, he will allow his wife to cut his hair. Nevertheless, the elders will ensure that a warrior does not wilfully keep his hair and thus deliberately forestall his progression into elderhood. In some respects it is a time of sadness when the old *laji* of *lmurran* is about to lose its finery, but the new generation is ready to take over and some of the young warriors already begin to stand prouder than their older brothers, to dance with more enthusiasm and to sing with more gusto.

The wife cuts her warrior husband's hair inside her house before their *lodo* ceremony. The event is witnessed by the husband's companion. He places a little water and milk on the man's

lorika, with which the wife wets her husband's scalp. She shaves her husband's head and places the hair on the stool. From this moment, the stool is regarded as the seat of an elder and will remain within the wife's house. The following morning, the wife wraps the hair in a cloth and gives it to the man's mother.

Within the next month or so, the mother of the former warrior will travel to flowing water, preferably the Ewaso Ngiro River, and there cast her son's hair into the water. Once she has found a suitably quiet spot on the riverbank, she will begin this intensely private ceremony, which she performs alone, and in which she bids farewell to her son's warriorhood and accepts that he will now eat with his wife and become an elder. The hair quickly sinks and she pours milk from an *nkarau* on the water, silently praying to Ngai and asking for his blessing. The man is now free to perform his *lodo* ceremony.

The *lodo* ceremonies occur close to a full moon. It is an emotional ceremony for the man, who has not eaten in a hut or *nkang* or in the presence of women for the duration of his warriorhood. Once all those taking part in the ceremony have assembled, the husband and his contemporaries smear ochre on their heads. After sundown they make a fire outside the wife's house and brew sweet tea which is distributed to all the elders present. As for all ceremonies, the drinking of tea with lots of sugar is considered vitally important; before the Samburu had tea or sugar they drank only milk.

Once everyone has drunk their fill, two elders of the girl's father's *laji* enter the wife's hut and sit around the fire at the entrance to the hut. Three contemporaries of the husband also enter the hut and sit within the sleeping area next to the the husband and the wife. The atmosphere is solemn. The wife passes a small portion of dried tobacco to each of the elders, who then deliver a blessing while slowly sprinkling tobacco on the fire. The hut fills with the acrid smell of tobacco.

Each elder asks Ngai to bless the house with these words: "Fire grow big, but do not burn those of this hut once children have come; grow warm but do not burn the children. Ngai help to bring children. Ngai help to bring wealth. Ngai bring good health." The wife then gives the two elders tobacco and they leave the hut. Next she removes the lid from a large *nkarau* and fills it with milk. She passes the milk for her husband to drink from her right hand to his right hand. The man's contemporaries tell the woman to watch her husband as he drinks. The husband spits on his chest three times, or on his beads which have been blessed by a *laibon*, and says: "Ngai help me, my wife has not before seen me drink the milk of my cows."

The man's contemporaries then say to the wife: "Now you have seen that your husband has become an elder and drinks from your hand. Look after him, give him food; do not leave him as a man who has no wife. From today we have delivered him from eating with us into your care; it has become your responsibility, he eats from your hand." This exchange is followed by dancing which continues late into the night.

The next morning the men of the husband's *laji* slaughter a fat ram. The two elders who blessed the house the previous night call one contemporary and instruct him to ask the wife which cow she will give to her husband, as they are waiting to hear her pledge. The contemporary calls the woman into her hut and says: "See now the ram is dead. It has died because your husband wants to eat in your house. Do you want your husband to become your husband, who eats from your hand? We want to hear which cow you will give." The wife offers her husband one of her own cows. It is customary for the husband to refuse the first cow and ask for another, until he is offered a cow that pleases him. The contemporary then tells the elders, who oversee all the proceedings, which cow has been offered and accepted, and the feasting continues.

Once a wife has given birth to a son, the husband may give the *lodo* cow to his son to become the first of the boy's cow-line and the basis of his future wealth. Sometimes, if the baby

refuses to suckle, the father will also give the child the *lodo* cow's offspring and say: "This is the cow of your mother and I return the thanks of your mother for giving me food and a cow of long before."

The meat of the ram that was slaughtered that morning is then divided between the men and women in the traditional way. The fat from the neck is placed in an earthenware pot with a little blood and milk and is made into a soup by the men and is eaten by anyone who wishes.

In the afternoon the wife, the husband and his three friends return to the hut. In some clans the two elders also enter the hut and again sprinkle tobacco on the fire and pray to Ngai. The elders instruct the new elders and then leave to eat outside with the other elders.

One of the husband's contemporaries puts fatty meat from the ram on a stick, and cuts it four times. He then smears it on the husband's forehead, down the right arm and the right leg four times. The left side is not smeared as it is associated with the female division of the meat. The first portion of fatty meat is discarded, then the three remaining sections are held out for the husband to eat. Again the contemporaries bid the wife watch as her husband eats. The smeared fat is a sign that the man has eaten with his wife, and begun his move toward elderhood. The man will not wash until the next day and all who see the fat are his witnesses. Then the dancing, uniting the new *laji* of elders, begins.

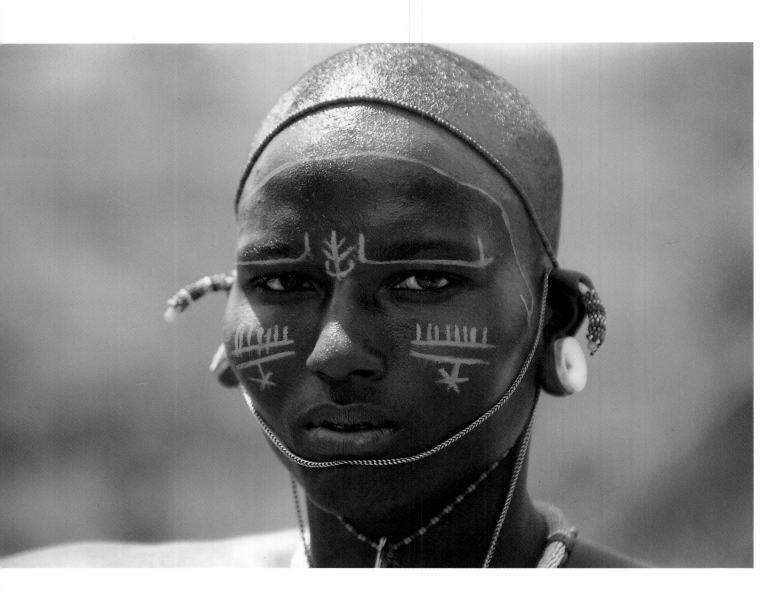

ABOVE: Once the circumcision ceremonies are complete, an air of calm and normality returns to the Samburu as the whole community moves on to new roles and the young warriors begin to take pride in their new adornments and painted faces.

RIGHT: The new warriors start to lose their childish ways and to assume a warrior's pride. The upper rims of this warrior's ears have been plugged with a stick although he does not yet wear ivory plugs in the hole in his earlobes. His beaded jewellery will have been given to him by a senior warrior or by his mother and his female relatives. The feather in his headband is a symbol that he now eats away from the women and the village.

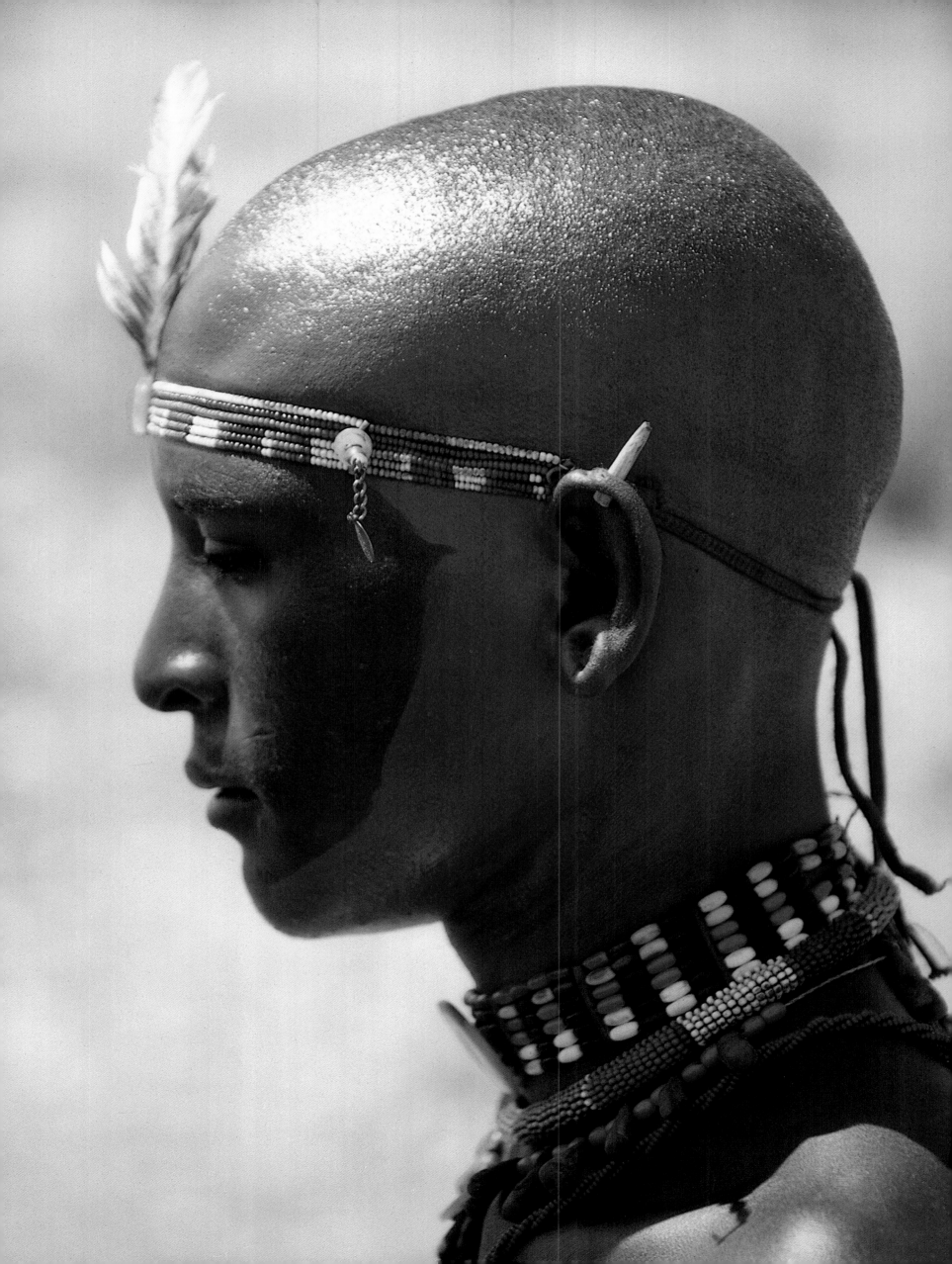

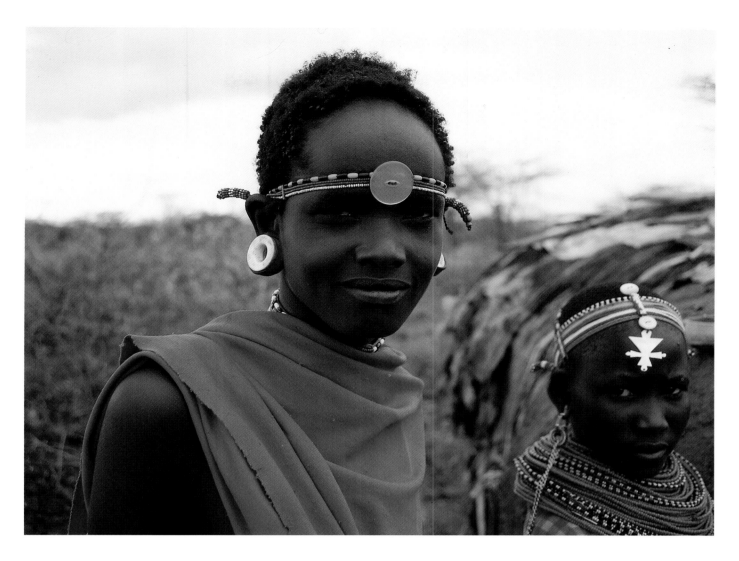

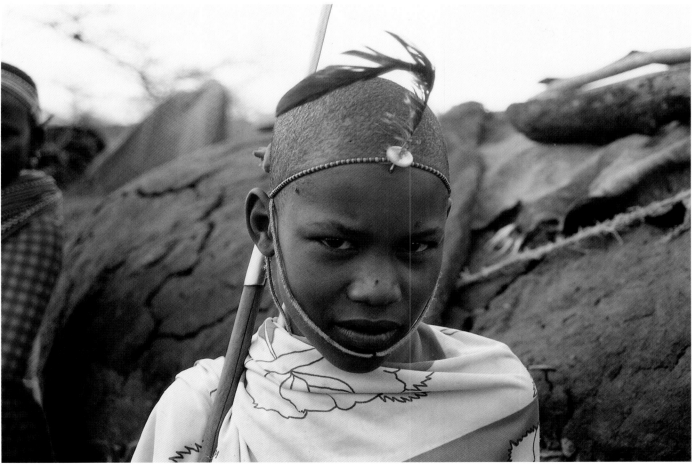

LEFT: Now that the new warriors eat away from the *nkang*, on their occasional visits they are only permitted to drink milk and then only in the privacy of their mother's house. Here a mother passes milk in an *nkarau* to her young warrior son.

TOP AND ABOVE: The hair of the young warriors begins to grow and their face-painting and jewellery will become ever more elaborate.

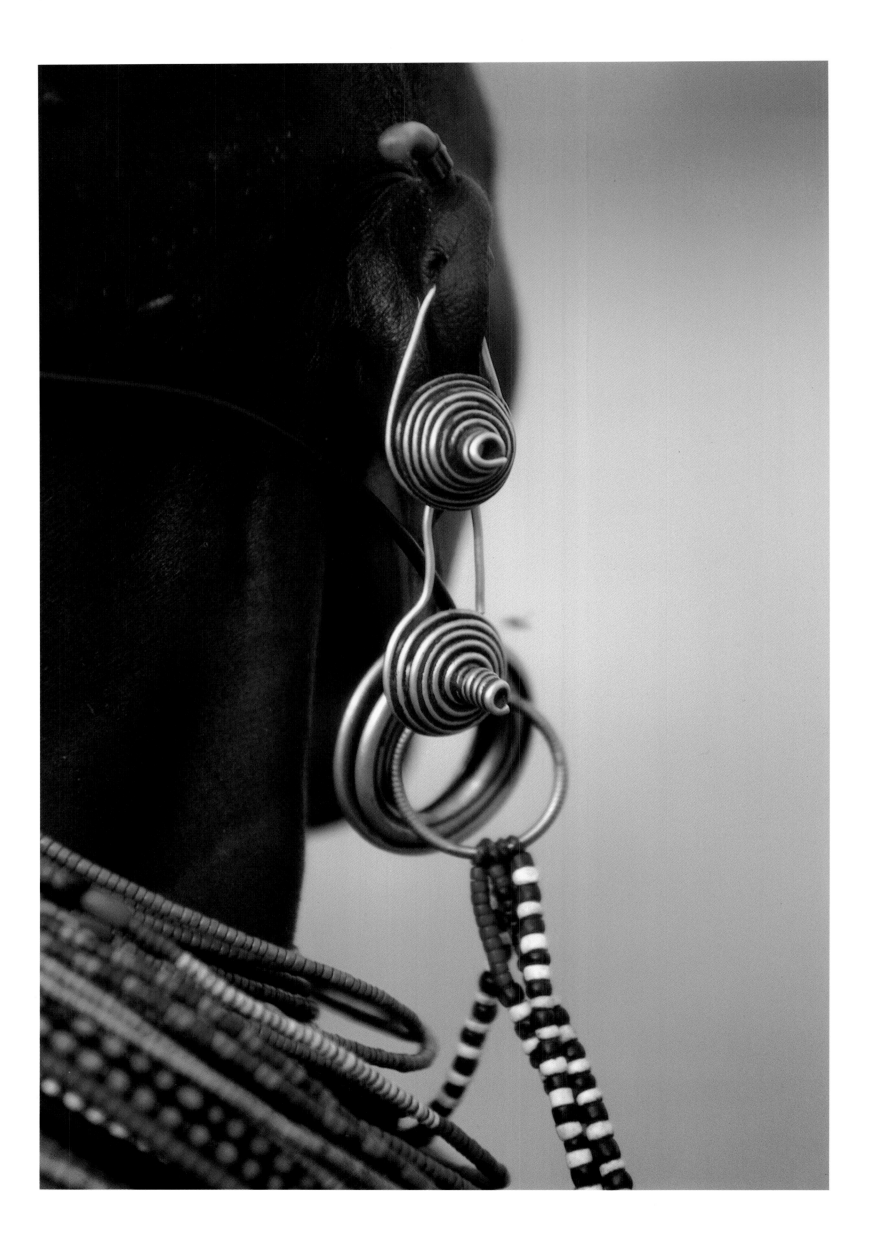

LEFT AND BELOW: The mother of a warrior, especially of the Lmasula clan, often wears her son's ceremonial circumcision earrings throughout his warriorhood. When he is ready to take a wife she returns the earrings to her son, who wears them on his wedding day. The same earrings are then kept by the man's wife until their son's or daughter's circumcision, when he will wear them again. Mothers of warriors wear a double strand of dark blue-and-white beads for each warrior son.

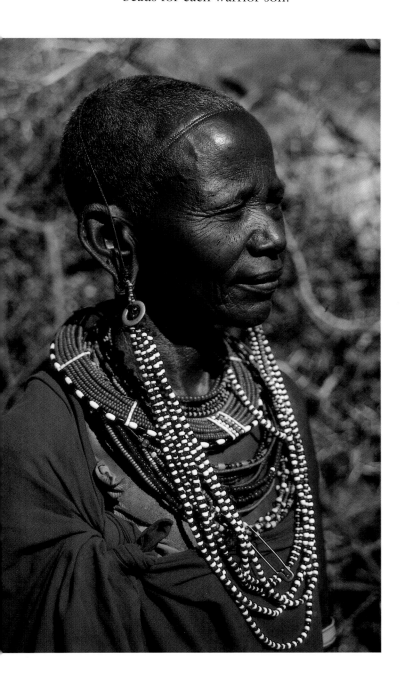

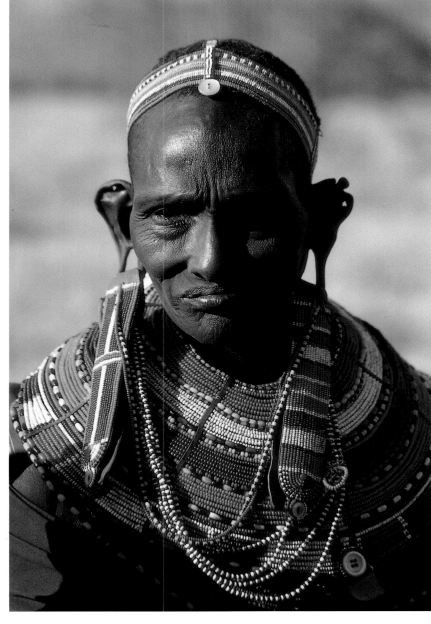

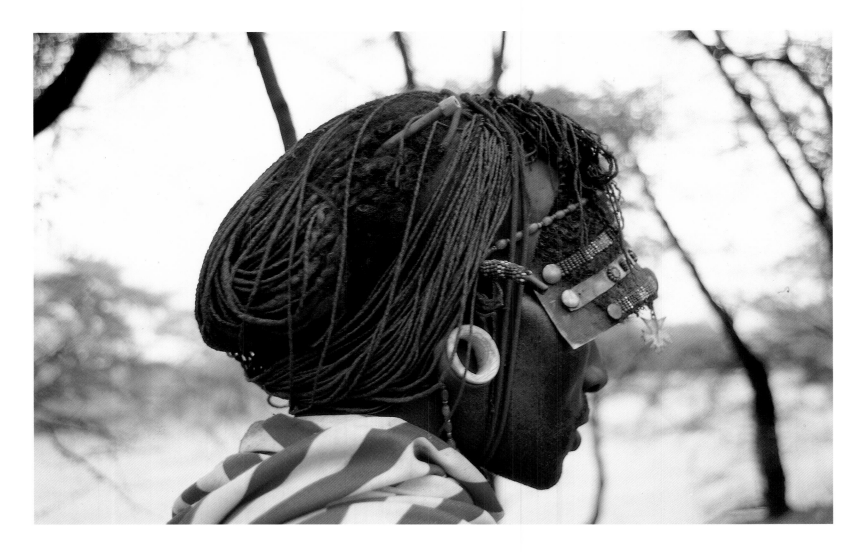

ABOVE: The transition from warrior to elder is a gradual process. The warriors of the previous generation begin to fade and soon their wives will shave off their men's long hair. The passing of warriorhood is an emotional time for both mother and son. *Lmurrano* was a time of strength, pride, elegance, vanity and finery. The cutting of a senior warrior's hair symbolizes the shedding of this carefree existence and the acceptance of responsibility in society as he becomes an elder.

RIGHT: When a mother feels ready to accept the passing of her son's warriorhood, and before his *lodo* ceremony at which his marriage is confirmed, she travels to a river, taking with her her son's hair.

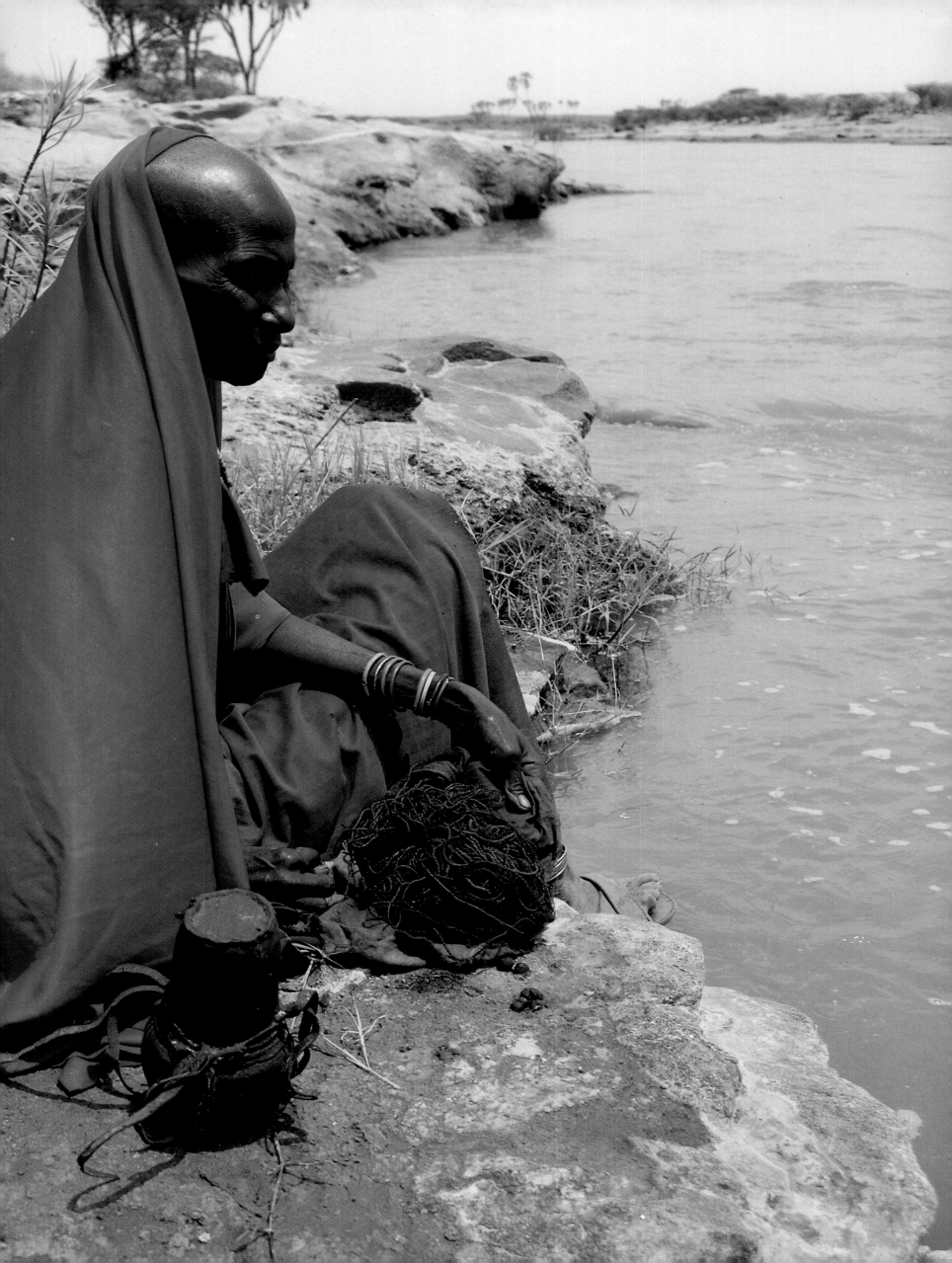

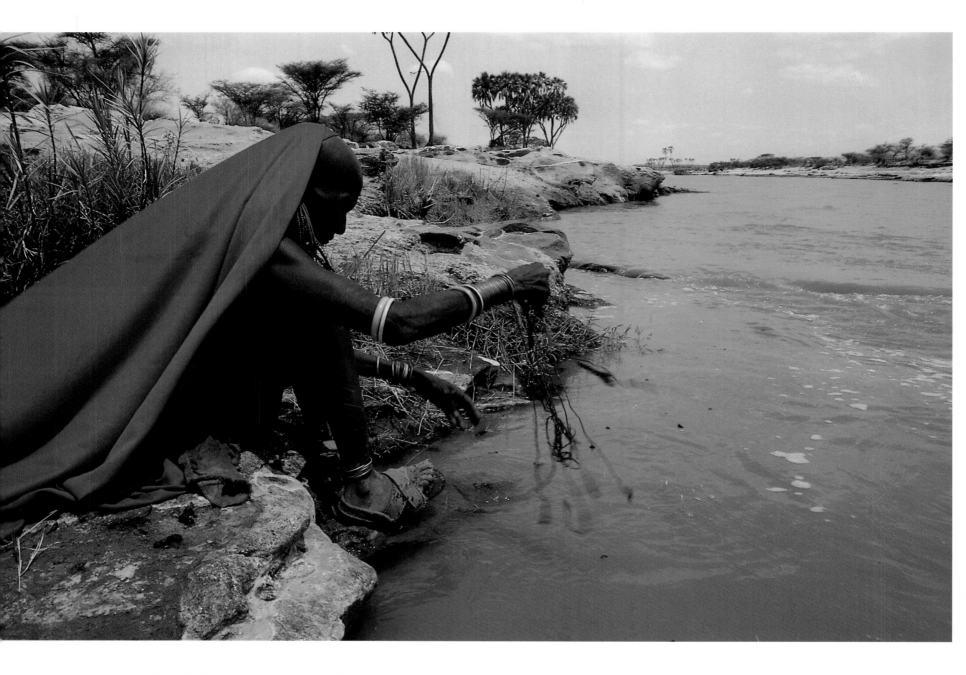

ABOVE: She finds a quiet place to perform a very private ceremony at which she bids farewell to her son's youthful prime. Casting the waist-length braids of her son's hair, a symbol of his warriorhood, into the water, she watches as they sink out of sight in the slow-moving river.

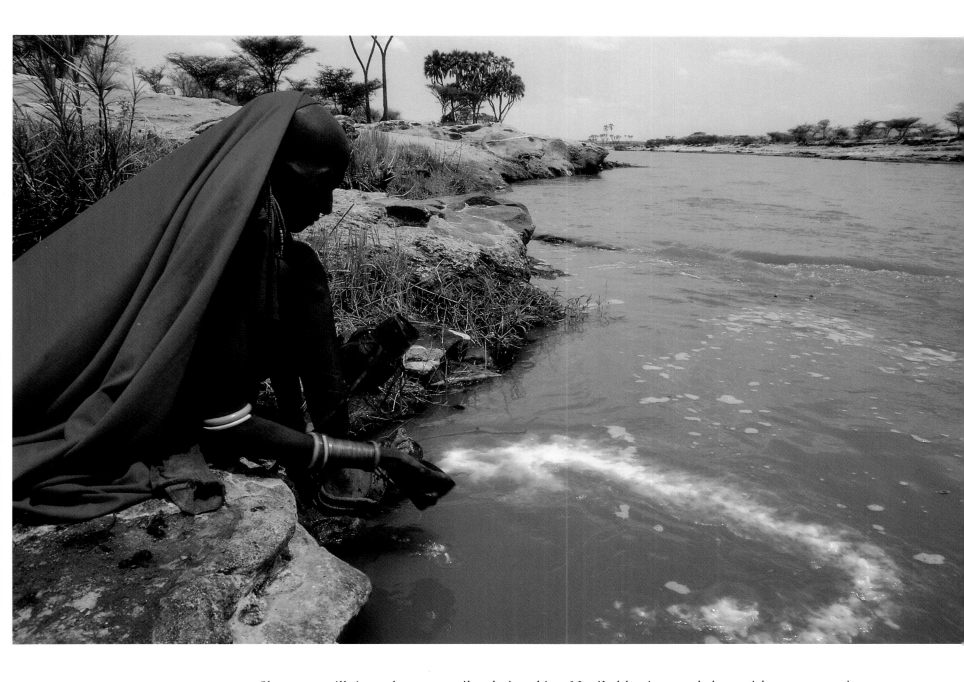

ABOVE AND OVERLEAF: She casts milk into the water, silently invoking Ngai's blessing, and then with great serenity watches the cloth that held the hair float gently downstream, finally accepting that her son will now eat with his wife, live in her house and become an elder.

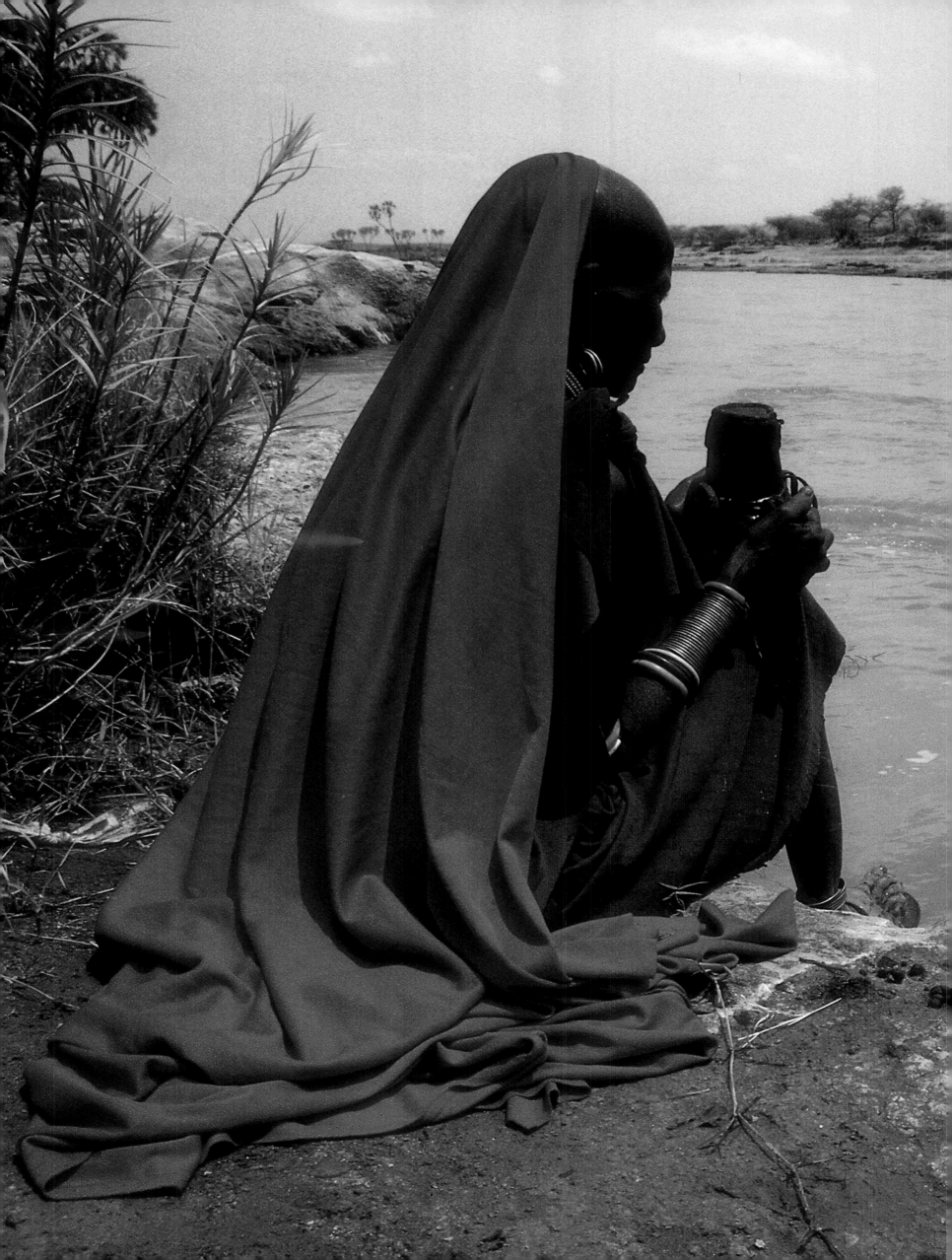

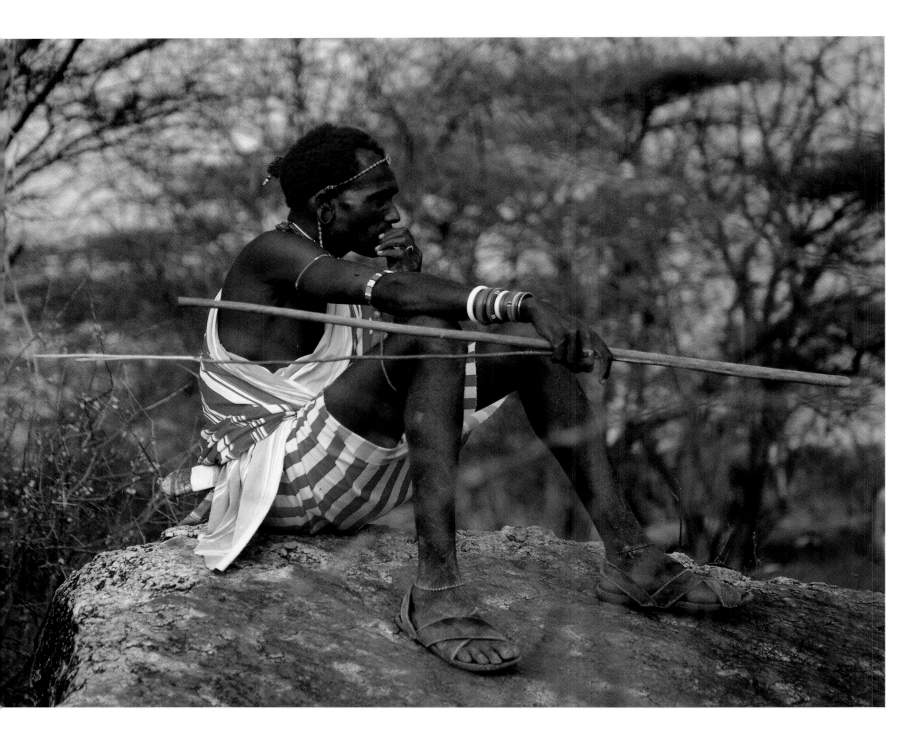

ABOVE AND RIGHT: The older warriors, or young elders, start to spend most of their time within the villages. They begin to debate community affairs and take up their place in the council of elders.

OVERLEAF AND SUCCEEDING PAGE: The elders of the community gather to oversee the *lodo*. The ceremony, which is performed between a man and his wife, occurs approximately two years after their marriage, and only takes place once the man has cut his hair. At the *lodo* a man eats in front of his wife for the first time after eating with his contemporaries in the open for more than a decade. It also marks the time when he leaves his mother's house to live in his wife's house.

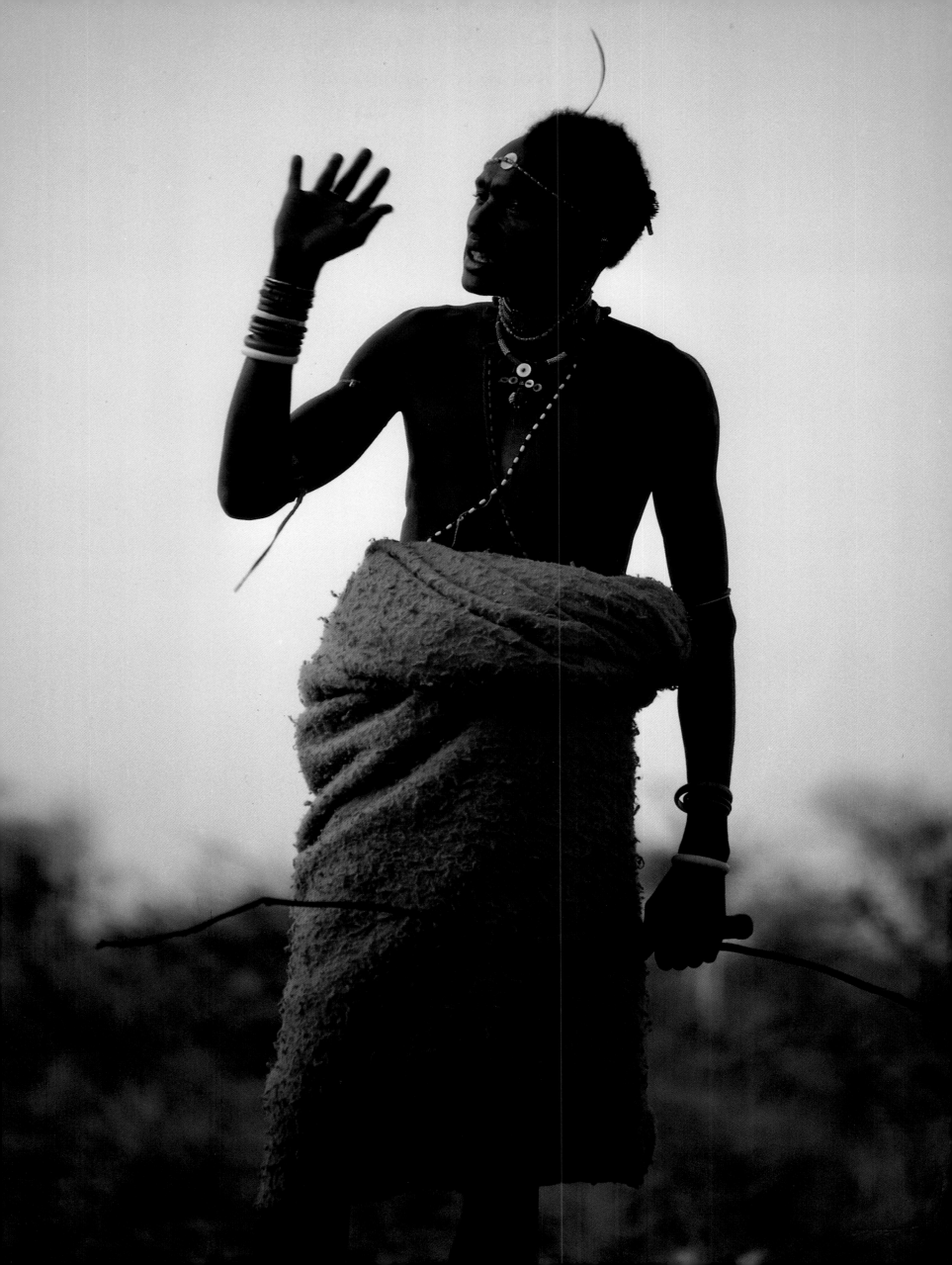

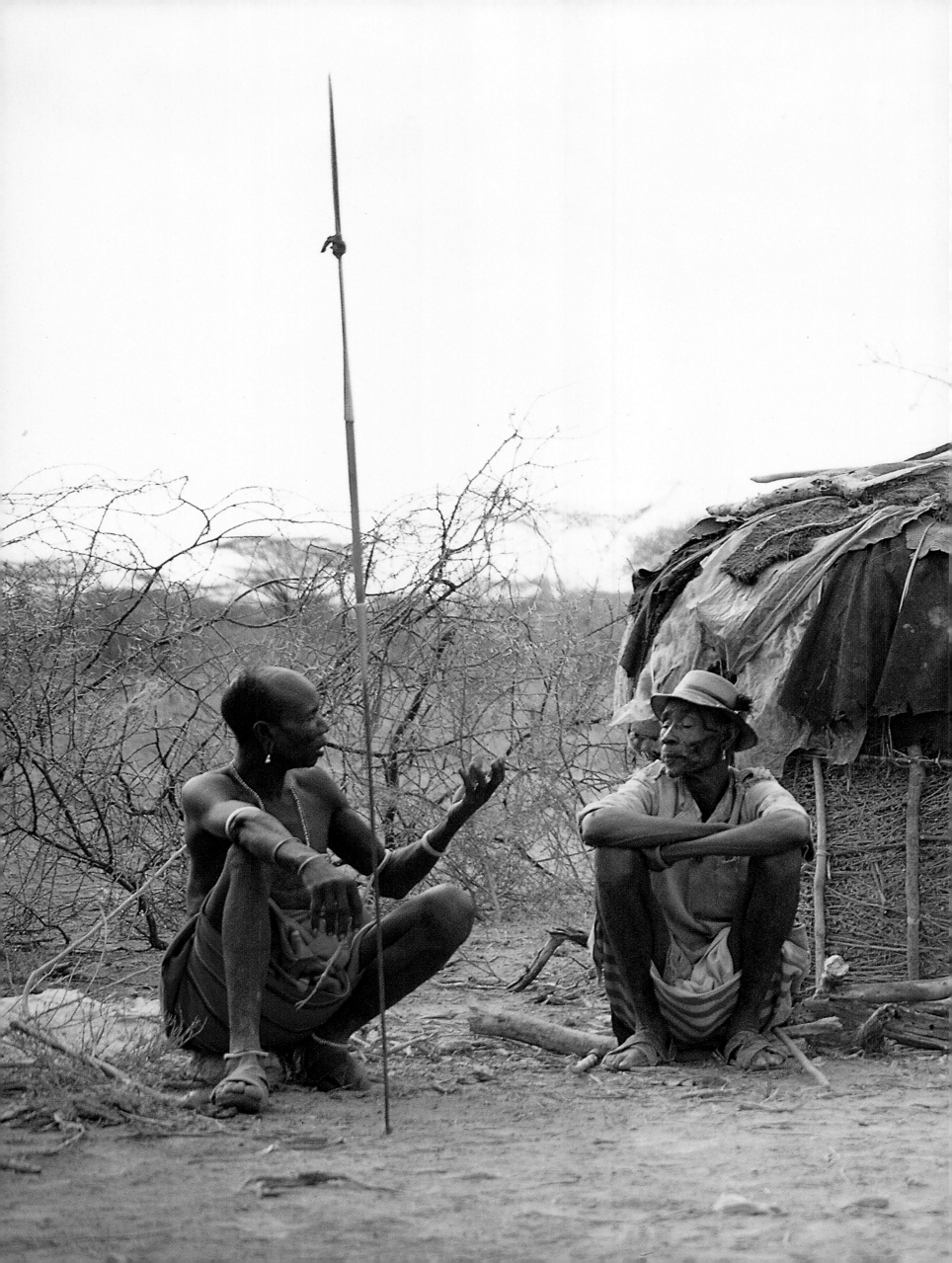

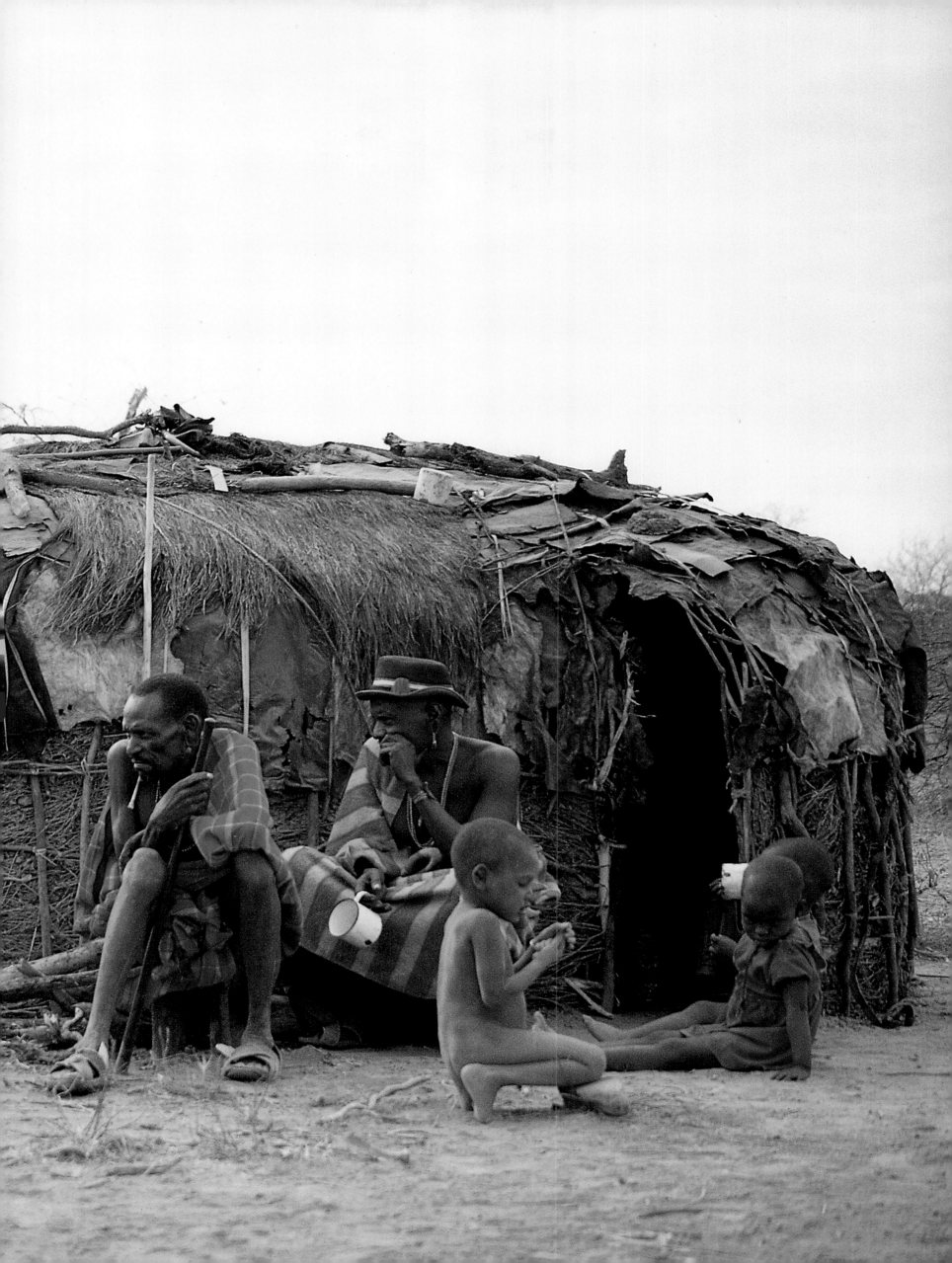

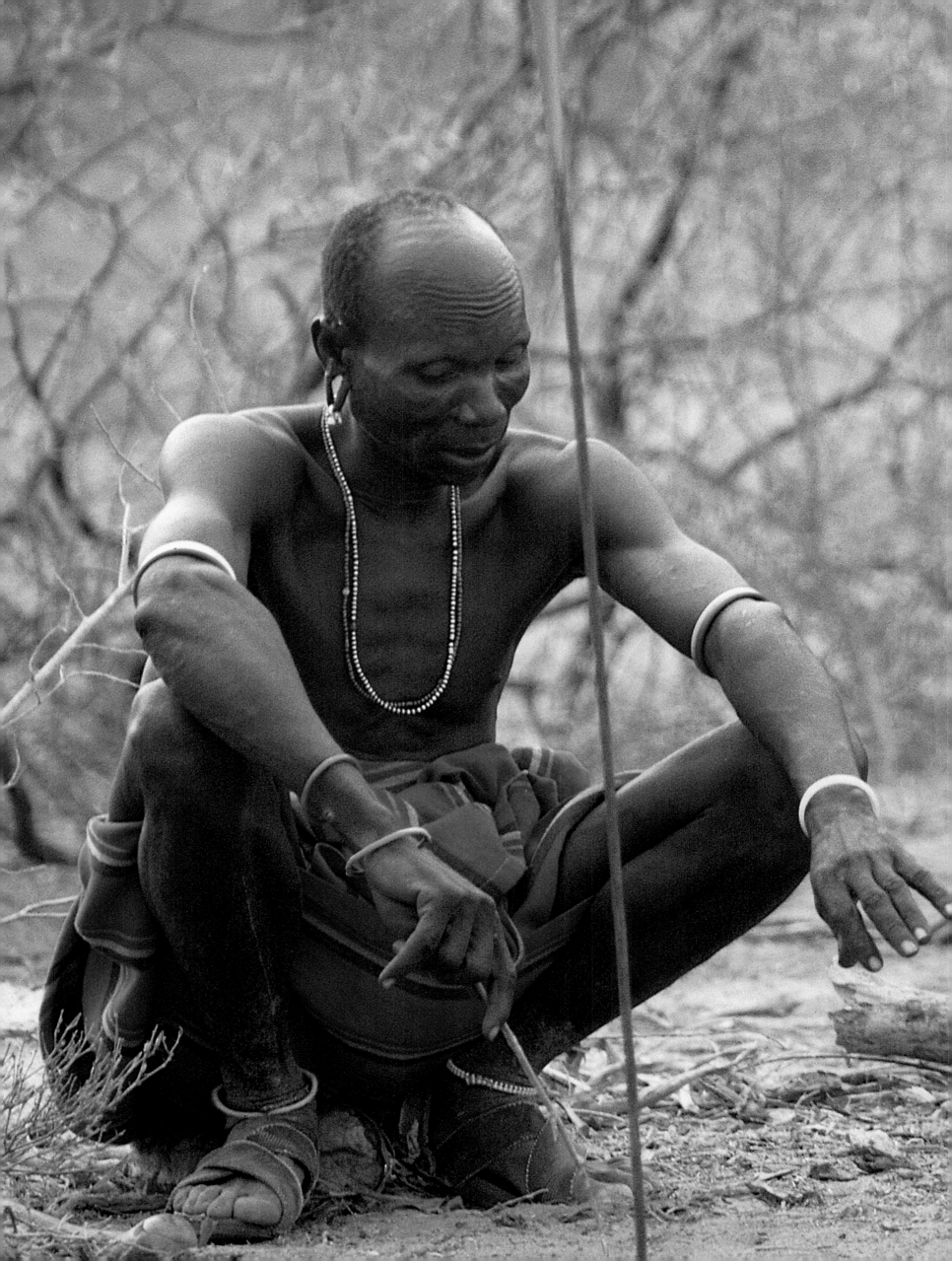

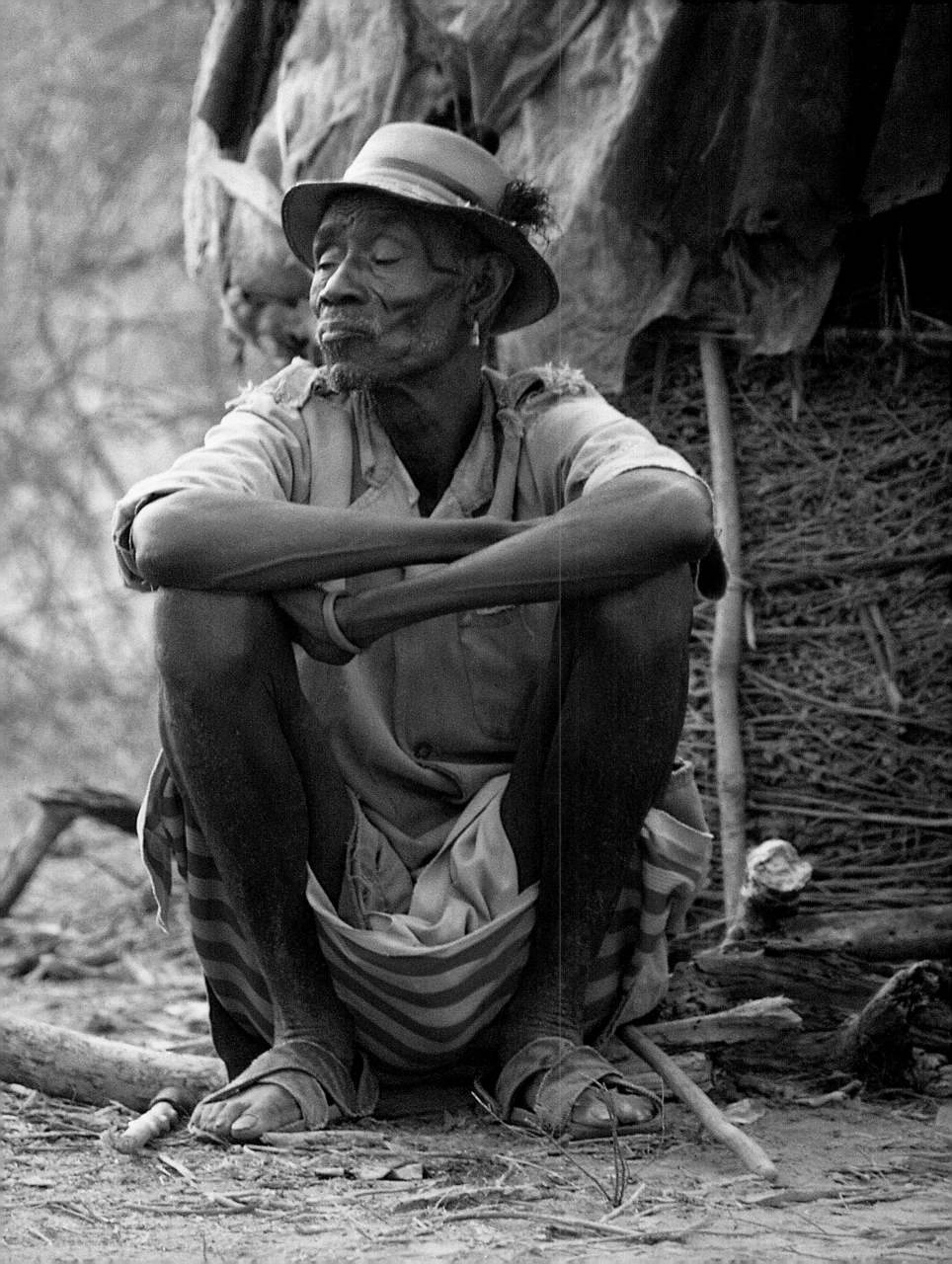

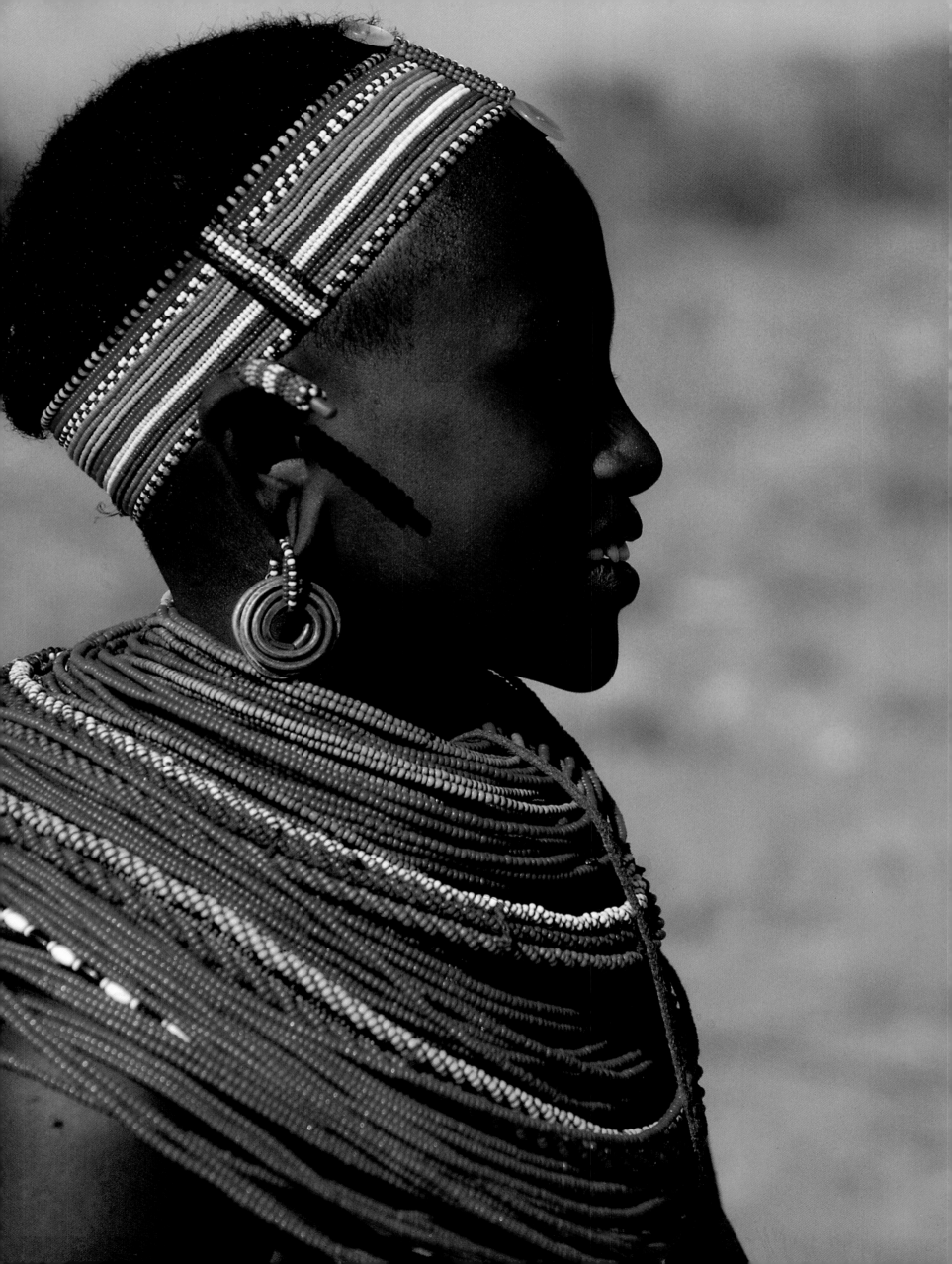

LEFT AND BELOW: The young wives of the new generation of elders begin to assert their place as married women. They will build their own houses, use their husband's entrance to the village and bear children. Occasionally they attach strings of green-and-blue beads to the crowns of their heads as a sign of prayer and reverence. Quite often this will accompany prayers in which they ask Ngai to bless them with children. Once a woman gives birth she incorporates these beads into her necklaces or adorns her child with them. If a woman has given birth to many daughters the *laibon* will bless a beaded anklet, which the woman wears on her right ankle in the hope of conceiving a son.

OVERLEAF: A young wife collects firewood in preparation for her *lodo* ceremony.

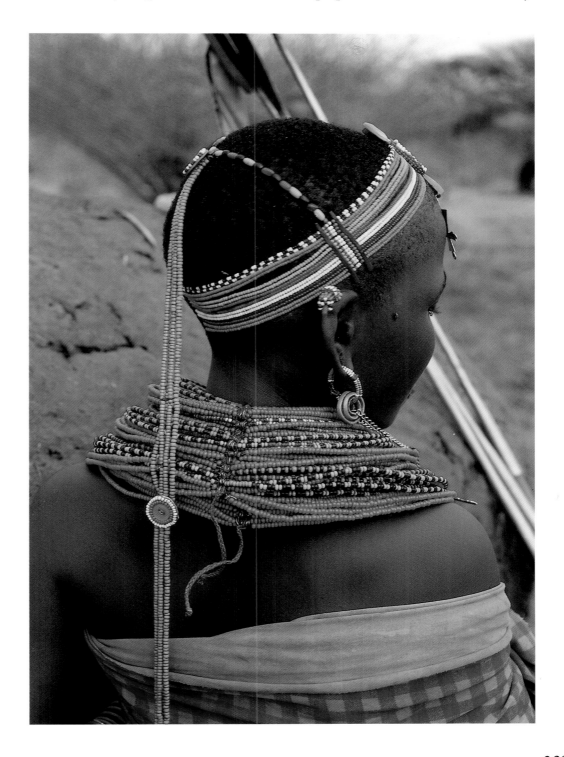

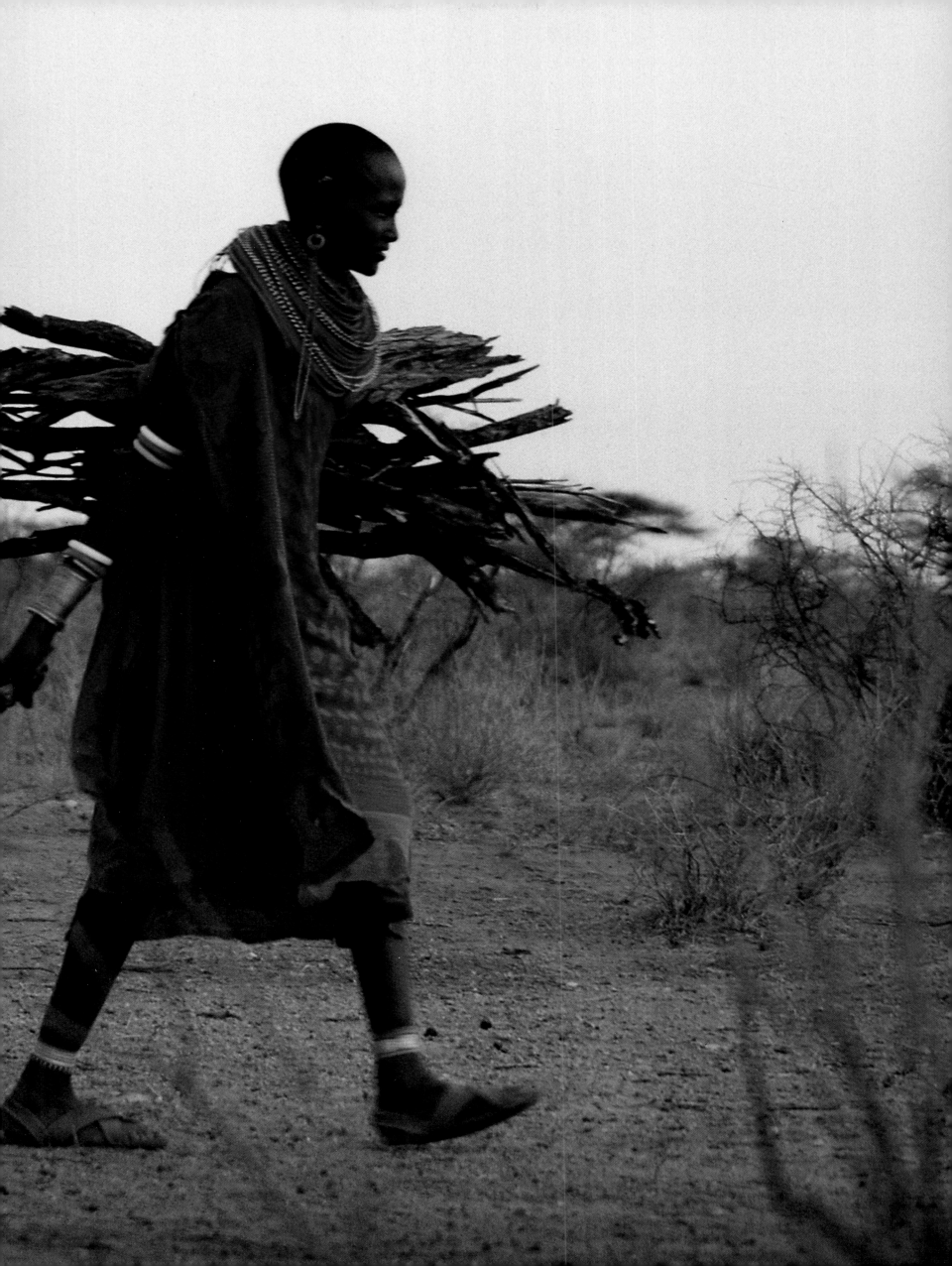

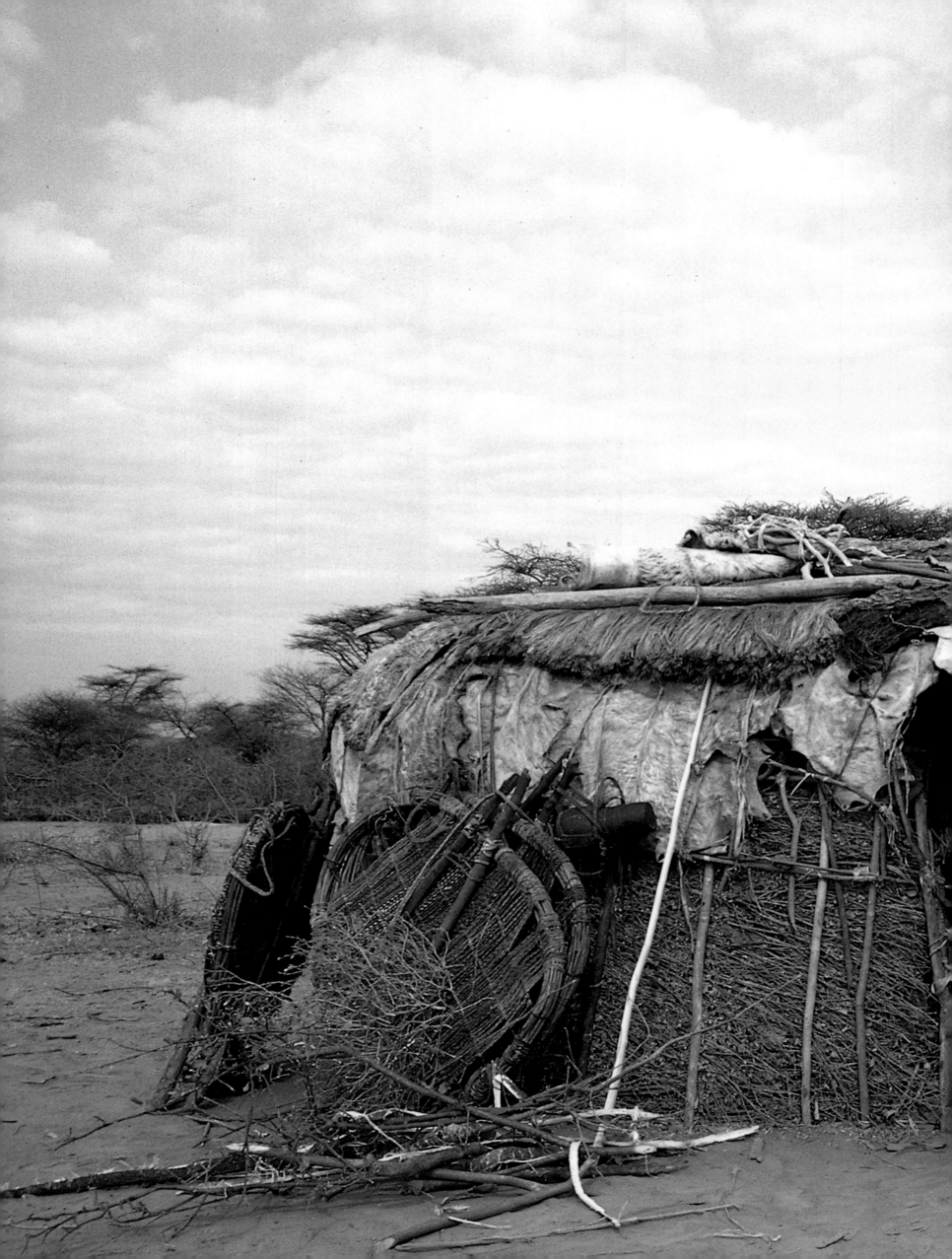

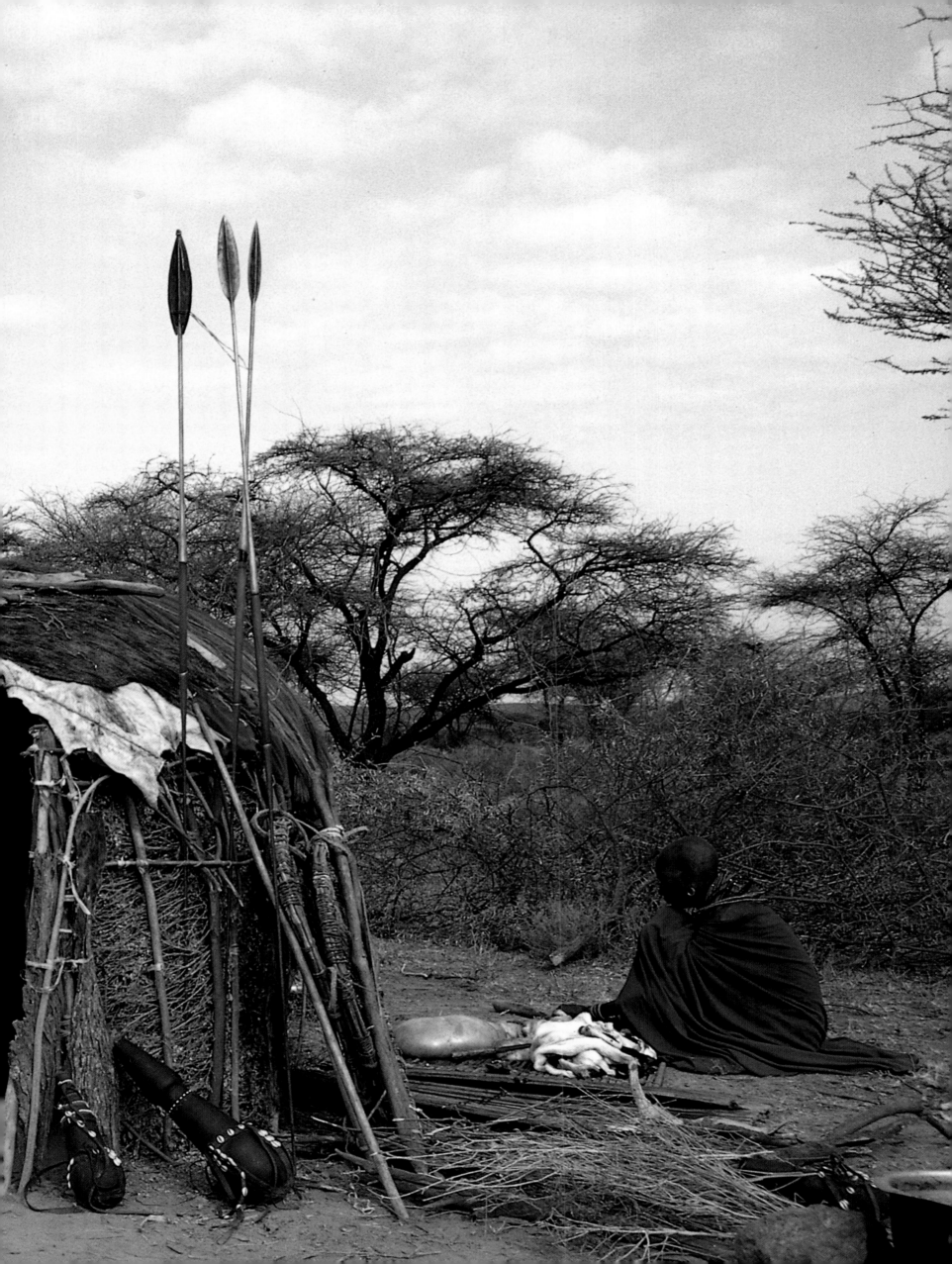

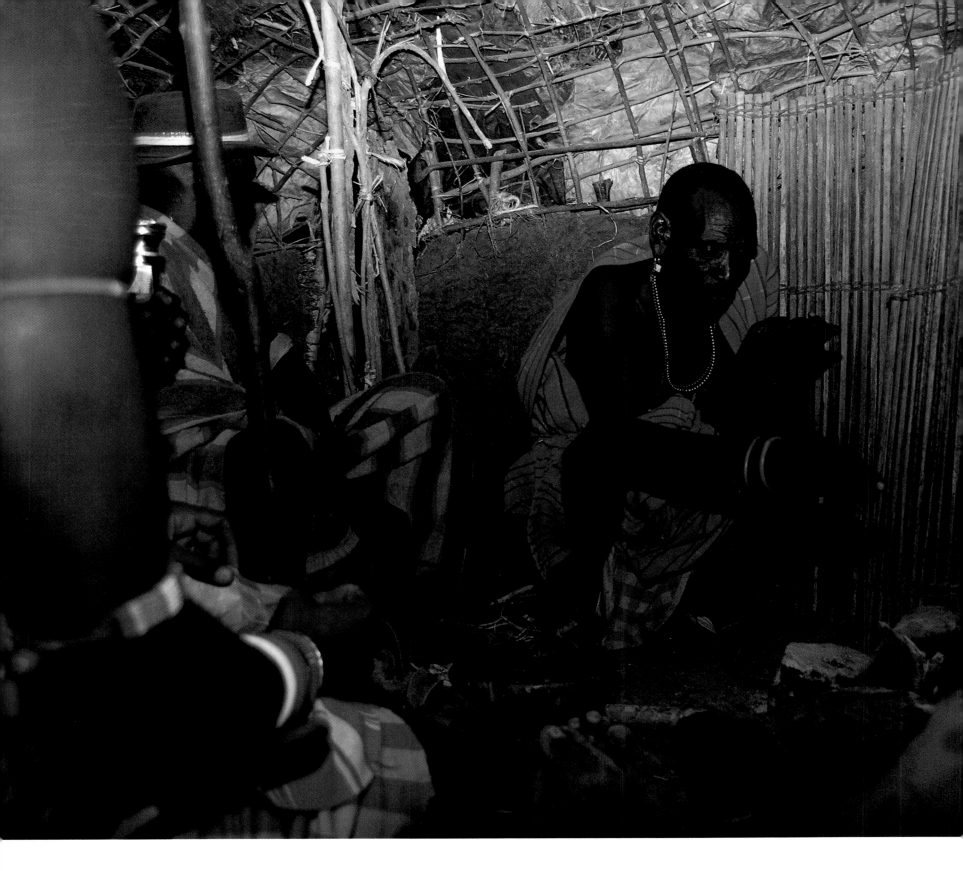

PRECEDING PAGE: The home of a married woman a year or more after her wedding, with its contents stacked outside to make space for her *lodo* which is performed within the house. Her mother-in-law prepares a fatted sheep for the feast.

ABOVE AND RIGHT: Two elders from the wife's father's *laji* sprinkle tobacco on the fire of a married couple to bless their union and home. The couple sits on the raised sleeping area of the house with three men of the husband's generation. With her right hand the wife passes an *nkarau* filled with milk to the right hand of her husband. The three contemporaries tell the woman to watch her husband as he drinks. Her husband drinks the milk and eats meat in her presence for the first time. His three age mates tell the woman to watch her husband as he eats and drinks, admonishing her that his welfare, once their responsibility, now lies in her care.

244

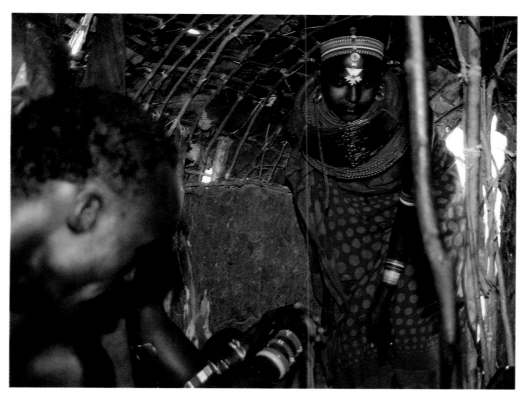

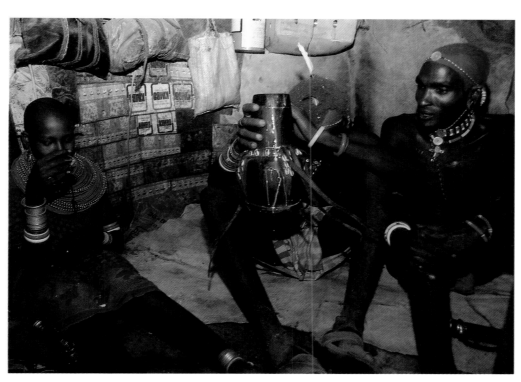

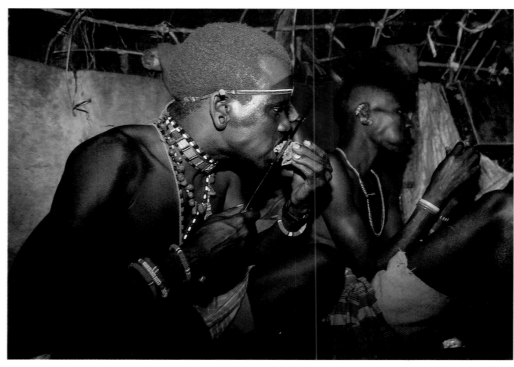

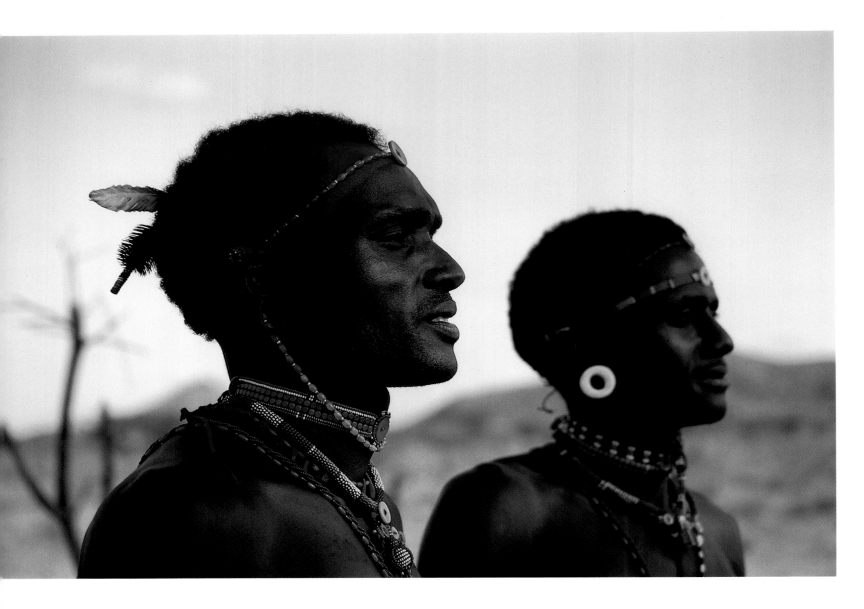

ABOVE AND RIGHT: The old generation of warriors dance together to celebrate a *lodo*. They will slowly discard their beaded jewellery as they become elders and leave warriorhood behind them.

OVERLEAF: The new elders kick up dust as they dance in a tight group, while the women dance to one side.

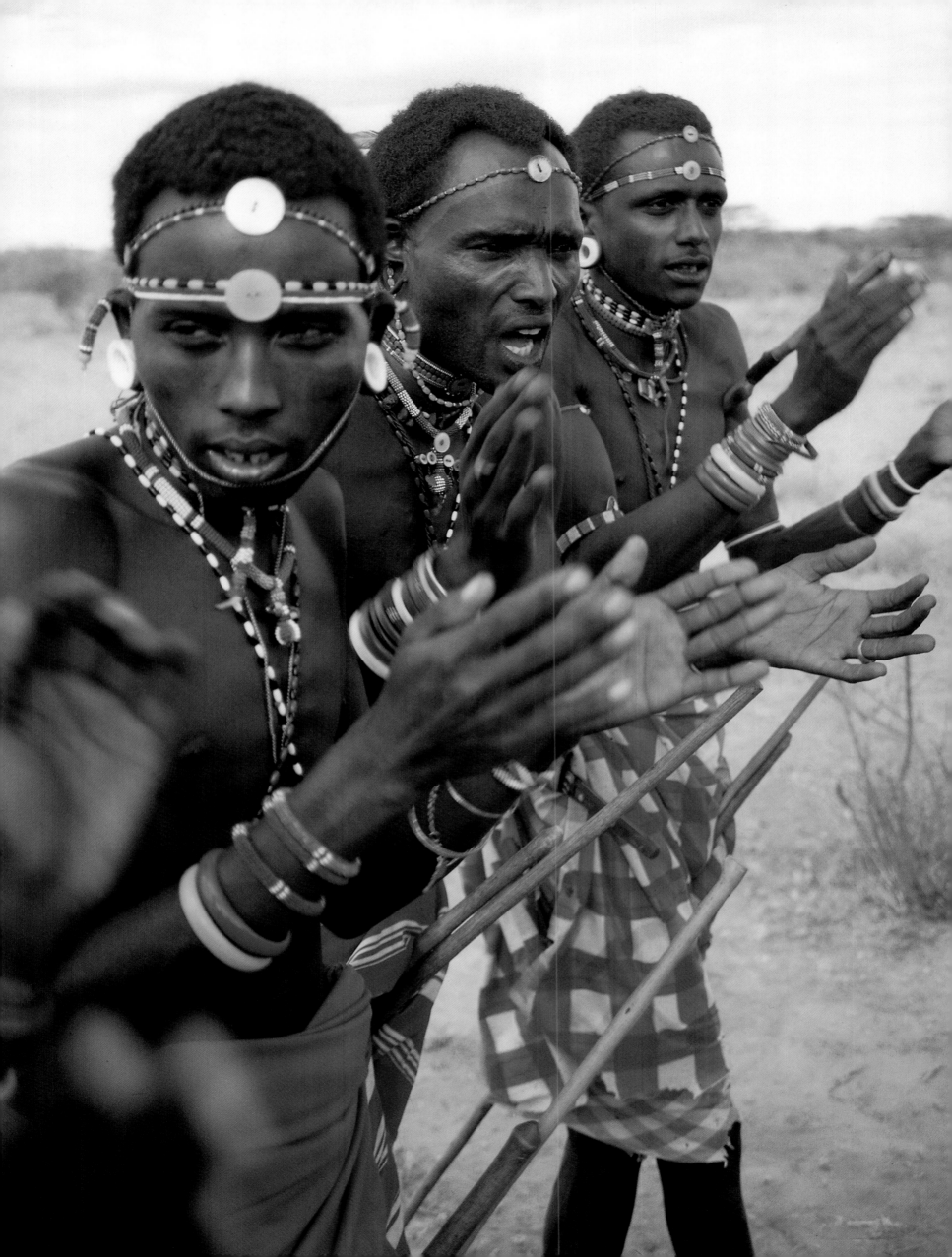

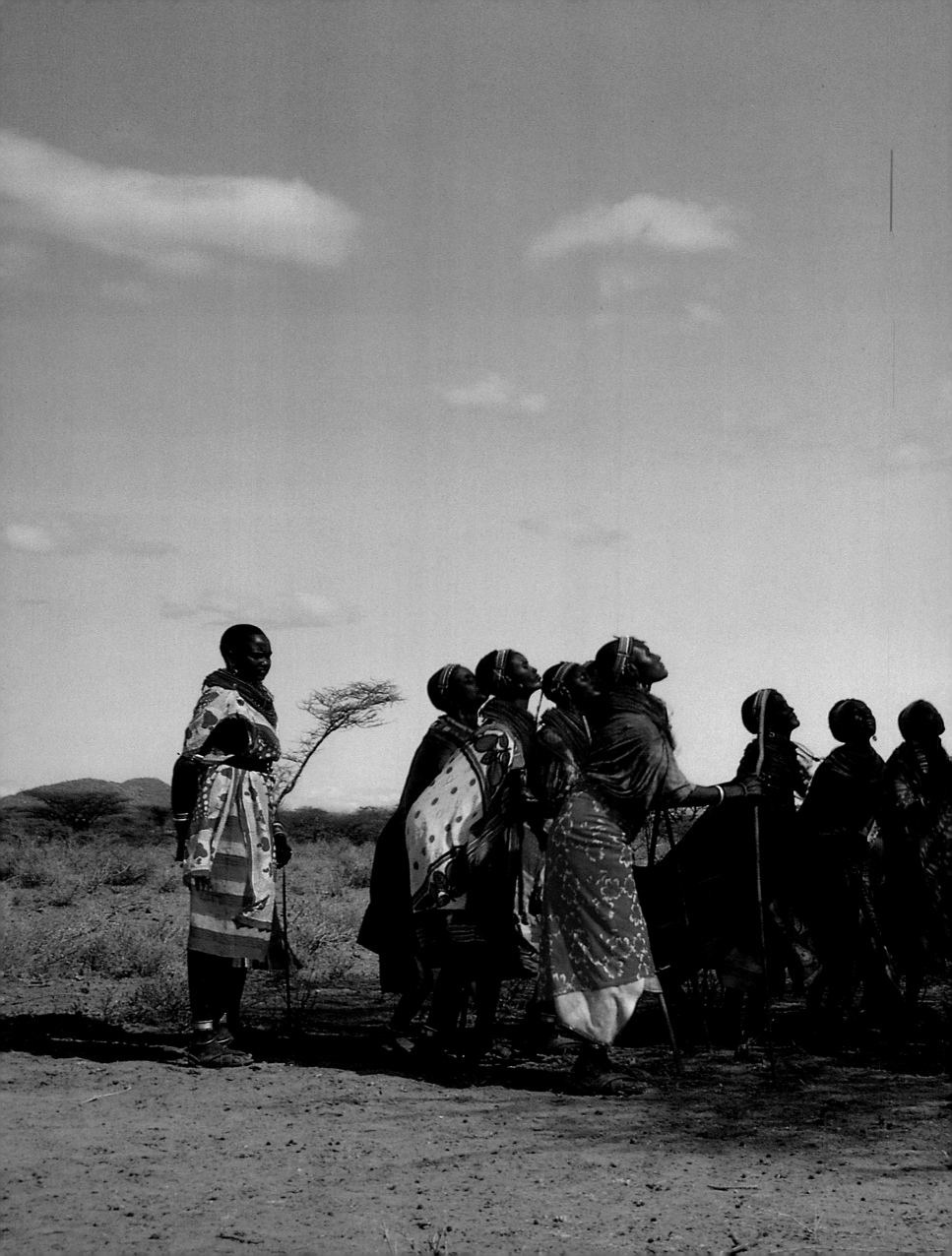

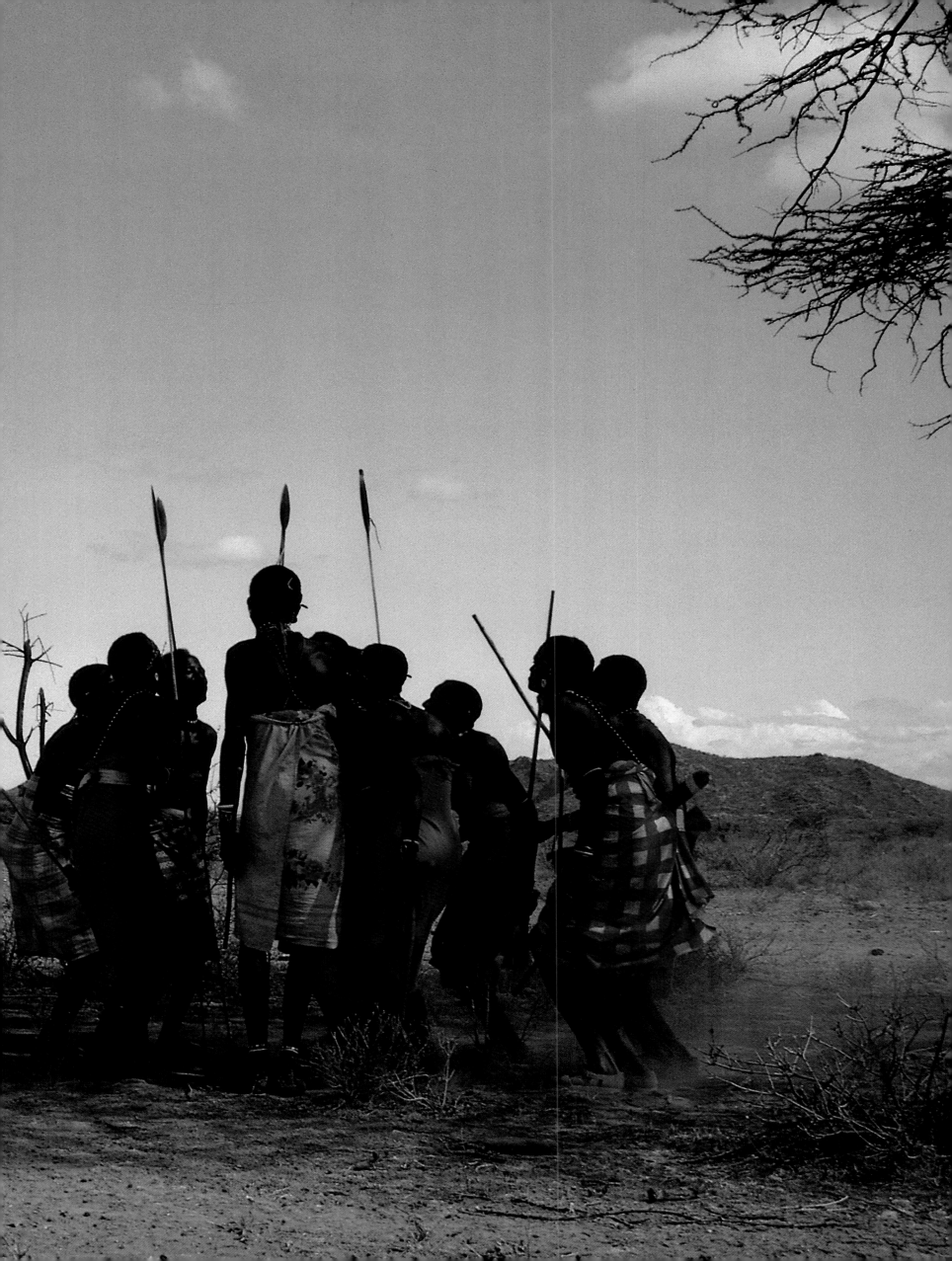

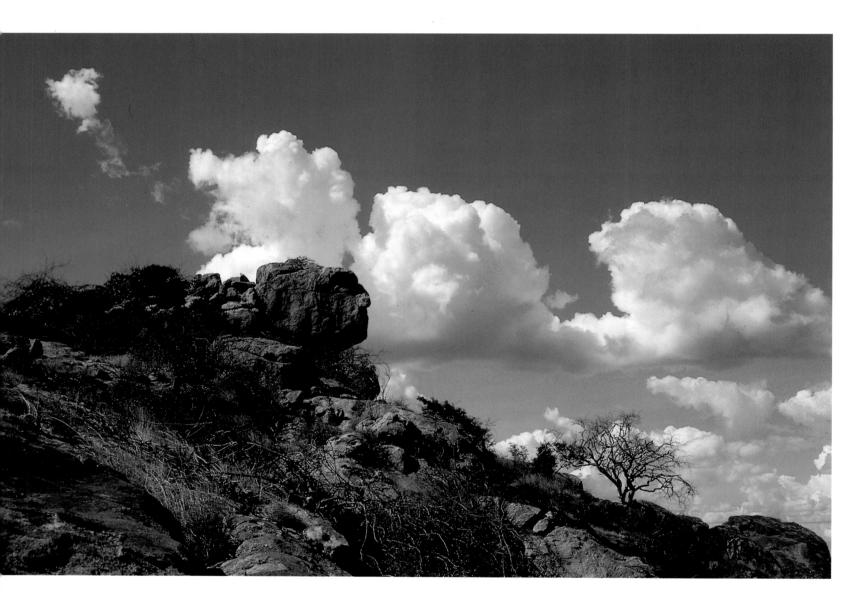

ABOVE: A rocky outcrop eroded by the elements over millions of years.

RIGHT: The new elders dance and leap high into the air.

OVERLEAF: The new warriors begin to grow into their new role. They adjust their jewellery and start to braid their hair.

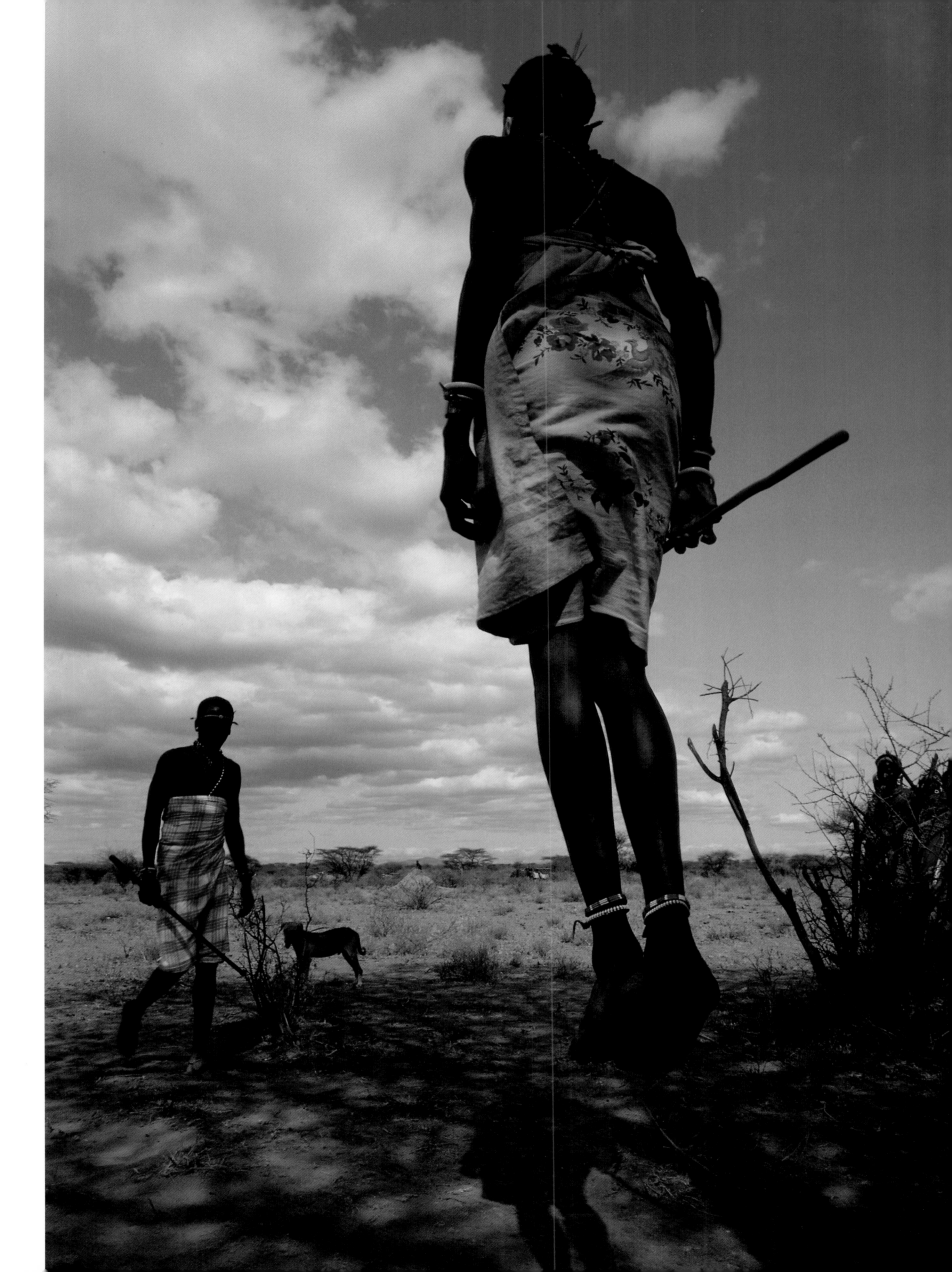

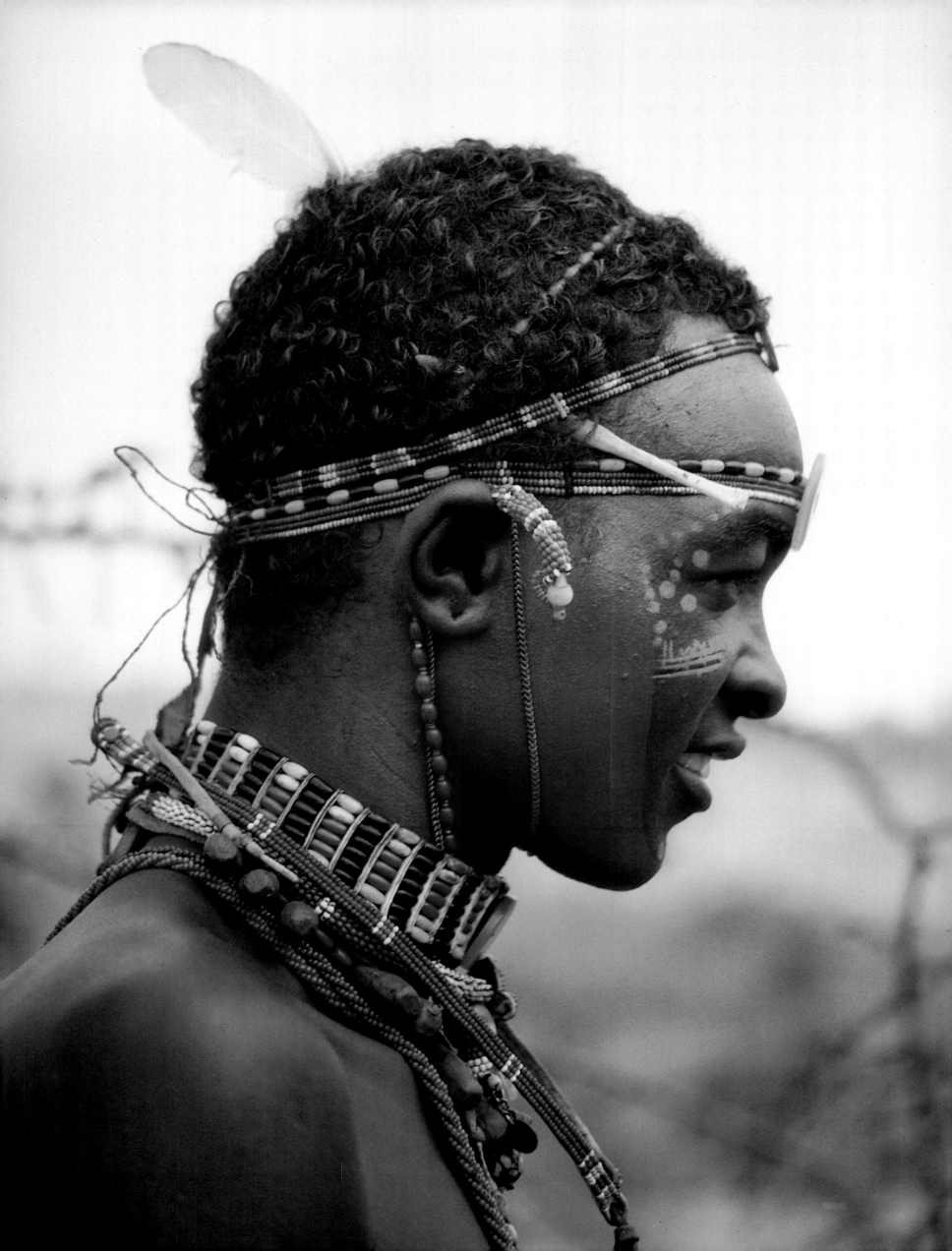

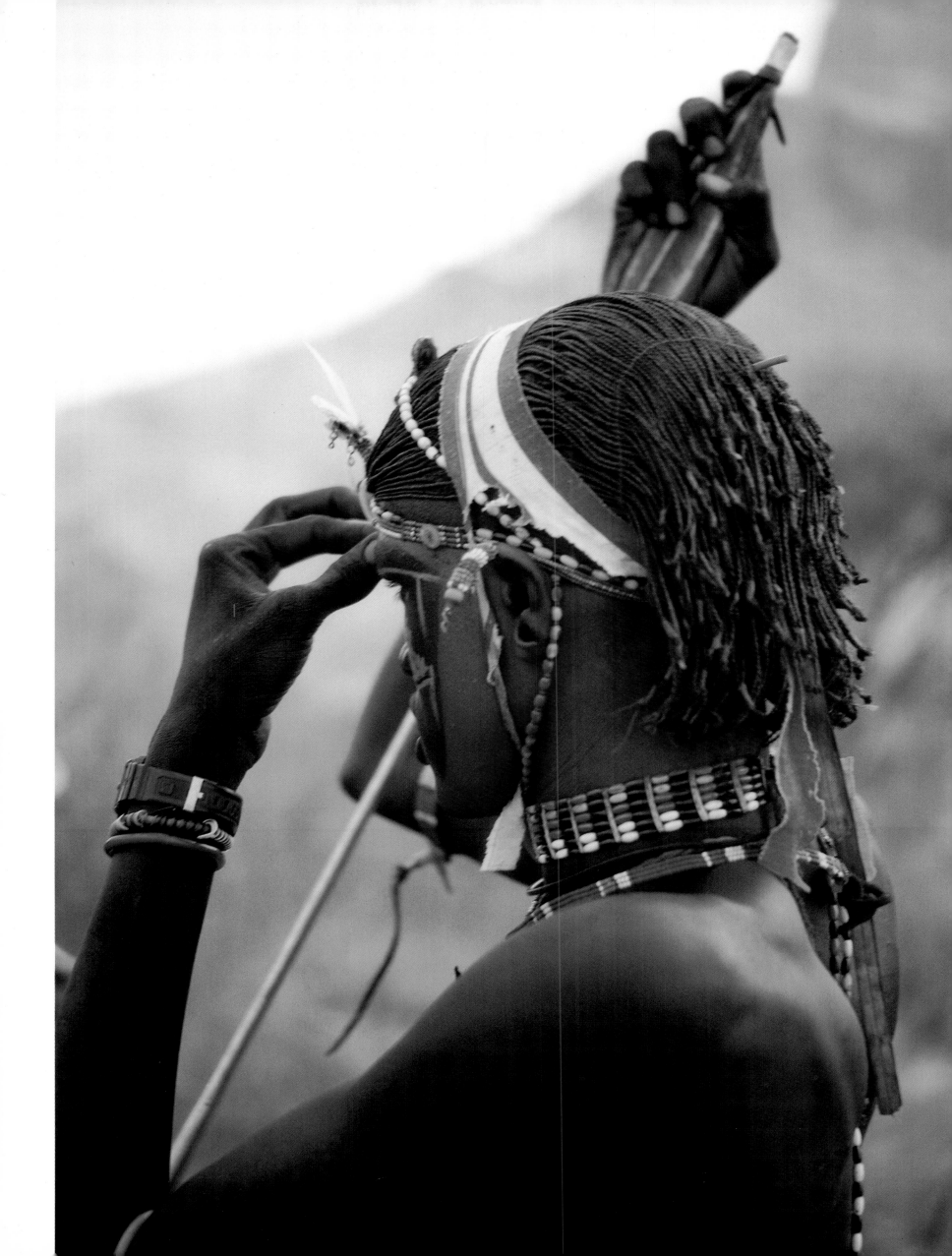

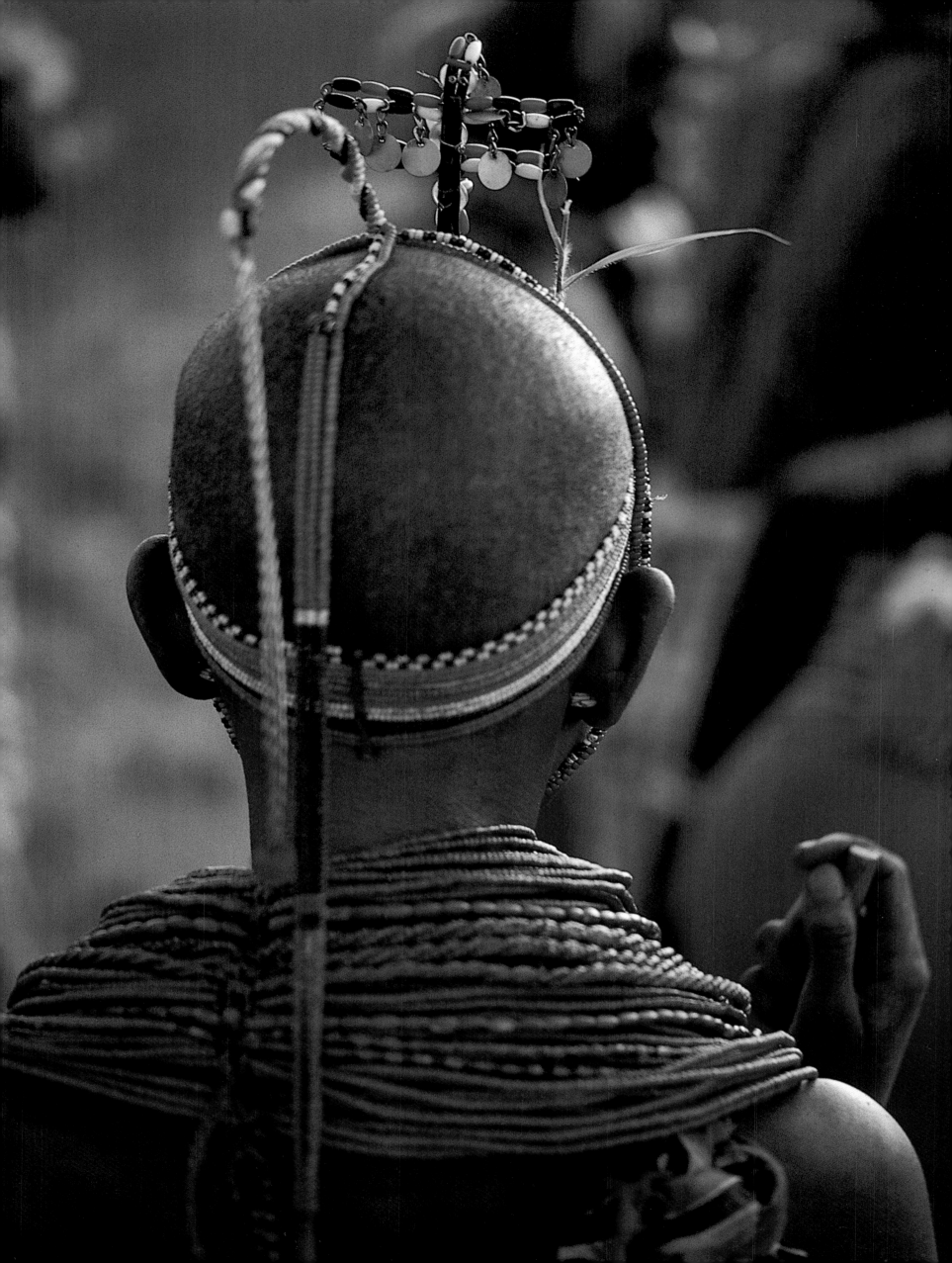

EPILOGUE

Warrior Grace

For generations the Samburu have retained a pride in their unique identity and have lived in harmony with a fragile eco-system which cannot support a static population. They have a natural grace and, once understood, their way of life is supremely civilized. Their land is beautiful, harsh and inspiring. It is a fierce creature and easily tosses aside those it finds fragile, yet it cradles those willing to respect its different facets. However, like so many peoples throughout the world who are steadily being forced to forsake their time-honoured ways, the Samburu, and also their land, are vulnerable to the tide of progress which threatens to overwhelm them.

During the years it has taken to make this book I have seen the Samburu at risk of losing their way of life in the name of progress. Yet progress where? Progress to what? For the Samburu, civilization is living in harmony with their land. I hope that these pages honour their ways and will contribute to their survival.

There is a Samburu legend which tells of some boys who took their cattle to graze far from the elders' village. As time passed they forgot to return, took wives and slowly adopted customs of their own, abandoning *nkanyit*. Living apart from the Samburu, who continued to observe their traditional rites, the boys and their descendants became a separate people.

I hope the legend will hold true, that even though some Samburu may stray there will always be young girls to place green grass in their headdresses, and young boys to answer the call of warriorhood.

LEFT: A young girl, who will perhaps take a lover from among the new warriors, wears a beaded cross which denotes her uncircumcised status. She has placed a fresh blade of green grass in her headdress as a symbol of good fortune.

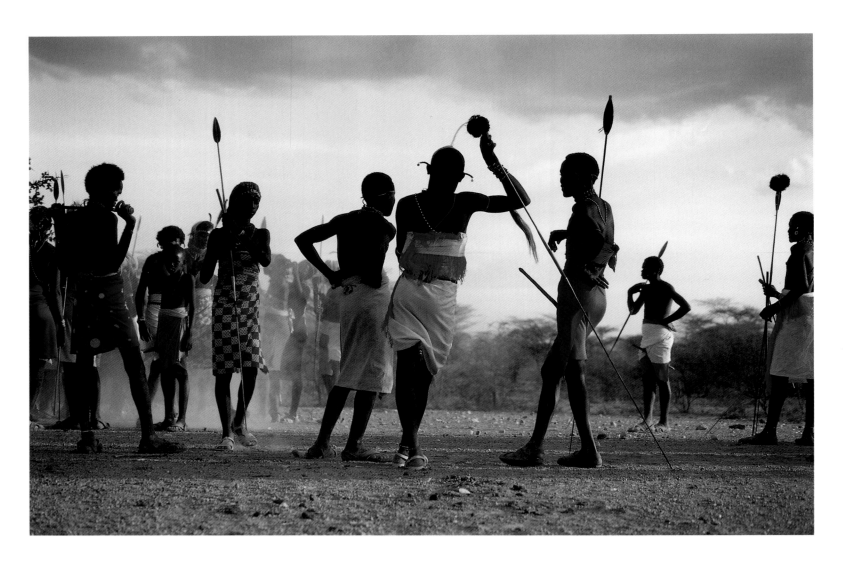

ABOVE: The young men of a new era embark on their time of warriorhood.